VENETIAN Views

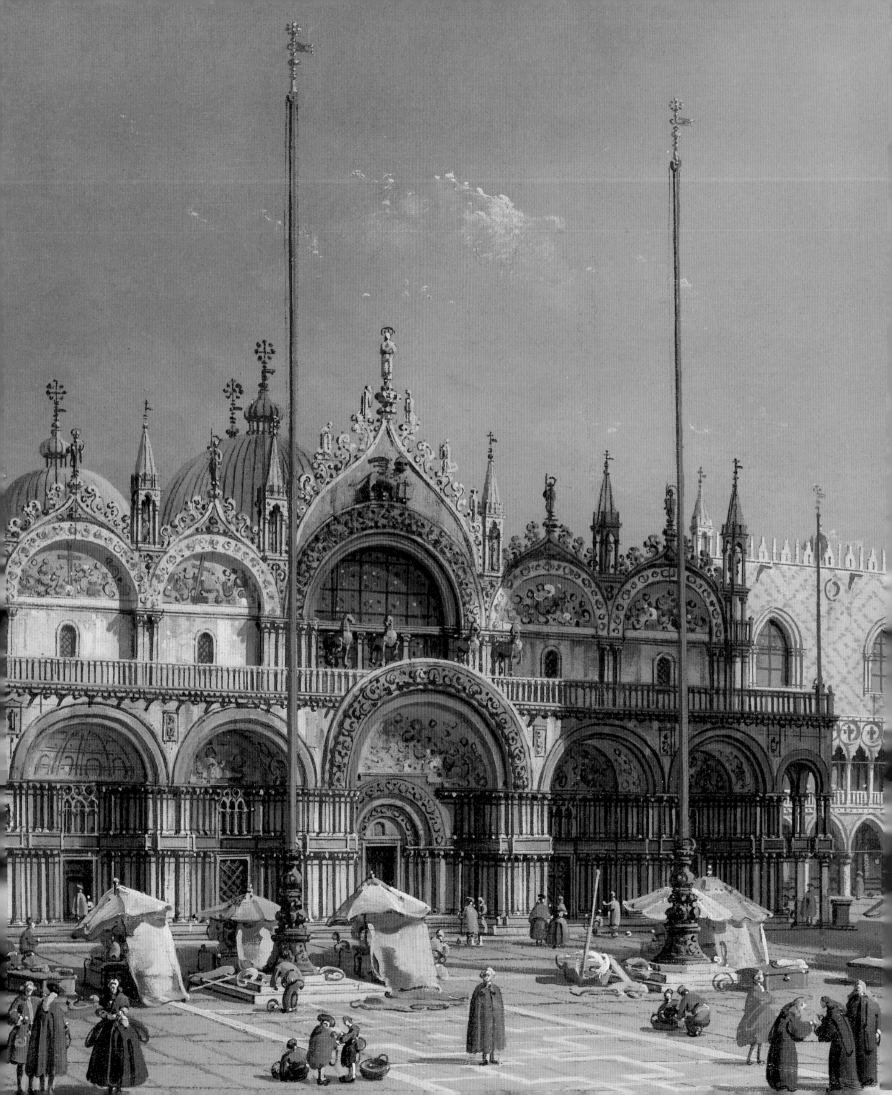

FILIPPO PEDROCCO

VENETIAN *Views*

RIZZOLI
NEW YORK

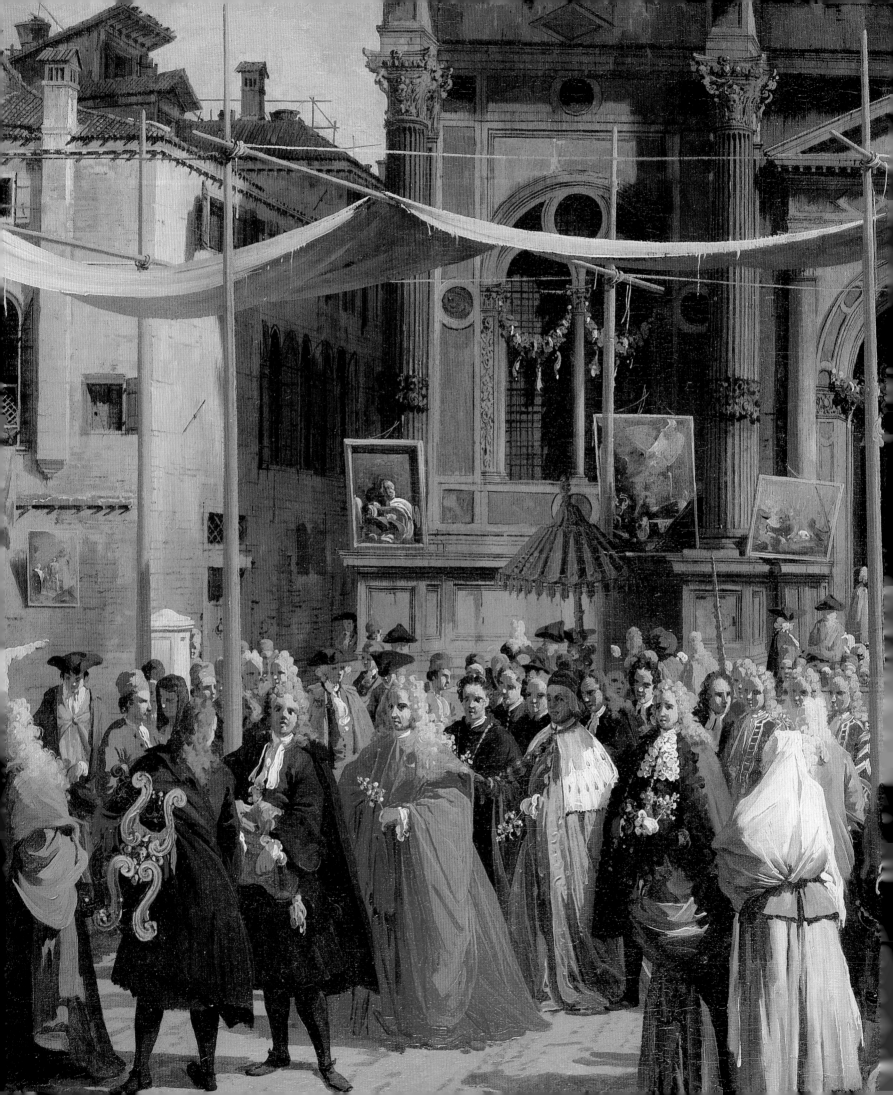

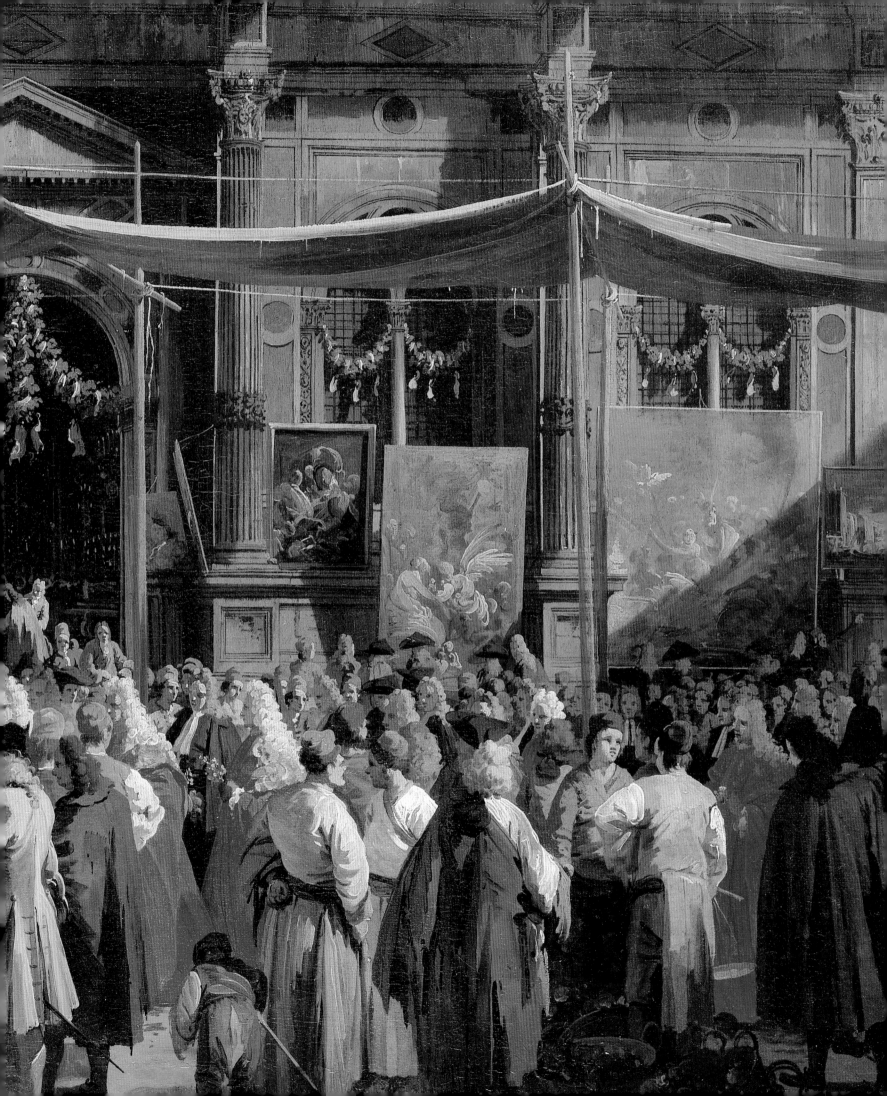

For my son Lodovico

ACKNOWLEDGEMENTS

When someone writes a book, there is usually a great many people to thank for their help. This book is no exception. So many friends have helped me with their advice, their willingness to spend time discussing a problem with me, even just giving me a photograph, that it is impossible for me to thank them all here. I limit myself to mentioning those who, with infinite patience, have read and amended the various drafts of the text: Terisio Pignatti, Federico Montecuccoli degli Erri, and Francesco Valcanover. Along with them, I must thank Luisa Sacchi, who enthusiastically accepted the idea of publishing this book, and the very capable and efficient Barbara Villani, Cristina Sartori, Antonietta Pietrobon, and Rosi Della Via, who brought it to completion with great professionalism. And to the friends who helped me, whose names I could not list, know that my greatest heartfelt gratitude goes to you.

First published in the United States of America in 2002 by
RIZZOLI INTERNATIONAL PUBLICATIONS, INC.
300 Park Avenue South, New York, NY 10010

Library of Congress Number: 2001089874
ISBN: 0-8478-2420-9

Translated by Susan Scott
Designed by Antonietta Pietrobon
Composition by Ultreya, Milan
Printed and bound in Italy

Opening pages:
p. 2 Canaletto, *St. Mark's Square toward the Church*, private collection (detail)
pp. 4–5 Canaletto, *The Feast of St. Roch, London, National Gallery* (detail)
Following pages:
p. 7 Canaletto, *The Grand Canal from Ca' Rezzonico toward Palazzo Balbi*, private collection (detail)
pp. 8–9 Bernardo Bellotto, *The Grand Canal at San Stae*, private collection
p. 10 Gaspar van Wittel, *View of the San Marco Basin*, London, Trafalgar Galleries (detail)
pp. 12–13 Francesco Guardi, *St. Mark's Square*, London, National Gallery
p. 14 Giacomo Guardi, *The Triumphal Arrival of Napoleon in Venice*, private collection (detail)

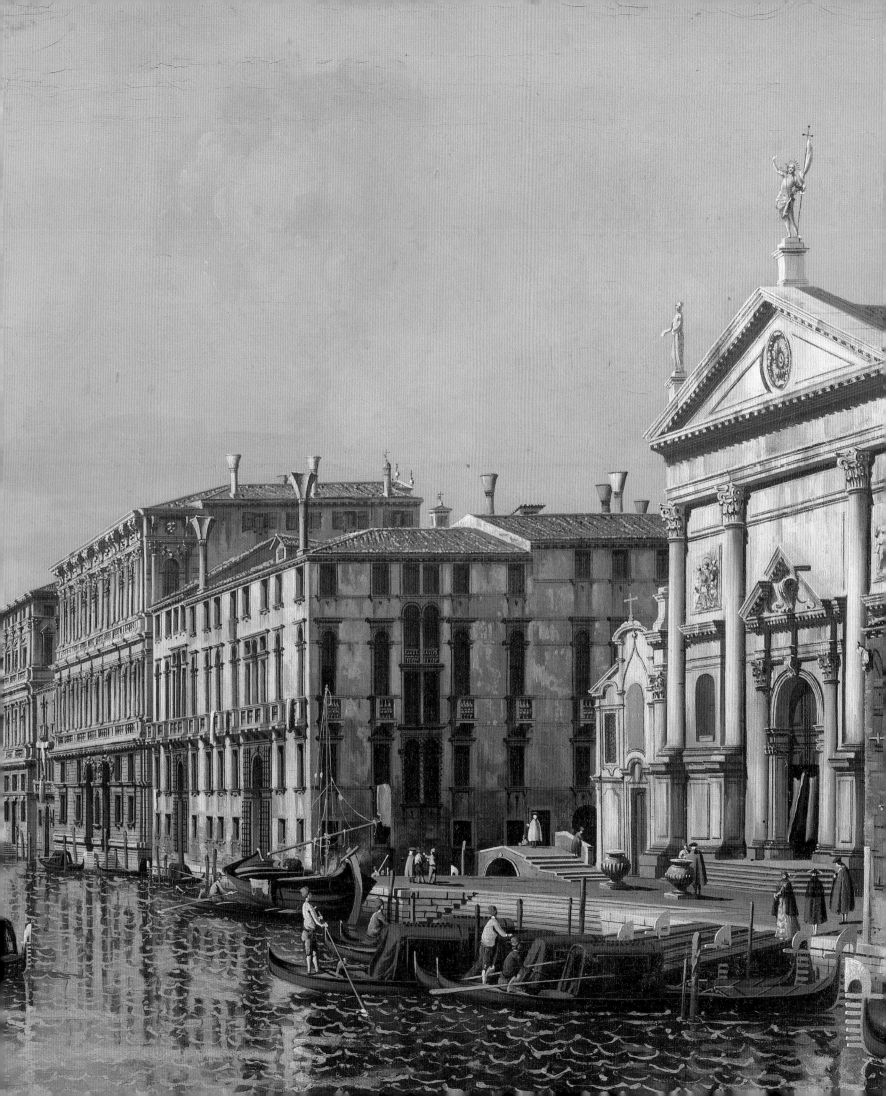

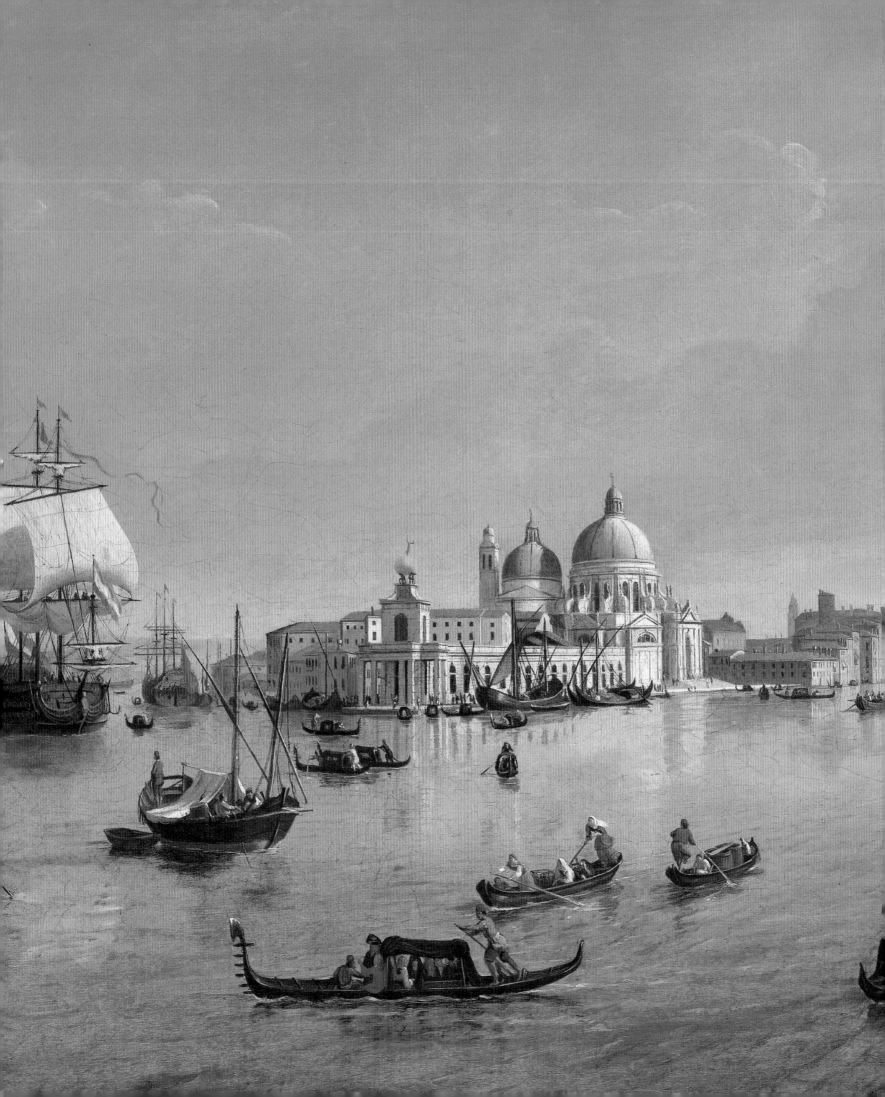

Contents

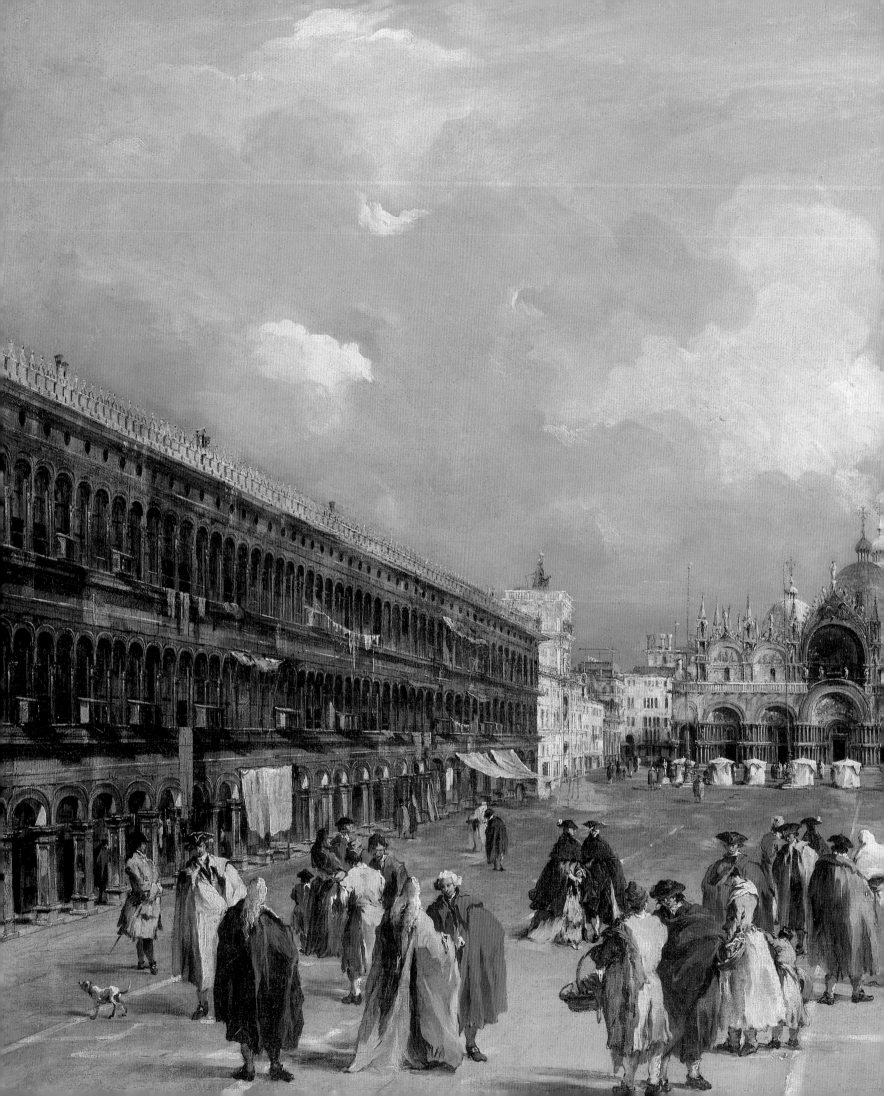

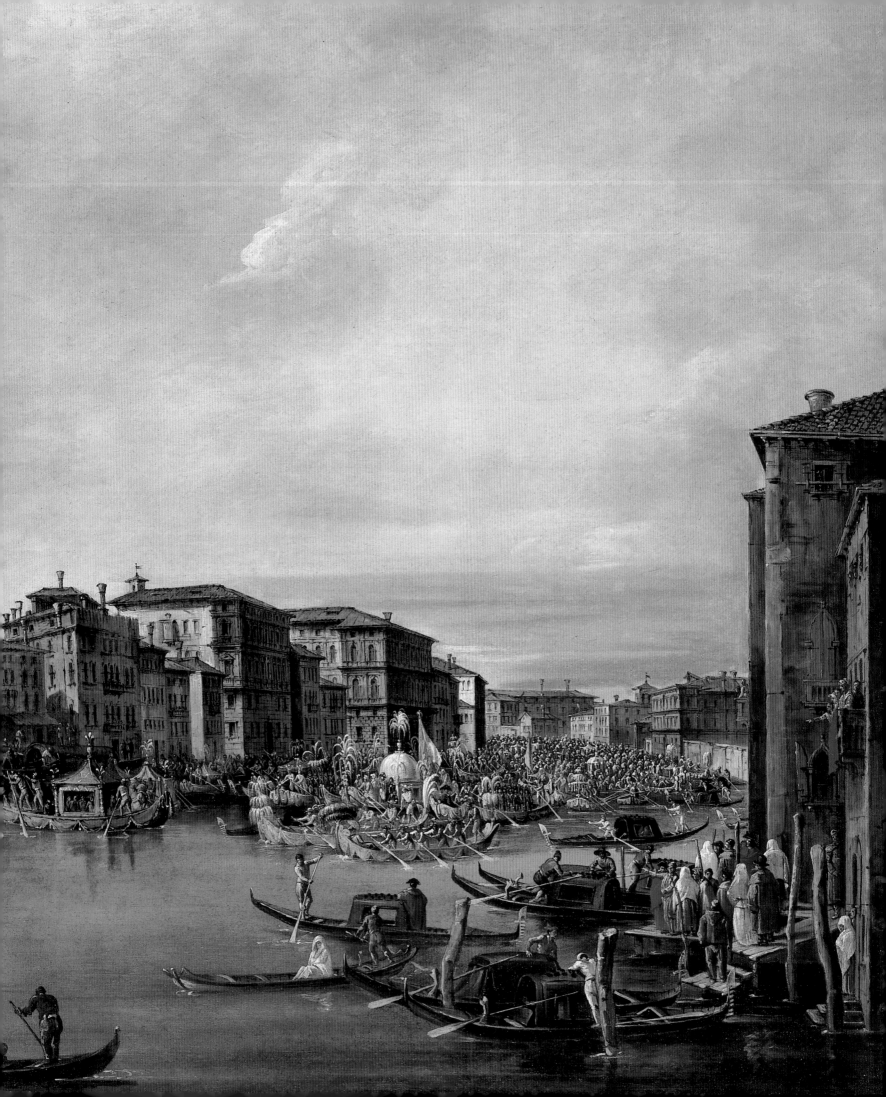

Preface

Among the rich artistic production in Venice in the eighteenth century, the genre of view painting is of great historical importance. The forerunners of the view painters were the great decorators of the Scuole and government palaces, who arranged the historical, political, and religious events they were engaged to depict against the backdrop of the urban landscape of this city that grew up out of the sea.

While not a particular favorite of Venetians during the sixteenth and seventeenth centuries, view painting gained considerable popularity at the beginning of the eighteenth century thanks mainly to the work of Luca Carlevaris, an artist from the Friuli area of northern Italy. This popularity was due in large part to its being a more populist art form, favored, for example, by wealthy and educated European tourists taking part in the "Grand Tour of Italy," the itinerary of which always included Venice. View paintings afforded the tourist an original work of art to commemorate their travels which both detailed the beauty of the city and evoked the events engaged in during their stay. And while Carlevaris moved into the mature phase of his career as the appeal of view painting grew, a rising star in the firmament of Venetian view painting was initiating his own activity: Canaletto. Like so many of the Venetian view painters, Canaletto too started as a set designer and painter for the theater, a field in which his father Bernardo worked extensively in the first twenty years of the century. But at the beginning of the 1730s, Canaletto broke free from the theater to pursue the more highly esteemed genre of view painting. Other important view painters soon came follow the style of Canaletto and become highly recognized in their own right. Besides Bernardo Bellotto, Canaletto's nephew (who followed in his footsteps working for the most part in the capitals of northern Europe), other painters active in Venice were Michele Marieschi, Tironi, Joli, and Francesco Guardi, considered a master of this particular genre.

Filippo Pedrocco offers here one of the few exhaustive accounts of this important moment in Venetian art offering a rare, in-depth understanding of the entire "industry" of view painting and its historical and socio-political importance. It also considers the stylistic development of the genre and the careers of all of the most important view painters.

Terisio Pignatti

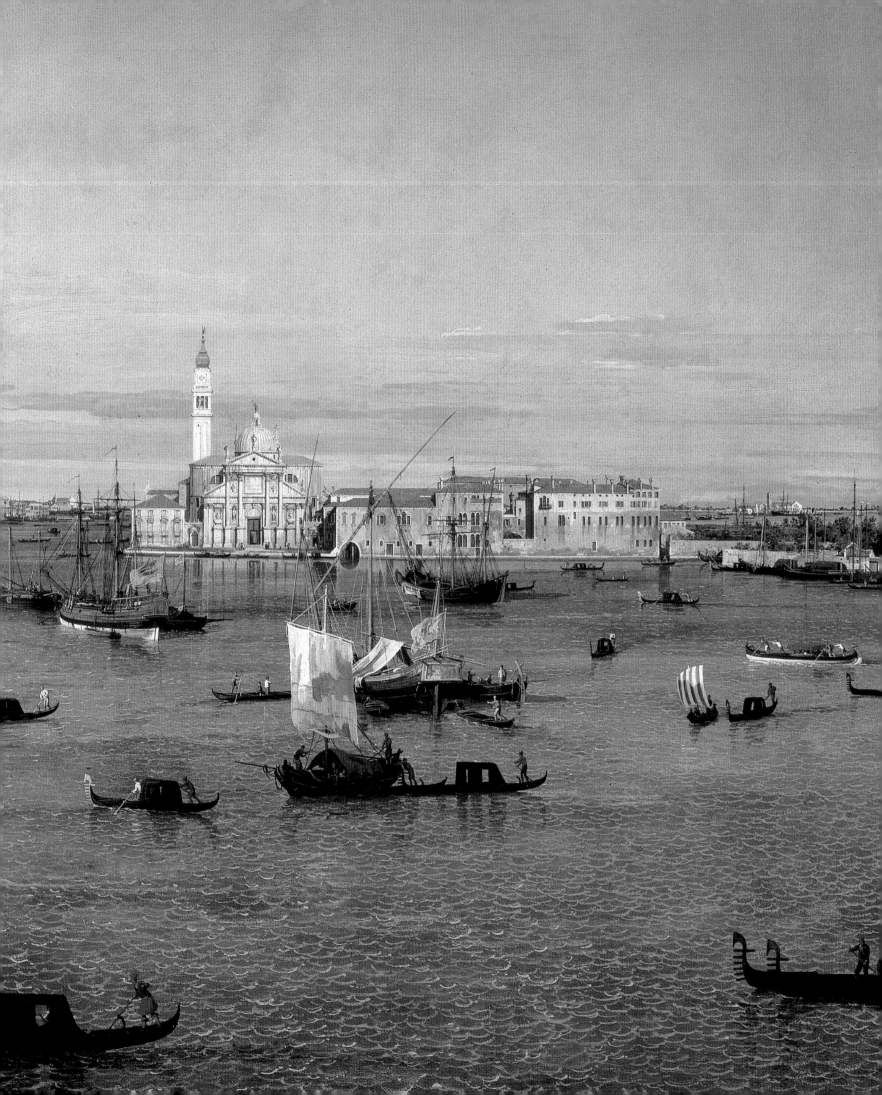

Venice
In The Eighteenth Century

A well-established historiographical tradition argues that in the course of the eighteenth century Venice underwent a profound economic, political, and even moral crisis, which was both the precursor to and the cause of the tragic epilogue in May 1797 to the Serenissima's thousand-year history. The image of a crumbling city-state that experienced an entire century of economic and institutional difficulty, during which the Venetians were intent only on revelry and endless Carnivals, and on dissipating in the casinos and at the Ridotto the enormous fortunes accumulated by their ancestors, is for the most part a figment of the imagination of late nineteenth century historians. However, it has been accepted unquestioningly by later scholars, to the point of almost obsessive recurrence and repetition.

It must be stated once and for all that the reality of the situation was quite different: for most of the eighteenth century, Venice was a hard-working and still very wealthy city, and in some areas even held positions of primacy over the other European states. This was principally the benefit of the long period of peace that resulted from a policy of neutrality in the numerous conflicts that were tearing Europe apart. In essence, from 1718, when Venice negotiated with the Turks the peace treaty of Passarowitz, until 1797, when pressure from Napoleon's army ended the Venetian republic's long and glorious existence, the Venetian troops were never seriously engaged in combat, excluding some fairly unimportant naval skirmishes against Ottoman pirates who were creating problems for the navigation of the diminished Venetian mercantile fleet in Europe. This situation enabled living conditions that were certainly better than elsewhere in Europe, permitting Venetians to concentrate their attention on their economic, social, and cultural activities.

A second positive element is the nearly complete absence—in Venice, but also in her territories on the mainland—of domestic unrest. This social peace in the eighteenth century is explained by both the existence of a vast and well-established public network of assistance, which gave even the poorer sectors of the population a relatively high standard of living compared with other parts of Europe, and by the essentially unanimous consensus of the citizens in support of their State, which was felt to be the best form of government possible.

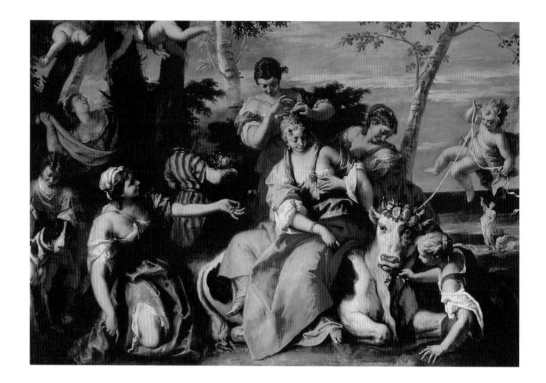

Sebastiano Ricci
The Rape of Europa
Rome, Palazzo Taverna

On matters of the economy, the situation of Venice was not at all bad, at least for most of the century. The state's coffers were largely replenished from the deficits created by the wars of the seventeenth and early eighteenth centuries against the Turks in the vain attempt to maintain soverignity over Venetian possessions in the Orient. This fiscal health, also due mainly to Venetian neutrality, allowed the Serenissima to exercise a relatively light fiscal pressure on her citizens. As a consequence, numerous private initiatives flourished (for example, Venice was the only city in Europe where three different enterprises were set up and remained active throughout the century, producing the very precious and costly porcelain), often encouraged and aided by the government itself, which supported business by the concession of privileges and tax exemptions. Granted, the large-scale international-trade economy, which had been the foundation of the enormous fortunes built up in preceding centuries, was by now reduced to a minimum, and port activity had also significantly diminished. Nonetheless, in the seventeenth century the Venetian nobility had successfully turned their economic interest towards real estate investments on the mainland, and the great state-owned activities, particularly the mint (Zecca) and shipbuilders (Arsenale), were still intensely active. Moreover, major development—with great profits for the citizenry—was seen in the sectors of domestic trade, artisan and proto-industrial production, services, and hospitality, given the city's new attractiveness to tourists.

Looking closely, except for the last fifteen or twenty years of the century, when the decadence of the political system became also economic decadence, to speak of a crisis in Venice in the eighteenth century means speaking of a crisis of the institutions. This was most evident in the inability of the oligarchy, which had long been in power, to renew its structure of government to adapt to changing political, social, cultural, and economic needs. With this exception, the city on the lagoon lived one of her eras of greatest splendor, a sort of new golden age,

Giambattista Tiepolo
The Banquet of Antony and Cleopatra
Venice, Palazzo Labia

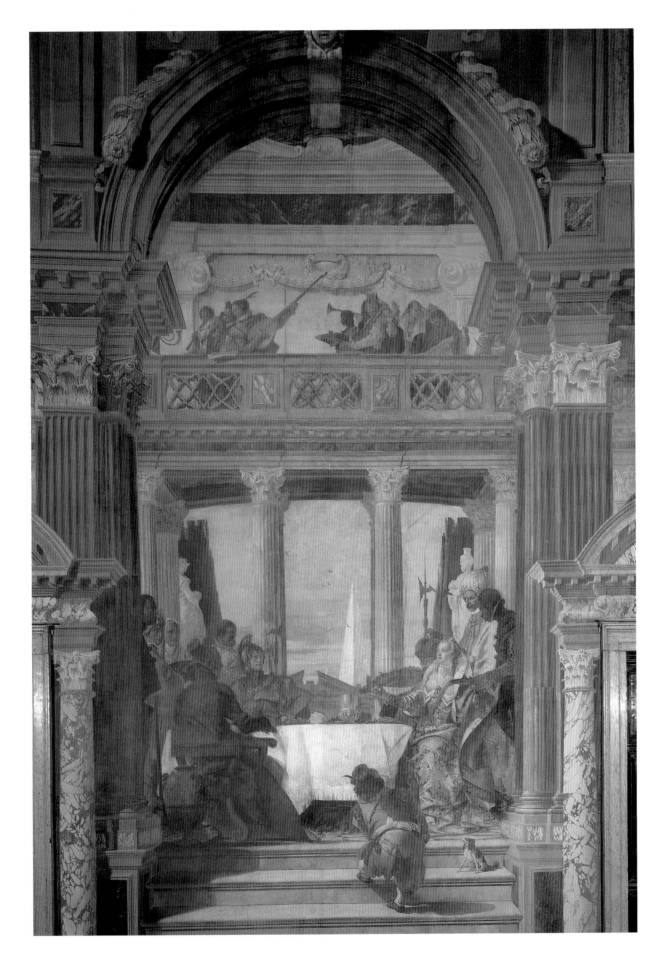

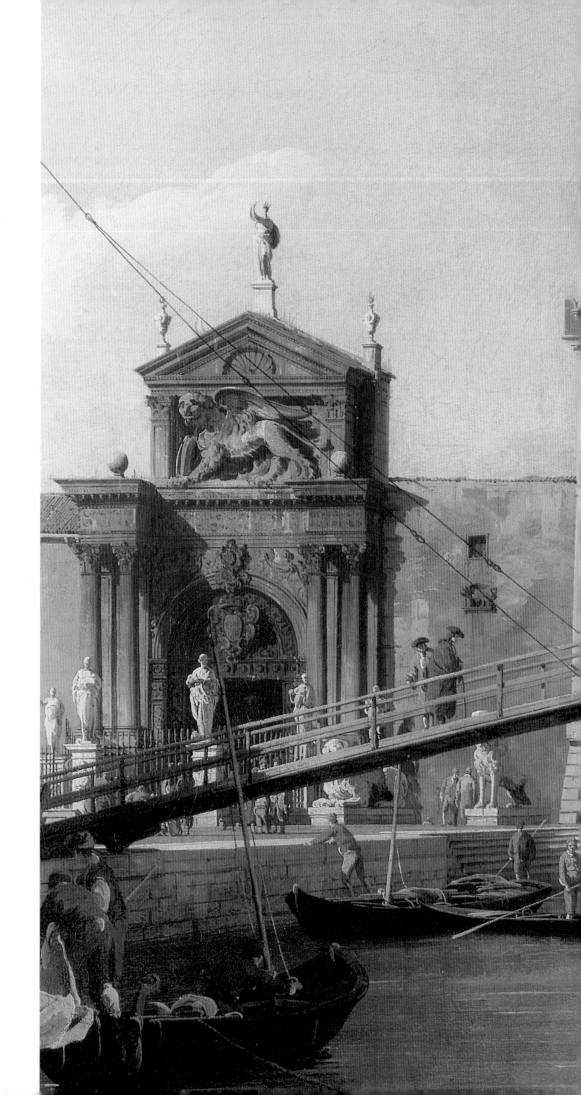

Canaletto
The Entrance to the Shipyards
Woburn Abbey, Private collection
Detail (entire painting on page 98)

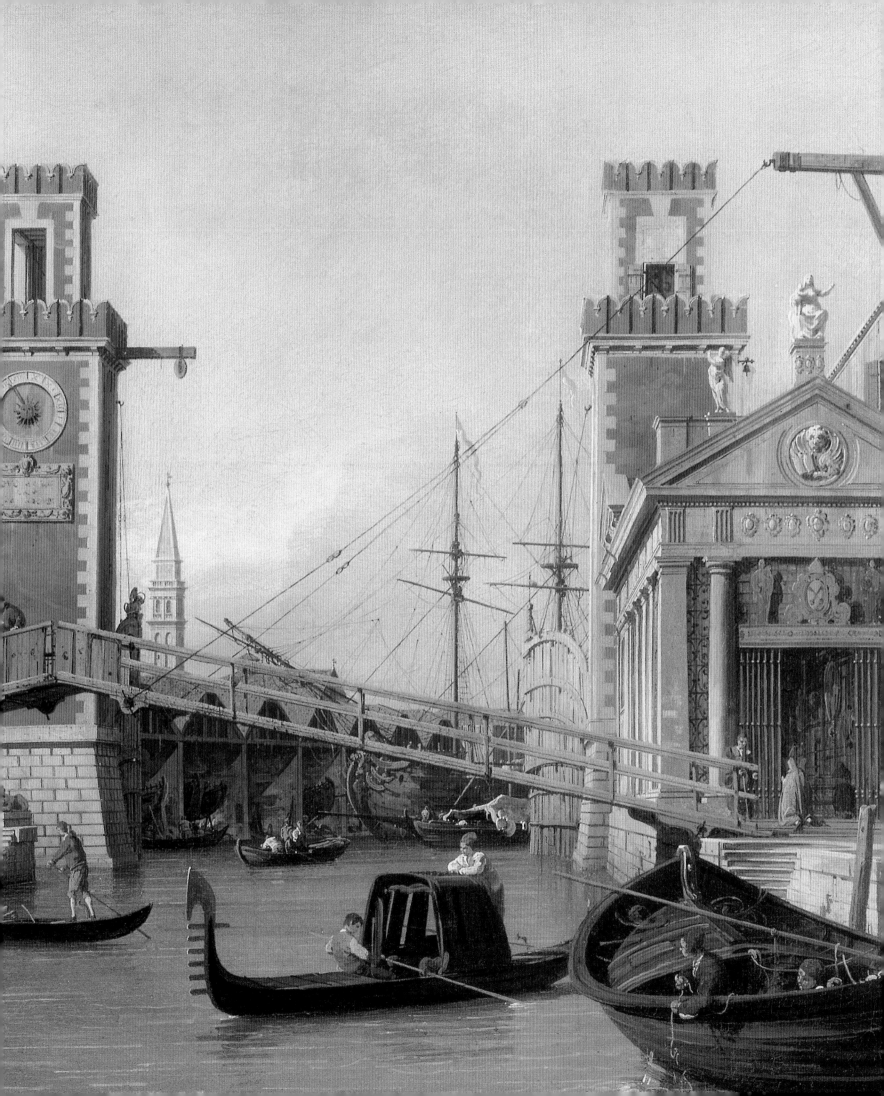

Giambattista Tiepolo
Apotheosis of Admiral Vettor Pisani
Venice, Palazzo Pisani Moretta

Giambattista Tiepolo
The Triumph of Eloquence
Venice, Palazzo Sandi
Detail

underscored by an exceptional fervor in the building, arts, and cultural fields that led to a real revitalization of the city.

Except for the area around St. Mark's Square, which had essentially taken its definitive form by the end of the fifteenth century and would only undergo a few minor changes in the eighteenth (replacement of the old paving of the Square and the Piazzetta in the early 1720s with a design by Andrea Tirali; the addition to Sansovino's Loggetta of the bronze railing by Antonio Gai in 1742; the raising of the side wings of the clock tower in 1755, as conceived by Giorgio Massari), the entire city was swept during this century by a great wave of new building and rebuilding which affected private palaces, churches, and the seats of the Scuole Grandi. Even if we limit our overview simply to the splendid parade of buildings along the Grand Canal, the vastness of the phenomenon is still astounding. The palaces of the Diedo family in the area of the Tolentini, of the Civran near San Tomà, Ca' Corner della Regina, Ca' Marcello, Ca' Venier dei Leoni, Palazzo Grassi, and Palazzo Smith near the Santi Apostoli were all built completely during that time, with Palazzo Smith being radically rebuilt twice. Construction was completed of several very important private buildings started in the preceding century, such as Palazzo Labia, Ca' Pesaro, and Ca' Rezzonico. Ca' Pisani Morretta, Ca' Balbi Valier, Ca' Calbo Crotta, Ca' Sagredo, Ca' Michiel delle Colonne, Ca' Barbarigo, and Ca' Dolfin Manin, the residence of the last Doge, Ludovico Manin, were all renovated in modern form. All the churches which face onto the Grand Canal were built then (San Simeone Piccolo, San Marcuola, San Stae, San

23

Alessandro Longhi
Portrait of a Gentleman
Milan, Private collection

Geremia), and the home of the Scuola Grande della Carità was also renovated. The situation was similar throughout the urban fabric of Venice, which was equally engaged in countless projects of rebuilding and restoration. One need only think of the new churches of the Fava, San Barnaba, Santa Fosca, the Maddalena, the Gesuiti, the Gesuati, and the Pietà (these last two, in particular, decorated with the great frescoes of Giambattista Tiepolo), and the renovation of the Scuola dei Carmini (decorated by a splendid series of Tiepolo canvases). Also done at this time was the construction or modernization of palaces such as the Correr and Diedo at Santa Fosca, the Grimani at the Servites, the Sandi at Sant'Angelo, and the Dandolo at San Moisè, the seat of the Ridotto. Not to mention the innumerable villas which sprang up on the mainland during the eighteenth century, of which the splendid symbol is the grand "royal palace" of the Pisani family at Stra, concrete expressions of the effect of a changed, but by no means diminished, way of living for the highest echelons of society. Moreover, at the end of the eighteenth century was the completion of the largest public project undertaken in that century: the building of the "*murazzi,*" the great levy erected by Bernardino Zendrini on a plan by Vincenzo Coronelli, which long and successfully defended the beaches of the Lido and Pellestrina from the pounding of the sea and only gave way partially during the terrible flood and high water of November 4, 1966. In this great fervor of building activity, a leading role was often played by the families just recently "promoted" to the aristocracy, who were disparagingly called the "new aristocrats" or the "Candia nobility." These were the families—among them the Labia, Rezzonico, Widmann, Giovanelli and many other important houses—who had attained their titles by giving large sums to the state treasury only after 1648, in the years of the war of Candia.

At any rate, this situation favored a vast array of skilled workers and craftsmen and, above all, a large group of painters who were called upon to decorate the new buildings with frescoes and canvases: from the unparalleled Giambattista Tiepolo to Sebastiano Ricci, from Giambattista Crosato to Giambattista Piazzetta, from Antonio Guardi to Gaspare Diziani and Francesco Fontebasso.

Nonetheless, the eighteenth-century Venetian painters did not specialize only in the large decorative projects on historical, religious and mythological themes requested by this kind of patron, but excelled also in other subjects. This talent was seen in portraiture, with the charming pastels by Rosalba Carriera, among the highest achievements of European Rococo, and with the solemn, academic portraits by Alessandro Longhi; in landscape, dominated by the classical works of Marco Ricci and those with a decidedly Arcadian air by Francesco Zuccarelli and Giuseppe Zais; in genre scenes, with the penetrating little canvases by Pietro Longhi, and in views, or *vedute,* of the city and urban life.

It is interesting to note that this last genre was considered by the local art world to be minor compared to the others, to the point that the most celebrated Venetian artist in this field, Canaletto, was admitted to the Venetian Academy of Painting and Sculpture only in 1763, a good thirteen years after it was founded. Furthermore, Canaletto's case is undoubtedly an exceptional one, substantially different from the experiences of his less famous colleagues, as his activity was tied to the international circuit headed by Joseph Smith, the English merchant who was later His Majesty's consul to the Republic of Venice. No other *vedutista,* or view painter, achieved fame and riches in his lifetime. Many—the great majority—did not receive any attention from eighteenth-century art writers,

Rosalba Carriera
Portrait of a Noblewoman
Private collection

Rosalba Carriera
Allegorical Portrait
Private collection

slipping into an oblivion from which only now, with great effort and sometimes with inexact and forced arguments and conclusions, modern critics are rescuing some of them. In the absence or at least great scarcity of important commissions from local patrons, who were instead very generous with their orders to the decorative painters, the activity of the *vedutisti* took place for the most part in the sphere of the numerous "picture shops" of Venice, where works of every sort were offered for sale: city views, architectural caprices, landscapes, genre scenes, still lifes, flowers, caricatures, and small devotional pictures.

Recent studies on the subject by Federico Montecuccoli degli Erri[1] have revealed to art historians a completely unexpected structuring of the market for this sort of painting. His research has made clear that it was not the painters who maintained contact with potential patrons and tried to sell their works, but rather that this was done by the merchants, the *bottegheri da quadri*. The merchants were members of the same guild as the painters, so that in the reports of meetings and the lists of the guild, the names of merchants and painters are mixed together, and it is impossible to distinguish the two categories. In reality, Domenico Coronato, Domenico Fontana, Concolo, Piccini, and just a few others—all with shops in the nerve center of the city, Campo San Basso, San Luca, San Polo, San Salvador, and so on—had most of the art market firmly in hand and managed it personally.

Pietro Longhi
The Singing Lesson
Private collection

Moreover, since they enjoyed an economic power greatly superior to that of the majority of artists of their time, they were in a position to abuse the situation. In this regard, a report dated 1757 discovered by Montecuccoli degli Erri[2] speaks openly of "shops [which] profit from others' labors," by buying pictures "from poor starving painters at a dastardly price then to sell them at a great markup." Montecuccoli degli Erri's discoveries thus represent a crucial turning point for any investigation of view painting, a genre that was in great demand by tourists as souvenirs, sometimes at a very low price. In particular, it seems we can accept without reservations his conclusions that the *bottegheri,* or shop-owners, not the painters themselves, decided the subjects to be painted and paid for the canvases and paints. Since the finished paintings had to be inexpensive and turned out at a fairly rapid rate, the fact that several painters worked on one picture is certainly due to the organization of work within the *bottega,* or shop, which would assign

tasks according to the artists' special skills, having this or that painter do the perspective rather than the figures, or the horses, boats, or other subjects.

It is superfluous to mention here that collaboration according to "specialization" was a frequent practice in the eighteenth century, and countless instances could be cited, from the series of *Allegorical Tombs* commissioned by Owen McSwiney from a large number of different painters who worked in groups, to the exceptional case of the painting of a *Landscape with Hermits* formerly in the Della Gherardesca collection in Bolgheri,[3] painted in 1705 by four different artists: Bianchi from Leghorn did the landscape; Alessandro Magnasco from Genoa did the figures; the Dutch painter Van Houbraken did the grass and branches; and the Venetian Marco Ricci did the rocks and water. Habitual interchange occurred between Marco and Sebastiano Ricci, between Battaglioli and Zugno, between Antonio Visentini and Francesco Zuccarelli, in one case also working as a trio with Giambattista Tiepolo, and other artists. This form of collaboration was thus not limited to exceptional instances or particular situations prescribed by the patrons (the example comes to mind of Simonini's interventions to add figures to paintings by other artists in the collection of Marshal Schulenburg), but should rather be considered a habitual practice of the "picture shops," dictated by the need to satisfy as quickly and adequately as possible the demand of a fairly unsophisticated but very broad market. This market was made up mainly of foreigners, who arrived in great numbers in Venice during their Grand Tour or on business or simply for pleasure, and who loved to take back home with them an image of the city or even, in some cases, entire series made up of numerous paintings.

It is interesting to note that the painters in the field of view painting were in large part recruited from the army of artists who painted stage sets for the opera, which, as is well known, enjoyed in the eighteenth-century Venice one of the eras of its greatest splendor. Theatrical set painters were some of the leading protagonists of decorative painting, from Sebastiano Ricci to Gaspare Diziani, from Giannantonio Pellegrini to Giambattista Crosato. But some landscape painters also painted sets, among them Marco Ricci in particular, and above all those who in the eighteenth century were called "perspectivists"—artists who specialized in creating stage backdrops characterized by buildings placed "in perspective," following a fashion set by artists of the Bibiena family. It goes without saying—demonstrated by their utilization by specialization within the structure of "picture shops"—that the work of these artists was particularly in demand to paint not just the fantasy images of houses and palaces in which to set the scenes taking place on stage, but also the "real" ones that were part of the city.

Eighteenth-century Venetian view painting is a phenomenon of enormous significance, not only for the quality of the works, which in many cases was exceptionally good, but also for having spread throughout the world the unique image of the city on the lagoons, contributing decisively to the birth of the "myth" of Venice.

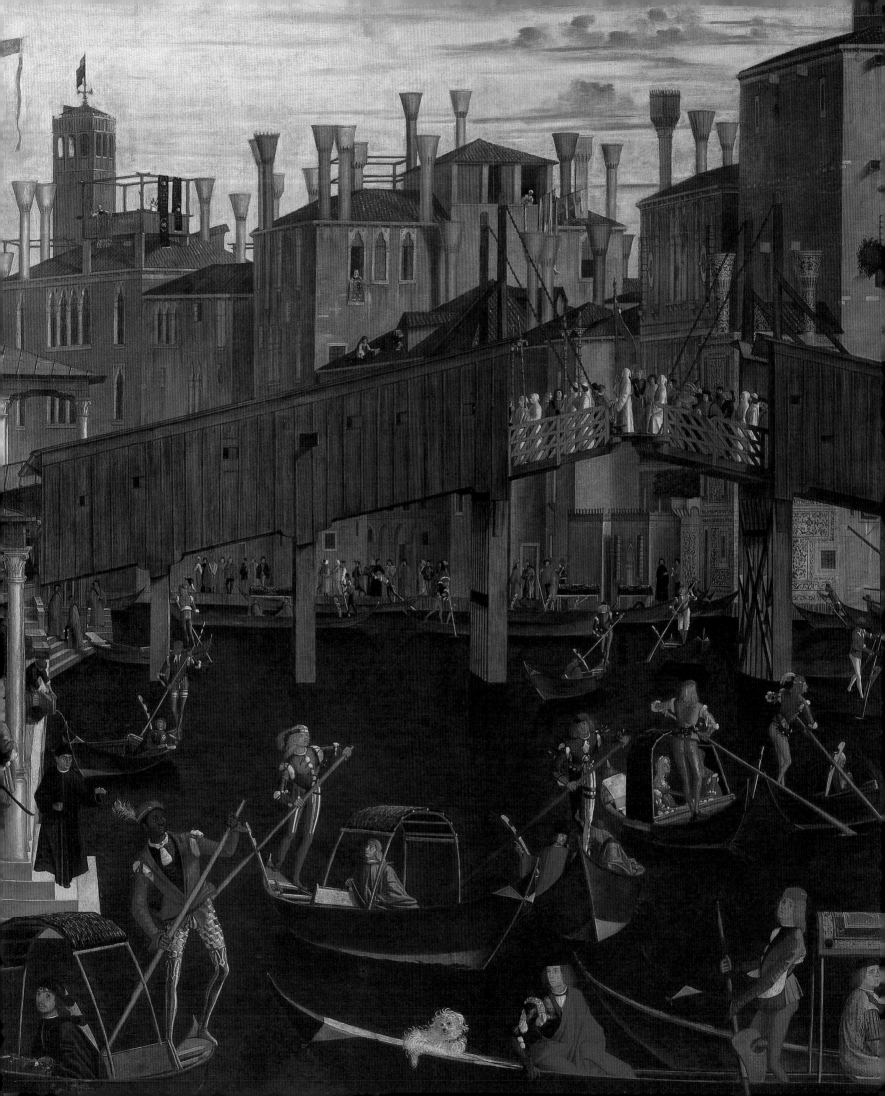

Eighteenth Century View Painting:
The Background

The practice of reproducing images of Venice on canvas is certainly not exclusive to the artists of the eighteenth century, but has deep roots in the city's artistic tradition. It is probable that the earliest decorations of the Doge's Palace, made in the thirteenth century and later destroyed, had precise visual references to real places in Venice. Such references would be manifest in the scenes narrating the peace between Pope Alexander III and Emperor Federico Barbarossa, which was brought about in Venice through the mediation of Doge Sebastiano Ziani. But while this is only a hypothesis, certainly Venice is triumphantly present in the series of *teleri*, or large canvases, painted in the last decade of the fifteenth century by Gentile Bellini and his co-workers for the Sala dell'Albergo in the Scuola Grande di San Giovanni Evangelista, now in the Gallerie dell'Accademia in Venice. To narrate the miraculous events whose origin was the precious relic of the True Cross, donated to the Scuola by the Grand Chancellor of the Kingdom of Cyprus Philippe de Meizières, Bellini chose the path of greatest realism, setting the events in the places where they actually happened. So we see, for example, the merchant Jacopo de Solis invoking divine aid for his sick son during the procession held in St. Mark's Square, and the miraculous healing of a possessed man by the Patriarch of Grado Francesco Querini taking place on a loggia of the patriarch's palace on the Riva del Vin, near the Rialto.

The images of the city given us by Gentile Bellini and Vittore Carpaccio—the authors of these two paintings, which are part of a vast series—are clear and distinct, marked by an almost northern type of realism. They now provide valuable visual documents for reconstructing aspects of the Venetian topography that have since been profoundly altered. In Bellini's painting we can easily identify the former appearance of the area around St. Mark's, with the hospice of the Orseolo on the right where the Procuratie Nuove now stand. We can read the iconography of the original mosaics on the façade of the basilica, of which only one—on the Sant'Alipio portal on the left—has survived the changes made over the centuries. In Carpaccio's canvas we see the wooden drawbridge that connected the area of the Rialto market with San Bartolomeo before the definitive one was built of stone at the end of the sixteenth century. The very

rare image of the Fondaco dei Persiani, with its exterior walls completely faced with marble inlays—almost like a refined Oriental carpet—is easily visible on the right, between the piers of the bridge.

It has been said on several occasions that these works are not views in the modern sense of the term, since the city only offers the setting for an event and is not the primary subject of the painting. But it seems evident that even if a narrative intent prevails in the pictures in question, the protagonist is still mainly late-fifteenth-century Venice, with the splendor of its architecture and the opulence of its everyday life—and this reality is the true central element of the images. Moreover, if the grand paintings made by Bellini and his students for the Scuola di San Giovanni Evangelista were excluded from the genre of view painting, then the same would have to be done for the many eighteenth-century pictures that are unanimously counted as vedute. This would discount many famous works, from the numerous "entrances" of ambassadors into the Doge's Palace depicted by Luca Carlevaris and Canaletto to the magnificent regatas in the Grand Canal, from the departures and arrivals of the Doge's great boat, the *Bucintoro,* to the festivities and celebrations by Francesco Guardi. Instead, the large canvases made for the Scuola di San Giovanni Evangelista, with their meticulous, accurate depiction of the city's aspect, should truly be considered the original root of eighteenth-century view painting, as they contain a large number of the elements present in the works of artists active two centuries later.

The same taste for representing the city with the evident intent to glorify and celebrate its wonders returns in numerous works of the sixteenth century. For example, in his canvas now in the Ashmolean Museum in Oxford (U.K.), Giorgione places the Virgin Mary reading next to an open window looking out over the San Marco Basin, revealing the Doge's Palace and the bell tower, the latter still lacking its

Gentile Bellini
The Procession in St. Mark's Square
367.5 x 746 cm
Venice, Gallerie dell'Accademia

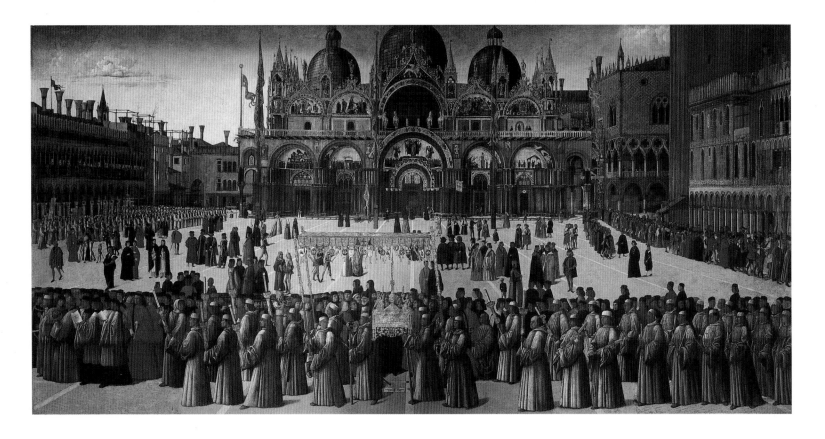

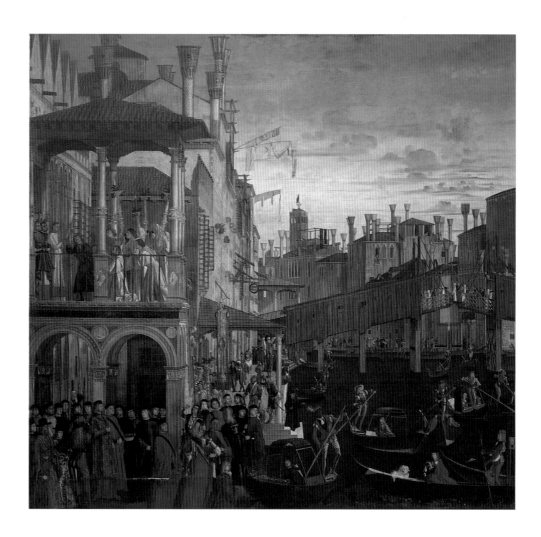

Vittore Carpaccio
The Miracle of the Relic of the Cross at Rialto
363 x 406 cm
Venice, Gallerie dell'Accademia

summit (which would be completed in 1514). Titian, too, in the altarpiece painted
in 1520 for the merchant Alvise Gozzi from Dubrovnik and now in the Museo
Civico in Ancona, rendered an evocative backlit view of St. Mark's Square as seen
from the Basin, showing the Doge's Palace with St. Mark's Church and the tall bell
tower behind it, and the Terranova Granaries on the left. A similar view appears in
the *Averoldi Polyptych,* delivered to the church of Santi Nazaro e Celso in Brescia in
1522, and in the fresco of *St. Christopher* painted by Titian in the early 1520s for the
Doge's Palace. In a canvas for the magistrates' offices in the Palazzo dei Camerlenghi,
Bonifacio de' Pitati gives us an animated bird's-eye view, following a fashion started
in Venice by the remarkable woodcut by Jacopo de' Barbari. The painting depicts St.
Mark's Square, looking towards the Basin, above which God the Father floats
emblematically, accompanied by the dove of the Holy Spirit.

In all these paintings the presence of Venice has a precise "political" significance: it
serves to reinforce that the Venetian state—it is no coincidence that the views
always show the area of St. Mark's, the site and symbol of the government of the
Serenissima—was under divine protection in everything it did, and was watched
over by the Virgin Mary, whom the Venetians considered to be the main
protectress of their city.

Other pictures, painted to celebrate the political and military grandeur of Venice,
also give a prominent position to the area around the Piazza. Emblematic of this
is the splendid "coat of arms" painted by Vittore Carpaccio in 1516 for the seat

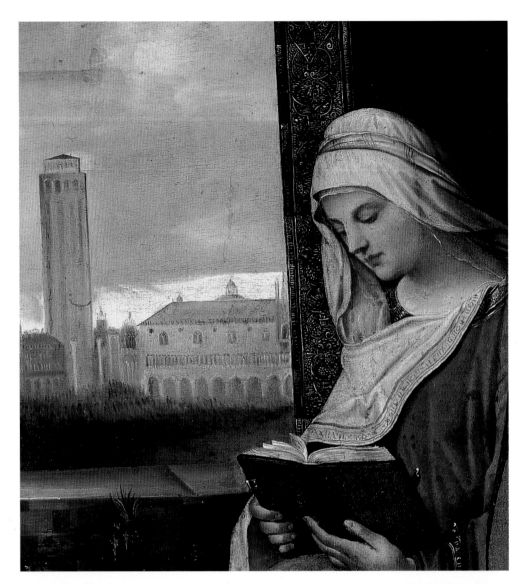

Giorgione
The Virgin Reading
Oxford, Ashmolean Museum
Detail

Titian
The Gozzi Altarpiece
Ancona, Museo Civico
Detail

Bonifacio de' Pitati
The Eternal Father and St. Mark's Square
Venice, Gallerie dell'Accademia
Detail

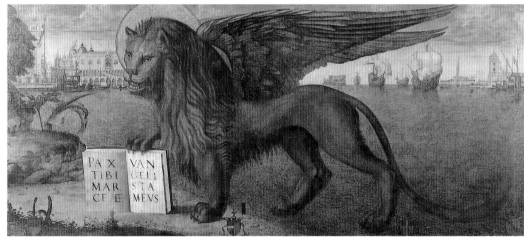

Vittore Carpaccio
St. Mark's Lion
130 x 368 cm
Venice, Doge's Palace

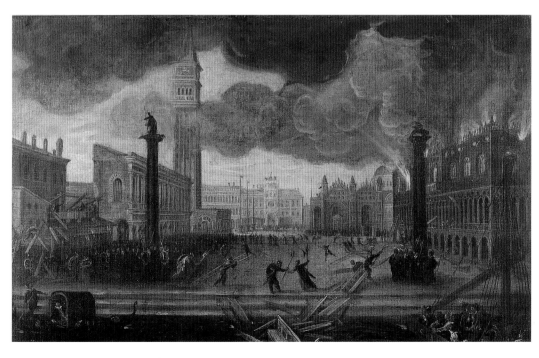

Pozzoserrato
*View of the Piazzetta during the Fire in the
Doge's Palace*
61.5 x 96.5 cm
Treviso, Museo Civico

of a magistracy in the Palazzo dei Camerlenghi and now in the Doge's Palace. The painting represents St. Mark's Lion with his front legs on the ground and his back legs on the water to emphasize that the power of the Serenissma extended over both land and sea. It gives a splendid and precise view that takes in not only the Piazzetta and the Doge's Palace, shown in full light, but also the *Arsenale,* the immense shipyards where the galleys were built to ply the seas under the Venetian flag. Other views of Venice can be found in many of the paintings that decorate the main rooms of the Doge's Palace itself, most done with the intent of glorifying the political, military, and civic prestige of the Republic.

However, these sixteenth-century view paintings are sporadic examples without immediate followers in the area of Venice. Some examples, in the years around the turn of the sixteenth century, can be found in the work of Andrea Vicentino, who painted important events of Venetian life, and of Pietro Malombra, the author—as Carlo Ridolfi testifies in 1648—of the "perspective views of the two St. Mark's squares" painted for Alfonso de la Queva, who was Spanish ambassador to the Serenissima from 1606 to 1618. A curious image of the *Piazzetta di San Marco* (Civic Museum, Treviso) shows the moment of the disastrous fire that struck the Doge's Palace in 1577. It was painted by the Flemish artist Lodewijk Toeput, called Pozzoserrato, probably during his first stay in Venice. However, despite the enormous importance of view painting in seventeenth-century Holland and northern Europe, Venetian artistic production at the time largely ignored the careful reproduction of the city.

A specific interest in painting the urban landscape began to take hold in Venice only after the middle of the seventeenth century. Northern artists were attracted to Venice by the increasing interest in landscapes and view paintings by collectors and the insufficient production by local artists to meet this new demand. In some cases, foreign artists furnished images of Venice without ever having been there, basing their views on prints or drawings by others. There are a number of paintings of this type, generally attributable to one of three artists: François de Nomé of Lorraine, the Frenchman Didier Barra, and the engraver Francesco Desideri from Pistoia, who used the pseudonym Monsù Desiderio.

The first painting reproduced here is probably the work, as Stefania Mason[4] concurs, of François de Nomé, a painter born in Metz, France, around 1593 and active for a long time in Naples, and to whom are attributed some other images of Venice now in public and private collections.[5] The canvas, datable to 1630, shows the *Piazzetta di San Marco* from the Basin, where the Doge's *Bucintoro* is sailing accompanied by a train of gondolas. The frontal view widens the scene disproportionately, giving a pronounced theatrical effect. Great emphasis is given to the buildings lining the Piazzetta, populated by numerous figures, and they combine fantasy elements with reality. For example, the structure of the Doge's Palace seems closer to the building designed by Palladio after the fire of 1577—known from a drawing in the Duke of Devonshire's collection at Chatsworth—than to the one that actually exists. The painting retains only a few elements, like the crenellation across the top of the Palace, and the church has essentially the shape of a cube topped by the three cylinders of the domes. The bell tower looms against a leaden sky in a position that is quite different from its real one, and the façade of the Library is unnaturally long (the actual number of bays is increased substantially), almost touching the Procuratie Vecchie visible in the background next to the clock tower.

François de Nomé
View of the Piazzetta di San Marco
93 x 181 cm
Venice, Antichità Scarpa

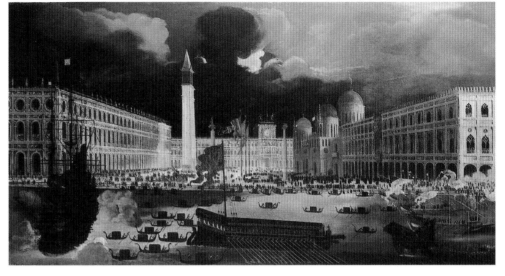

François de Nomé
View of the Piazzetta with a Street Performer
73 x 123.5 cm
Venice, Antichità Scarpa

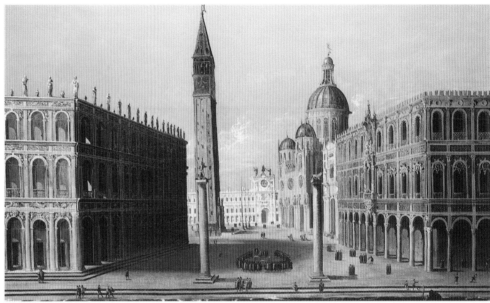

A second view, by Monsù Desiderio, is similar and can be dated to about ten years later. However, the painter's viewpoint is much closer, leaving out the Basin and limiting the image to the dock and the Square. Only a few figures are shown, for the most part gathered in a circle between the columns to watch a charlatan perform. The buildings thus take on a more realistic aspect, at least in relationship to the space, even if they still retain a number of fantastical elements (especially the façade of the church, which is pure invention). These are two very impressive paintings, of high artistic quality. Yet the latter, with its depiction of the buildings in the calm light of noon, more than the former, whose visionary emphatic aspect is underlined by the dramatic darkness of a stormy sky, seems to be a direct forerunner of the eighteenth-century vedute.

Another interesting example is furnished by a large, anonymous canvas now in the Museo Correr in Venice. It shows the *Piazzetta* from the Basin, which contains two large galleys ready to sail for the East and numerous other cargo barges, boats, and gondolas. The viewpoint—as is true in a great number of eighteenth century view paintings—is about halfway between the island of San Giorgio and the

Customs House Point. The angle of vision is wide, depicting the area of the dock from the Terranova Granaries to the prison and beyond. Compared to the views by Monsù Desiderio cited above, there is a more careful attention paid to perspective, even if some details, such as the unusual height of the clock tower and the length of the buildings lining the square, are certainly imprecise.

It was Joseph Heintz the Younger (ca. 1600–ca. 1678), who first gave expression, toward the middle of the seventeenth century, to the specific interest in views. Born in Augsburg, he was trained as a painter by his father Joseph the Elder, the court painter to Rudolph II in Prague. Upon his arrival in Venice from Bohemia, Heintz painted religious subjects, producing numerous large canvases that were fairly awkward and mechanical, and were marked by the mingling of the Mannerist style of Tintoretto and Palma the Younger with elements learned in his German training. But his most interesting work is certainly that devoted to the narration of Venetian events, where the painter portrays, often in lively and "noisy" scenes, the festivities and particular happenings taking place as part of the city's daily life.

The largest series of Heintz's views was formerly in the Palazzo Doria-Pamphilj in Rome. Four of them were donated in 1937 to the Museo Correr of Venice by Count Giuseppe Volpi, while a fifth, *St. Mark's Square Facing the Church,* remained in Rome. The canvases now in the Museo Correr represent *Chasing the Bulls in Campo San Polo, The Procession for the Feast of the Redeemer, The Entrance of the New Patriarch Federico Correr into San Pietro di Castello,* and *A Boat Picnic at Murano;* the second and fourth painting are inscribed, along with the painter's signature, with the date 1648, while the third is dated the following year. Because of their certain date and attribution, these works provide the foundation for the reconstruction of Heintz's activity as a view painter. In them, the typically northern taste for an exact description of reality pushes the painter to give a quite precise documentation of the setting. Even more interesting is the unusually colorful liveliness of the numerous figures, faithfully rendered in both clothing and pose,

Anonymous painter of the 17th century
The Piazzetta from the Basin
82 x 231 cm
Venice, Museo Correr

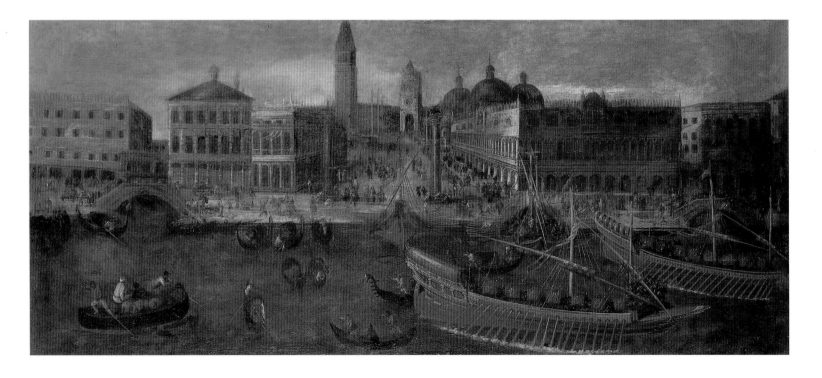

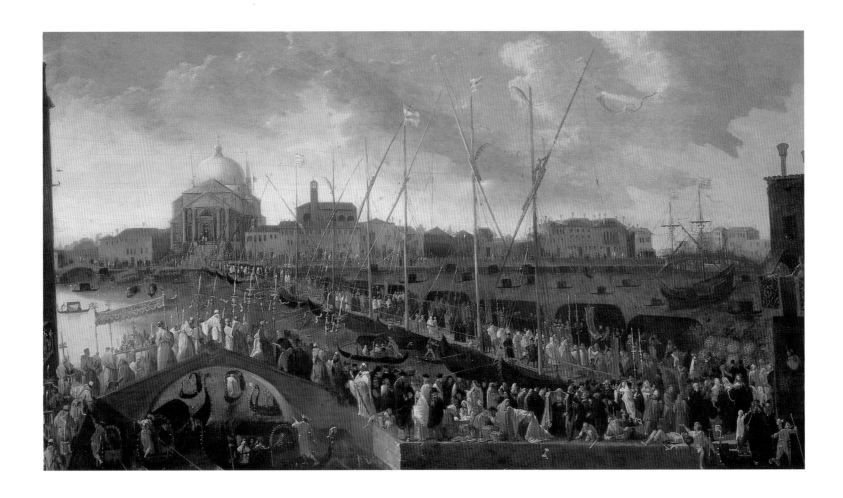

Joseph Heintz the Younger
The Procession for the Feast of the Redeemer
115 x 205 cm
Venice, Museo Correr

which foreshadows the work of some eighteenth-century vedutisti, above all Luca Carlevaris.

This same spirit enlivens other works which can credibly be attributed to Heintz, for example *The Coronation of the Doge at the top of the Giants' Staircase* in the Doge's Palace, (Städtische Kunstsammlungen, Augsburg, Ger.). This is a curious, highly animated depiction of one of the most solemn moments of Venetian public liturgy, when the newly elected Doge, after crossing the square in a sedan chair, distributing coins to the citizenry, presents himself to the senators and populace from the top of the grand staircase designed by Antonio Rizzo. Here he receives the signs of his office, the typical headgear worn only by the Doge. The scene is divided into two levels, following a structure found in other works by Heintz, such as the very lively *View of the Ridotto of Palazzo Dandalo at San Moisè* (Alte Pinakothek, Munich). In the upper section the senators, dressed in their ritual scarlet, motionlessly watch the coronation, while on the lower level the festive populace keep the police busy, almost to the point of physical violence, holding their overly enthusiastic crowd at bay.

The same frenetic excitement which animates these views appears in *The Fist Fight* (private collection),[6] a painting which shows one of the best-loved spectacles—and one of the group war-like games—of the Venetian people. The purpose of the skirmish was to occupy the top of a bridge by any possible means. The game was often played at Santa Fosca or San Barnaba, but also elsewhere. The fighting was between two opposing factions, above all between the historical enemies of the Castellani (the inhabitants of the *sestiere* of Castello) and the

Joseph Heintz the Younger
*The Entrance of the New Patriarch Federico Corner
into San Pietro di Castello*
Venice, Museo Correr
Details

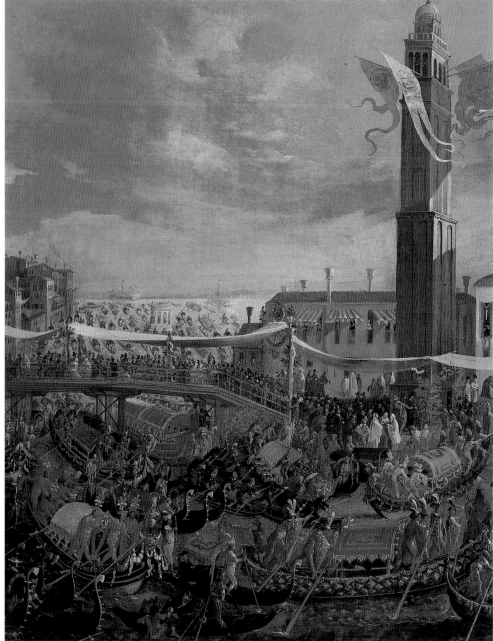

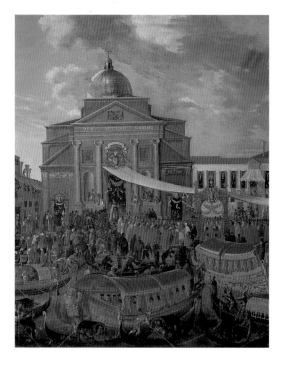

Joseph Heintz the Younger
The Fist Fight
Private collection
Detail (entire painting on page 41)

Nicolotti (the residents of the parish of San Nicolò dei Mendicoli, at the Dorsoduro). Until 1574, the use of sticks was also permitted, resulting in a disproportionate number of victims not only among the contenders but even among the spectators. After 1574, an attempt was made to contain the game's violence with a prohibition of any kind of weapons, and from then on it was played only with bare hands. The very lively scene portrayed by Heintz seems to be taking place on the Santa Fosca bridge. Spectators crowd the windows, terraces, and even the roofs of the houses and palaces lining the Rio; some of the nobility have come in their gondolas as far as under the bridge, on which a violent fight has broken out, and numerous combatants fall into the waters of the canal below. It is an astonishingly effective image, notable for the quality of its color and its dynamic action.

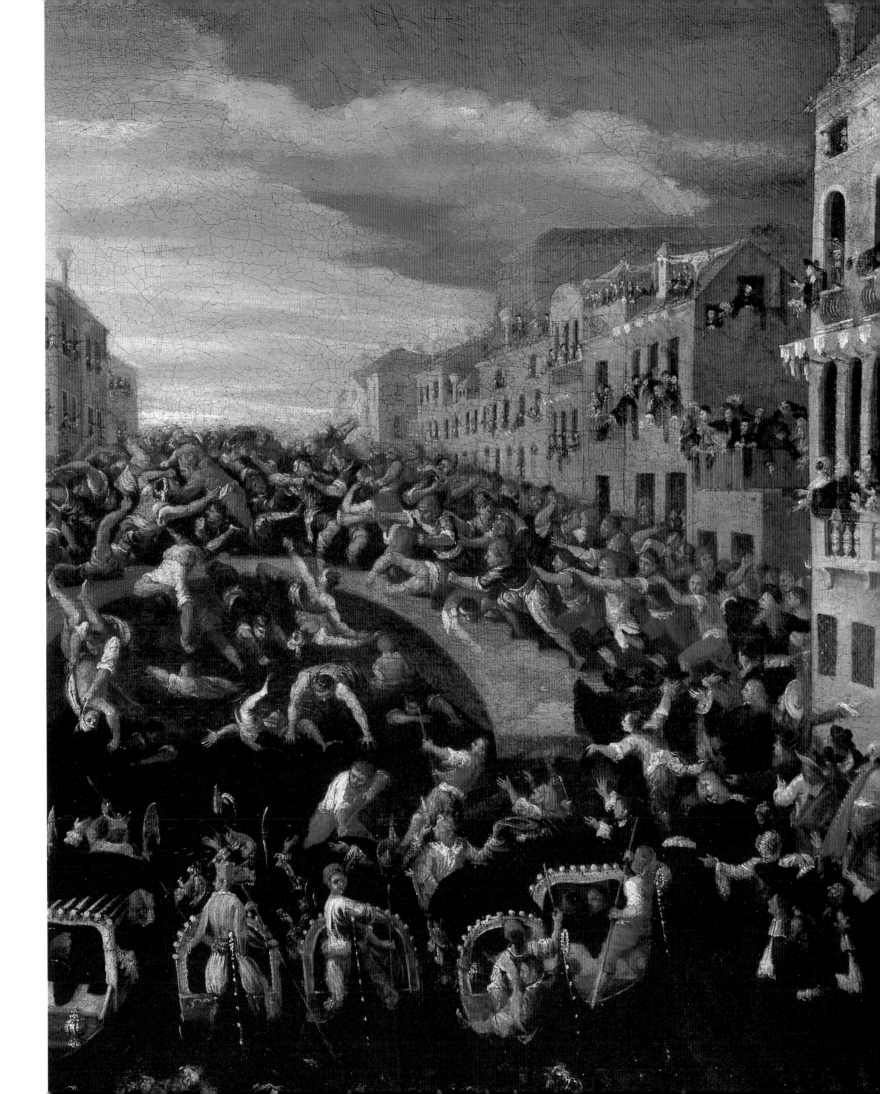

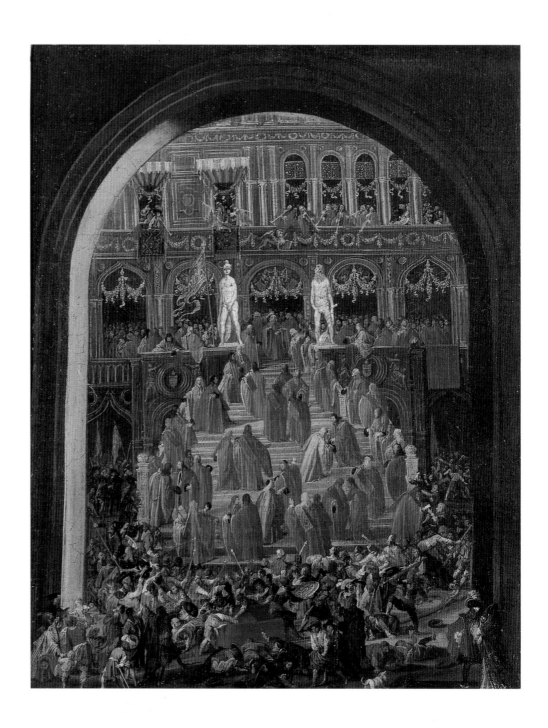

Joseph Heintz the Younger
The Coronation of the Doge
at the Top of the Giants' Staircase
Augsburg, Städtische Kunstsammlungen

Heintz appears to have been very successful with his views, judging from the quantity of images of Venetian public events and festivities available in the art market. While these were often attributed to Heintz himself, the lower chromatic quality and less precise attention to architectural detail make many of these likely to be the work of a student or imitator of the master.

Joseph Heintz the Younger
The Fist Fight
55.5 x 72.7 cm
Private collection

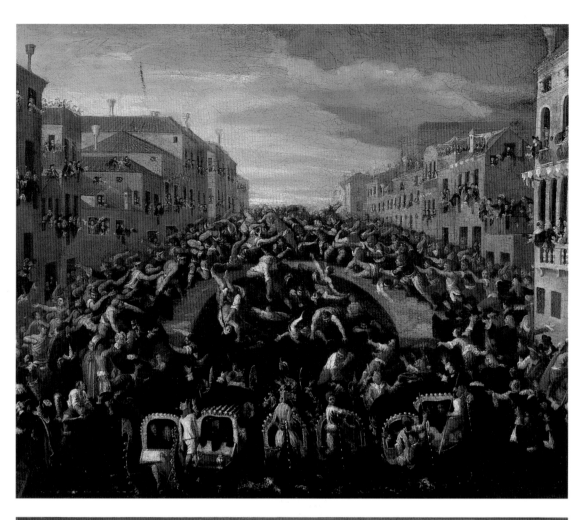

Follower of
Joseph Heintz the Younger
Chasing the Bulls in Campo San Polo
84 x 118 cm
Private collection

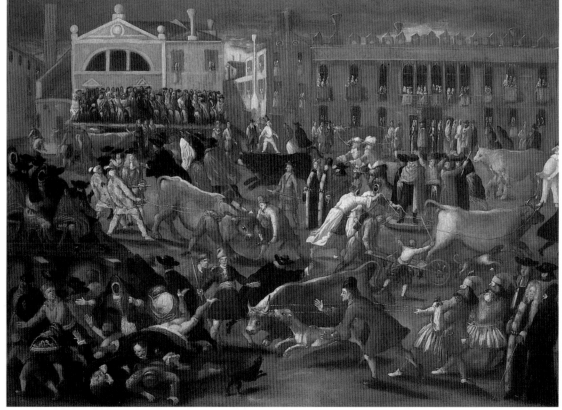

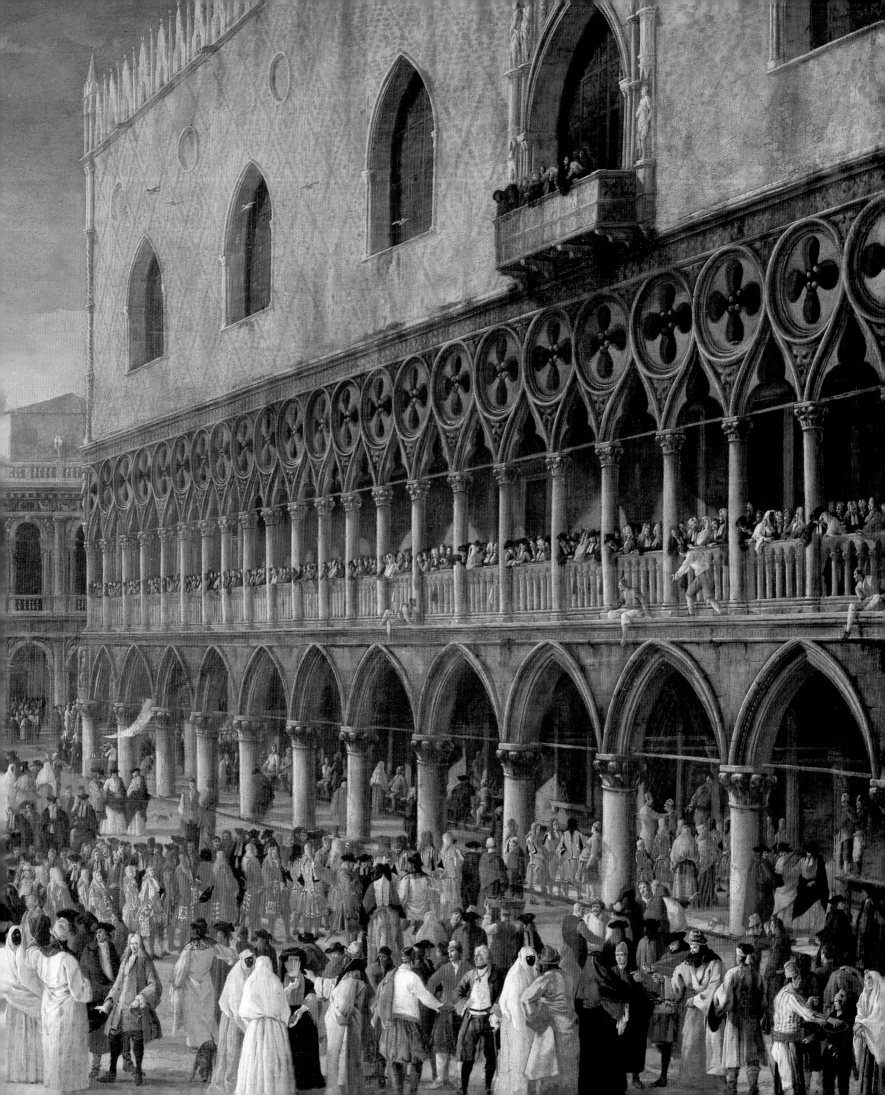

The Early Eighteenth Century:
Luca Carlevaris and Gaspar Van Wittel

Luca Carlevaris
The Entrance of the French Ambassador Henri-Charles
Arnauld, known as the Abbot of Pomponne,
into the Doge's Palace
Amsterdam, Rijksmuseum
Detail (entire painting on page 49)

Luca Carlevaris (Udine 1663–Venice 1730) is justly considered the father of eighteenth century Venetian view painting. Sources describe Carlevaris as a great expert in architecture who evidently studied the science of perspective, as demonstrated by his preparatory drawings for engravings. He came to *vedutismo* by degrees: his earliest activity was in the field of landscape, with numerous paintings—especially views of ports or invented images in which real elements are mixed with fantasy—stylistically linked to the models of northern artists like Pieter Mulier (called the Cavalier Tempesta), Hans de Jode, and Johann Anton Eismann. He might have seen their work in Rome, during a trip made there in his youth, described by the authoritative Giannantonio Moschini (1806). It is also possible that he encountered it in Venice, where many of these artists from northern Europe (among them Tempesta and Eismann in particular) spent considerable time in the last decades of the seventeenth century. Tempesta himself has testified, in a letter written to Monsignor Angelo Maria Arcioni in Parma on 15 March 1687— thus immediately after the beginning of his stay in Venice, which lasted until 1690—as to the lack at the time of specialists in landscape painting in that city, even though this genre was in great demand among local patrons. "There is a good number of Painters of figures," the Dutch artist writes, "but of Landscapes and seascapes and little animals there are none, or the ones there are, are not very good."

Thus Carlevaris's early activity was aimed at filling this hole in the market and satisfying the new demands of the Venetian patrons. His passage from landscape to view painting took place later[7] and is probably marked by two significant works: his splendid collection of 104 engravings entitled *Buildings and Views of Venice*, printed in 1703 but the fruit of a long preparation which must have kept the artist busy for some years; and the execution of a series of canvases depicting solemn "entrances" of foreign ambassadors who were coming to present their credentials to the Venetian government. These solemn occasions were celebrated by regatas in the Grand Canal, processions on the water, and festivities, and in this sense Carlevaris's canvases fit perfectly into the tradition whose most distant roots lie in the works of Gentile Bellini's workshop, mentioned previously.

Gaspar van Wittel
The Piazzetta
27 x 42 cm
Rome, Galleria Doria Pamphilj

Gaspar van Wittel
View of the San Marco Basin
99 x 174 cm
Madrid, Prado

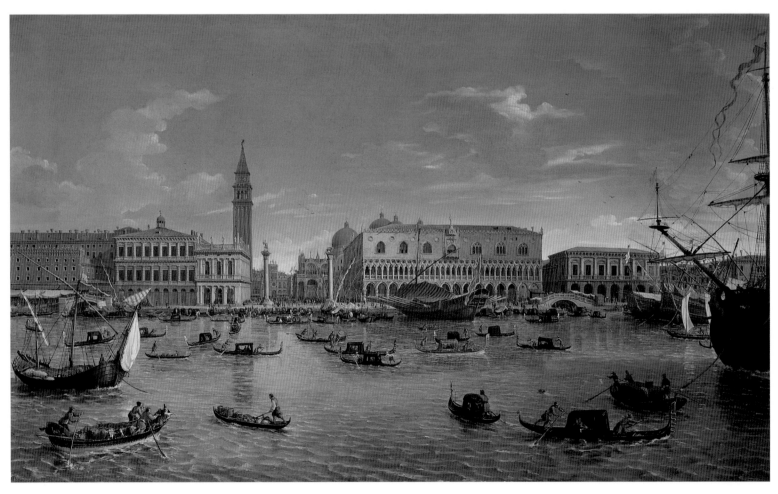

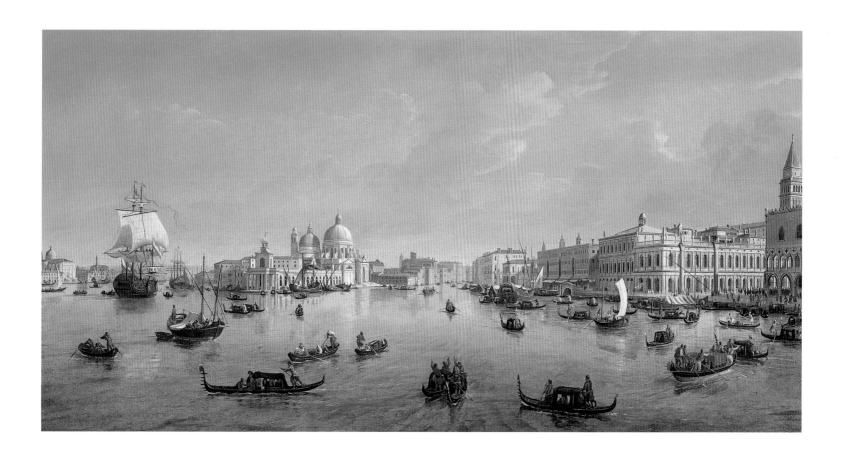

Gaspar van Wittel
View of the San Marco Basin
54 x 106.5 cm
London, Trafalgar Galleries

The literature on Carlevaris often emphasizes the role that may have been played in his style and choice of subject by the Venetian views of the Dutch painter Gaspar Van Wittel. Born in Amersfoort, near Utrecht, in 1652 or 1653, he arrived in Rome when he was about twenty years old, hired in 1675 by the hydraulic engineer and inventor Cornelis Mayer for the job of assistant topographer. Mayer had been engaged by Clement X to study the possibility of making the Tiber River navigable once again from Perugia to its mouth. But in the papal city, once his work with Mayer was finished, the young Gaspar devoted his efforts—probably starting in about 1680—to view painting, reproducing the ancient and modern architecture of Rome with a calculated, cold approach, in open contrast with the local landscape tradition whose leading interpreter was Salvator Rosa. In this sense, his example would be particularly important for the birth of the school of Roman *vedutisti* of the eighteenth century, which would grow up around the figure of Gian Paolo Pannini, from Piacenza.

In the last decade of the seventeenth century, Van Wittel probably made two separate journeys through northern Italy, stopping in Florence, Bologna, the Isole Borromee on Lake Maggiore, Vaprio d'Adda, Verona, and even reaching Venice, where it is thought he stayed from the end of 1694 to the early months of the new year. It appears certain that during his brief Venetian sojourn he did not paint any views of the city (those that are known all bear dates after 1697), but limited his activity to making some drawings from life, which he would use later to paint his canvases in his studio in Rome. In any case, Van Wittel's Venetian views—such as the *Piazzetta* (Galleria Doria Pamphilj, Rome) or the *View of the San Marco Basin* (1697; Museo del Prado)—are distinguished by careful rendering of details, topographical

precision, crystalline colors, exact proportions between the architecture and space, and a single viewpoint.

In his fundamental study on the painter (1966), Giuliano Briganti[8] listed fifteen Venetian *vedute* by Van Wittel, almost all of them of places looking onto the San Marco Basin, for most of which preparatory drawings exist. The only exception is two views of the *Island of San Michele*, with Murano in the background, one in the Bruscoli collection in Florence and the other in the Colonna collection in Rome, for which no preparatory drawings are known. Over time, other views by Van Wittel have appeared on the art market, some of them of very high quality. Among them, one that was shown in 2000 at Trafalgar Galleries in London is especially outstanding for its technical excellence. It gives a sweeping vista of the *San Marco Basin* from the Giudecca Canal (on the far left are the churches of the Redentore and the now gone San Giacomo) to the Doge's Palace, of which the corner overlooking the Piazzetta appears on the far right.[9] Briganti mentions two other paintings by Van Wittel with a similar subject. Whereas one, in the Fittipaldi collection in Florence, signed and dated 1710, does not go so far as to show the Doge's Palace, the other in the Duke of Leicester's collection at Holkham Hall has a panoramic breadth comparable to the painting shown at Trafalgar Galleries. However, it is significantly different in the number and position of the cargo boats, gondolas, and ships scattered across the surface of the basin.

In the view presented here, "Gaspar of the Eyeglasses"—as Van Wittel was called by his contemporaries because of his pronounced near-sightedness—offers further proof of his established analytic ability, describing with photographic precision every element of the buildings bathed in the bright light of a sunny summer

Gaspar van Wittel
View of San Giorgio Maggiore
31.5 x 59.5 cm
Private collection

Gaspar van Wittel
View of the Customs House
31.5 x 59.5 cm
Private collection

noon. Even the buildings in the far distance lining the Grand Canal can be identified precisely. It is easy to distinguish the outline of the abbey of San Gregorio to the right of the church of Santa Maria della Salute, which is essentially the focal center of the scene. Beyond it is the palace of the Venier family, torn down at the beginning of the nineteenth century, which was called the "Torresella" because of the tall tower on the roof, well visible in this view. Boats of various types and the oarsmen are also clearly painted from life, as the details are so specific that Van Wittel must have studied them carefully to have been able to reproduce the scene so realistically on canvas.

Analogous characteristics are seen in two other heretofore unpublished views, albeit in a smaller format, also dedicated to the buildings lining the San Marco Basin. The first shows the Island of San Giorgio Maggiore from the dock. There are two other versions of the view of the island of San Giorgio Maggiore (in the Theodoli and Colonna collections, both in Rome), which differ in the details of the boats. The second previously unpublished view is the *Customs House*, with the church of Santa Maria della Salute on the right and the beginning of the Giudecca canal on the left.[10]

Briganti recalls three other views by Van Wittel showing this same scene: a signed one in the Galleria Doria, another in the Colonna collection in Rome, and one in the Bruscoli collection in Florence. They share the same viewpoint, probably from a boat moored in the center of the San Marco Basin, whose aspect differs from the first in the number and position of the boats. At any rate, the versions presented here seem, in their meticulously rendered architecture, topographical precision, and fine chromatic quality, superior as paintings to the versions known up to now.

Luca Carlevaris
*The Entrance of the French Ambassador
Henri-Charles Arnauld, known as the Abbot
of Pomponne, into the Doge's Palace*
130 x 260 cm
Amsterdam, Rijksmuseum

Luca Carlevaris
*The Entrance of the British Ambassador
Charles de Montagu, Earl of Manchester,
into the Doge's Palace*
132 x 264 cm
Birmingham, City Museum and Art Gallery

(overleaf)
Luca Carlevaris
*The Regata in Honor of the Visit
of Frederick IV of Denmark*
135 x 260 cm
Hillerod, Nationalhistoriske Museum

The question arises as to the relationship between these Venetian views by Van Wittel and those that Carlevaris would begin painting in the earliest years of the eighteenth century. In the work of the latter artist there is an evident concession to the pictorial quality typical of the Venetian tradition. Often, even if his rendering of the architecture is substantially precise it often dissolves into a pinkish fog that softens the details, especially in the backgrounds. Additionally, the relationship between the architecture and the boats and figures peopling the views is usually not as precise as in Van Wittel's paintings. These characteristics are evident even in the earliest paintings by Carlevaris: for instance, in the canvases representing ambassadorial "entrances" into the Doge's Palace, among which we must list authentic masterpieces like *The Entrance of the French Ambassador, Abbot de Pomponne* (1706; Rijksmuseum, Amsterdam) or *The Entrance of Charles de Montagu, Earl of Manchester*, which took place on September 22, 1707 (Birmingham City Museum, U.K.); in the splendid canvas documenting the *Regata* held in the Grand Canal on the occasion of the visit to Venice of Frederick IV of Denmark in March 1709, now the property of the Nationalhistoriske Museum, Hillerod; and in the early views of Venice, like *The Customs House* (private collection, Venice), with the island of San Giorgio Maggiore in the background, and the pair of canvases in Sans-Souci Castle in Potsdam, representing *The Dock facing the Doge's Palace* and *St. Mark's Square with Charlatans*.

In addition to stylistic differences, there is an objective element that contributes decisively to refuting the existence of a relationship between Van Wittel and Carlevaris: the information available points to the conclusion that it is unlikely Carlevaris could have seen Van Wittel's views of Venice. Critics agree completely that Van Wittel painted his canvases of Venetian subjects only after returning to Rome: his earliest known view of Venice is the one dated 1697 now in the Museo del Prado (and the painting was already in Spain by 1746, in the collection of Elisabetta Farnese at La Granja, which could lead one to think that it was painted for a Spanish patron). Moreover, all the ones known to us are dated or datable with certainty in the first or even second decade of the eighteenth century. Nor does it appear that Van Wittel ever worked for Venetian patrons in the course of his career. Therefore, in order to have seen Van Wittel's views, Carlevaris would have had to have made his trip to Rome not as a young man, as stated by Giannantonio Moschini in 1806 and as critics all agree, also on the basis of a note which appears appended to the Roll of Venetian Painters dated June 5, 1690, reporting that Luca "at present is away" (from Venice), but much later, when he would already have been painting views for some time.

Throughout his entire career, Carlevaris alternated landscape paintings—often in the vein of "caprices," fantasy landscapes, for the most part characterized by the presence of crumbling classical buildings and ruins—with his better-known views of Venice. In particular, Carlevaris concentrated his attention on the area around St. Mark's and on repeating ad infinitum his animated views of the square, the Piazzetta, and the dock with the entrance to the Grand Canal. Nonetheless, he did not scoff at views of Rome, producing the splendid *St. Peter's Square* (private collection), or of the Venetian countryside, such as the crystalline image of *Villa Baglioni* at Massanzago, which appeared on the Venetian art market in the 1990s, or the *Visit to a Villa* (private collection, London), prepared in a beautiful washed drawing (Museo Correr, Venice). He created excellent work under commission as well, such as the prestigious commission from Alvise Pisani, in the middle of the

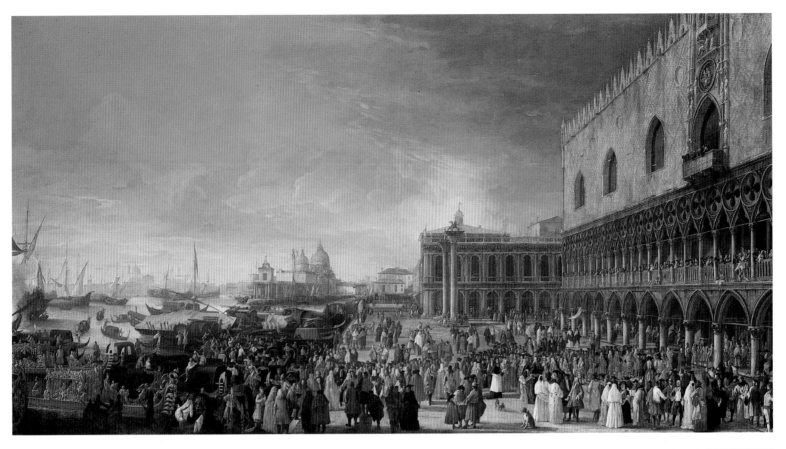

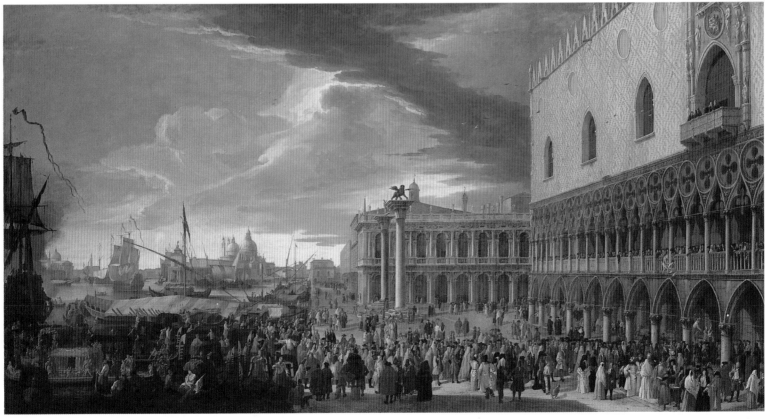

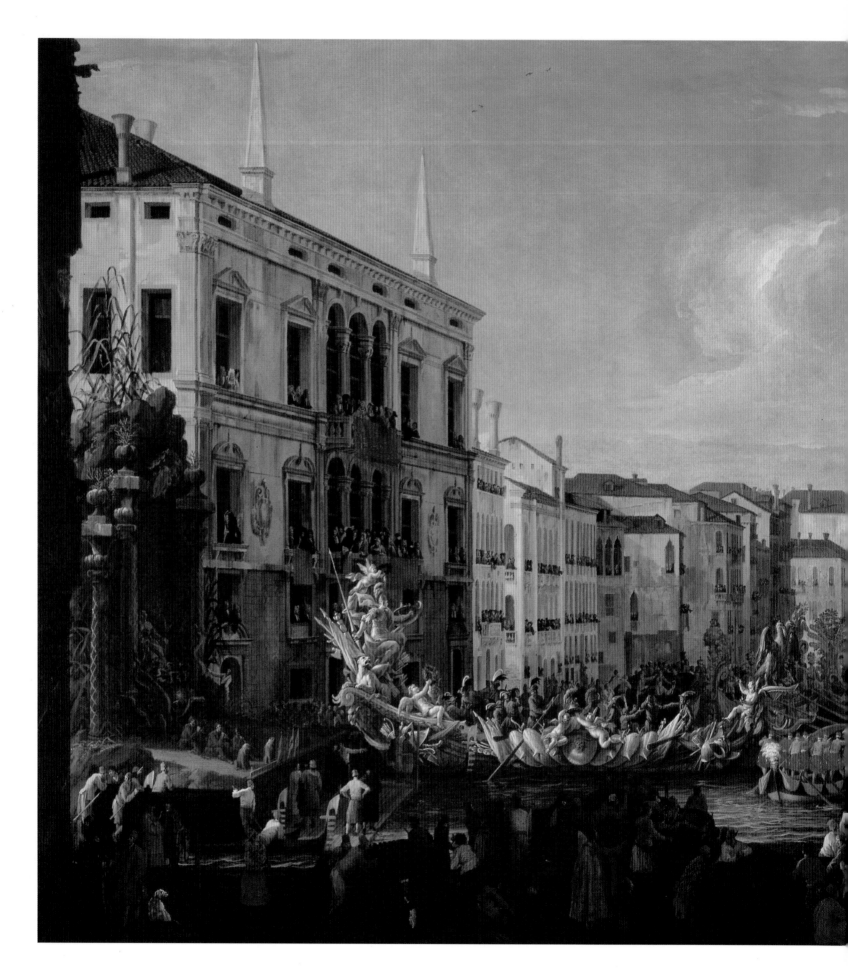

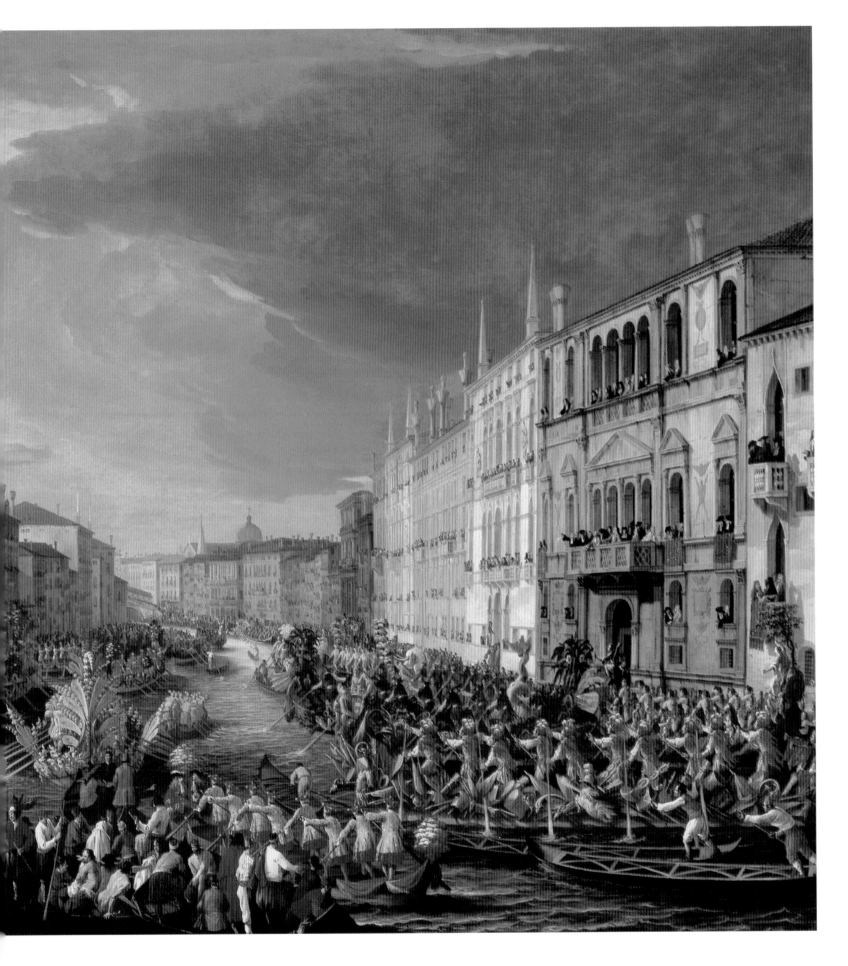

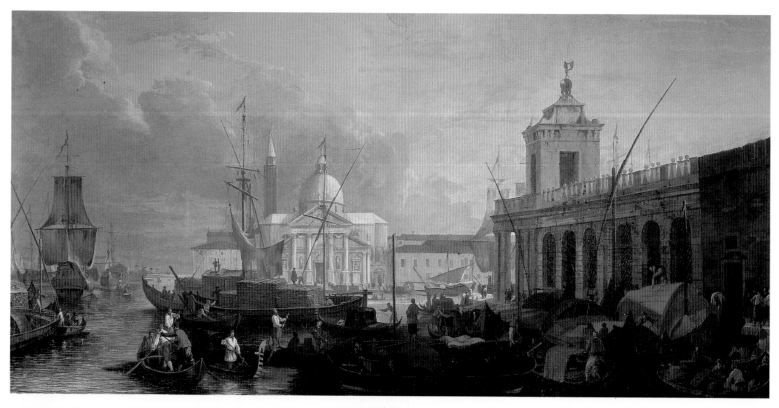

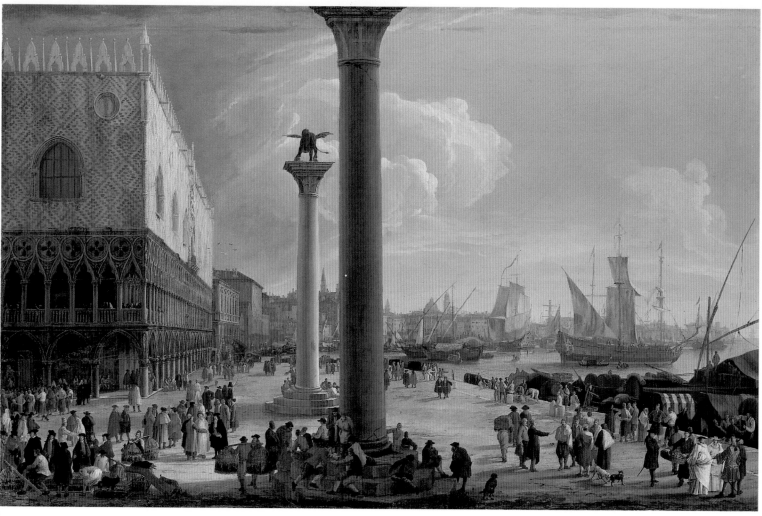

Luca Carlevaris
St. Mark's Square with Charlatans
73.2 x 117.2 cm
Potsdam, Sans-Souci Castle

(opposite page)
Luca Carlevaris
*View of the Customs House
with San Giorgio in the Background*
50 x 96 cm
Private collection

Luca Carlevaris
The Dock Facing the Doge's Palace
73.4 x 117.4 cm
Potsdam, Sans-Souci Castle

first decade of the eighteenth century, for some canvases celebrating key moments in Pisani's diplomatic career and culminating in his election to Doge in 1735. Among them, the best is without doubt *The Entrance into London of the Venetian Ambassadors Nicolò Erizzo and Alvise Pisani* (Bayerische Staatsgemäldesammlungen, Munich) an event of 1707, marked by great narrative liveliness.

Carlevaris's style did not change substantially up until his death on February 12, 1730, after having been struck two years earlier by a progressive paralysis which forced him to cease his activity. His last works still manifest his refined ability to stage his views of San Marco with great skill, populating them with numerous variegated sketches of popular life. It is precisely these little figures, drawn from life with black pencil in his sketchbooks—many of which are now in the Museo Correr in Venice and the Victoria and Albert Museum in London—that enliven his paintings with their bright colors and frenetic activity. Works like the *View of the Dock from the San Marco Basin* in Montecarlo or *The Piazzetta and the Library* in the Ashmolean Museum in Oxford (U.K.), or the beautiful image of *The Island of San Giorgio Maggiore* seen from the dock, where a large group of fish vendors are busy about their business, which appeared at a Christie's sale in London on 7 July 2000, all dating to the last decade of Luca's life, stand among the highest achievements of Venetian view painting in the eighteenth century

Luca Carlevaris
View of the Dock from San Marco Basin
85.7 x 163.8 cm
Montecarlo, Private collection

Luca Carlevaris
The Island of San Giorgio Maggiore from the Dock
46.5 x 61.5 cm
Private collection

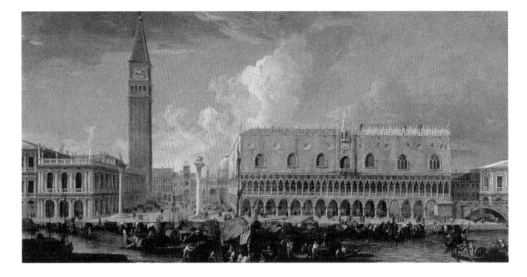

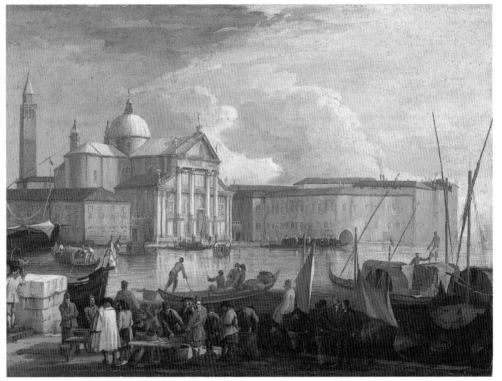

Carlevaris has not yet received the critical acknowledgment he deserves; nonetheless, he should be recognized for having made a crucial contribution to the renewal of Venetian art in its break from the Baroque. Carlevaris helped to draw the attention of the market, and thus of local artists, towards genres neglected until that point, such as landscapes and *vedute*.

(opposite page)
Luca Carlevaris
The Piazzetta with the Library
46 x 39 cm
Oxford, Ashmolean Museum

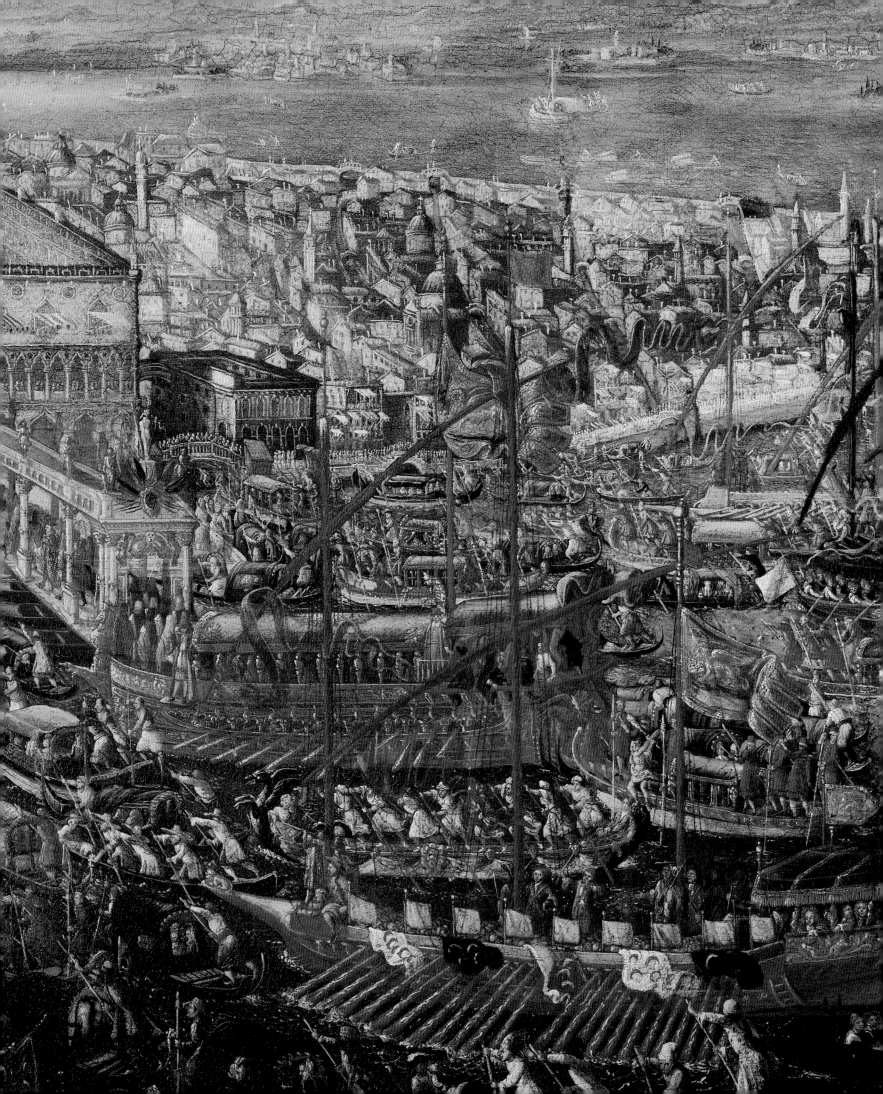

Contemporaries of Luca Carlevaris:
Giovanni Richter, Tonino Stom, and Others

Alessandro Piazza
The Triumphal Return of Francesco Morosini's Fleet
Venice, Museo Correr
Detail (entire painting on page 58)

The line traced out by Heintz and raised to far higher levels of achievement by Carlevaris was followed, in the early eighteenth century, by numerous other view painters. Among them, along with the otherwise unknown Menichino, whom Moschini (1806) mentions as a student of Carlevaris,[11] is a gifted artist whose precise biographical information is unknown. This is Alessandro Piazza, who signed two distinct series of paintings, the first now in Worcester Art Museum in Massachusetts and the second in Museo Correr in Venice, dated to the early years of the eighteenth century. Seven canvases make up the series in Venice, which narrate the main events in the life of Francesco Morosini, known as the Peloponnesian, who was the victorious commander of the Venetian fleet against the Turks in the war of Morea and Doge from 1688 to 1694. They were painted for the family palace at Santo Stefano after the commander's death, which occurred during a military campaign in Nauplion, Greece, as evidenced by the depiction of his funeral. These are works characterized by a rich, pasty brushstroke and an interesting, vivacious chromatic effect, in a style that recalls more closely that of Heintz than of Carlevaris.

Among these canvases, two are of special interest. The first (which bears the artist's signature) celebrates *The Triumphal Return of Francesco Morosini's Fleet*. This is essentially a bird's-eye view, showing in the foreground the Venetian fleet as it pulls into the San Marco Basin, where in front of the façade of the Doge's Palace a pier has been erected with a sort of triumphal arch. In the background appears the entire north east section of the city, from the Arsenale shipyards all the way to the island of Sant'Elena. Farther back is a rare image of the lagoon toward the port of the Lido, on the right, and toward the islands of Murano and Burano more to the left. It is clear that Piazza painted from a map, but the agitation of the scene in the foreground recalls the work of Heintz.

The second view shows *St. Mark's Square* with the temporary structures built for the procession in celebration of the return of the victorious admiral, and has quite different characteristics. The scene is much more subdued: the festive air created by excitement at the arrival of the victorious fleet and the lively, multicolored world of the ships and sailors is replaced by the solemn atmosphere of an official Republic

Alessandro Piazza
*St. Mark's Square During the Procession
in Honor of Francesco Morosini*
64 x 93 cm
Venice, Museo Correr

Alessandro Piazza
The Triumphal Return of Francesco Morosini's Fleet
64 x 93 cm
Venice, Museo Correr

Johann Richter
St. Mark's Square
Facing the Church of San Geminiano
42 x 65 cm
Private collection

ceremony. The view of the square, with the Procuratie Nuove and the looming bell tower in the background, and Sansovino's church of San Geminiano on the right, is more precisely rendered than the city in the other canvas in the series.

Johann (Giovanni) Richter

An artist whose style is very close to Carlevaris's own is Johann (Giovanni) Richter, who was born in Stockholm around 1665 and lived in Venice from 1710 to his death on December 27, 1745.[12] It is probable that Richter spent some years in Carlevaris's workshop; he is listed as a student of Carlevaris in the inventory of drawings made by the Florentine collector Francesco Gaburri in 1722. It is curious to note that the Swedish artist was undoubtedly in close contact with Antonio Balestra, who wrote a letter in 1717 to Gaburri to recommend that the collector buy some small pictures by Richter, "made with real love." This detail sheds new light on the artist's little-investigated production of religious subjects, which we know only through the existence of an altarpiece discovered by Egidio Martini in the parish church of Spinea, signed and dated 1739.[13]

Richter, too, devoted his efforts to reproducing the San Marco sites dear to Carlevaris and appreciated by patrons, as is well illustrated by the view of *St. Mark's Square from the Porta della Carta* (1717; Sirén collection, Stockholm), or the

Johann Richter
*The Votive Bridge for the Feast
of Santa Maria della Salute*
Hartford, Wadsworth Atheneum

one of a similar shape and size in the Ringling Museum of Art (Sarasota, Fla.). To this phase belongs also another view heretofore unpublished, signed on the back of the canvas "G. Richter pinx. / Venetie," of *St. Mark's Square facing the Church of San Geminiano* (private collection).[14] The date of this painting can be assigned to the late 1710s or very early 1720s, since the square is shown still paved in brick, which was replaced with the existing pavement in the early 1720s. The view is clearly indebted to Carlevaris's models in the overall layout of the scene, but typical of Richter's style are the color tones and the tendency to dilate unnaturally the background architectural structures (notice the unusual height given the loggia of the bell tower and the Procuratie Nuove on the left). Also common for Richter is the placement of numerous little figures scattered through the picture, both in the foreground and in the background, where there appears, next to the loggia of the bell tower, the usual street actors attracting the attention of many spectators.

Similarities of style and subject have led to some real difficulty for critics in attributing certain works, which have variously been assigned to Carlevaris or Richter. An emblematic case is the painting showing the *Votive Bridge* erected across the Grand Canal for the festivities of the Madonna della Salute, celebrating the Virgin Mary's delivery of the city from the plague (Wadsworth Atheneum, Hartford, Conn.). This painting has been variously attributed to Carlevaris, Richter, and, in a more recent, Solomonic proposal, to a collaboration between the two. In this case, "Carlevaris would be responsible for the overall structure of the view, with its open, spacious feeling, while the groups of figures crossing the bridge or crowding into the boat in the foreground would have been done by his Swedish student."[15] However, above and beyond the fact that this would be the only painting surviving to our day that would have been the result of collaboration between the master and his pupil, the architectural elements characterizing the view seem to fit Richter's style more closely than Carlevaris's. This is evident above all in the forced transposition of the buildings making up the "wing" on the left, where the palaces of the Gritti and Fini are given an unnaturally imposing appearance. This same manner of treating the architecture is seen in works like the *View of the Grand Canal at Santa Lucia,* a pendant to the above-mentioned view of *St. Mark's Square* in the Sirén collection in Stockholm, or another beautiful *View of the Grand Canal from Palazzo Grimani toward the Rialto Bridge* (private collection, Venice), which Martini published about twenty years ago.[16] The latter is an astonishing image, characterized by the great emphasis given to the zone in shadow on the left, into which a boat is about to enter, carrying some elegant young ladies dressed in multicolored clothing. This area contrasts with the brightly lit area on the other side of the canal, whose architectural elements, even though described fairly generically, are "enlarged" in the manner typical of Richter.

Johann Richter
*The Grand Canal from Palazzo Grimani
toward the Rialto Bridge*
91.8 x 127.3 cm
Private collection

In addition to the *Votive Bridge* in the Wadsworth Atheneum, there are other paintings that at one time were thought to be by Carlevaris and now seem more correctly assigned to the Swedish artist. Examples are the two canvases formerly in the Brass collection in Venice, showing *St. Mark's Square Facing the Church* and *St. Mark's Square Facing the Piazzetta*, or an interesting *View of the Piazzetta with St. Mark's Square in the Background*, formerly in the Galleria Lumina in Bergamo,[17] published as the work of Carlevaris by Aldo Rizzi. To justify the anomaly of the little figures compared to the ones usually seen in Carlevaris's work, Rizzi hypothesized that they could have been done by a collaborator, perhaps his daughter Marianna. Her work is known, through some canvases in Ca' Rezzonico in Venice, as that of a modest portraitist and follower of Rosalba Carriera. It seems much more probable that the entire painting was done by Richter, including the somewhat slender figures, which are completely similar to those in paintings known to be his.

More original than Richter's views of the sites around San Marco are his numerous images of the lagoon, in some of which he takes an approach unprecedented in the Venetian world. Noteworthy among such paintings are views of *The Island of San Giorgio Maggiore* (National Museum, Stockholm), and the one, engraved by Vogel, showing *The Dock from the Terranova Granaries to the Doge's Palace*, as seen from the San Marco Basin (Richard Green collection, London). In his views of the lagoon the painter favors a distant viewpoint and shows a propensity to place at center stage, in an area of shadow that serves to give depth to the more distant planes, boats that are often graced by the presence of young girls, elegantly dressed and easily distinguishable by their colors. The principal architectural structures are almost never represented frontally, but from an angle, and are calligraphically described in minute detail. Often—for example, in the view showing *The Giudecca Canal* from the church of the Redentore toward the since-destroyed church of San Biagio (private collection, Milan)—the use of an optical chamber led the painter to shrink significantly the real space between the

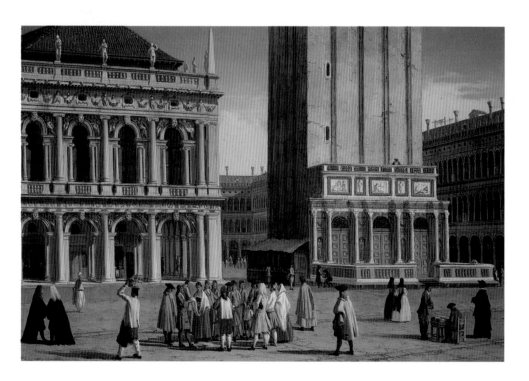

Johann Richter
*View of the Piazzetta
with St. Mark's Square in the Background*
59 x 97 cm
Bergamo, Private collection

62

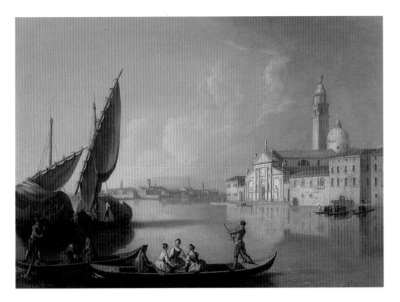
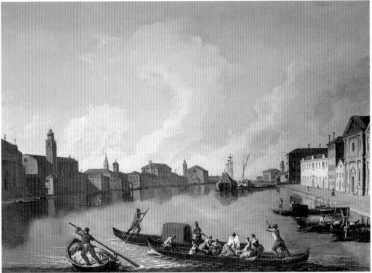

Johann Richter
View of San Giorgio Maggiore
Stockholm, Nationalmuseum

Johann Richter
The Giudecca Canal
60 x 80 cm
Private collection

buildings. This often achieved curious "corridor" effects never seen in reality, thus exasperating the traits noted in the San Marco views mentioned earlier.

These lagoon paintings—certainly less successful technically than the views of San Marco sites done around 1717—can probably be assigned to a time after Richter left Carlevaris's workshop. Another unprecedented—and very curious—view, datable to Richter's late period, shows a procession of decorated Venetian eight-oared state boats accompanying a parade boat in the section of the Grand Canal in front of the church of San Simeone Piccolo. The fact that the church is complete allows the canvas to be dated later than 1738, when construction was finished on the new building, designed by Giovanni Scalfurotto. This work demonstrates late-career traits such as the topographic type of observation already mentioned, and a slightly different quality of the brushstroke. As in other works that presumably belong to his late period, the brushwork tends to be more pasty and less attentive to the meticulous rendering of details than earlier canvases.

Critics agree that another view belongs in this series, of *San Michele in Isola* with Murano in the background (Nationalmuseum, Stockholm), which is curiously reversed. It is surprising that there exists, of this same subject, not only the view painted by Richter with the correct image of San Michele seen from the Fondamenta Nuove with Murano in the background (private collection, Tricesimo), but also its matching engraving, which is part of the ten plates made by Bernard Vogel of paintings by the Swedish artist. All this leads to the suspicion that the view in the National Museum, Stockholm—which, as we have said, shows the scene reversed, with the Emiliani chapel on the right with respect to the façade of the church and the convent on the left—is not a caprice. Nor does it seem an occasion in which "the use of the optical chamber... has even made the artist forget the real direction, and place the church and the Miani chapel, and Murano, reversed with regard to the way they really are."[18] Rather, it may be nothing more that a modest interpretation, with variants in the boats, made by another artist from the preparatory drawing for Vogel's engraving, where the image would have necessarily been reversed.

Above and beyond the uncertainties that might arise in the attribution of this work, there can be no doubt that Richter—and before him, albeit in a less evident

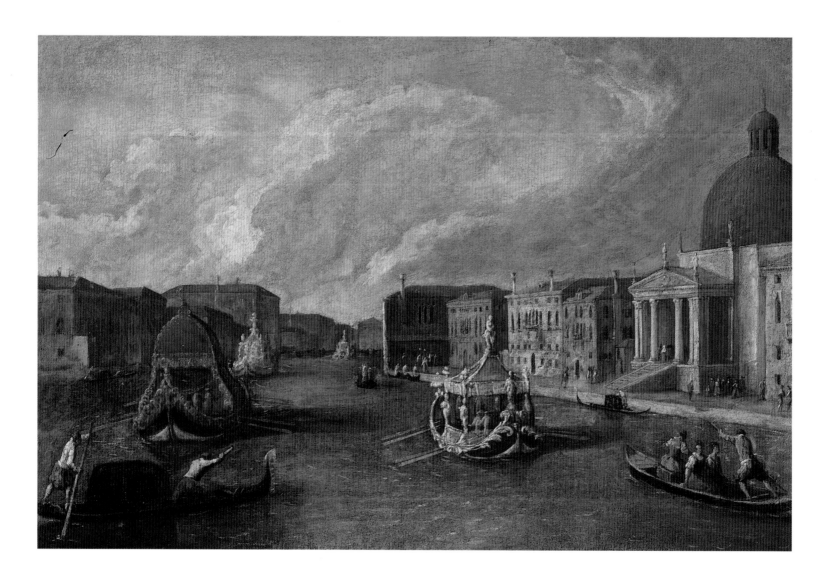

Johann Richter
The Grand Canal from San Simeon Piccolo
toward the Rio di Cannaregio during a Parade
46 x 70.5 cm
Private collection

manner, his teacher Carlevaris—can justly be considered the forerunner of the Venetian manner of understanding the *veduta*: not as the faithful reproduction of reality, but rather almost an assemblage of architectural elements. In the canvases by Canaletto, Bernardo Bellotto, Michele Marieschi, Francesco Guardi, and the other eighteenth-century *vedutisti*, we should not look for the perfect reproduction of what appeared to their eyes: in a word, the "photographic" view. This aspect can be found in the work of cartographers, such as the invaluable map of the city made by Ludovico Ughi and printed in 1729, the result of scientific measurements and observations. The painters—and the example of Richter's canvases becomes particularly significant in this sense—see Venice with their own eyes, and thus they reproduce it, filtered through their own sensibility and culture, without feeling obligated to give an exact correspondence with reality.

Antonio (Tonino) Stom

We find the same approach to figurative reproduction in the works of another painter, probably from northern Europe, who devoted sporadic efforts to producing views of Venice in the early decades of the eighteenth century: Antonio (Tonino) Stom (c. 1688–1734). He was the author not only of caprices, but also of battle scenes and large historical paintings (particularly interesting are those in

Palazzo Mocenigo in Venice, representing important episodes in the history of the noble Venetian family). Stom also painted a series of paintings to be hung over doors, originally in Palazzo Priuli in Pieve di Sacco and later transferred to a private collection in Bologna, with scenes from Venetian festivities (*The Regata, The Feast of the Sensa, The Fist Fight on the Bridge; Chasing the Bulls; The Parlor; The Ridotto*), and some views, in which he appears to attempt to combine the manner of Joseph Heintz with Carlevaris's taste for little genre scenes as seen in their larger compositions.

In his production of Venetian images, a particularly interesting role, to my mind, is played by the *View of St. Mark's Square* seen from a window in the Procuratie Vecchie, now in a private collection, which was shown at the exhibition of Carlevaris's work held in Padua in 1994 (no. 79). This canvas stands out for its original framing, a characteristically cool palette that plays on grayish tones of color, pasty brushstrokes, and the rendering of the lively figures in the foreground, of a much higher quality than the more static and generic ones sketched into the background. This painting also reveals the limitations in Tonino's ability to represent perspective. This weakness is evident in the anomalous stretch upwards of the imposing bell tower, whose summit is lost beyond the upper edge of the canvas, in the incorrect angle given to the façade of the Doge's Palace with respect to the Piazzetta, and in the unfortunate rendering of the detail of the island of San Giorgio Maggiore, almost a miniature in the background. The framing of the view in this work was a favorite of Tonino, who repeated it at least twice: in the canvas

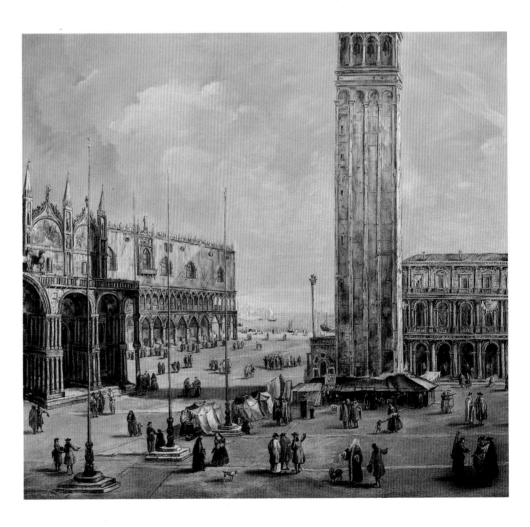

Antonio Stom
St. Mark's Square from the Procuratie Vecchie
106 x 123 cm
Private collection

now in the Galleria Estense in Modena, earlier attributed to Carlevaris and restored to Stom by Antonio Morassi (1962),[19] and in another, in a private collection in Venice and previously unpublished, characteristic for its cool colors and the type of figures utilized in the larger composition. The three views can all be assigned with certainty to the second decade of the century, since they show the old brick paving of the square.

It is to Morassi's great credit that he also restored to Stom a beautiful image of the Grand Canal with the Fondamenta del Vin, formerly in a private collection in Rome, a highly picturesque site that was neglected by the Venetian *vedutisti*. The view is distinguished by his typical cool colors and an improbable heap of architectural elements, which seems to foreshadow not the production of Michele Marieschi, as has been written, but rather the more advanced manner of representing views characteristic of Francesco Guardi.

The catalogue of Tonino's Venetian views also should include, without doubt, the canvas belonging to the Querini Stampalia Foundation in Venice representing *The Departure of the Bucintoro for the Feast of the Sensa*. This is a large picture, painted for the Giustinian family, which in the past has been attributed to Canaletto and then to Francesco Battaglioli. It too shows the same kind of forced perspective, cool palette, and taste for a cursory rendition of the figures found in other pictures by Stom.

Bernardo Canal

Bernardo Canal (Venice 1664–1744), father of the much more famous Antonio, called Canaletto, could be defined as a late follower of Carlevaris. His name is registered in the Guild of Venetian Painters in 1717 and again from 1737 to 1743. Canal achieved his greatest success in the field of theatrical scenery, with the collaboration of his sons Cristoforo and Antonio; nonetheless, he did not disdain view painting. Works known to be his are not numerous, being limited to a group of five views of St. Mark's Square and its surroundings formerly in the Salom collection at Segromigno Monte near Lucca, discovered by Pallucchini.[20] These include one representing *St. Mark's Square Facing the Church of San Geminiano,*

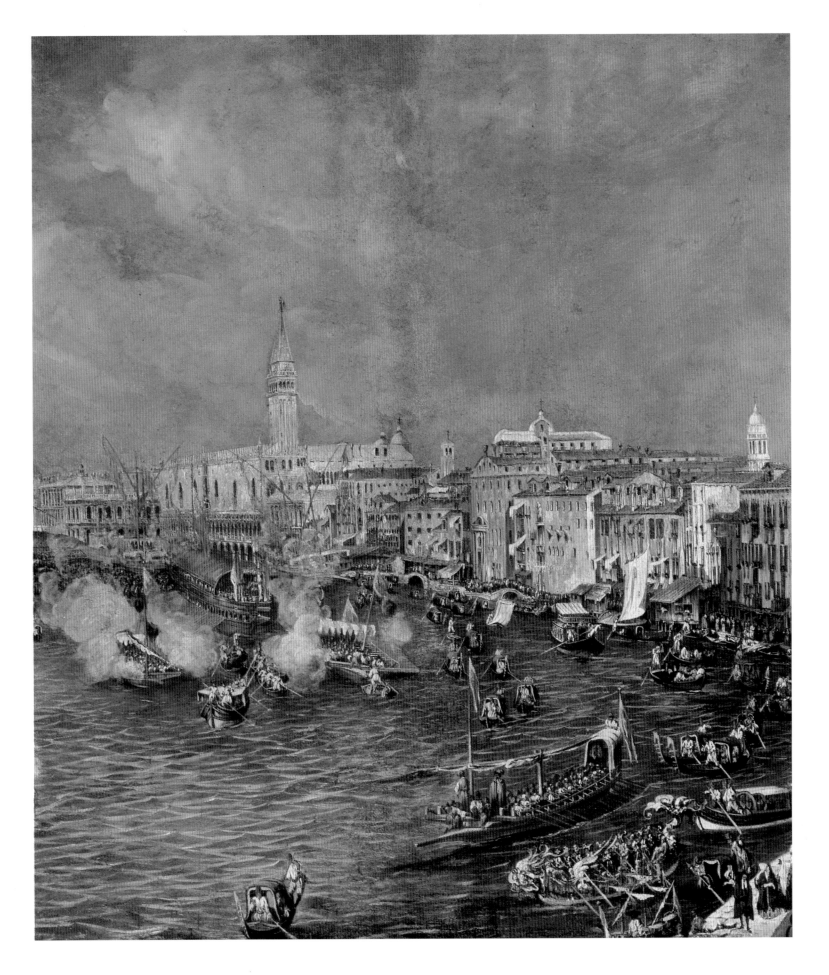

Antonio Stom
The Departure of the Bucintoro
for the Feast of the Sensa
132 x 265 cm
Venice, Querini Stampalia Foundation

signed and dated on the back of the original canvas "Bernardo Canal fecit 1734," and two others, signed and dated January 1737, which appeared on the art market in the 1990s and are derived from two of the engravings made by Antonio Visentini of paintings by his son Canaletto. Critics have recently grouped some other views with these, on the basis of stylistic analogies,[21] among which is *The Rialto Bridge* with the Palazzo dei Camerlenghi on the right, in a private collection, noteworthy for the sharply defined description of the architecture. The fact that his few certain works are all datable to the 1730s indicates that Bernardo Canal took up view painting at a fairly advanced age, probably stimulated by his son's success and the market's growing demand. Nonetheless, it is surprising that his Venetian images are not modeled on works by Canaletto, but rather on those by the then dead—and in many ways, outdated—Carlevaris. The latter could have furnished the example for Canal's atmospheric rendition, the type of lively, but rare, figures, and even for his characteristic way of scaling the clouds in the sky to give the picture greater depth of space. In any case, Canal displays his own personality in the rendering of the architecture, characterized by meticulous clarity and bathed by a bright light which makes legible all the decorative details.

Bernardo Canal
*St. Mark's Square Facing
the Church of San Geminiano*
56 x 73 cm
Milan, Private collection

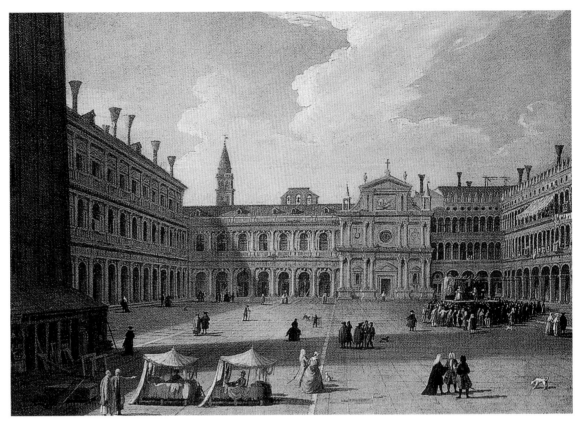

Bernardo Canal
*The Rialto Bridge
with the Palazzo dei Camerlenghi*
66 x 88.5 cm
Rome, Private collection

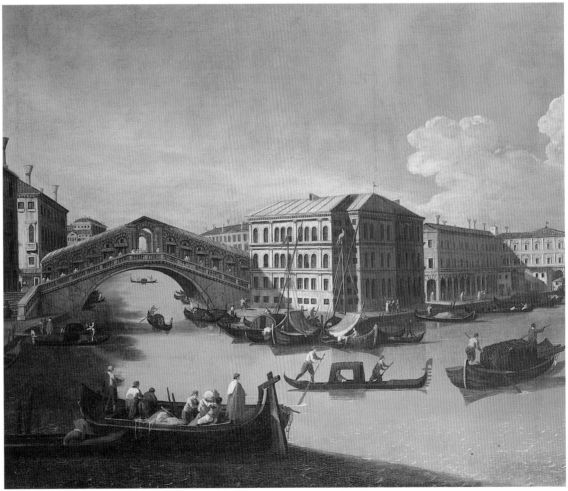

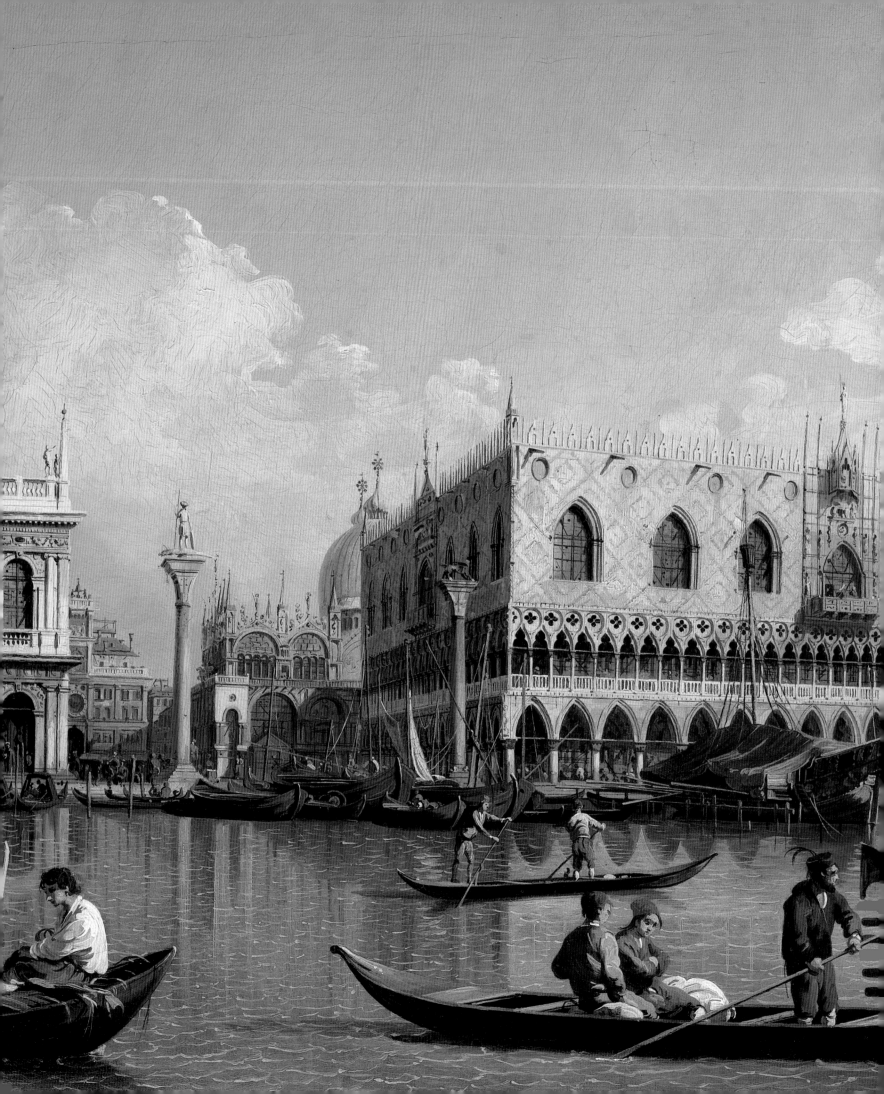

Canaletto

Canaletto
View of the Dock from the Basin
Private collection
Detail (entire painting on page 105)

The Beginnings

A great deal of information is available about Zuanne Antonio Canal, called Canaletto, who is without doubt the most famous and widely appreciated exponent of eighteenth century Venetian view painting. We know enough, certainly, to reconstruct his life events and artistic activity more or less from the middle of the 1720s onward; conversely, we know very little about his training and the earliest years of his work. This lack of information, reinforced by the scarcity with which he is mentioned in the literature of his time, results in a general uncertainty among critics as to how he was trained.

On this topic, scholars have divided into two opposing camps: on one side are art historians from the Veneto area, headed by Rodolfo Pallucchini, who have preferred to exclude the influence of the Roman world—and especially, to use Pallucchini's own words, the "anemic perspectives" of Gaspar Van Wittel—on the formation of the young Venetian *vedutista*. Others—among them the leading Van Wittel scholar, Giuliano Briganti—have forcefully underscored the importance, in their opinion determinant, of the Venetian views of the Dutch artist not only on Canaletto, but more generally on the formation of the entire school of eighteenth-century Venetian view painting.

To settle the matter, we must examine certain works of Canaletto dating from the early 1720s. Such analysis will make clear how at the beginning of his career the young painter paid close attention to the local Venetian tradition, and particularly, for reasons I shall give later on, to Marco Ricci.

The scarce documentary information provides a few details concerning the very earliest years of Canaletto's activity. He was born in Venice, in the neighborhood of San Lio, on October 28, 1697. His father, Bernardo, is mentioned by eighteenth century writers such as Anton Maria Zanetti (1771) and Lanzi (1795–96) as a "theatrical painter," and it is probable that he was, at the beginning of his career, a specialist in perspectival stage sets like those painted by the Bibiena family. Bernardo Canal is listed as a member of the Guild of Venetian Painters in 1717 and from 1737 to 1743, and was elected Prior of the guild in 1739. He worked continuously between 1711 and 1728 for the theaters of Sant'Angelo and San

Cassiano, which were among the most famous of those operating at the time in Venice, yet he also worked outside Venice. Bernardo was in Rome between 1719 and 1720, and in 1731 he was in Vicenza where he did the stage sets for M.A. Gasparini's *Arsace* for the Teatro della Piazza.

His assistants, from the second half of the second decade on, were his sons Cristoforo—probably older than Antonio—and Antonio. The three collaborated on various undertakings: in 1716 they did the sets for *Arsilda Queen of Pontus* and *The Coronation of Darius*, with music by Antonio Vivaldi, and for *The Chaste Penelope* by Fortunato Chileri for the Sant'Angelo theater. In the following year they did sets for *Innocence Recognized* by C.F. Pollarolo and for *The Loser Triumphant over the Winner* by an anonymous author, again for the Sant'Angelo, and for *Agrippus* by G. Porta for the San Cassiano. In 1719 the trio was dissolved. Cristoforo remained in Venice, where he designed for the Sant'Angelo the sets for *The Fall of Gelon,* and, the following year, for *Disappointed Armida*; Bernardo, accompanied by Antonio, went to Rome, where he staged at the Teatro Capranica *Titus Sempronius Graccus* and *Turnus Aricinus* by Alessandro Scarlatti.

Apart from this dry list of jobs, little else is known about the activity of Bernardo and his sons for the theater. Especially lamentable is the fact that no drawings survive to testify to their work in this field, nor any literary descriptions of their designs for the stage. It is, however, easy to hypothesize the involvement of Bernardo—who was without a doubt, given the official jobs he was awarded and the importance of the theaters for which he worked, an outstanding figure in this world—in the debate concerning the renewal of stage design, which was particularly lively and impassioned in the early decades of the eighteenth century. This was when in Venice, as also in Rome and Turin, the first examples appeared of a new type of stage set, usually called "pictorial," as opposed to the

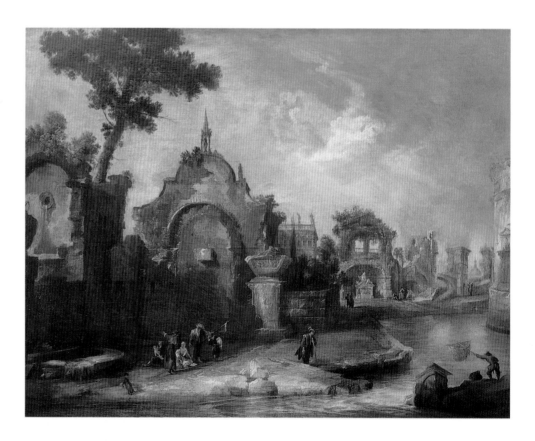

Canaletto
Architectural Capriccio
113 x 149 cm
Private collection

Canaletto
Architectural Capriccio
113 x 149 cm
Private collection

"perspectival" type derived from the models of the Bibiena family. No longer in favor were fantastic, absurd stage machinery marked by a heavily Baroque taste, nor agitated forms and fancies, with great "receding colonnades, tangles of architectural monuments, [and a] profusion of decorative elements,"[22] but rather scenes confined essentially to the backdrop, with elements borrowed from paintings of ruins and landscapes.

In Venice, one of the leading protagonists of this change of direction was Marco Ricci (1676–1730). It is known that this artist, born in Belluno, was very active in the field of theatrical design. Indeed, he must have been highly respected, as evidenced by his first trip to England, made with Giannantonio Pellegrini from late 1708 to 1712, which had as its primary purpose the staging of Italian works at the King's Theater in Haymarket. The two Venetian painters worked together on the sets for *Pyrrhus and Demetrius* by Alessandro Scarlatti and Nicolò Haym, staged on April 2, 1709. In the following season, they collaborated on Bononcini's *Camille*, while Ricci alone made the designs for *Faithful Idaspe*. Later, he resumed stage design in Venice, where he returned in 1716 after his second trip to England and lived with his uncle Sebastiano, also an aficionado of the theatre and an impresario in his own right. In 1718 Ricci designed the sets for *A Daughter's Love* by Giovanni Porta and in 1719 those for *Generous Repentance* by Stefano Andrea Fiore and *Amalasunta* by Chileru, all put on by the Sant'Angelo. Later works were the sets for *Siroe King of Persia* by Leonardo Vinci and *Syphax* by Nicolò Porpora, both performed in 1726 at the San Giovanni Crisostomo theater.

Unlike for the Canal family, we do have record of Marco Ricci's style in his theatrical work: fifty *Stage Designs* now in the Royal Library of Windsor Castle, in all probability made during the years of Ricci's last stay in Venice. This dating

is supported not only by their stylistic traits, which correspond to the works that can definitely be assigned to the artist's mature period, but also the bequest of the drawings to the Royal Library directly from the collection of the English consul in Venice, Joseph Smith—a collection that was put together exclusively in the Italian city.

The drawings in question testify to Ricci's determination to break with the Bibienesque tradition, still marked by a Baroque taste, by proposing "vast, luminous squares, porches, colonnades, courtyards, dark prisons... ports and wide bays... staircases and gardens, parks and ceremonial entrance halls, frescoed rooms glimpsed beyond the perspective of an illustrated arch, comfortable and inhabitable interiors."[23] In other words, Ricci utilizes in his work for the theater the same repertoire that he was using in his paintings in those very years.

It seems reasonable that a young stage designer at the beginning of his career, as Antonio Canal was when Ricci was in Venice and working for the local theaters, could not help paying attention to the brilliant innovations being introduced by the older, more famous artist. That both father and son could have known Ricci's creations is beyond doubt, given their professional work in the same specialized and restricted field, and considering that it was Ricci who took over in 1718 for Bernardo and his sons at the Teatro Sant'Angelo.

These elements provide certain confirmation for the hypothesis of a relationship between Marco Ricci and Canaletto. The dates confirm that this relationship did not grow up after Canaletto's Roman sojourn in 1719–20, but before. It follows, then, that the sojourn in question should no longer be considered the pilgrimage of a young and unversed set designer who, suddenly and as though by chance, saw before him a new world and new expressive possibilities in the works of painters like Viviano Codazzi, Emilian Pannini, Gaspar Van Wittel, and the masters of the northern school (who are variously indicated by some critics as his earliest models). The decision to go to the papal city, above and beyond his professional duties, seems instead to be the fruit of a precise, conscious choice. Besides, what place was so well suited to furnishing suggestions and models to an artist devoted to the *veduta ideata*, or "ideal (imaginary) view"? The fact that Canaletto may have worked in Rome for the theater and have helped his father to design the sets mentioned above for the Capranica seems a secondary matter, a routine professional episode. Evidently, by that time, for the young painter trained on Ricci's examples, stage sets and natural views were already one and the same. Thus, the trip to Rome in 1719–20 seems not to be an indispensable turning point in the formation and development of the early career of the young Canaletto, as some critics have maintained.

All this is confirmed—or at least is not contradicted—by Anton Maria Zanetti's report that Canaletto, "having left the theater, annoyed by the indiscretion of the dramatists (this was around the year 1719, when he solemnly excommunicated, as he said, the theater), gave himself totally to painting natural views." There is no reason to believe that Zanetti meant that only "after" having "excommunicated" the theater, Canaletto devoted himself to "natural views." If, following Ricci's example, Canaletto's stage sets were actual "ideal views," as is reasonable to suppose, it seems likely that Antonio devoted his efforts to this genre at an early age. That is, he began view painting in the years before his trip to Rome, therefore before "excommunicating"—abandoning definitively—the theater. And perhaps to this time can be assigned some of the paintings that are usually dated in the painter's early period: for example, the *Caprice with Ruins and a Renaissance Building*

Marco Ricci
Stage set
20.1 x 30.3 cm
Drawing
Windsor, Royal Collections

(Wadsworth Atheneum, Hartford, Conn.) which was once paired with a similar image in the Venetian collection of the Donà delle Rose family, or the *View* (not necessarily Roman) published by Rodolfo Pallucchini in 1964. These are the canvases—not coincidentally attributed to Marco Ricci when they appeared and only recently recognized as Canaletto's work—where the presence is most evident of elements deriving in equal measure from Ricci's manner and from the practice of designing for the theater. They are also closest, particularly in the framing of the views, to the *Stage Designs* that Ricci was producing toward the end of the 1710s. The relationship of Canaletto with Marco Ricci—born, thus, out of their shared interest in the world of the theater—was probably important not only in Canaletto's early formation but also in the development of his career. In fact, Ricci's contacts with the English world are well known, the earliest signs of which may date to a sojourn of his in Rome preceding his first trip to England in 1708. On this occasion, it is likely that Ricci met the Sicilian architect and stage designer Filippo Juvarra, who was working at the time in the papal capital for Cardinal Ottoboni. Through Juvarra, Ricci would have come into contact with Owen McSwiney, the impresario of the works that would be performed at the King's Theater with stage sets by Ricci and Giannantonio Pellegrini. McSwiney also conceived and commissioned on behalf of Lord March, the future second Duke of Richmond, the famous series of paintings (the so-called *Tombeaux des Princes*) executed in collaboration by several painters, some of them of the Venetian school, including Ricci, and, later, Canaletto. Thus Ricci may have been Canaletto's link to the world of the English living in Venice, and possibly even to Joseph Smith, who would become the most influential person in Canaletto's career and who was a great friend of both Ricci and his uncle Sebastiano.

In the course of his brief Roman sojourn, Canaletto made a goodly number of drawings, as the twenty-two sheets now in the British Museum in London and the one in the museum in Darmstadt testify, as well as some paintings. The authorship of the drawings has been doubted in the past by some critics, but scholars now

seem to agree that they are by him. This argument is supported by the fact that the hand in these drawings is the same as in other definitively Canaletto drawings, and by the use of some of the sheets now in the British Museum by the engraver Giovan Battista Brustolon. Brustolon acquired the drawings directly from the painter's heirs, and used them as models for a series of prints bearing inscriptions such as "Antonio Canal pinxit Romae." Moreover, two canvases known to be Canaletto's are closely linked in subject to two of these sheets: one of *The Arch of Constantine,* formerly in the Bracaglia collection in New York, and one of *The Arch of Septimius Severus* in a private collection in Bergamo. Both of these—to judge from their photographs—are closely linked stylistically to Ricci's work, from which they derive the type of figures, very similar to those in the *Ideal View* formerly in the Agosti collection in Belluno of circa 1722.

The work of Marco Ricci also influenced the two large, dramatic *Caprices* formerly in the Cini collection in Venice, one of which—the *Ideal View with Roman and Medieval Ruins and a Renaissance Building*— shows in the background a sixteenth-century building that closely recalls Sansovino's Library in St. Mark's Square. This element suggests that the two canvases, which are pendants to each other, may have been painted immediately after Canaletto's return to Venice in 1720. This series of ideal views is concluded by two other large canvases painted, as Federico Montecuccoli degli Erri has demonstrated,[24] to decorate, along with two other architectural views by the Lombard artist Giovanni Ghisolfi, the walls of a room in the Giovannelli family villa at Noventa Padovana. These are a *Caprice with the Pyramid of Caius Cestius* (1723; private collection, Switzerland) and an *Architectural Caprice*. Publishing the first of these paintings in 1963, Antonio Morassi wrote: "The scene is taken from a large sketch, without accentuating the lines of the persective, without established outlines: but nonetheless with a skill... with a perspectival intuition which blocks incisively every form in its essentiality." This perfectly describes the splendid painting technique of which Canaletto shows himself to be

Canaletto
The Grand Canal from Campo San Vio
140.5 x 204.5 cm
Madrid, Thyssen Bornemisza collection

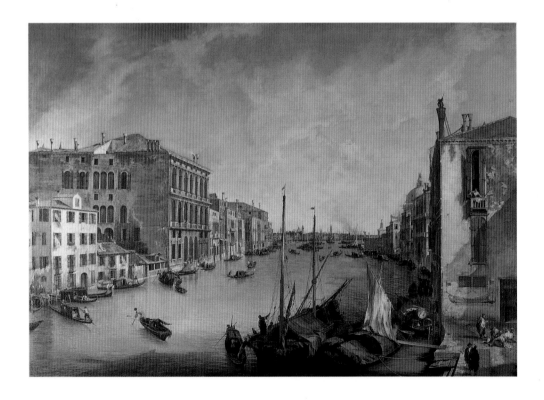

already in full command, typical, in its essentiality, of the ephemeral world of painters of theatrical scenery. And from this practice—"helpful for developing a quick hand and for awakening the imagination of youth, and for forcing it to work with promptness," wrote Anton Maria Zanetti—came the familiarity, rare for a painter at his outset, that Canaletto demonstrated with large canvases: not only these caprices, but also many of his early views of Venice, are works of very large size, more than two meters wide.

The Early Views of Venice

Canaletto returned to Venice in 1720, the year in which his name appears recorded for the first time in the Guild of Venetian Painters. He had probably already made the choice that would turn out to be crucial for his career; he decided to devote himself to painting views of the city on the lagoon.

With some exceptions, critics seem to agree in identifying his earliest surviving views as the four paintings, formerly in the collection of the princes of Liechtenstein in Vienna, which represent respectively *St. Mark's Square Facing the Church*, *The Grand Canal from Campo San Vio* toward the San Marco Basin, *The Grand Canal from Palazzo Balbi toward Rialto*, and *The Rio dei Mendicanti*. The first two have been in the Thyssen collection since 1956 and now hang in Madrid; the others, which passed into the Crespi collection in Milan, were purchased in 1983 by the City of Venice and are now in the Museo del Settecento Veneziano in Ca' Rezzonico.

It is obvious that the four paintings, similar in size (approximately 140 by 200 cm), were made for the same patron, who was not necessarily one of the princes of Liechtenstein since the presence of the canvases in the Vienna collection is recorded only after 1780. Lionello Puppi[25] has offered the hypothesis that the patron could have been Gerardo Sagredo, one of the *procuratori di San Marco,* or high government officials, who were involved in the repaving of St. Mark's Square, an operation that

Canaletto
The Grand Canal from Palazzo Balbi toward Rialto
144 x 207 cm
Venice, Ca' Rezzonico

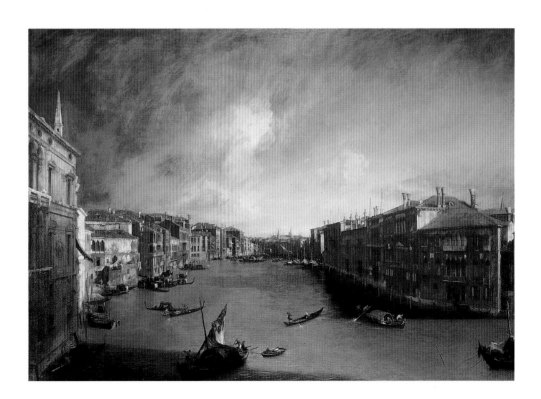

Canaletto
St. Mark's Square
140.5 x 204.5 cm
Madrid, Thyssen Bornemisza collection

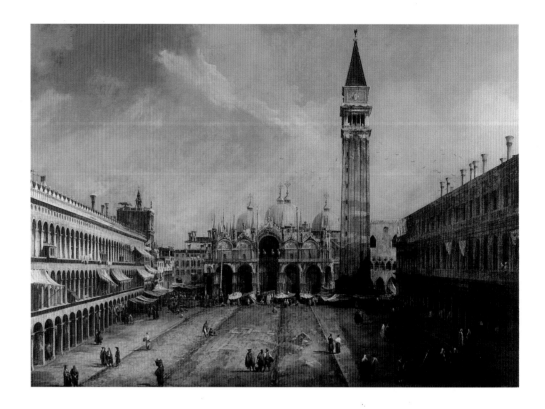

appears to have just begin in one of the paintings now in Madrid. On the basis of this detail documented by the painting, Pallucchini[26] has dated the entire series to 1723, the year in which, according to him, work began to replace the old brick pavement of the square with the present pavement, of trachyte with geometric decorations of white marble, designed by Andrea Tirali. Further research by Puppi has pinpointed the moment when the work was at the stage represented in Canaletto's painting as January 1724, when only the paving of the *liston* under the porch of the Procuratie Vecchie had been done. This would thus be the *terminus post quem* for all four views.

However, another chronology of the paintings can be assigned.[27] Such a chronology derives from the noticeable differences in style among the four views and also from "internal" elements in the paintings themselves. In particular, as Levey has noted,[28] the view of *The Grand Canal from Campo San Vio* in the Thyssen collection shows the dome of the church of Santa Maria della Salute covered with the scaffolding that was mounted—as the reliable Giannantonio Moschini testifies[29]—after September 11, 1719, when restoration and structural consolidation of the building began in order to repair damage caused by the elements. This image is the only one in which this scaffolding appears, out of the countless representations of the church made by Canaletto, including those chronologically closest to the Thyssen picture: the view now in the Gemäldegalerie in Dresden, generally dated to 1725 or shortly thereafter, and the one painted for the collector Stefano Conti, of Lucca, between 1725 and 1726, now in the collection of the Hosmer heirs in Montreal.

Considering Canaletto's habit of bringing his views up to date by recording, in the depictions of a given site made at different moments in time, the work in progress or executed in the meantime on the buildings appearing in the pictures, it is likely that this canvas was executed soon after his return to Venice from

Rome, an event of 1720. Stylistically similar to the Thyssen collection's view of *The Grand Canal from Campo San Vio* is the view of *The Grand Canal from Palazzo Balbi toward Rialto* in Ca' Rezzonico, which shows the same sort of dense, Ricci-esque atmosphere. In the latter picture as well, the view has a large area in shadow in the foreground, which serves to emphasize the theatrical parade of buildings facing onto the water up to the Rialto Bridge, visible in the background. Indeed, to achieve his purpose, Canaletto went so far as to project simultaneously onto the water of the Grand Canal the shadows of Palazzo Balbi and of the palaces on the opposite bank that belonged to various branches of the Mocenigo family. Thus it appears that the painting has two different light sources opposite each other, almost as though two different suns were shining at the same time, one in the eastern sky and one in the west. It is clear that this is not a banal error on the artist's part, but rather a solution which probably came to Canaletto from his custom of working with theater scenery. The characters in the two paintings are also very similar: small in size, just barely characterized, the figures seem often to have been captured in forced poses, like actors playing their part in daily life in a stiff and unnatural manner.

Canaletto
The Rio dei Mendicanti
143 x 200 cm
Venice, Ca' Rezzonico

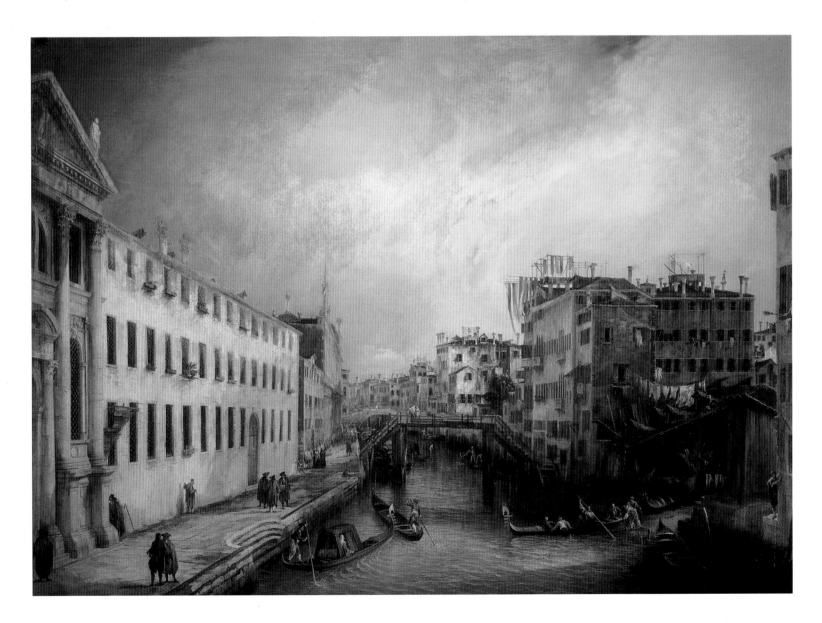

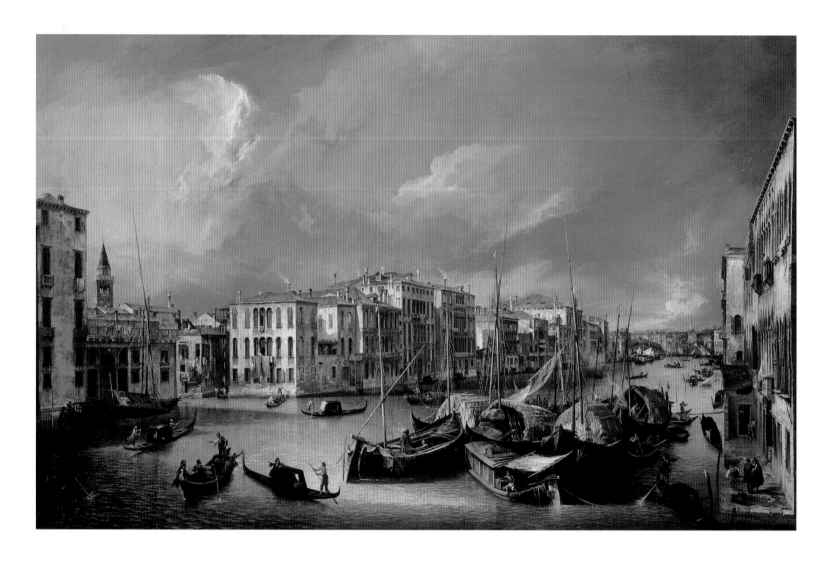

Canaletto
The Grand Canal from Palazzo Corner Spinelli toward Rialto
146 x 234 cm
Dresden, Gemäldegalerie

The style of the view of *St. Mark's Square* in the Thyssen collection is quite different. It can be dated without doubt, as we have seen, after January 1724. The figures are now significantly larger in relationship to the architecture and are less generic, the scene is more brightly lit, and the palette more varied, even though still tending toward the dark tones deriving from Ricci. These characteristics are even more evident in *The Rio dei Mendicanti* in Ca' Rezzonico, which marks a further step forward in the development of Canaletto's style. Here the color becomes even lighter, foreshadowing the stupendous luminosity of the *View of Santi Giovanni e Paolo* purchased at the St. Roch fair in 1725 by the imperial ambassador Count Giambattista di Colloredo Walsee and now in the Gemäldegalerie in Dresden, the views painted between August 1725 and 1726 for Stefano Conti, and the first images of Venice made for Joseph Smith between 1726 and 1728. The characters are now in proportion to the architecture and precisely identifiable in their clothing and gestures: the women at the balconies; the workmen launching the gondola in the shipyard; the bewigged aristocrat in the cabin of a gondola rowed by a gondolier in his elegant yellow and blue livery, the old beggar disrespectfully urinating on a pillar of the façade of the church of San Lazzaro, the others stopping for a conversation on the quays, even the fishermen in the background selling their wares, with their nets spread on the wall to dry in the sun.

Therefore, it is probable that the four canvases formerly belonging to the princes of Liechtenstein were not painted at the same time, but that two of them (those showing the two adjoining sections of the Grand Canal, toward the San Marco Basin and toward the Rialto bridge) were made in the very early 1720s, while the other two were painted immediately before the middle of the decade.

Thus spread over time, these canvases enable us to pin down the chronology of other early works by Canaletto whose dating is still in debate. For example, the splendid view of *The Grand Canal from Palazzo Corner Spinelli toward Rialto*, which is

Canaletto
The Church of San Giovanni dei Battuti on Murano
66 x 127 cm
St. Petersburg, Hermitage

Canaletto
The Islands of San Michele and San Cristoforo from the Fondamenta Nuove
142.2 x 150.5 cm
Dallas, Museum of Art

Canaletto
The Islands of San Michele and San Cristoforo from the Fondamenta Nuove
140 x 152 cm
Private collection

now in the Gemäldegalerie in Dresden and probably formerly the property of the Count of Colloredo. This canvas shows evident and very close analogies both in technique and the handling of the light with the later pair of paintings formerly in the Liechtenstein collection, and thus I would date it quite confidently to 1724–25. The pair of views in The State Hermitage Museum in St. Petersburg were most likely executed around the same date. The first shows *The Church of San Giovanni dei Battuti on Murano*, a very rare image of this building, which was demolished in 1833, and one that gave Canaletto the opportunity to try his hand at a splendid panorama of Venice from a distance (note in the background on the left the Fondamente Nuove with the bell towers of San Francesco della Vigna and San Marco and the domes of Santi Giovanni e Paolo). The second depicts *The Islands of San Michele and San Cristoforo* seen from the Fondamente Nuove. These views have been assigned in the past to the years immediately preceding Canaletto's departure for England in 1746; but the thicker paint used to portray the architecture and the predilection for large characters, which foreshadow those appearing in the first canvases painted for Consul Smith between 1726 and 1728, necessitate a date around the mid-1720s.

A number of replicas exist of this second view, and at times critics have placed their authorship in doubt. Besides those already known in the literature (the highly debatable one in Windsor Castle, one of very high quality in the Dallas museum, others in a private collections in Chicago and elsewhere), we can now add another, which appeared in 1999 for sale by Semenzato in Venice. This work is of high quality, even if its enjoyment is a bit compromised by the surfacing in a few spots of the Armenian bole preparatory layer. The fine quality of the characters, quite large in size, and the rendering of the architecture on the islands, described with a well-soaked brush and a free, easy hand and bathed in strong light, seem to dispel any doubts that they are works of Canaletto. The evident references to the art of Marco Ricci in the scintillating sky and the dark tones suggest for this work a date even earlier than that of the other versions, perhaps the same time of the caprices formerly in the Cini collection or of the first two canvases which once belonged to the princes of Liechtenstein.

Canaletto and Joseph Smith

In the brief span of two or three years Canaletto's style veered significantly toward a more precise relationship with reality. Already evident in the *Rio dei Mendicanti* in Ca' Rezzonico and the contemporaneous *St. Mark's Square* in the Thyssen collection are the beginnings of a research that, pursued in the mid- to late 1720s, would lead the painter to the "mastery of light" that characterized and distinguished his subsequent production. Significantly, this occurs at the same time as the investigation of light being carried out by the other great protagonist of eighteenth-century Venetian painting, Giambattista Tiepolo. More or less at the time of the execution of the frescoes for Palazzo Santi (1725), Tiepolo was progressively abandoning the use of darkness and shadows in the tradition of Giambattista Piazzetta and Bencovich, and producing increasingly luminous results, in the vein of the sixteenth-century artist Paolo Veronese. Corboz[30] has explained clearly that this simultaneous "conversion" to "light" in the painting of the two men who are rightfully considered the greatest figures in eighteenth-century Venetian art did not occur only because of a generic harmony of taste or the coincidence of the demands of their patrons. Rather, the use of pure colors had roots in the treatise published by

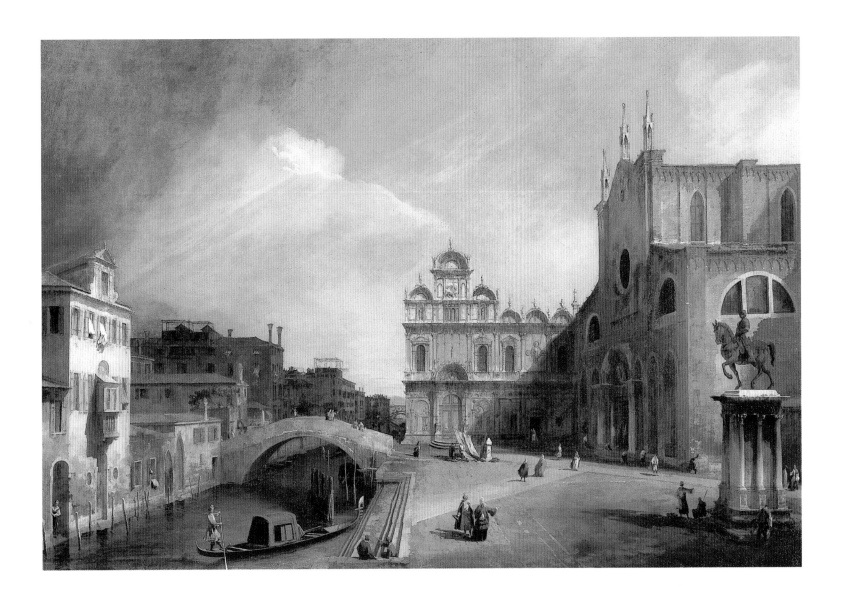

Canaletto
Campo Santi Giovanni e Paolo
90.5 x 135.9 cm
Formerly Montreal, Private collection

Newton in 1704 under the title of "Optiks," where the separation of colors using a prism is described scientifically for the first time. This procedure is precisely and not coincidentally described in *The Allegorical Tomb of Isaac Newton*, which is part of the previously mentioned series commissioned by McSwiney and painted by Giambattista Pittoni and the Valeriani brothers, and is now in Cambridge.

Canaletto's success in the Venetian world must have been immediate, to the point of replacing the already well-established Carlevaris in the affections of collectors. Giannantonio Moschini (1806) states that Carlevaris died of a broken heart after seeing his fame eclipsed by the rising star of Venetian view painting, and even if this may not be literally true, it does provide a meaningful metaphor for the astounding achievement of the young artist. The reasons for this appreciation of Canaletto's work by his contemporaries are made clear in the correspondence exchanged in 1725–26 between the painter Alessandro Marchesini, from Verona but living in Venice, and the merchant and collector Stefano Conti in Lucca. Conti had asked Marchesini—who alternated his activity as a painter of historical and religious subjects with that of mediator between his fellow painters and collectors—to procure for him two views of Venice, to go with some others he already owned by Carlevaris. Answering his request, Marchesini informed him that "Mr. Luca... is now

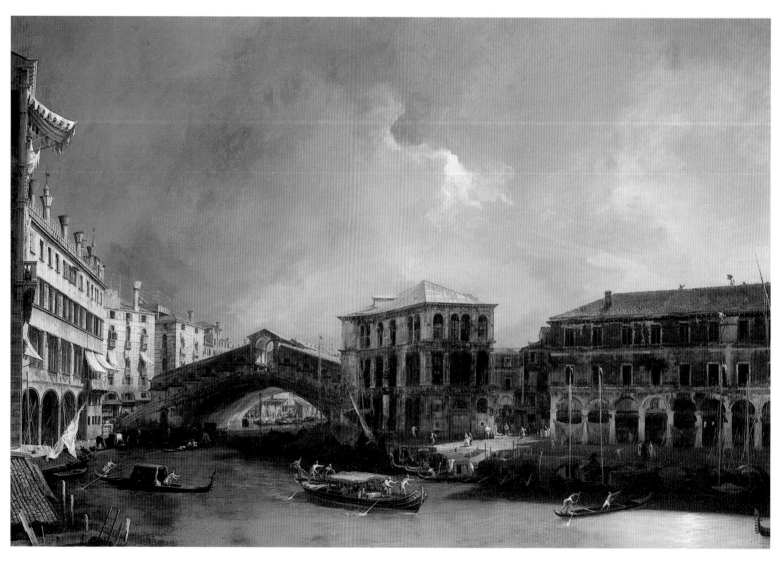

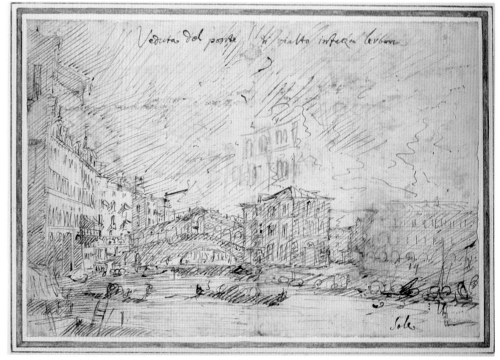

Canaletto
The Rialto Bridge from the North
90.5 x 134.6 cm
Montreal, Private collection

Canaletto
The Rialto Bridge
14.1 x 20.2 cm
Drawing
Oxford, Ashmolean Museum

elderly" and that his place had been taken by "Mr. Ant. Canale, who is astonishing everyone in this town who sees his works, which are on the order of Carlevaris's but you can see the sun shining in them."

Thus Marchesini points out the continuity of subject between Canaletto's and Carlevaris's work, but at the same time shows his ability to grasp fully Canaletto's new way of understanding views ("you can see the sun shining in them"). Marchesini's enthusiasm was clearly transmitted to Conti, as demonstrated by the fact that he—overcoming all the difficulties caused by the painter's already numerous commitments and the high cost of his works—purchased not two, but four views by Canaletto.

The canvases in question, formerly in the collection of the Hosmer heirs in Montreal, have recently been brought back to Italy. For the first to be painted, representing *The Rialto Bridge*, the preparatory drawing is now in the Ashmolean Museum in Oxford (U.K.). This drawing was made from life—Marchesini specifically wrote to Conti that "Canaletto is painting not using his imagination in the usual rooms of the Painters themselves as Mr. Luca does, but he always goes on site, and shapes everything from life." It is extremely interesting for the particular attention the painter pays to the effects of light, underscored by his pen and ink notation of the word "*sole*" (sun) in the area of the view where the light was supposed to be strongest and most dazzling, as in fact is the case in the finished canvas.

However, the paintings for Stefano Conti, characterized by a free, pasty brushstroke, do not yet meet the achievement of the heights of luminosity that distinguishes Canaletto's views of the late 1720s: the contrast is very strong between the areas in full sunlight and those in shadow, a lingering residue of Ricci's teaching which was still clinging to Antonio's style.

The next step, perhaps the definitive one, came immediately after the work for Conti was finished, when Canaletto came into (or renewed) contact with Owen McSwiney, an Irishman who was a failed theatrical impresario forced to leave England for this reason. McSwiney at first persuaded Canaletto to collaborate—together with Giambattista Pittoni, Giovan Battista Cimaroli, and Giambattista Piazzetta—on the execution of two of the *Allegorical Tombs* mentioned earlier. At the same time, he persuaded him to paint two small views on copper for the same Duke of Richmond who had commissioned the large series *Tombeaux des Princes*. In these small works, sent to England in 1727, Canaletto abandoned the dramatic, strong contrasts of his youthful phase for an intense luminosity that heightened the precise rendition of details. It is hard to say how influential McSwiney's advice was in this final step, but the intermediary's desire to have views more in tune with the taste of his English clients, and thus more precise topographically and more "polished" in painting technique, found a ready welcome in the painter, perhaps accelerating a stylistic evolution that was already underway. Additionally, it was in these same years that Newton's theories on the science of light and its breakdown into the spectrum on one hand and on absolute space on the other were beginning to circulate in Venice. This was due to the publication by Pasquali—the Venetian publisher who worked for and was financed by Joseph Smith—of *Newtonianismo per le Dame* (Newtonianism for the Ladies) and the *Dialogues* on Newtonian optics written by Francesco Algarotti. It thus seems obvious that the young Canaletto came to know and appreciate these revolutionary scientific innovations, which were arriving from England at the same time that he was beginning to enter Smith's circle of acquaintances.

Canaletto
*The Grand Canal from
the North, with the Rialto Bridge*
45.7 x 61 cm
Goodwood Collections

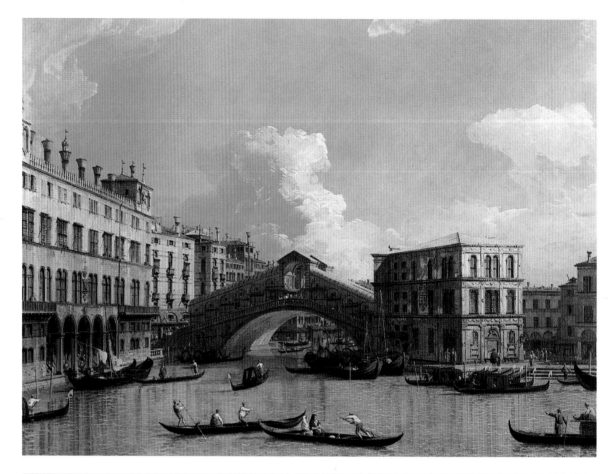

Canaletto
*The Grand Canal
at the Fabbriche Nuove*
45.7 x 61 cm
Goodwood Collections

(opposite page)
Canaletto
*The Piazzetta
Facing the Clock Tower*
172 x 135
Windsor Castle,
Royal Collections

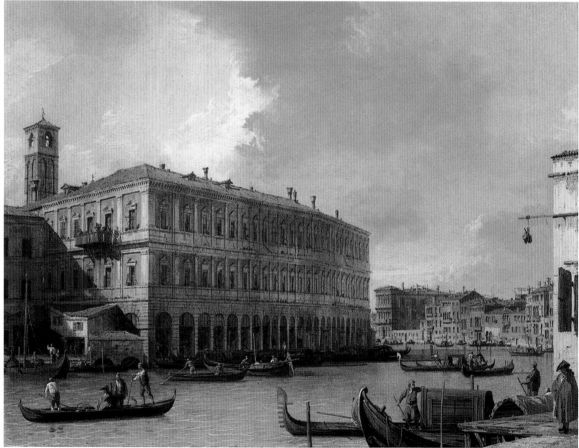

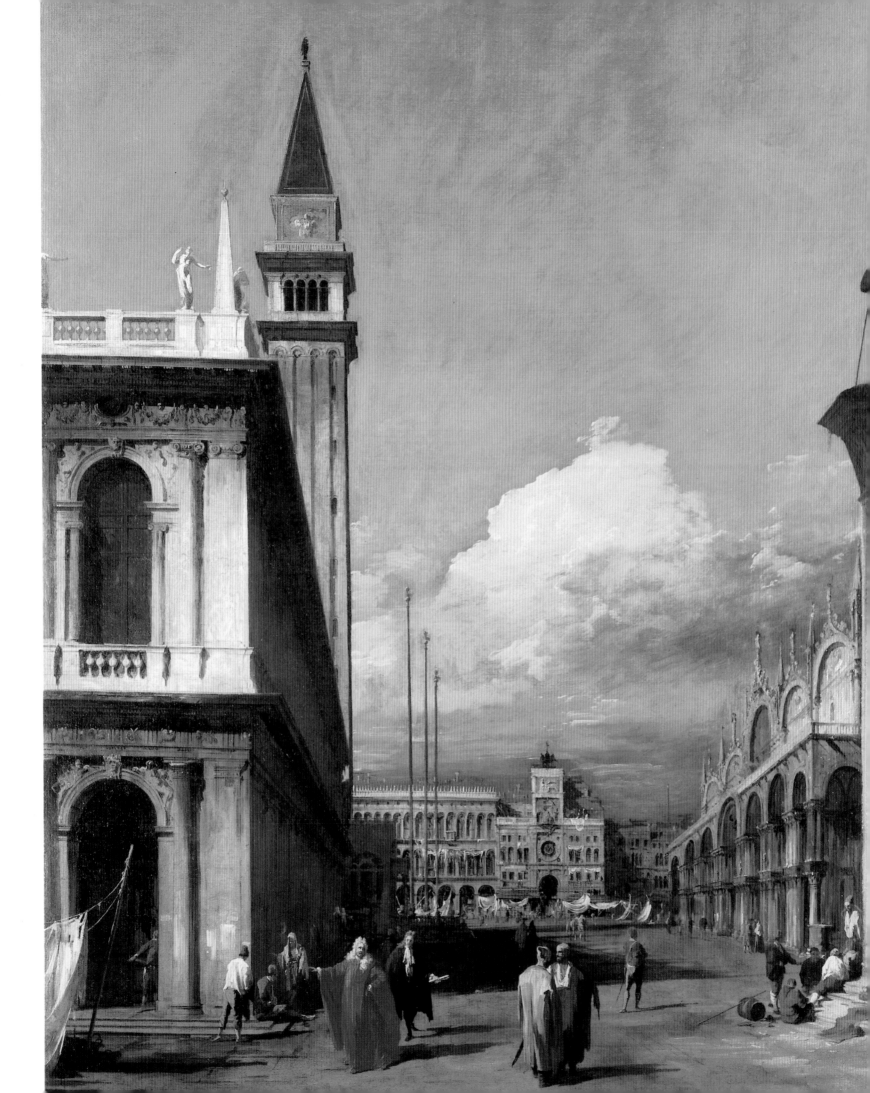

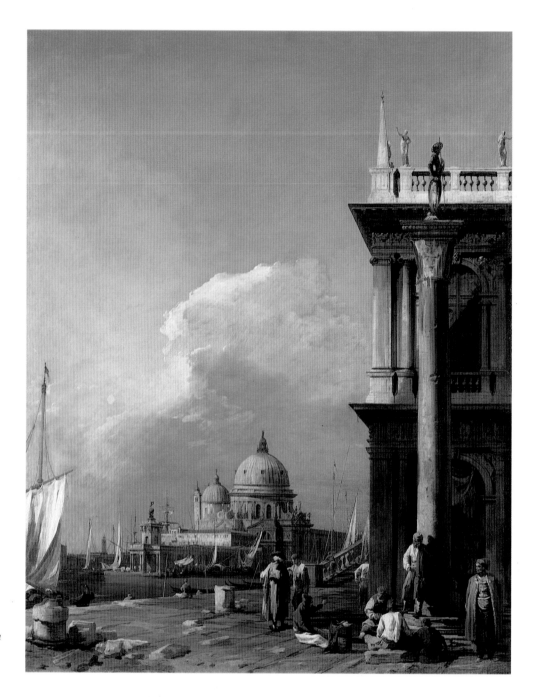

Canaletto
The Entrance to the Grand Canal from the Piazzetta
170 x 133.5 cm
Windsor Castle, Royal Collections

In the meantime, the collaboration between Canaletto and McSwiney was drawing to an end: already by 1730 the impresario was complaining to the Duke of Richmond that the artist was late in delivering two other paintings on copper which had been ordered by the illustrious patron. This neglect on Canaletto's part could have been a sign of his new connection with the intermediary who would launch him definitively on his career, Joseph Smith. A banker and merchant, a man of vast culture and even vaster interests, Smith was a collector on the highest level. Moreover, he was the point of reference, because of his role as British consul in Venice (a post he held from 1744 on), for the English nobility who came to the city on business or during their Grand Tour.

Almost immediately, Smith and Canaletto established a close relationship that served as the conduit for most, if not all, of the lucrative commissions the painter

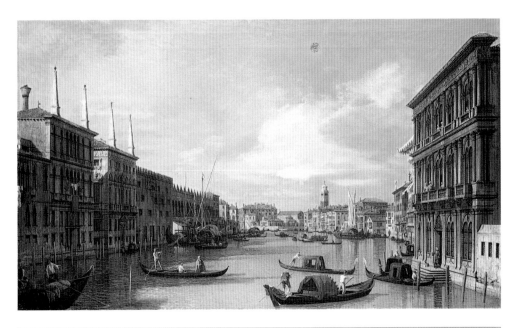

Canaletto
The Grand Canal toward San Geremia
from Ca'Vendramin Calergi
43.7 x 79.4 cm
Windsor Castle, Royal Collections

Canaletto
The Grand Canal from the Scalzi
toward the Fondamenta della Croce
47 x 79.5 cm
Windsor Castle, Royal Collections

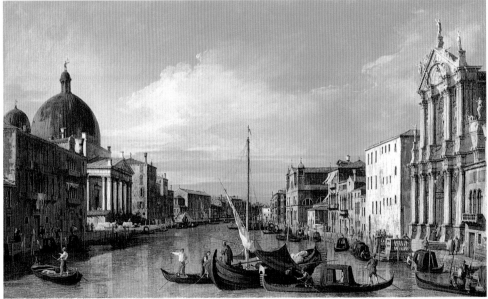

received from the English world. But Canaletto also painted many works for Smith himself, to the point that, when the consul sold his art collection to King George III in 1762, a good fifty Canaletto views were delivered to Windsor Castle that had earlier hung in Smith's home in Venice or his country villa near Mogliano, as well as 150 drawings.

The first canvases painted for Smith are the six with views of the square and surrounding areas, fairly large paintings made for hanging above a door. On the basis of topographical details appearing in them, they can be dated with certainty between 1726 and 1728, at a time close to the execution of the first two paintings on copper for the Duke of Richmond. Compared to the latter, the canvases now at Windsor Castle show characteristics closer to Canaletto's early manner, in the dark color tones and thick paint, while the figures are unusually large. But starting with the works immediately after these, Canaletto changes key sharply to paint a Venice flooded with sunlight, animated and luminous, its details described with meticulous care.

Canaletto
The Piazzetta Facing the Clock Tower
52.7 x 70.5 cm
Kansas City, Nelson-Atkins Museum of Art

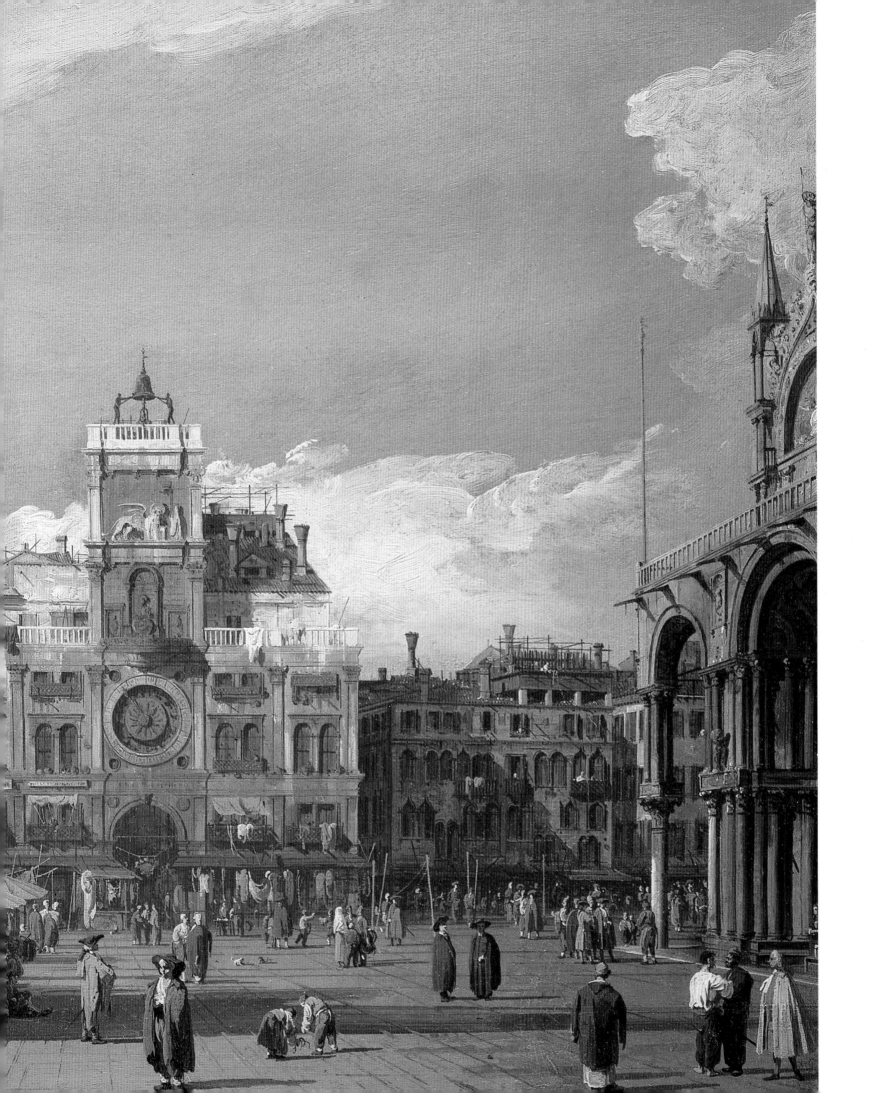

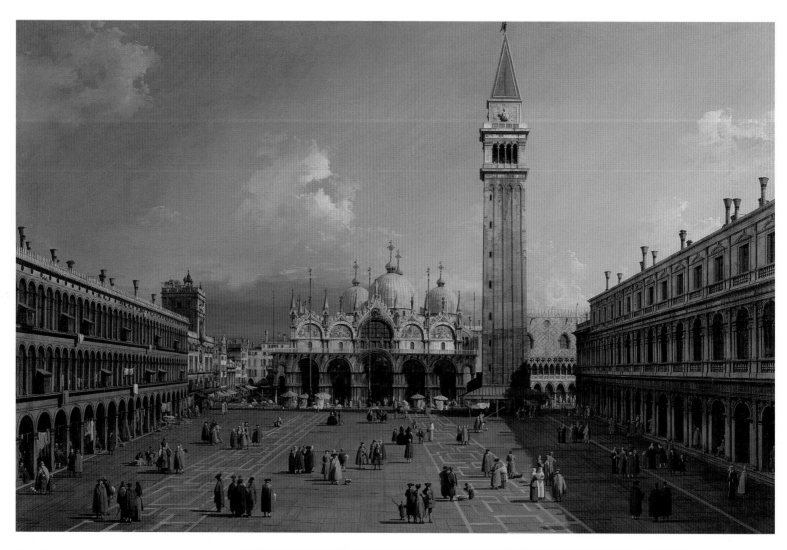

Canaletto
St. Mark's Square Facing the Church
76 x 114.5 cm
Cambridge (Mass.), Fogg Art Museum

Canaletto
Campo Santa Maria Formosa
Drawing
23 x 34 cm
Venice, Gallerie dell'Accademia

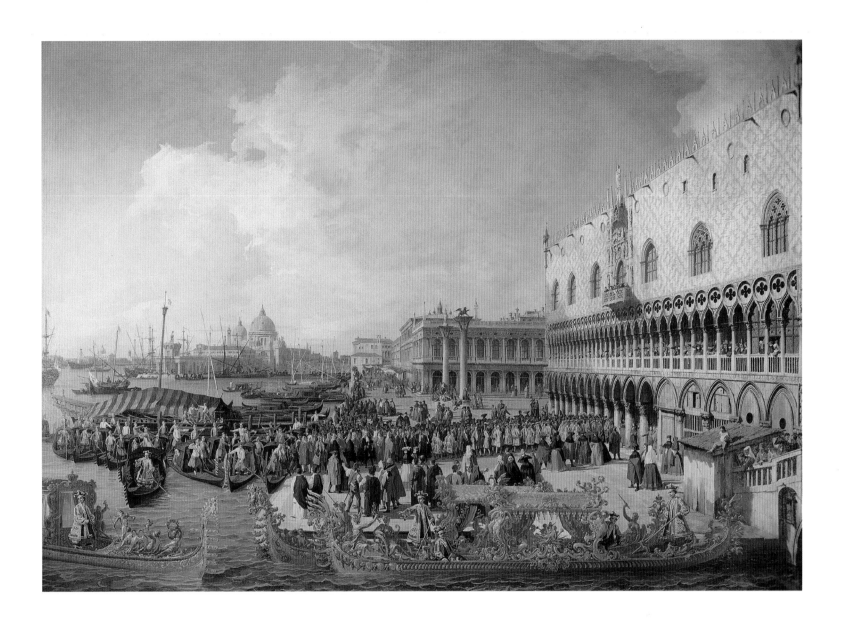

Canaletto
The Ambassador Being Received at the Doge's Palace
184 x 265 cm
Milan, Private collection

(overleaf)
Canaletto
*The San Marco Basin with the Bucintoro
on Ascension Day*
182 x 259 cm
Milan, Private collection

Canaletto's new approach is evident—besides in the twelve canvases for Smith now at Windsor, datable to 1730—in works like the views of *The Piazzetta Facing the Clock Tower* (The Nelson-Atkins Museum of Art, Kansas City, Mo.), *The Entrance to the Grand Canal* (Museum of Fine Arts, Houston), and *St. Mark's Square Facing the Church* (Fogg Art Museum, Cambridge, Mass.) particularly notable for its wide-angled vision seen from a high viewing point. Canaletto's views cannot be described as photographic: the painter combines various viewpoints simultaneously, adapting reality to his own intentions and poetics. The testimony of Marchesini ("he paints on site and not from an idea at home as does Mr. Luca"), besides being ungenerously fals, does not mean that Canaletto, armed with canvases, easel, paints, and whatever else he needed, went to his chosen spot and painted there *en plein air* according to what he saw. Rather, he made observations at the site—aided by the use of the optical chamber—which he would then utilize in his studio to execute the paintings. An outstanding example of this modus operandi is the so-called *Quaderno Cagnola* (Cagnola notebook), now in the Gallerie dell'Accademia in Venice, which contains numerous sketches made on-site in pencil and subsequently retraced in pen and ink.[31] These sketches, often marked with inscriptions useful to the painter for

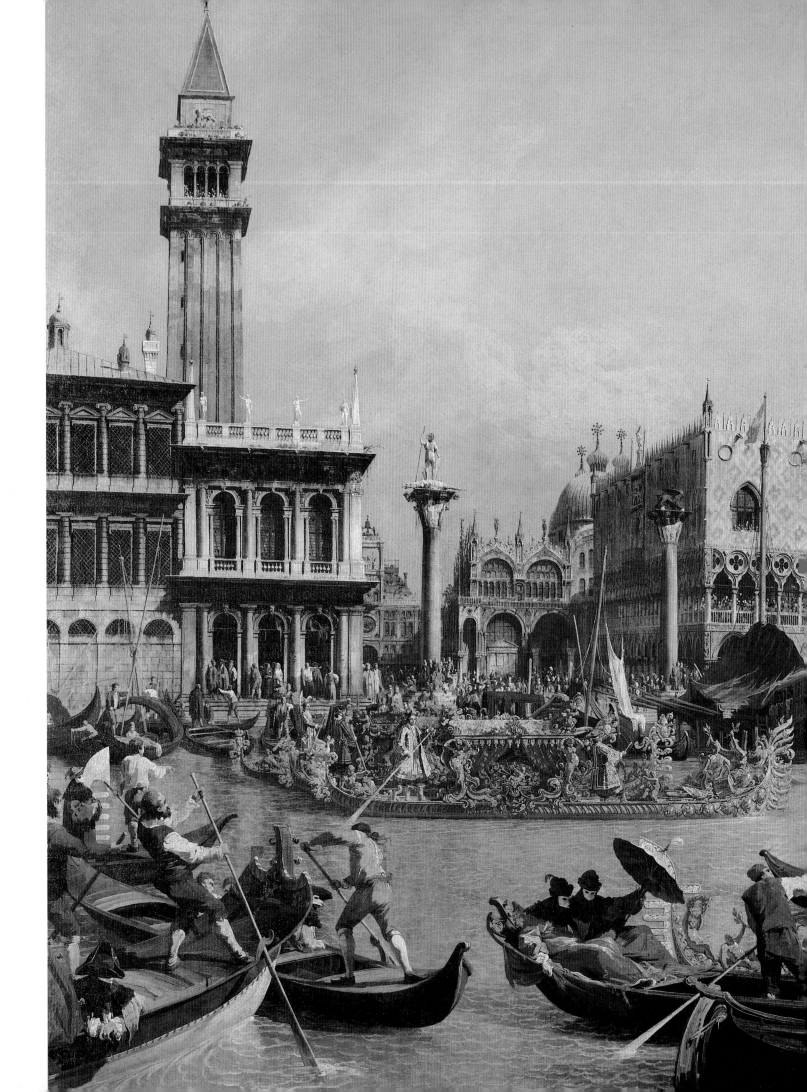

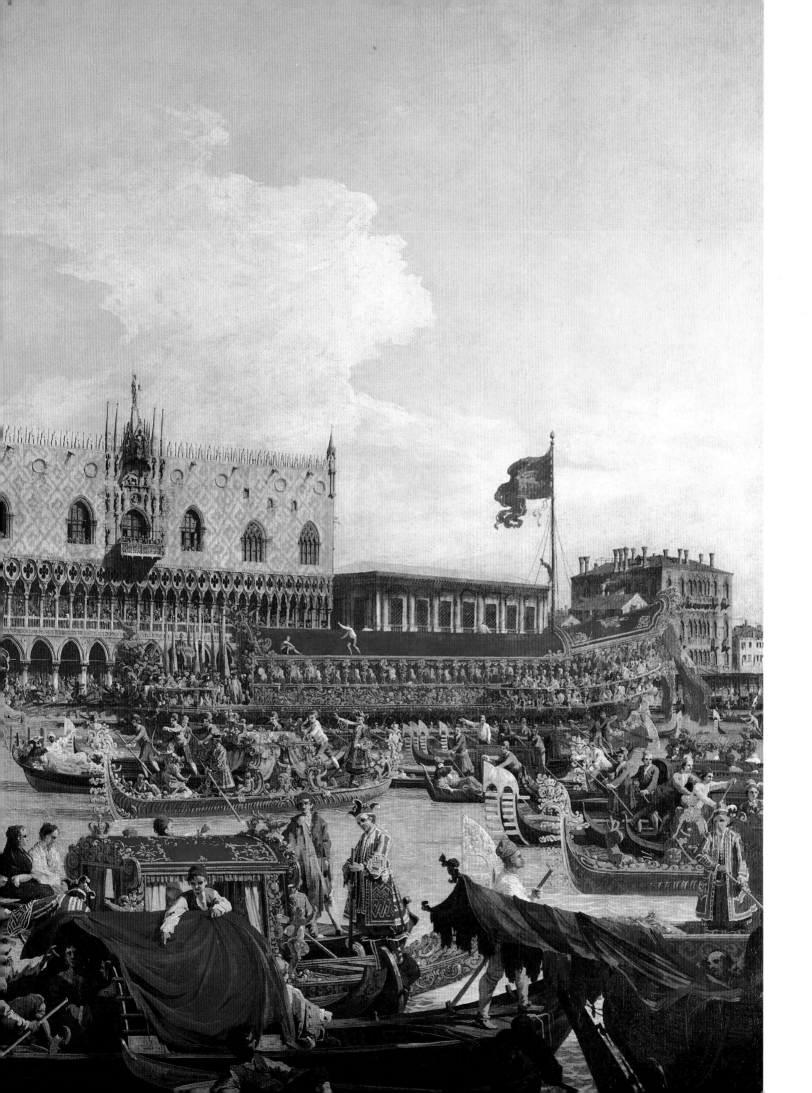

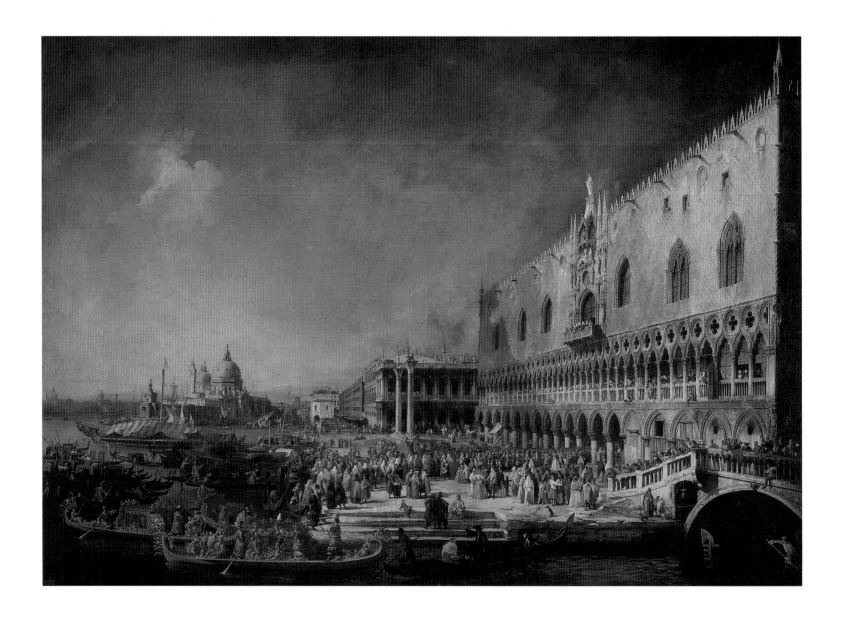

Canaletto
The French Ambassador, Comte de Gergy,
Received at the Doge's Palace
181 x 259 cm
St. Petersburg, Hermitage

identifying the places later ("*Campo S.M.a formosa parte prima/ alla sinistra verso la chiesa*" [Campo Santa Maria Formosa, first part/ to the left facing the church]) and sometimes bearing notations as to color or particular tones ("*zala*" [yellow]), were then assembled on the canvas to compose the view, which preserved the individual viewpoints of the drawings that did not always coincide. This method of working sometimes results in distortions of the perspective and unnatural dilations of distance which leap to the eye of a close observer. However, these views are the fruit of the creative genius of an artist who, not being obligated to a faithful reproduction of reality, elaborates—sometimes to the point of caprice— certain aspects of reality in order to obtain more satisfying results.

Canaletto's views thus constitute a rather curious case: the operation of assembly of exact observations—those in the *Quaderno Cagnola*—produces images that do not exactly correspond to reality overall. Thus the intense critical debate on Canaletto's presumed realism, considered by some almost as a precursor of photography— it has also been written that his views are distinguished by an "absolute sense of truth"—but which others, perhaps more correctly, consider a "search for an effect of reality" from the artistic point of view.

Canaletto
*The San Marco Basin with the Bucintoro
on Ascension Day*
187 x 259 cm
Moscow, Pushkin Museum

Canaletto
The Fonteghetto della Farina
66 x 112 cm
Venice, Private collection

The works painted by 1730 for Smith constitute a homogeneous group of twelve
views of sections of the Grand Canal. They initially hung in Smith's house in
Venice; two decades after their execution, they were transferred to his new
residence in the neighborhood of Santi Apostoli, overlooking the Grand Canal.
This was a small palace belonging first to the Trevisan family, then to the Ceffis,
from whom it passed into the hands of the future consul, and at his death became
the property of the Mangilli Valmarana. Smith had it renovated in the neoclassical
style by Antonio Visentini betwen 1740 and 1753.[32] The canvases served as an
example for potential purchasers, who were generally Smith's English guests.
Indeed, with the aim of making these paintings known to the greatest possible

number of art lovers, Smith had engravings made of them by Visentini himself. The engravings ultimately included versions of two other views by Canaletto, representing *The Regata on the Grand Canal* and *The Bucintoro at the Dock on Ascension Day*, painted in 1734.

The edition of these fourteen engravings saw the light in 1735 in a collection entitled *Prospectus Magni Canalis Venetiarum*. This publishing enterprise was met with great success, to the point of inspiring Smith to publish a second edition seven years later, adding twenty-four more plates, all derived by Visentini from Canaletto paintings in Smith's own collection. The effect of this advertising must have been enormous, given that the paintings were replicated numerous times, albeit with some modifications in the position and number of the figures, for various purchasers.

At the same time that he was painting this series for Smith, Canaletto also executed canvases for the imperial ambassador to the Republic of Venice, Count Giuseppe Bolagnos, who wanted to commemorate the ceremony of the presentation of his credentials to the Doge, which took place on May 29, 1729. This date is the *terminus post quem* for the execution of the two paintings, formerly in the Crespi collection in Milan. The first represents *The Reception of the Ambassador at the Doge's Palace* and repeats analogous subjects painted by Carlevaris, of which the closest one seems to be *The Reception of the Count of Colloredo*, now in Dresden (1726). Canaletto borrows the structure of the scene, but invents the solar clarity of the light and the lively palette. The second painting represents *The San Marco Basin with the Bucintoro on Ascension Day* and should be considered one of Canaletto's very highest achievements. The painting style is absolutely clear and limpid, soaked with light. The brushwork is free yet precise in the description of the most minute details of the parade boats and the animated characters that make up the multicolored procession waiting to fall in behind the Doge's boat as it sails toward San Nicolò on the Lido.

The question has been raised of whether these paintings mark Canaletto's debut in the specific field of representing public ceremonies, or if they were preceded by those on a similar theme painted as a commemoration of the "entrance" of the

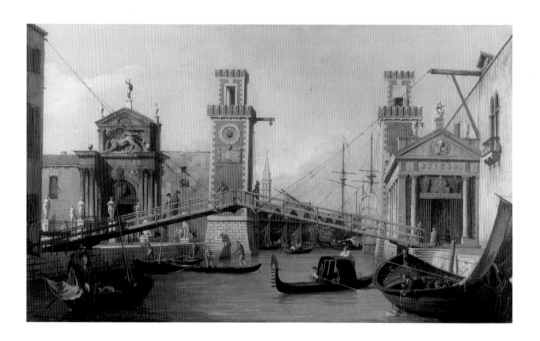

Canaletto
The Entrance to the Shipyards
47 x 78 cm
Woburn Abbey, Private collection

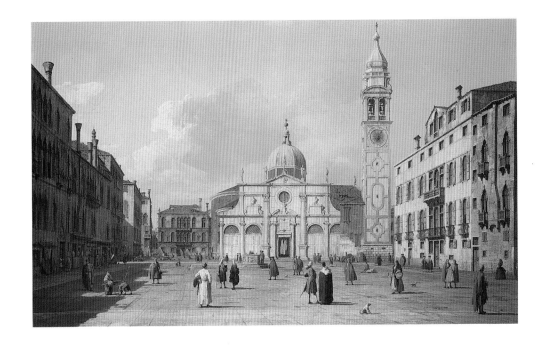

French ambassador Jacques-Vincent Lanquet, Count of Gergy, which took place on November 4, 1726. The two canvases identified as marking that event, now in The State Hermitage Museum in St. Petersburg and the Pushkin Museum in Moscow, can be dated with certainty within the same time span as the views commissioned by Count Bolagnos. The latter must then have been replicas brought up to date by Canaletto himself of the pictures made in 1726 for the Count of Gergy, and are without a doubt autograph works, given the high quality of the painting technique. These are in fact mentioned in the correspondence between Alessandro Marchesini and Stefano Conti cited above.

Some other superb masterpieces can be dated to the years between the end of the third and beginning of the fourth decade. Among them is the brilliantly lit *Stonecutter's Workshop* (National Gallery, London), formerly the property of Sir George Beaumont, which shows stonecutters at work in the Campo di San Vidal in a dazzling sunlight. Across the Grand Canal, still lacking the bridge that was built in the twentieth century, are the buildings of the Scuola and church of Santa Maria della Carità, and next to the church the slender bell tower that collapsed in 1741. Painted at about the same time was the *Fonteghetto della Farina* (private collection, Venice) probably made for the man of letters and bibliophile Giovan Battista Recanati, which presents an intensely luminous image of the building that would become—in 1750— the first seat of the Academy of Painting and Scultpure (now housed in the Capitaneria di Porto of Venice). This view is extremely interesting topographically, as it depicts a site that was profoundly modified in the early nineteenth century, when the elegant Coffee House designed by Lorenzo Santi was built. At this time, the bridge was dismantled that crossed the Rio della Luna and led, through the arches under the Fonteghetto building, to Calle Vallaresso, thus isolating the area of San Marco from that of San Moisè. Only subsequently was the narrow quay built that still exists today, served by a new bridge placed in a position external to the Fonteghetto.

In the 1730s Canaletto received, thanks to Smith, numerous commissions from the English world: suffice it to mention the twenty-four views for the Duke of

Canaletto
The Stonecutter's Workshop
124 x 163 cm
London, National Gallery

(overleaf)
Canaletto
The Grand Canal between Palazzo Bembo
and Ca' Vendramin Calergi
47 x 80 cm
Woburn Abbey, Private collection

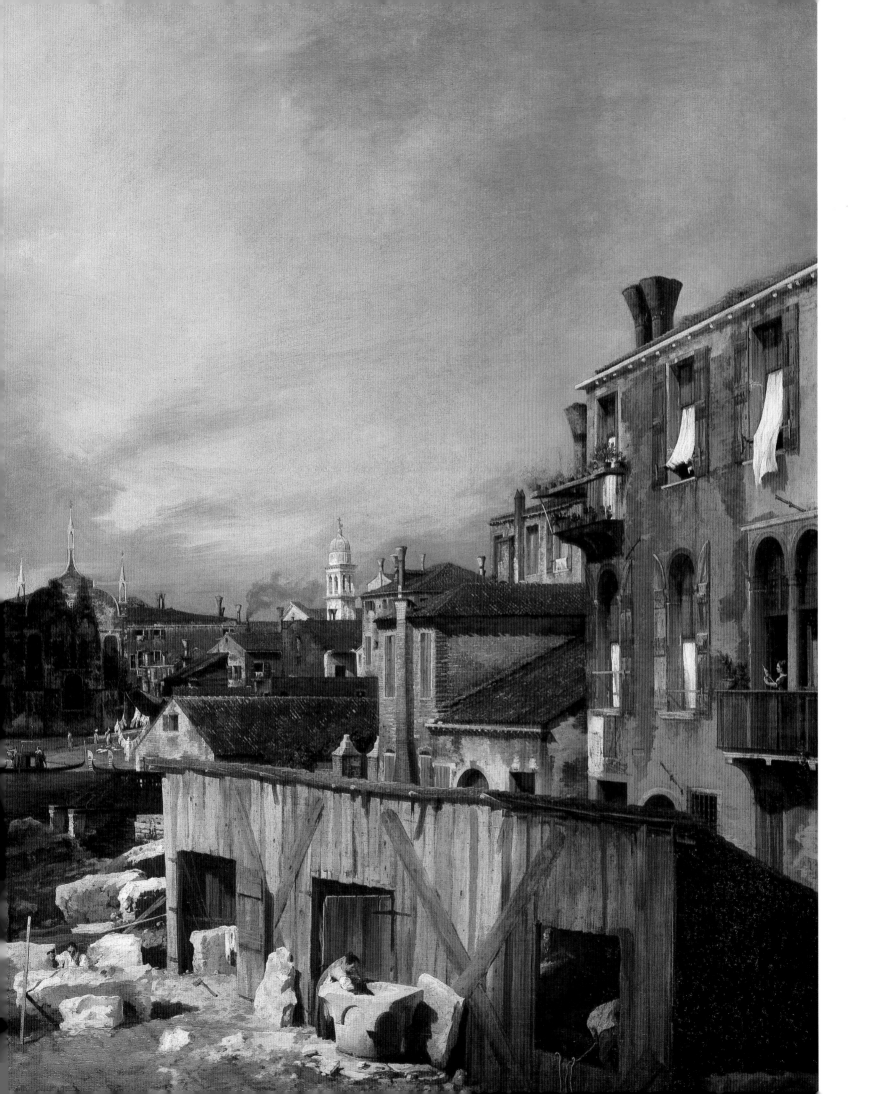

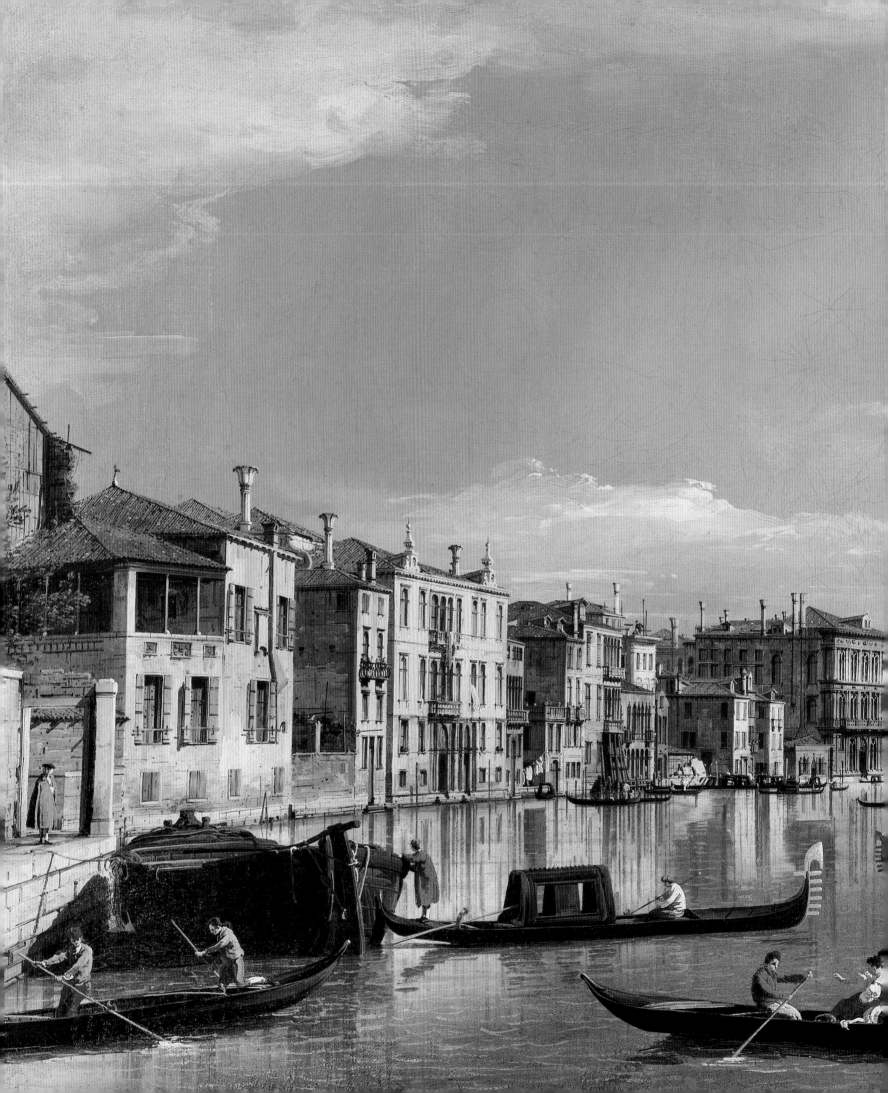

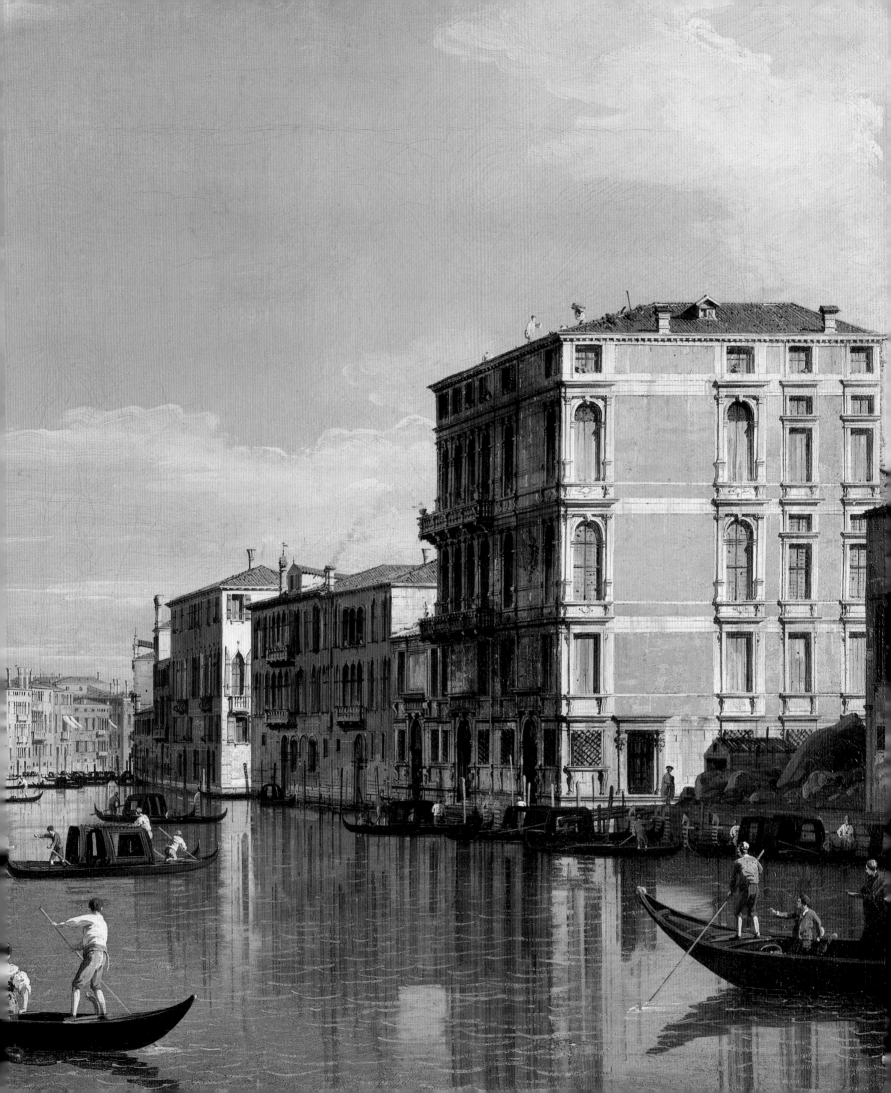

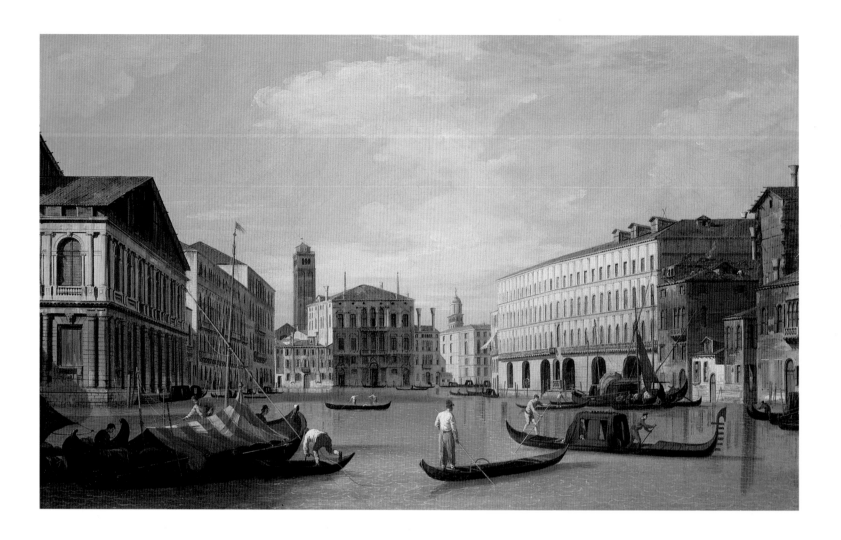

Canaletto
*The Grand Canal from Ca' Rezzonico
toward Palazzo Balbi*
68.3 x 115.5 cm
Private collection

Bedford, now at Woburn Abbey; four views for William Holbech at Farnborough Hall, lost in 1930; six for Francis Scott, second Duke of Buccleuch, which repeat subjects already treated in the canvases for Smith; and seventeen for the Earl of Carlisle at Castle Howard, some of which were sold before the first world war and some destroyed in a fire in 1940.

The views painted for the Duke of Bedford, datable close to 1731, depict both the most famous places in Venice, from St. Mark's Square to the Grand Canal, and less well known sites in the city. Among the latter are a limpid *View of the Entrance to the Shipyards,* that shows, to the right of the Rio della Tana, which leads into the docks, the sixteenth-century Oratorio della Madonna, demolished by the French in 1809; *Campo Santa Maria Formosa*, with the church designed by Codussi serving as the fulcrum for a very theatrical view that unnaturally dilates the real space; and *Campo San Rocco,* where the sixteenth-century façade of the Scuola made famous by Tintoretto's great painting cycle fills the same function as Codussi's church in the preceding view. Many of these paintings are derived from the images produced using the optical chamber that are part of the *Quaderno Cagnola.*

Canaletto himself made numerous replicas of the paintings in this series. Among these is the splendid *Grand Canal from Ca' Rezzonico toward Palazzo Balbi,* now in a private English collection,[33] which has remained unpublished until now. Particularly noteworthy among the various replicas is the *View of the Dock from the Basin,* formerly the property of the Sedelmeyer gallery in Paris,[34] as is demonstrated

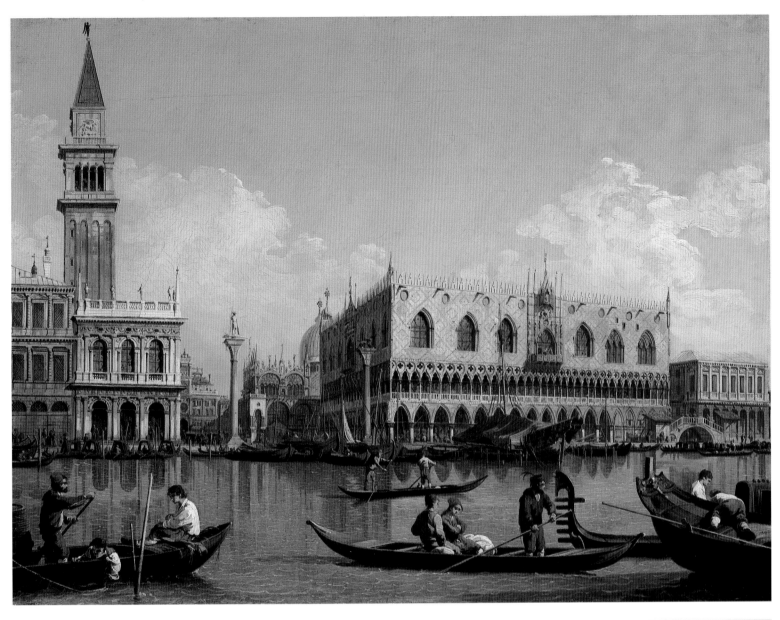

Canaletto
View of the Dock from the Basin
53.4 x 70.8 cm
Private collection

Canaletto
View of the Dock from the Basin
48 x 85.5 cm
Private collection

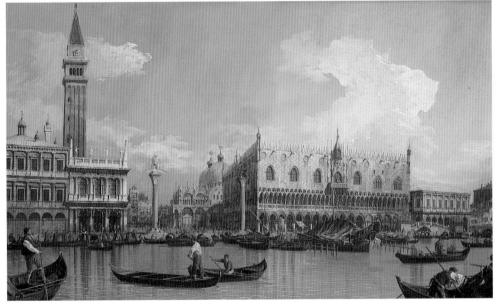

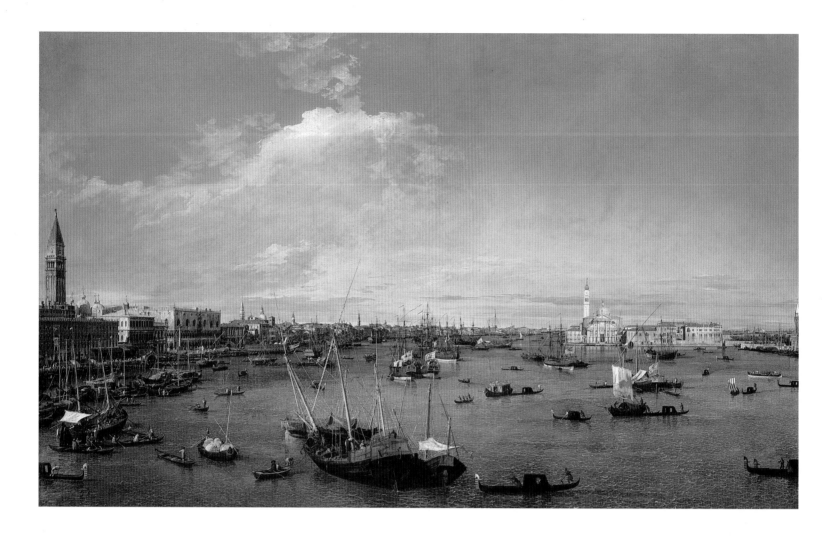

Canaletto
View of the San Marco Basin
124.5 x 204.5 cm
Boston, Museum of Fine Arts

irrefutably by the presence of the gallery seal. It is commonly believed that the former Sedelmeyer canvas is the one that has been in the Pinacoteca di Brera in Milan since 1928. Yet, the view presented here was in the Van Diemen collection in Berlin in 1931, and in the Giese Gallery in Zurich in 1942, which proves that the version in the Brera has a different provenance. In any case, the subject of the Doge's Palace seen from the Basin is a favorite theme of all the Venetian view painters, and Canaletto himself replicated it on numerous occasions. This version—published in the second edition of J.J. Link's revision of the fundamental catalogue put together by Constable—would probably have been done in the second half of the 1730s. It was formerly the property of Marchese Ridolfi in Pisa, then was purchased in Florence by Andrew Wilson in February 1838, acting on behalf of the Marchioness of Linlithgow at Hopeton House in Scotland. It is a truly remarkable work, for the clarity of the image and the quality of the characters.

It has long been thought that the patron of the Canaletto paintings sent in the early eighteenth century to Castle Howard was the third earl of Carlisle, Charles Howard, who employed for the decoration of his grand house Venetian artists like Jacopo Amigoni and Giannantonio Pellegrini. Recently, the hypothesis has gained credibility that it was his son Henry Howard, the fourth earl, who bought the numerous views of Venice that decorated his magnificent residence in Yorkshire. The purchases were probably mediated by Howard's Venetian friend Anton Maria Zanetti, and included works by Marieschi and Bernardo Bellotto along with the Canalettos.

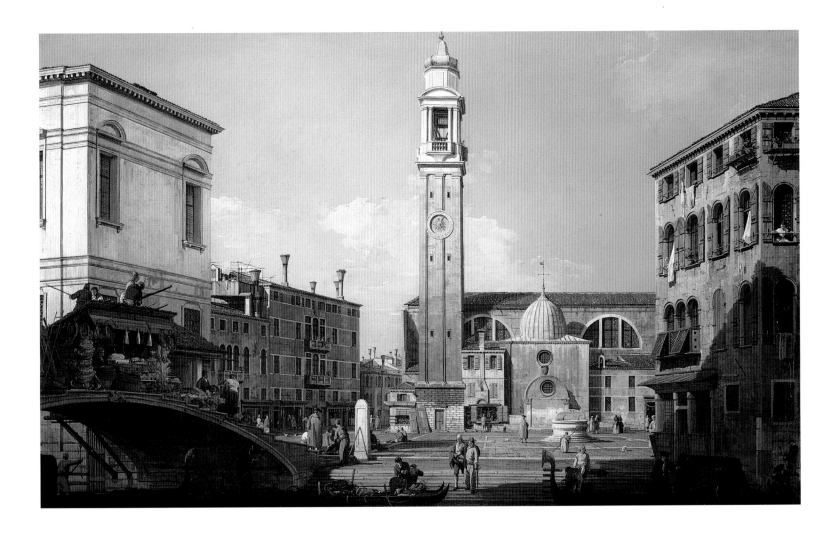

Canaletto
Campo Santi Apostoli
45 x 77.5 cm
Milan, Private collection

Among the Canaletto paintings at one time in Castle Howard are some of the artist's greatest masterpieces. Outstanding even among them is the sensational *View of the San Marco Basin*, in the collection of the Museum of Fine Arts in Boston since 1939. This panoramic view, seen simultaneously from various high view points located by the Customs House, extends from the far eastern end of the Giudecca on the right to the Terranova Granaries on the left. A strong light floods the view, with its "impossible" breadth. Boats of every sort ply the water of the Basin, crowded with various characters. The procession of buildings and architectural structures is meticulously described, and the new bell tower of the church of Sant'Antonin, visible in the background, enables us to date the view with complete certainty to after October 1738, when the construction of the bell tower was finished.

Another important nucleus of Canaletto's works of the 1730s is the twenty-one views purchased in Venice in the mid–nineteenth century by the last Duke of Buckingham and Chandos; at his death the canvases came by inheritance into the Harvey collection at Langley Park and were lost in the 1950s. Nine of these paintings were engraved by Visentini and appear in the 1742 edition of the *Prospectus*. This gives credibility to the hypothesis that this group, before coming to England, was also in Joseph Smith's collection in Venice.

Many of the canvases formerly the property of Buckingham have since returned to Italy, and a number of them are in a private collection in Milan. Among these

Canaletto
Campo San Giuseppe di Castello
47.5 x 77.5
Milan, Private collection

Canaletto
The Grand Canal from the Rialto Bridge
toward Ca' Foscari
68.5 x 92 cm
Rome, Galleria Nazionale di Palazzo Corsini

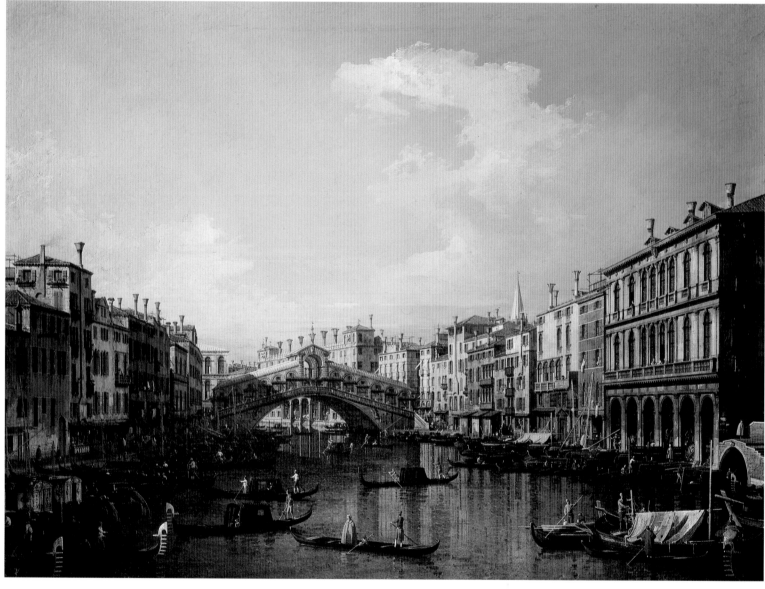

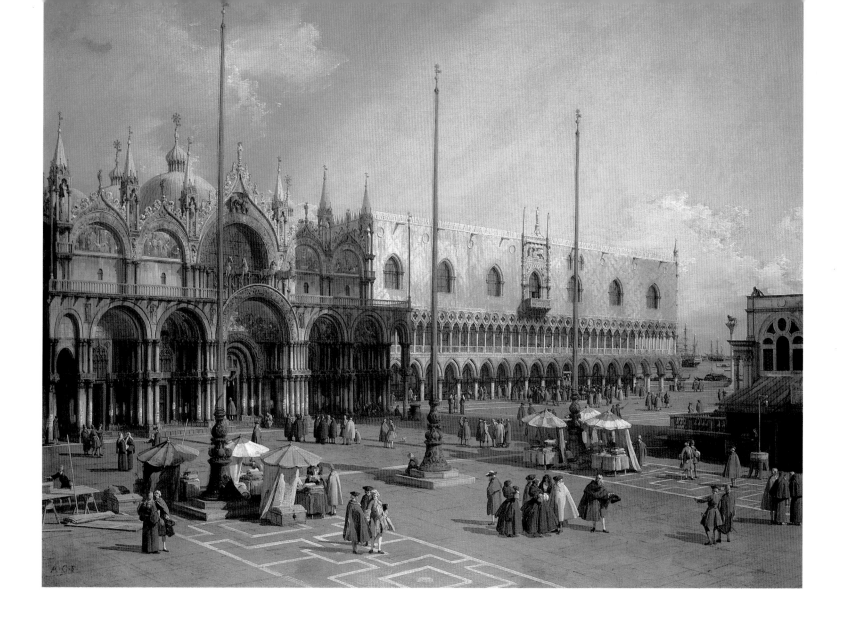

Canaletto
*View of the Church and the Doge's Palace
from the Procuratie Vecchie*
114.2 x 153.5 cm
Washington, National Gallery of Art

are some exceptional masterpieces, such as the *View of Campo Santi Apostoli*, dominated by the high seventeenth-century bell tower which already shows the elegant belfry installed at the beginning of the eighteenth century on a design by Andrea Tirali. Also in this collection is the view of *San Giuseppe di Castello*, showing the buildings—among them the old church dedicated to St. Nicholas— that occupied the area where Giannantonio Selva designed the Napoleonic Gardens in the early nineteenth century. Four other views that are stylistically very close to the Buckingham group are now in the Galleria Nazionale di Palazzo Corsini in Rome, showing *The Piazzetta Facing the Basin, The Square Facing San Geminiano, The Grand Canal from the Rialto Bridge toward Ca' Foscari*, and *The Rialto Bridge Seen from the South*. All of these are subjects that Canaletto had already painted in his early works, and now reworked with his characteristic dazzling light pervading the entire scene.

The date of 1742, or soon thereafter, can be assigned to the views of *The Church and the Doge's Palace from the Procuratie Vecchie* and *The Entrance to the Grand Canal from the San Marco Basin* both signed "A.C.F.," and now in the National Gallery of Art in Washington, coming from Castle Howard. From approximately the same time is the crystalline vision of *St. Mark's Square Facing the Church*, formerly the property of Lady Delia Mary Innes and now in an English private collection,[35]

which is a replica, with significant variations and a much smaller size, of the first two canvases now in Washington.

Another indisputed masterpiece by Canaletto dates to the mid-1730s, the celebrated *Feast of St. Roch* in the National Gallery in London. The painting commemorates the annual visit paid by the Doge to the votive church on the feast day of the saint—August 16—when works by the artists enrolled in the Guild of Venetian Artists were exhibited to the public in the Campo. It is not known who commissioned the painting: the only indication of the early history of the canvas is contained in a catalogue of an auction held in London in 1804, where its provenance is listed as "from the Vatican." This too is a view distinguished by a dazzling light. The figures of the Doge, ambassadors, and senators emerging in procession from the church are described with exceptional clarity, as are the architectural details, which include even the hooks used for hanging the festoons. And yet, none of the paintings displayed on the façade of the Scuola and the houses on the left can be identified, not even the one—the first on the right—that has erroneously been thought in the past to be the reproduction of Canaletto's own early view of the Campo Santi Giovanni e Paolo, purchased by the imperial ambassador and now in Dresden. It is almost as though Canaletto had refused to give other artists any space in his painting.

Indeed, Canaletto does not seem to have been of an easy-going disposition. Evidence of this emerges in the letters and writings of those who had dealings with him. For example, Owen McSwiney wrote to the Duke of Richmond in 1727: "The man is extremely difficult and does nothing but change his prices every day;

Canaletto
St. Mark's Square facing the Church
56.8 x 102.3 cm
Private collection

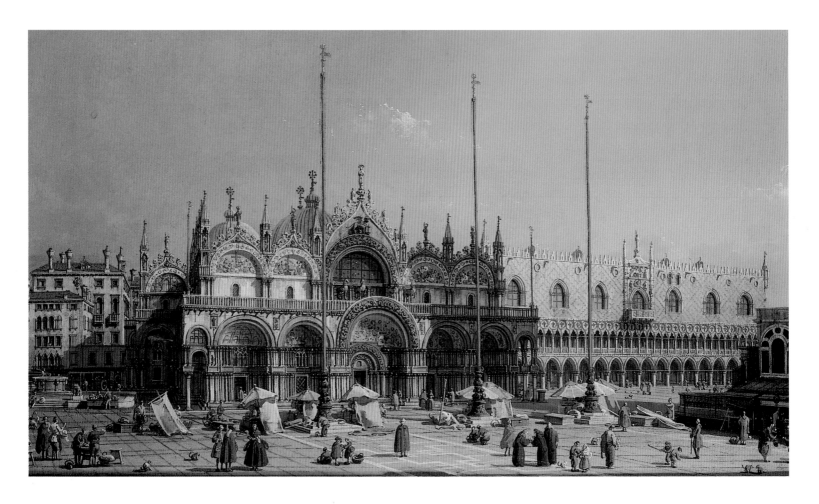

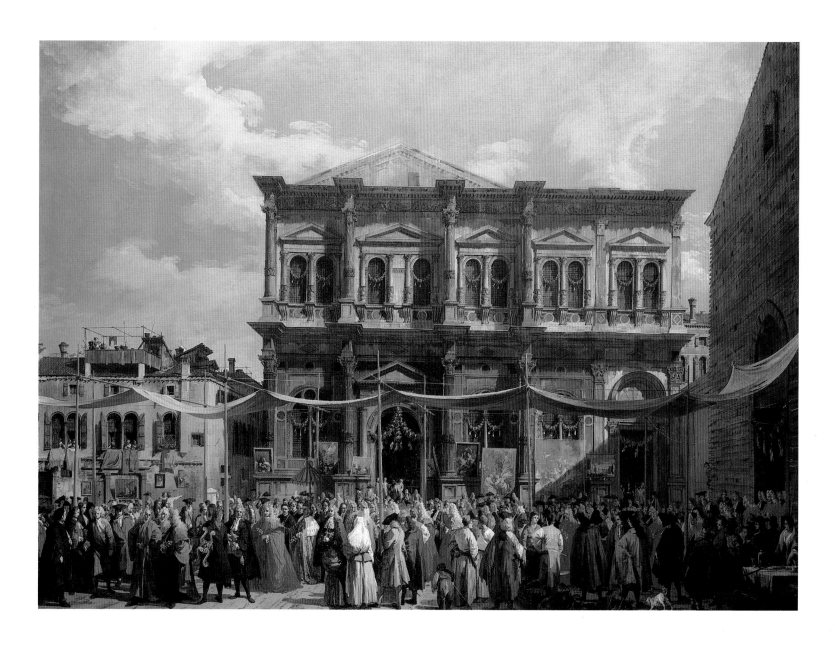

Canaletto
The Feast of St. Roch
147 x 199 cm
London, National Gallery

and if you want to have a painting, you must be very careful not to let him know it too much, because you risk losing, both in terms of price and quality." Three years later, McSwiney wrote to John Conduit: "He is a greedy and grasping man, and as he is famous people are happy to pay him whatever he asks." Canaletto's relationship with Joseph Smith, too, must not have always been idyllic, since on at least one occasion the Englishman complained to a correspondent about the painter's "impertinence." Count Tessin used even more explicit terms: after coming to Venice from Stockholm in 1736 and trying in vain to persuade Giambattista Tiepolo to move to the court of the king of Sweden, he described Canaletto as miserly, full of pretension, and even somewhat of a cheat. De Brosses, in 1739–40, also highlighted the distinctive greed of the painter, bitterly concluding that it was impossible to deal with him.

Canaletto's splendid season of the 1730s concludes with numerous other masterpieces, among which is the noteworthy *View of the Riva degli Schiavoni* (1740) from the basin, now in the Toledo (Ohio) Museum of Art. The painting was part of a subsequently dispersed group of thirteen views, which came,

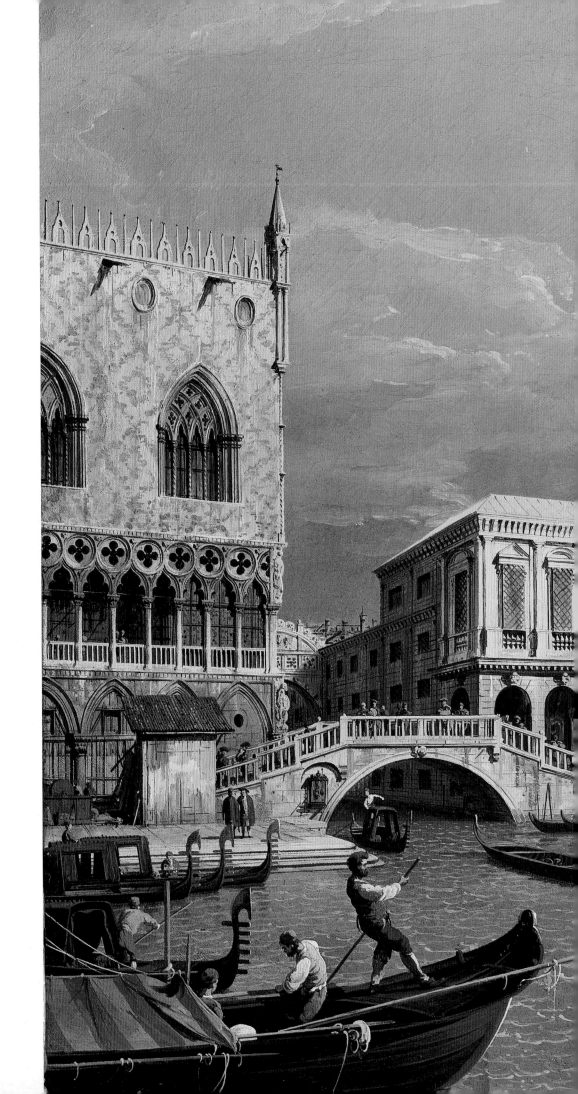

Canaletto
View of the Riva degli Schiavoni from the Basin
46.5 x 63 cm
Toledo (Ohio), Museum of Art

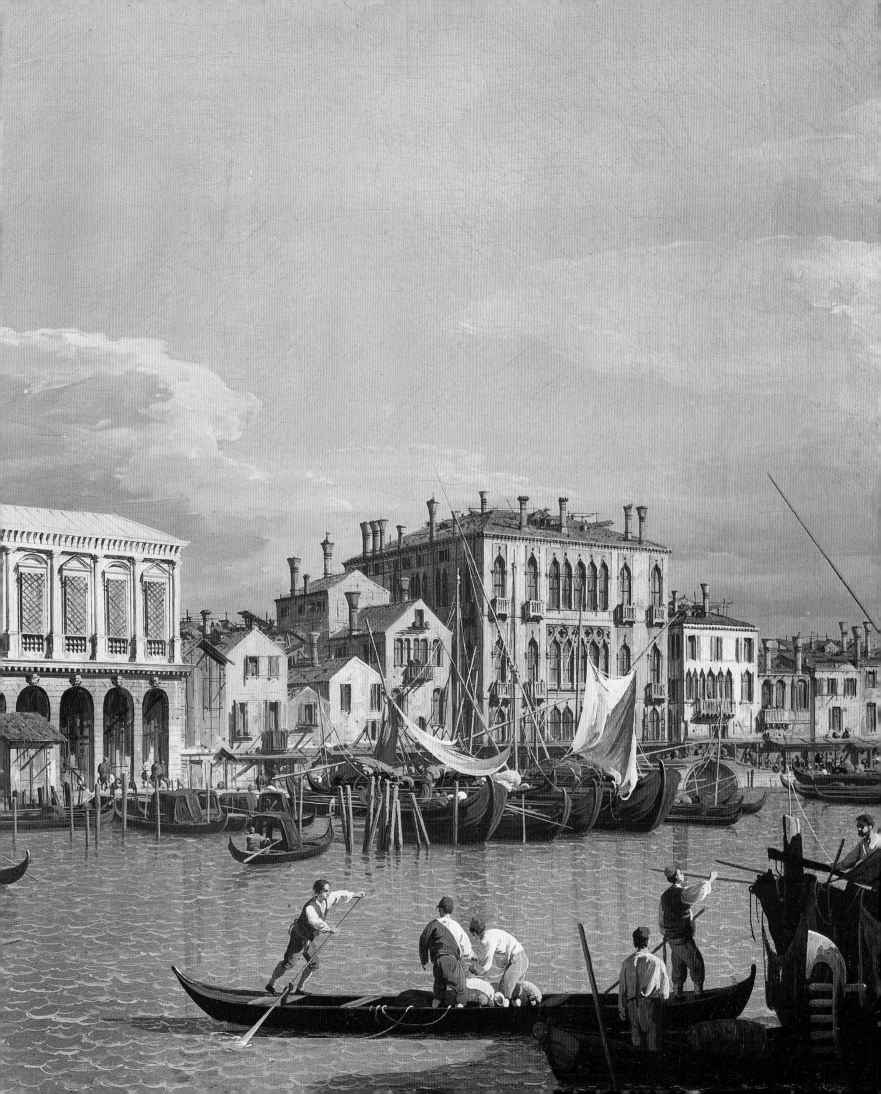

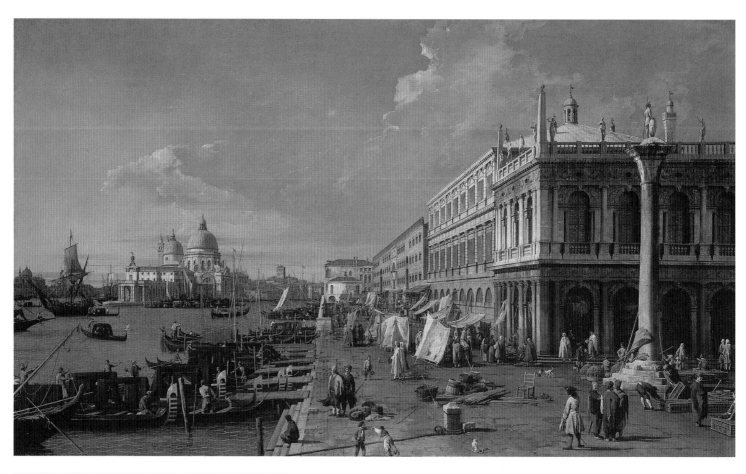

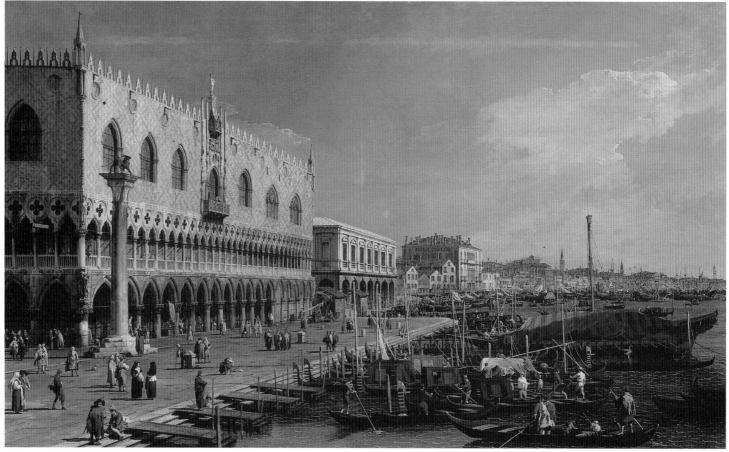

Canaletto
The Dock Facing West with the Mint
110.5 x 185.5 cm
Milan, Civiche Raccolte d'Arte
del Castello Sforzesco

Canaletto
*The Riva degli Schiavoni Facing East
with the Doge's Palace*
110.5 x 185.5 cm
Milan, Civiche Raccolte d'Arte
del Castello Sforzesco

Canaletto
*Capriccio with the Horses of St. Mark's
in the Piazzetta*
108 x 129.5 cm
Windsor Castle, Royal Collections

Canaletto
*Capriccio with the Rialto Bridge
Designed by Palladio*
90 x 130 cm
Windsor Castle, Royal Collections

probably at different moments in the eighteenth century, into the collection of the princes of Liechtenstein in Vienna along with the four early canvases mentioned above. The painting in the Toledo Museum of Art is a splendid example of Canaletto's mature style, for the extraordinary brilliance of the colors and the superb clarity of the image. Also exemplary are the views of *The Dock Facing West with the Mint and the Entrance to the Grand Canal* and of the *Riva degli Schiavoni Facing East*, formerly the property, along with two other Canaletto views, of the Duke of Leeds, and now a part of the collections of Castello Sforzesco in Milan. These can be dated to this moment in Canaletto's career, rather than the beginning of the 1730s, as has been proposed in the past.

As the fifth decade began, Canaletto's production seems to have entered a special phase: in the years between 1741 and 1744 he engraved thirty-one etchings which, gathered in a volume entitled *Vedute Altre prese da i luoghi altre ideate (Some Views Taken from Places, Others Imagined)*, were published without a date. It is thought that they appeared in the same year as Joseph Smith's long-desired appointment as English consul in Venice, because they were dedicated to him on the frontispiece "as a sign of esteem and homage." A copious series of Roman views was made in 1742, most of them now at Windsor Castle, deriving certainly from the drawings made by Canaletto's nephew Bernardo Bellotto during his stay in the papal capital. In the years immediately following, he resumed production of caprices, a typical theme in his early years. The thirteen above-the-door paintings (of which only eleven have survived) made for Smith between 1742 and 1744 must also be considered caprices, as the artist takes apart and reassembles Venetian reality to suit his fancy. Famous examples are the painting in which he moves the four horses from the top of the façade of the basilica to the ground in front of the church, or the one in which he imagines the Rialto Bridge designed in the late sixteenth-century by Andrea Palladio—at the time discarded in favor of the one proposed by Antonio da Ponte—as bridging the Canal between the Riva del Carbon and the Riva del Vin. These works are imbued with a strong "political" flavor, given that the painter—and through him, his illustrious patron—was alluding to the decadence of the Republic by upsetting the details of the San Marco area, the very emblem of the Venetian state. Or, perhaps, it may be only a visual elaboration of the theoretical debates

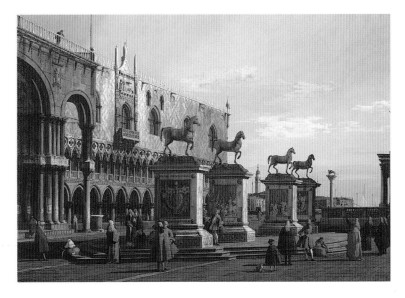

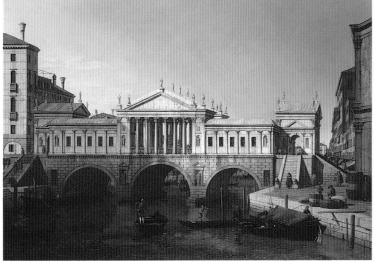

Canaletto
*Westminster Bridge
from the North*
96 x 137.5 cm
New Haven, Yale Center
of British Art

Canaletto
Walton Bridge
46.5 x 75 cm
London, Dulwich
Picture Gallery

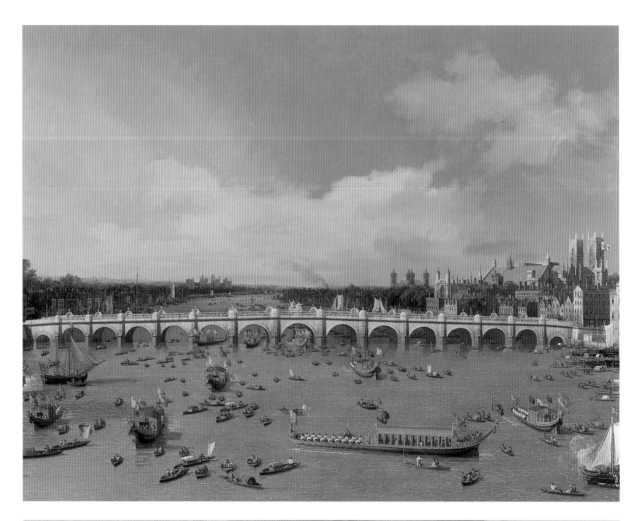

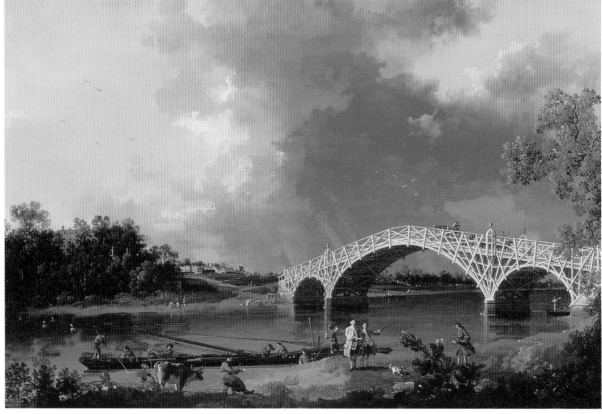

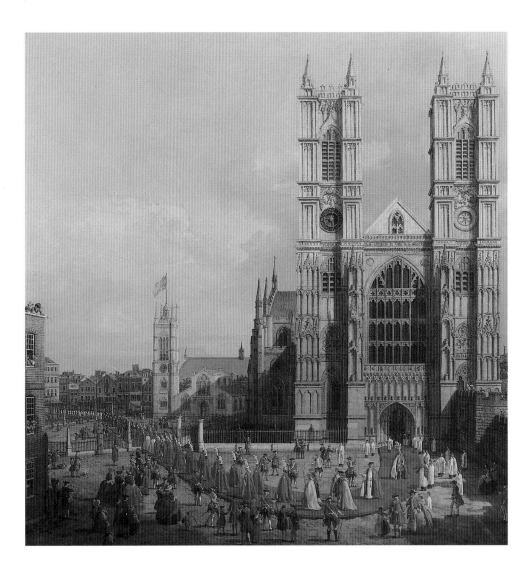

Canaletto
*Procession of the Knights
of the Order of the Bath*
99 x 101.5
London, Westminster Abbey

going on at that time in Smith's salon, concerning a "possible Venice," amended and renewed, which those in Smith's circle wanted to be different from the actual city. Perhaps it was simply an attempt made by the painter to enlarge a repertory that was growing stale.

The Trip to England

This change in artistic direction, with a search for new themes and new techniques of expression, can perhaps be interpreted as a consequence of the changed political conditions in Europe. The ongoing Wars of Austrian Succession had reduced the flow of tourists to Venice, which may have diminished, if not completely cancelled, Canaletto's lucrative commitments from abroad. This situation is probably also the cause of Canaletto's decision to go to England, a decision that was naturally favored by his very close relationship with Smith. Canaletto arrived in London in May 1746, carrying with him a letter of recommendation from Smith to Owen McSwiney, who had returned to London about ten years earlier, in which the consul asked McSwiney to place the painter directly in contact with the Duke of Richmond. But, as the Duke was absent, Canaletto had the good fortune to be presented to Sir High Smithson, the future Duke of Northumberland, who became his first English patron and his protector.

Despite this influential protection, Canaletto's English sojourn must not have been an easy time for him, due to strained relations with the local artists. Indeed, it seems that they tried to discredit him by spreading the rumor that he was not the real Canaletto, but rather his nephew, Bernardo Bellotto, who by that date had left Venice for the court of Dresden. Canaletto reacted to this provocation by putting announcements in the *Daily Advertiser* in 1749 and 1751, inviting art lovers to come watch him paint in his studio on Silver Street (now Beak Street near Regent Street, in the center of London).

Despite this hostility, in London Canaletto obtained numerous commissions, and during his stay in England produced some fifty large views, some of them of very high quality. Works like *The Thames from an Arch of Westminster Bridge*, painted in 1747 for the Duke of Richmond, two *Views of the Thames* painted simultaneously for Prince Lobkowitz and now in Prague, and the well-known *Walton Bridge*

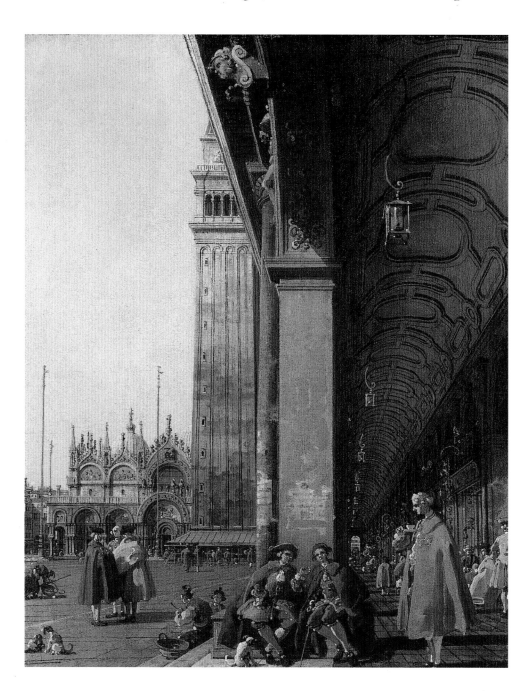

Canaletto
The Procuratie Nuove at the Caffè Florian
45 x 35 cm
London, National Gallery

Canaletto
St. Mark's Square from the Porch of the Ascensione
46.5 x 38 cm
London, National Gallery

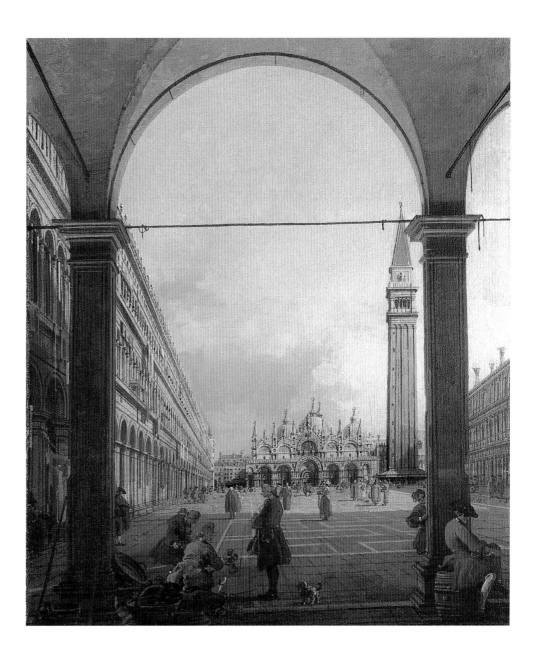

(Dulwich Picture Gallery) painted for Thomas Hollis, can all stand up to comparison with his luminous, animated Venetian views. Canaletto paid special attention to the portrayal of daily life, and in all his English paintings the description of the ceremonies (see for example the *Procession of the Knights of the Order of the Bath* [1749; Westminster Abbey], or even just the customs and clothing of the inhabitants, is meticulously done.

Canaletto remained in England until 1755–56, interrupting his stay there twice: first in 1750, when he returned to Venice for eight months, and perhaps a second time—according to the nobleman Pietro Gradenigo—at the end of July 1753.

The Last Venetian Years
Upon his definitive return to Venice in 1755–56, Canaletto resumed his activity for his foreign patrons who, with the improvement in the European political situation, had returned in great numbers to visit Venice. His works from the last decade of his life have not always been appreciated and fully understood by critics, who have

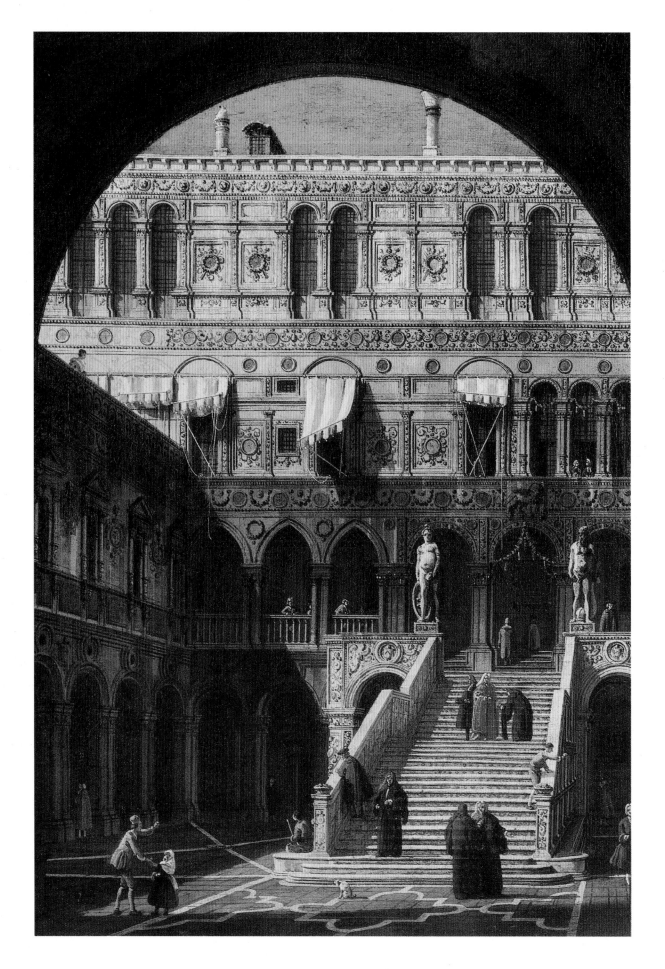

Canaletto
*The Giants' Staircase
in the Doge's Palace*
42 x 29 cm
Private collection

Canaletto
*The Interior of the Church
during the Good Friday Procession*
33 x 22.5 cm
Windsor Castle, Royal Collections

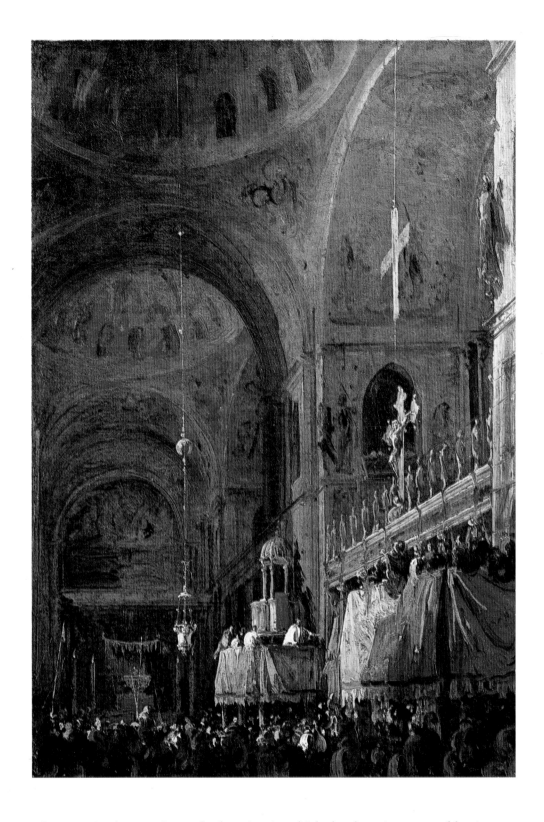

often seen in them a phase of exhaustion in which the then sixty-year-old painter reached only rarely the heights of quality of the works done before he went to England or during his English sojourn.

It seems to me, conversely, that the final chapter of Canaletto's activity is a very successful time for the painter, in which he attempts to renew his iconographical repertory by trying new angles and paying particular attention to the play of light, which often becomes whimsical. On closer examination, many paintings

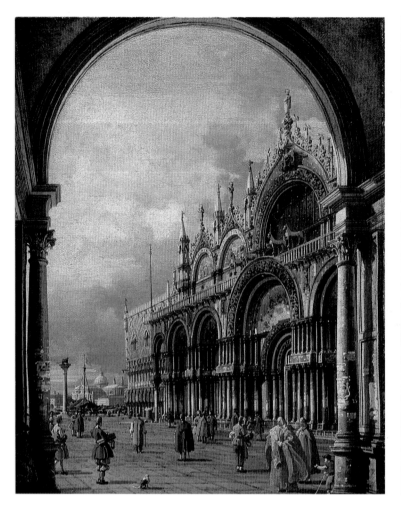

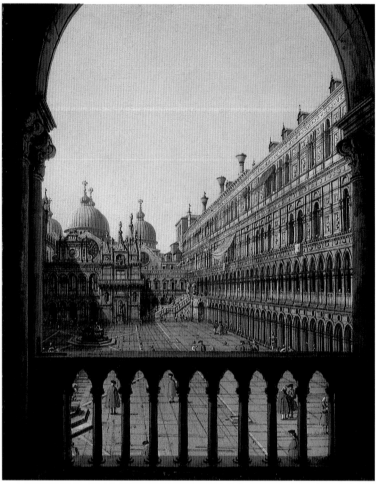

Canaletto
St. Mark's Square from the Porch of the Clock Tower
45.5 x 37 cm
Cambridge, Fitzwilliam Museum

Canaletto
The Courtyard of the Doge's Palace from the Loggia
46 x 37 cm
Cambridge, Fitzwilliam Museum

Canaletto
The Church of Santa Maria della Salute
46 x 35.5 cm
Private collection

which were certainly done during the last years of Canaletto's life are of the highest quality. Among these is the large group of vertical paintings, a format that is rarely found in his work until this point, datable around 1760. This group includes masterpieces like the two refined small views now in the National Gallery in London, representing *The Procuratie Nuove at the Caffè Florian* and *St. Mark's Square from the Porch of the Ascensione*—both splendid pictures for the very personal handling of the light and the quality of the figures, enlivened by the luminous auras around them painted with the tip of the brush. Another exceptional vertical painting depicts *The Giants' Staircase in the Doge's Palace* from the Foscari arch (private collection, Mexico City), and was originally the pendant of a canvas representing the *Interior of St. Mark's Church* (Museum of Fine Arts, Montreal). Also remarkable is a second view of the *Interior of the Church*, perhaps seen during the Good Friday procession, painted for Joseph Smith and now in Windsor Castle, which is particularly charming for its nocturnal representation of the shimmering interior of gold mosaics, painted with an unprecedented whirling brushstroke. Two canvases in the Fitzwilliam Museum in Cambridge (U.K.), showing *St. Mark's Square* seen from the porch of the clock tower and the *Courtyard of the Doge's Palace* seen from the loggia on the second floor, also belong to this group. These views are astonishing for their innovative angle and framing, just as a new way of looking at an old subject characterizes the *View of St. Mark's Square Facing the Church*, seen from the arch on the southwest corner of the

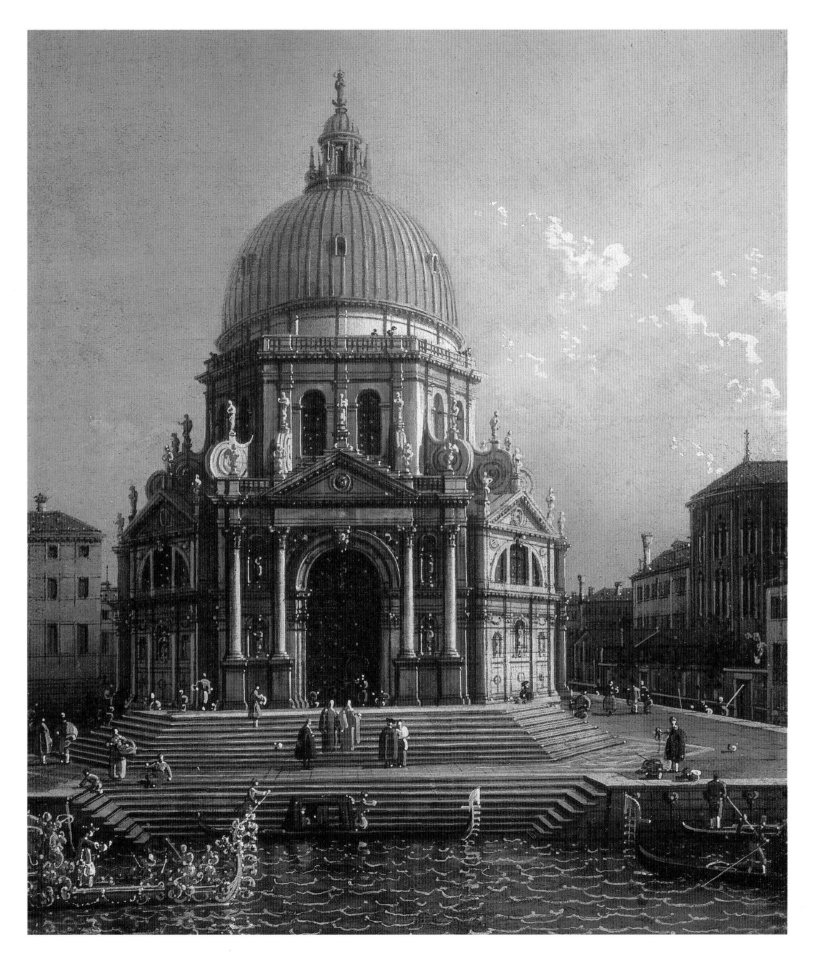

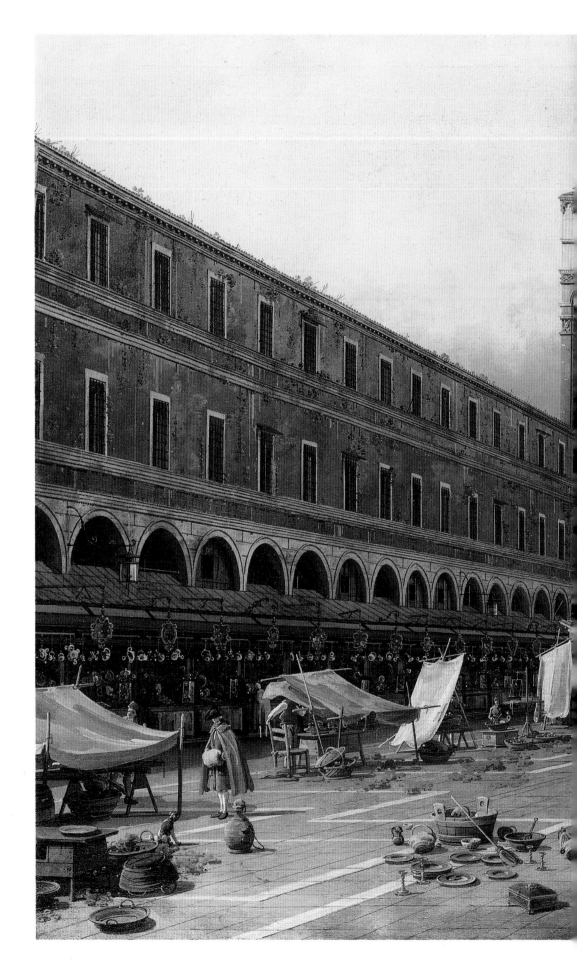

Canaletto
Campo San Giacomo di Rialto
119 x 186 cm
Berlin, Staatliche Museen

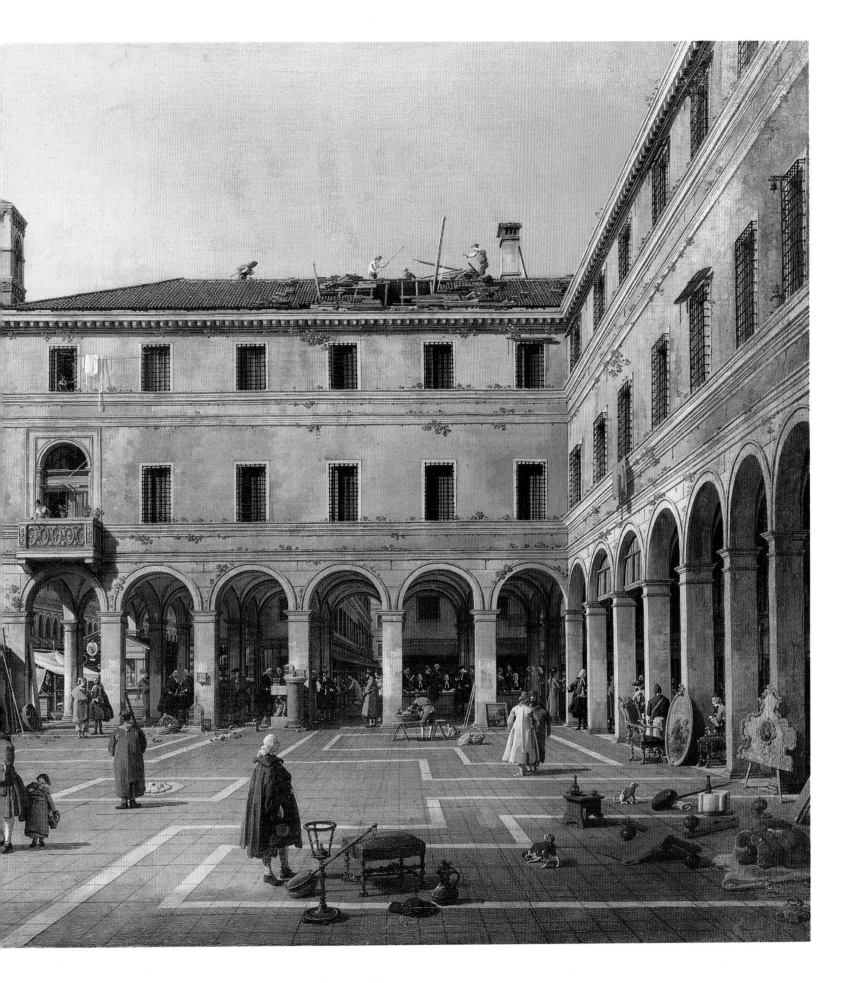

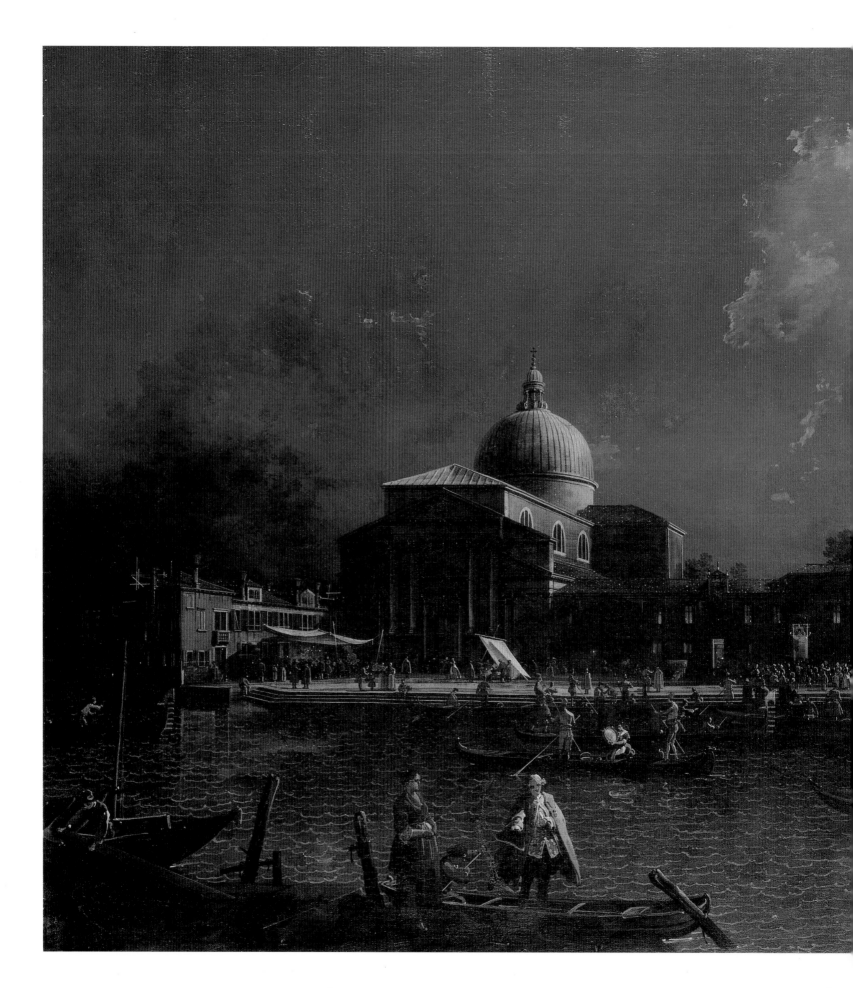

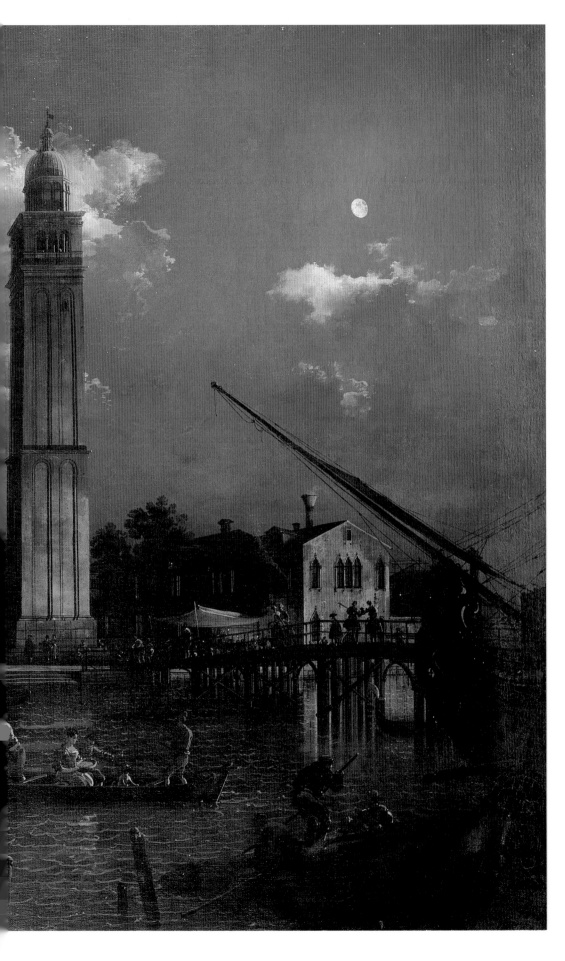

Canaletto
The Feast of San Pietro di Castello
117 x 187 cm
Berlin, Staatliche Museen

Canaletto
The Grand Canal from Palazzo Foscari toward Rialto
118 x 188 cm
Berlin, Staatliche Museen

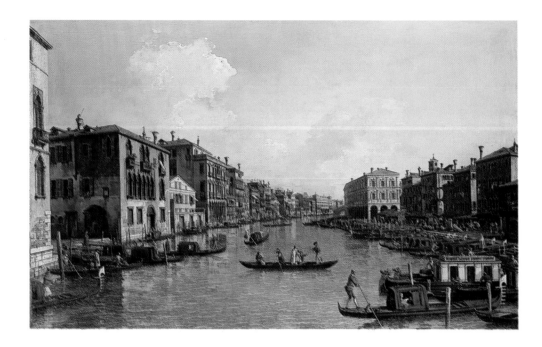

Procuratie Nuove, which is now in the collection of Lord Wharton at Halswell Park. In this painting the Square, from the short end of the Procuratie all the way to the bell tower, is filled with shops decorated for the feast of the Ascension, and a colorful crowd mills about.

Stylistic similarities link these canvases with the brilliantly luminous, almost frontal view of *The Church of Santa Maria della Salute*, (private collection), also vertical in format, which shows the grand structure of the votive church designed by Longhena. In front of the church, waiting its turn to dock at the broad staircase, is one of the magnificent parade gondolas decorated with gilt carvings that were used by imperial ambassadors and papal legates. Unfortunately, there seem to be no elements that could help identify the owner of the boat, which would be useful in establishing a date for the painting. However, a rather late dating— perhaps in the 1760s—is supported by the identical technique found in other Canaletto views of that period.

The final phase of Canaletto's activity included the production of a series of four large views, now in the Staatliche Museen in Berlin, commissioned by the rich German merchant Sigismund Streit. Two of these canvases depict places where Streit had lived and worked before his move to Padua in 1754: the section of the *Grand Canal* that goes from Palazzo Foscari in front of the Pescheria—where the Venetian residence of the patron had been located—up to the Rialto Bridge seen in the background, and the *Campo San Giacomo di Rialto*, where Streit had practiced his trade. A detail appearing in this work—the presence of the new paving of the Campo laid, according to Tassini, in 1758—enabled Schleier[36] to establish a date for them between 1758 and 1763, when they were sent by the patron, along with the numerous other paintings from the Venetian school in his collection, to the Gymnasium Zum Grauen Kloster in Berlin. The two other canvases painted for Streit portray two of the typical feasts of the Venetian popular religious tradition: *The Feast of San Pietro di Castello* and *The Feast of Santa Marta*. The fact that both these feasts took place after sunset allowed the artist to create two nocturnes of incomparable charm.

Canaletto
The Feast of Santa Marta
119 x 187 cm
Berlin, Staatliche Museen

Canaletto
The Musicians in St. Mark's
47 x 36 cm
Drawing with wash
Hamburg, Kunsthalle

In 1765 Canaletto, admitted just two years earlier to the Academy of Painting and Sculpture as a "perspectivist," donated to the Academy a *Caprice with a Colonnade* (Gallerie dell'Accademia, Venice) which reveals, in the arrangement of the scene, precise analogies with the other vertical views mentioned above. This work must have met with resounding success, as it was replicated by the master himself on at least two occasions (these are the paintings in the Narodni Galerie in Prague and Ca' Rezzonico in Venice; the latter was the property of the last Doge, Ludovico Manin) and copied numerous times by other painters.

These may be the master's last works; however, a drawing of his survives as the last witness to the excellence of his art, a pen and ink and wash now in the Kunsthalle in Hamburg. It bears the artist's inscription "*Io Zuane Antonio da Canal, hò fatto il presente disegnio delli Musici che canta nella Chiesa Ducal di S. Marco in Venezia in età de Anni 68 senzza Ochiali, l'anno 1766*" ("I, Giovanni Antonio da Canal, made the present drawing of the musicians who sing in the Ducal Church of St. Mark's in Venice at the age of 68 years without eyeglasses, the year 1766"), a touching testimony to the elderly artist's pride, who makes a point of recounting that he was able to draw without the aid of eyeglasses despite his advanced age.

Antonio died on April 18, 1768 "of fever and bladder infection." His death is recorded also by Pietro Gradenigo in his *Notatori*: "After long suffering from illness, we must bear here the loss of a valorous paintbrush, dead today in the quarter of San Leone: we mean the painter Mr. Antonio Canal, called Canaletto, distinguished for his views." Strangely, the inventory of property left by the artist reveals a financial situation much less florid than one would have expected, judging from his generally remarked austerity and the enormous number of paintings he produced. At the moment of his death Canaletto possessed 2,150 ducats deposited at the Scuola dei Luganegheri, destined to be divided among his three surviving sisters (he never married), 300 ducats in cash on hand, a few pieces of very modest furniture, some practically worthless jewelry, twenty-eight paintings still in his studio, and a modest wardrobe composed for the most part of old, worn-out clothes and cloaks.

Canaletto's "Creations":
Bernardo Bellotto, William James, and a Hypothesis Concerning Antonio Visentini, View Painter

Bernardo Bellotto
The Entrance to the Grand Canal, with the Customs House and the Church of Santa Maria della Salute
Private collection
Detail (entire painting on page 137)

Bernardo Bellotto

An irascible and difficult man, Canaletto did not have a true workshop, nor did he ever—as Giambattista Tiepolo did intensely from the earliest years of his career—carry out any didactic activity aimed at training young painters to work with him in the realization of his works. Attempts have been made to assign to him some pupil, identifying this person as Giuseppe Moretti, Francesco Tironi, or Jacopo Fabris. However, these are most likely simply autonomous painters who imitated his manner, which was particularly well appreciated, especially by the foreign market, and were in any case inferior to him as artists.

The only painter that definitely worked alongside Canaletto—albeit only for a brief period—was Bernardo Bellotto, his nephew, the son of Antonio's younger sister Fiorenza Domenica. Recent discoveries have confirmed that Bernardo was born on May 20, 1722, the third son of Lorenzo Antonio Bellotto, a man of good social position whose family originated in the Lombard territories subjected to Venetian dominion.

Reconstruction of the early events of Bernardo's life hinges on the testimony of Pietro Guarienti, a painter and art connoisseur who had become Belloto's friend in Venice, acting even as godfather at the baptism of his third daughter, Francesca Elisabetta. Guarienti is the author of the entry on Bellotto published as an addition to the 1753 edition of the *Abecedario* by Pellegrino Antonio Orlandi. We know from this source that Bellotto began working with his uncle at a very young age, probably starting around 1735. Nonetheless, it is still surprising that in 1738, at the age of just sixteen, he was already enrolled in the Guild of Venetian Painters; from this we can deduce that by that date he was already working independently.

At any rate, at least at the beginning of his precocious activity, Bellotto must have worked essentially at making copies of the paintings and drawings of his famous uncle. Guarienti writes that Bellotto "began imitating him [his uncle and teacher] with all his study and diligence." The same source informs us of the various trips taken by Bellotto: the first, to Rome and briefly Florence and Lucca, can be reasonably assigned to the span of time between November 1741 (on the fifth of

that month, Bellotto married Maria Elisabetta Pizzorno in Venice) and 1742, the year in which Canaletto painted five large canvases for Joseph Smith using the iconographic material accumulated by Bellotto during his Roman sojourn. Back in Venice, Bellotto showed two of his views at the Feast of St. Roch on August 16, 1743, after which he made another trip to the major cities of northern Italy. In the course of 1744, he was present in Milan, Gazzada, Canonica, and Vaprio d'Adda, where his major patrons were the Milanese count Antonio Simonetta, Prince Antonio Melzi d'Eril, and probably even the governor of Milan himself, the Bohemian count George Christian Lobkovic. The following summer he was summoned to Turin by King Carlo Emanuele III of Savoy, for whom he painted the two large views of that city now in the Pinacoteca Sabauda. On his way back to Venice he stopped in Verona, where he made some drawings "from life" that he used later for various views of the city, done in the two years preceding his departure for Dresden, painting for either some unknown English patrons or at the suggestion of Smith himself, who may then have sold the works on the London market.[37]

At the conclusion of his text, Guarienti adds also that Bellotto "painted many of them [views] of Venice so carefully, and made them from life, that a very great discernment is required in anyone who wants to distinguish them from those by his uncle." This well-known statement by Guarienti about the difficulties that contemporaries were already having in distinguishing the nephew's works from the uncle's may have some foundation for Bellotto's earliest activity, before the trips he took before the mid-1740s. But already in the numerous works painted in Lombardy and in Turin, his style is clearly a very personal one, and can certainly be distinguished from Canaletto's. This emerges with incontrafutable evidence in masterworks like the splendid, analytic *View of the Old Bridge over the Po River* of 1745 (Galeria Sabauda, Turin) which, together with its pendant of the *View of*

Bernardo Bellotto
View of the Old Bridge over the Po River
127 x 174 cm
Turin, Galleria Sabauda

Bernardo Bellotto
The Shipyards
151 x 121 cm
Ottawa, National Gallery of Canada

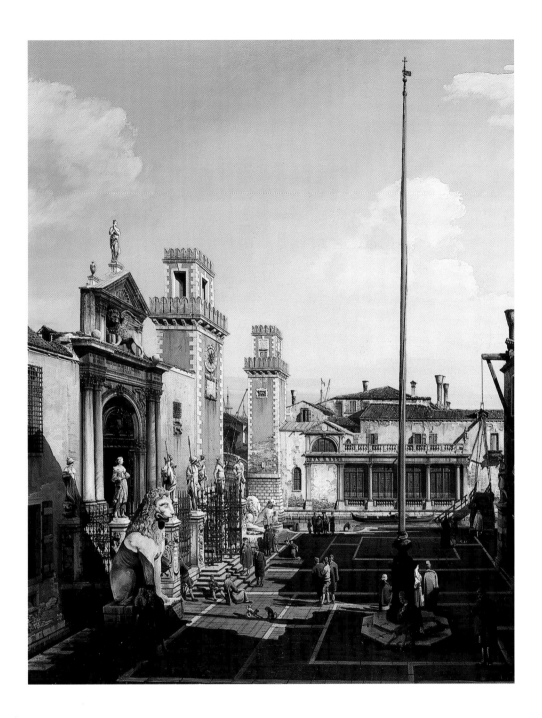

Turin from the Royal Gardens, constitutes one of the greatest achievements of Bellotto's Italian phase. Nonetheless, the task of distinguishing between the views of the two artists has profoundly engaged modern critics. But this—as Kowalczyk[38] has justly pointed out—is a consequence of the fact that Canaletto's fame very soon obscured that of his nephew, who had gone at a still young age to Dresden: "the result [was] that the more famous painter, because of the prestige of his name, was soon attributed not only Bellotto's Venetian views, but also those of Florence, Rome, and Lombardy, and without making too much distinction, even a considerable number of paintings by other *vedutisti*, for the most part anonymous, whose work was of a much lower quality."

Currently, the young Bellotto is assigned with confidence a fairly large number of views of Venice, a good part of which were once said to be by Canaletto. Among

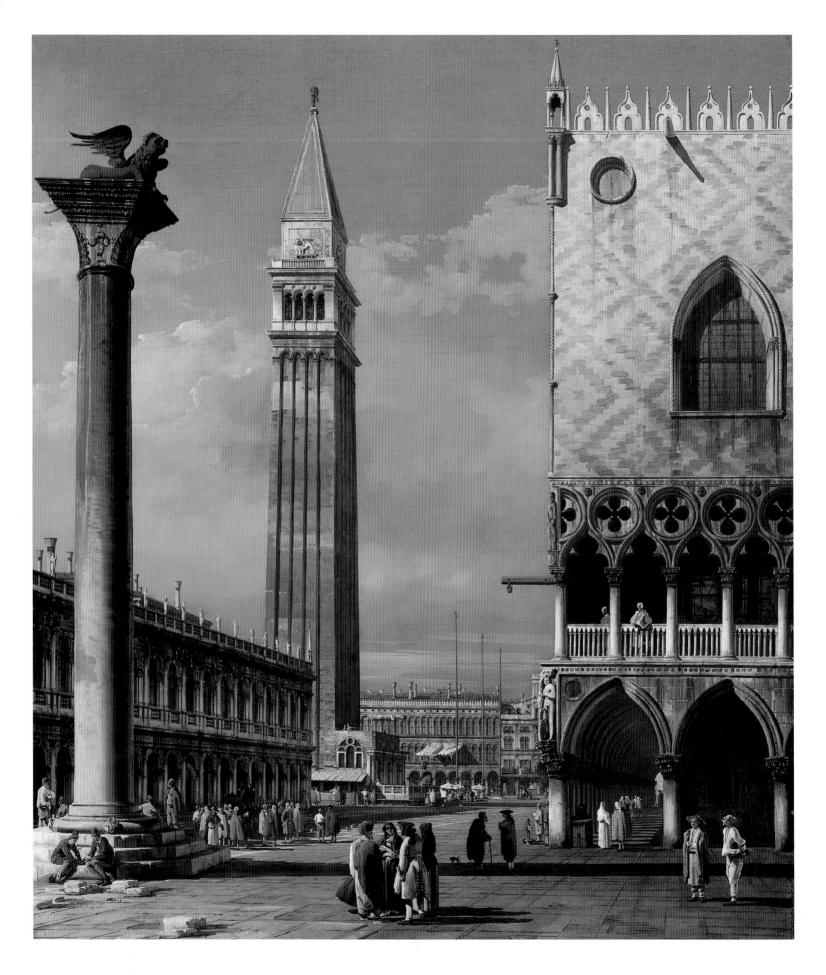

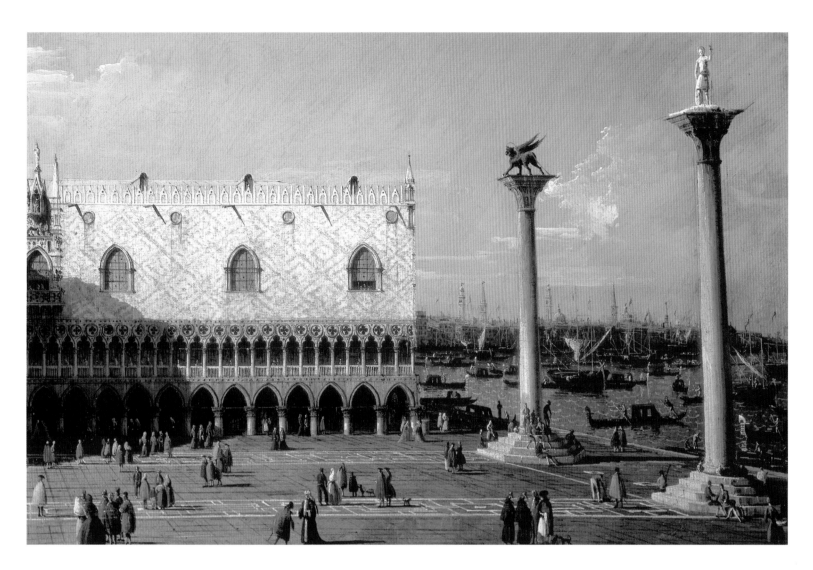

Bernardo Bellotto
The San Marco Basin from the Piazzetta
60.5 x 92.3 cm
Private collection

Bernardo Bellotto
*The Piazzetta from the Dock
Facing St. Mark's Square*
151 x 122 cm
Ottawa, National Gallery of Canada

these are four canvases, originally making up one series and now equally divided between the National Gallery of Ottawa and the Mills collection in Ringwood. Their attribution to Bellotto by Terisio Pignatti,[39] refuting the then-current attribution to Canaletto under which the views were exhibited in Canada in 1964, opened the path for the deeper critical investigation which appears to have finally reached significant results in the reconstruction of Bellotto's early oeuvre. In essence, Pignatti underlined the presence in the four canvases of stylistic elements that would recur throughout Bellotto's production: the meticulously precise definition of the architecture; the vibrance of the light; and the use of dense, sharply defined shadows, "like ink spots." Pignatti also noted the robust, well-modelled characters that appear in these paintings, created using "a simplifed palette, made up of a few pure colors, only rarely mixed to give nuances in certain areas," and applied with a "movement of the brush... in a straight line, so that in the end the figures have a *squared* effect that characterizes them unmistakeably." These are substantially different from those in Canaletto's views, also because they show "an insistence on 'journalistic reporting,' and the effect of *caricature* accentuated by the particular intensity of light which gives an exaggerated, *mask-like* emphasis to the faces, with their darkly rimmed, black eyes, and button nose planted in the middle of the face like a cork." In other words, Pignatti was demonstrating how already in these paintings the tendency was emerging toward a

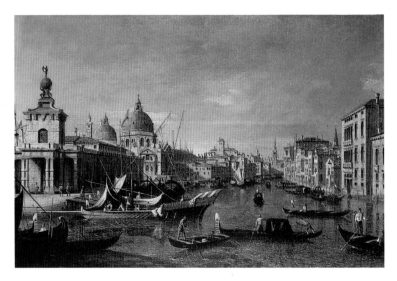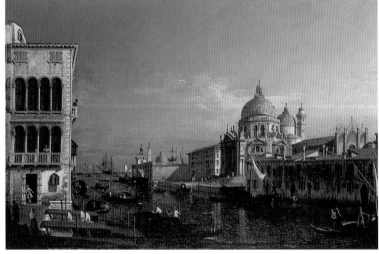

18th century Venetian painter
The Entrance to the Grand Canal, with the Customs
House and the Church of Santa Maria della Salute
48 x 74 cm
Venice, Ca' Rezzonico

18th century Venetian painter
The Grand Canal from Santa Maria del Giglio
toward the San Marco Basin
48 x 74 cm
Venice, Ca' Rezzonico

search for "objective truth," which would characterize all Bellotto's subsequent production, so different from the "virtual" reality that distinguishes Canaletto's views.

There can be no doubt that the great privilege of having been able to work alongside Canaletto helped his nephew not only to learn his art but also to have immediate access to important commissions. While in 1740 Marshal Schulenberg purchased for his collection four views by Bellotto (two showing the San Marco area and two the Shipyards), Canaletto's familiarity with Joseph Smith probably helped the younger painter garner some of the English commissions that the merchant was procuring in great numbers for Canaletto. Further confirmation of the existence of a relationship between Bellotto and Smith lies in the fact that Smith counted in his own collection four works by Bellotto, two views of the Roman Forum and two of Venice, representing *The San Marco Basin from the Piazzetta* and *The San Marco Basin with San Giorgio Maggiore*.

The first of these views of Venice, sold at Christie's in London on July 9, 1993 with the traditional attribution to Canaletto, was properly restored to Bellotto by Dario Succi.[40] The scholar has attempted to reconstruct the painter's activity in Venice from his beginnings to the moment just before his departure for Lombardy in 1744, presenting numerous unpublished works, for the most part now in various private collections, which can be largely connected with early drawings by Bellotto now in the Hessisches Landesmuseum in Darmstadt. This task that Succi has undertaken is undeniably arduous and full of pitfalls, given that Stefan Kozakiewicz, in his fundamental monograph on the painter published in 1972, only cited six views of Venice which he considered to be definitely by the hand of Bellotto. The commendable work done by Succi is lacking in a methodical aspect: the author does not take into consideration the fact that the correspondence between the painted image and the drawing cannot alone be the decisive element for attributing the view to Bellotto. We certainly cannot exclude that the drawings now in Darmstadt—and even more, the engravings by Antonio Visentini made from Canaletto's paintings, another important source in the attribution of paintings to Bellotto, along with the views belonging to Smith—could have been seen and used as models by other artists. Nor can it be excluded that Bellotto's own views might have been copied by other painters.

In other words, even in the difficult case of the works of Bellotto's youth, the pictorial and technical quality of the paintings, which can be attributed to him on the basis of other factors, must be considered. The two views of the *Grand Canal* (from the San Marco Basin, showing Santa Maria della Salute and the Customs House, and from Campo Santa Maria del Giglio toward the Basin) now in Ca' Rezzonico, which Succi considers works by Bellotto datable to 1738, seem substantially too modest and above all too different in technique from certain early works to be considered even only very early trials by the young artist.

It seems absolutely crucial to compare one of the views, the one showing *The Entrance to the Grand Canal with the Customs House and the Church of Santa Maria della Salute,* with the view that is definitely by Bellotto, showing the identical image and now in a private collection in London.[41] It is not necessary to spend too much time describing the differences between these two canvases, which fall into the categories of color, technique, quality, and even of figurative "philosophy." Simply seeing the two pictures side by side demonstrates the great distance separating an original (the one in London, it goes almost without saying) from a derivative product by a much less gifted hand. The hypothesis that the two views in Ca' Rezzonico are truly derivatives is confirmed by the existence of various versions of the second scene, of a quite different quality and certainly assignable to Bellotto, among them the splendid picture in the J. Paul Getty Museum in Los Angeles. This was originally the pendant of another early masterpiece by the

Bernardo Bellotto
The Entrance to the Grand Canal, with the Customs House and the Church of Santa Maria della Salute
62 x 98 cm
London, Private collection

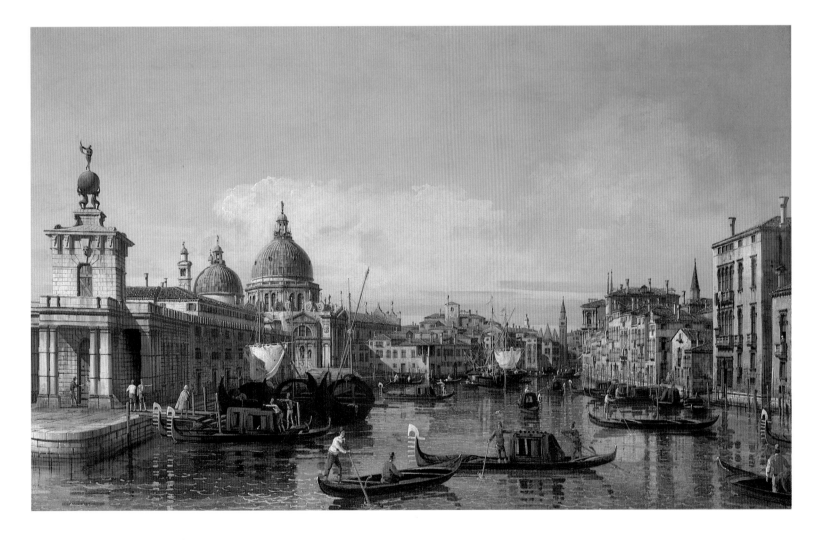

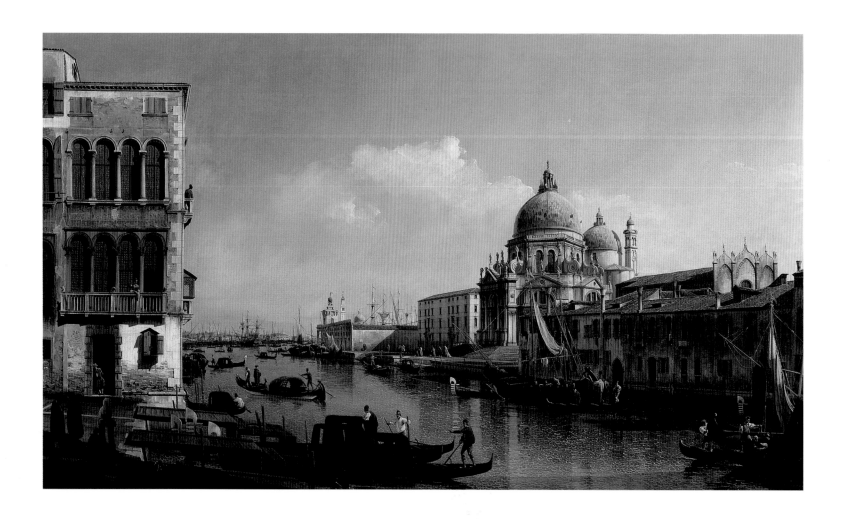

Bernardo Bellotto
The Grand Canal from Santa Maria del Giglio
Malibu, Paul Getty Museum

painter, the view of *St. Mark's Square from the Clock Tower Facing the Procuratie Nuove* in The Cleveland Museum of Art.

It is to Succi's merit that he finally clarified the identity of the works by Bellotto located at Castle Howard, along with those by Canaletto, Marieschi, and other eighteenth-century Venetian artists. It emerges from his thorough investigation that the collection originally had a good fifteen views of Venice painted by Bellotto, of which only four are still in the house. Among these, particularly interesting is the *View of Campo Santo Stefano*, which more or less repeats Canaletto's view painted during the 1730s for the Duke of Bedford. A comparison of these two paintings reveals the differences between Canaletto and Bellotto, evident in the latter's use of a more pronounced contrast between the sunlit and shaded zones, and in his unique fashion of painting his elongated figures. Six of the other eleven views were burned in the fire that profoundly damaged the building on November 9, 1940. Of the remaining, three were sold, between 1895 and 1898, to the merchants Donaldson and Duveen, while the last two were sold in 1895 to Colnaghi and changed hands numerous times before coming to the Musée du Louvre in 1977. These are views of *The Entrance to the Grand Canal with Santa Maria della Salute* and *The Rialto Bridge with the Palazzo dei Camerlenghi*, commonly attributed by critics to Canaletto.

Succi reports on correspondence between the fourth earl of Carlisle, Henry Howard, and Anton Maria Zanetti, who were linked by bonds of friendship from the time of Zanetti's sojourn in England in 1720–21—a friendship which was later

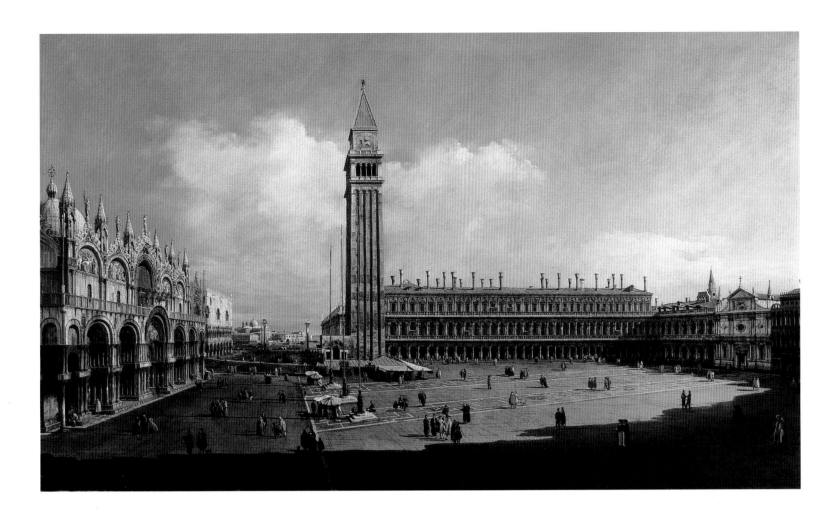

Bernardo Bellotto
St. Mark's Square from the Clock Tower
Facing the Procuratie Nuove
136.2 x 232.5 cm
Cleveland, Museum of Art

strengthened when the two met again in Venice during Carlisle's journey to Italy between 1738 and 1739. His analysis has established that the Venetian views came into Castle Howard at the beginning of 1740. This date seems to be confirmed by a comparison with the works by Bellotto that can be dated with certainty to the early 1740s. Notable similarities exist in three canvases derived from a drawing in the Darmstadt museum, signed and dated December 8, 1740: the canvas in the Museum of Fine Arts in Springfield; a similar one in the National Gallery of Art in Washington, D.C. which probably dates from a few years later; and the view of *The Rio dei Mendicanti and the Scuola Grande di San Marco* in the Gallerie dell'Accademia in Venice. These works are characterized by an intense contrast between the zones in full light and the quite extensive ones wrapped in dense, sharply defined shadow, and by the thick paint spread on the canvas in parallel brushstrokes.

After his return to Venice from his trips made in 1742 and 1745, and before leaving the city for good in May 1747, Bellotto, although engaged in painting views of Verona, also painted some other views of Venice. Among these are works like the View of *The Entrance to the Grand Canal with the Customs House and the Church of Santa Maria della Salute* (private collection, England) the pair mentioned above that is now divided between The Cleveland Museum of Art and the J. Paul Getty Museum; and the view of *The Grand Canal at San Stae toward Rialto* (private collection), with its prevalence of cool colors and Bellotto's unmistakable lanky characters, rendered with touches of a well-soaked paintbrush, that provide an almost caricatural effect.

In 1746 Canaletto left Venice temporarily to go to London; in May of the following year, his nephew left as well, for Dresden. There Bellotto would find again his friend Pietro Guarienti, who had accepted the position of inspector of the court gallery. The fact that Bellotto took his wife and children with him, leaving only his elderly mother in Santa Marina, was an indication that his time away from his home city would not be short. In effect, Bellotto never returned to Venice, but continued working for the rest of his life in the countries of northeast Europe, in Saxony, Vienna, and Munich. He died on November 17, 1780, in Warsaw, where he had arrived in 1766 during a journey in which he intended to continue all the way to St. Petersburg to offer his services to Tsarina Catherine II of Russia. In his work for these courts, Canaletto's nephew (as he signed paintings and is often cited in the local sources) would meet with success and honor, thanks to his exceptional ability to reproduce the "reality" of that world, and revealing in this also a sensitivity to the work done by northern landscape painters, present in large quantity in the collections of the courts to which he was called.

There can be no doubt that the numerous views of Dresden and the Saxon cities, of Munich and of Vienna, as well as the later ones of Warsaw, constitute one of the highest achievements of eighteenth-century European figurative culture. In these highly evocative works, Bellotto reached the height of his artistic expression, enhanced by the use of a pure cystalline light. The buildings are meticulously rendered, and just as carefully done is the narration of the episodes of daily life or the rituals of public ceremonies that appear in the pictures. In their accuracy they

Bernardo Bellotto
Campo Santo Stefano
66 x 84.5 cm
Castle Howard, Private collection

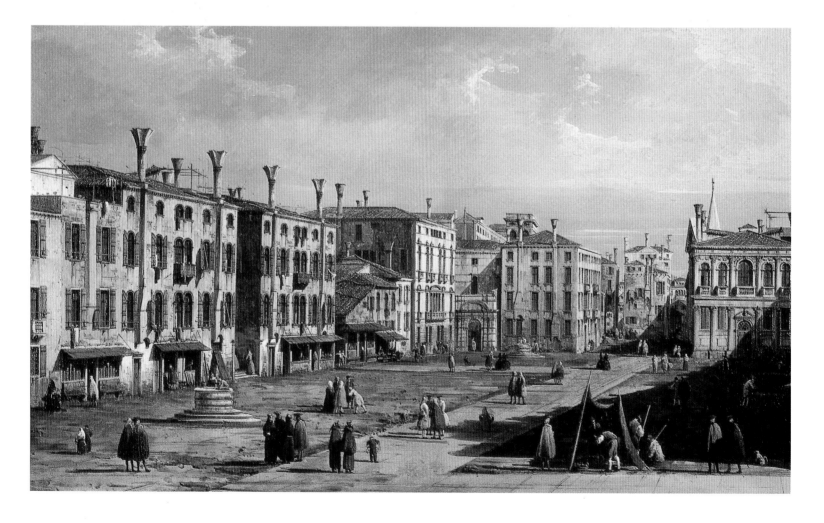

Bernardo Bellotto
The Grand Canal from the Church
of Santa Croce and the Convent
of Corpus Domini Facing San Geremia
60 x 92 cm
London, National Gallery

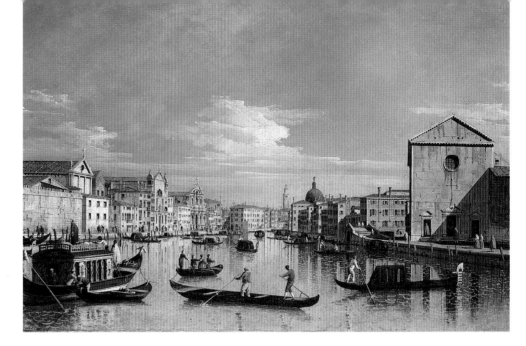

Bernardo Bellotto
The Church of Santa Maria dei Miracoli
and the Apse of Santa Maria Nuova
41 x 66 cm
Hannover, Niedersächsisches Landmuseum

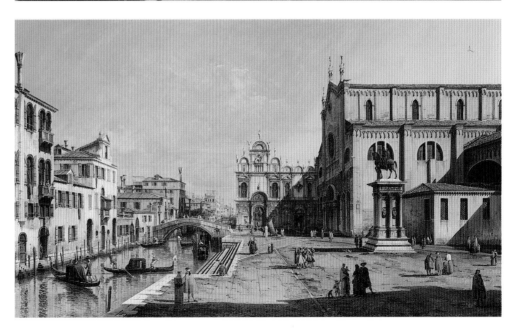

Bernardo Bellotto
Campo Santi Giovanni e Paolo
61 x 98.5 cm
Springfield, Museum of Fine Arts

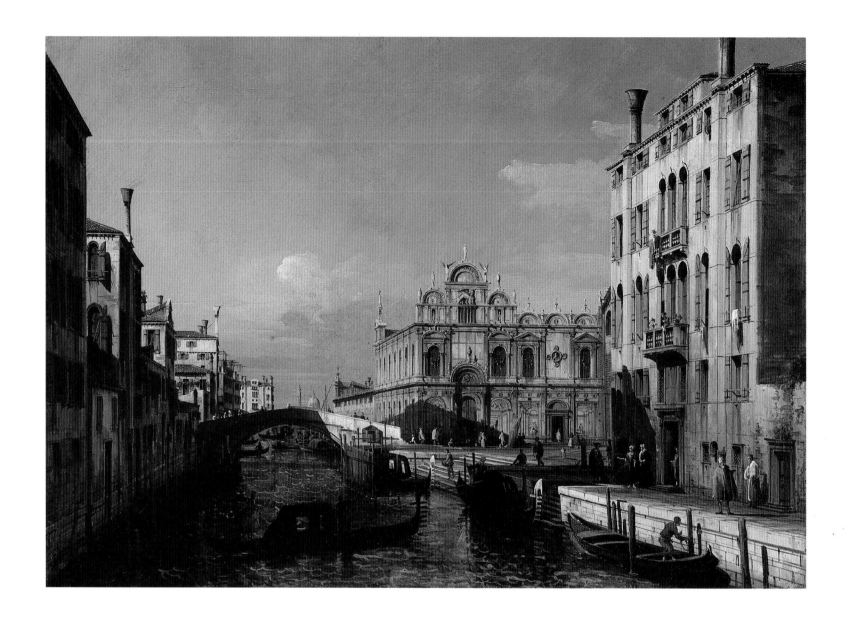

Bernardo Bellotto
*The Rio dei Mendicanti
and the Scuola Grande di San Marco*
42 x 60 cm
Venice, Gallerie dell'Accademia

Bernardo Bellotto
The Fortress of Königsberg
135 x 235.5 cm
Washington, National Gallery

Bernardo Bellotto
Vienna from the Belvedere
135 x 213 cm
Vienna, Kunsthistorisches Museum

constitute a unique and invaluable document, not only because they enable us to reconstruct the physical appearance of some cities (especially Dresden and Warsaw) that underwent devastating destruction in the course of the last world war, but also because they constitute an exceptional testimonial of the life being lived in the courts and in the streets.

William James

During his years in England, between 1746 and 1755, Canaletto had working at his side as a pupil the young English painter William James. James was destined to attain a certain degree of success in his homeland, exhibiting regularly at the Royal Academy and at the Society of Artists, where he was a member from 1761 to 1771.

The core of James's oeuvre consists of the views of London now in the Ashmolean Museum in Oxford (U.K.) and the Royal English collections at Hampton Court, and a watercolor of his also in the Ashmolean Museum. But some views of Venice are also attributed to him, deriving substantially from the engravings made by Antonio Visentini of Canaletto's paintings and probably

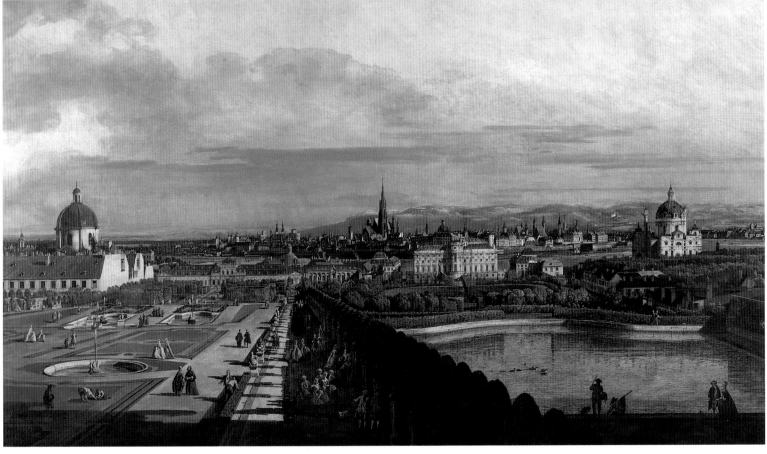

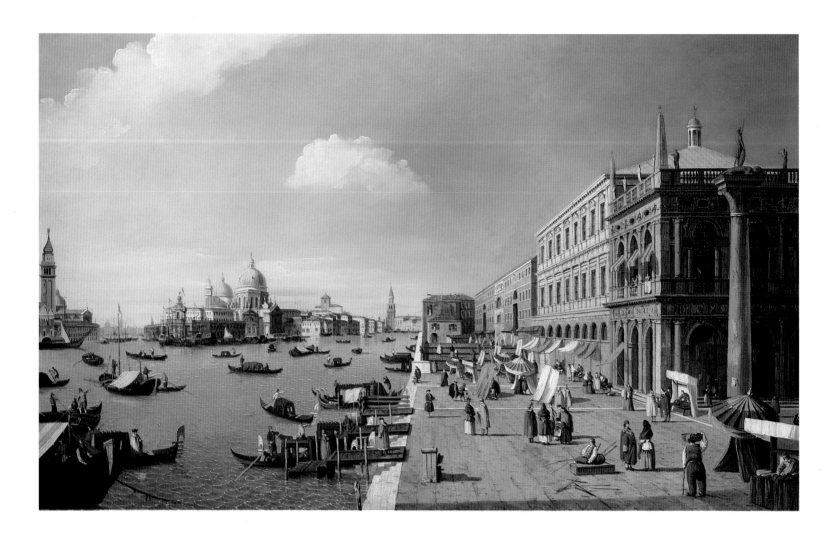

William James
*View of the Dock toward the Entrance
to the Grand Canal*
76 x 128 cm
Vicenza, Private collection

executed in the years when he was a co-worker or pupil of the Venetian master. Among them, the *View of the Dock toward the Entrance to the Grand Canal*[42] is especially interesting. It is in the Alfonsi collection in Vicenza, after being purchased on the New York market; earlier, it had passed through the collections of Walter Ripper in Norfolk, Madame Dujardin in Rouen, Richard Green in London, and Richard Smart in the United States.[43] Another version of it exists, but of the same size but with a few variants, now in the Museo Borgogna in Vercelli, also thought by critics to be by James.

To Visentini's engraving of the picture, once in the collection of the Duke of Leeds and now in the Castello Sforzesco in Milan, James adds on the far left of the canvas an "impossible" view of the island of San Giorgio, even going so far, in order to make Palladio's church more recognizable, as to rotate the façade by ninety degrees, making it face the Piazzetta directly. However, except for this license he repeats the model quite faithfully, modifying only the perspective of the farthest reach of the Grand Canal, where there is a too evident and too massive bell tower of the church of the Carità. He also changes the arrangement of the multicolored figures, characterized by rather stocky and stilted shapes, and of most of the boats, as the very Venetian throng of gondolas and barges and cargo ships tied up at the dock in the painting and its relative engraving seemed too simplified. But it is especially in the colors, playing on strong, vivid tones, and in the use of a strong, crystalline light that facilitates reading of every minute element

of the architecture, that James betrays the lesson he learned from Canaletto, creating a substantially autonomous and thoroughly interesting work.

A Hypothesis Concerning Antonio Visentini, View Painter

In the great "workshop" of ideas and works that surrounded the volcanic personality of Joseph Smith, a leading role was played, along with Canaletto and others, by the eclectic artist Antonio Visentini (1688–1782), who was an engraver, draftsman, architect, and theoretician of architecture, as well as painter. Curiously, his work as a painter is the least well known and investigated of his activity, despite the fact that Visentini began to paint at a young age, in the workshop of Giannantonio Pellegrini in the period preceding the master's transfer to London in 1708.

Thus, despite the fact that Visentini's familiarity with paintbrushes, canvases, and easels dates back to his youth, as is confirmed by the listing of his name in the Guild of Venetian Painters in 1711, when he was twenty-three, and his election to Prior of the College in 1726, his painting portfolio contains only a limited number of works, no more than thirty. Of these only a few, and in particular the eight large *Scenes with Imagined Architecture* (Palazzo Contarini, Venice), and the *Perspective View with Architecture Scholars* (Gallerie dell'Accademia, Venice), are now unanimously considered completely autonomous works.[44] In the other paintings, Visentini painted only the architecture. These include the series of eleven above-the-door paintings showing modern English buildings, painted in collaboration with Francesco Zuccarelli, the author of the landscapes and figures; one canvas with Palladian buildings inserted into broad landscapes, also made in collaboration with Zuccarelli; the two canvases in a Milanese private collection showing *The Interior of the Church of the Redentore* and the *View of San Francesco della Vigna*, where the figures were done in part by Zuccarelli and in part by Giambattista Tiepolo.

It seems astonishing that among his painted works, not one is a view of Venice, as one would expect given Visentini's inclination to try every artistic genre. Moreover, he was a pure perspectivist, to the point that he was not coincidentally chosen to engrave a large number of Canaletto views; it is well known that he had intense contact and relations with Canaletto, not only in the course of his professional activity but also for the fact that they both moved in Smith's circle. However, it is certain that Venetian views painted by Visentini did exist at one time. This is confirmed by the citation which appears in the sale catalogue of the paintings belonging to the deceased Gian Maria Sasso, published in 1803, when the memory of Visentini's activity was still very much alive, as he had died only twenty years earlier. Catalogue numbers 153 and 154 cite a pair of views of the same size ("one foot and nine inches in height and two feet and three inches in width") reproducing: "1. Sts. John and Paul; 2. The Doge's Palace," listed as works "by Vicentini, terminated by Canaletto his Master." Unfortunately, it is not currently possible to track down these views, which may have been lost or hidden among the great number of paintings variously, yet not with certainty, assigned to Canaletto's imitators. Nonetheless, the mere information about the certain existence of works of this sort is interesting in and of itself, and may open new horizons for research.

I present a hypothesis—and I reiterate that it is only a working hypothesis, thus requiring verification, in the absence of the opportunity to make an indispensable

comparison with other, definitely autograph views. It is possible to assign to Visentini views of the sort reproduced here, showing the *Grand Canal* with, on the right, Ca' Foscari, in front of the seventeenth-century palace built for Pietro Liberi by his student and friend, the Tuscan Sebastiano Mazzoni and now known by the name of the subsequent owners, Moro Lin, and the Scuola Grande della Carità in the background. This work presents stylistic and technical characterics that seem compatible with certain other works by the master.[45] Elements within the painting[46] enable us to date it with absolute precision to the years between 1759 and, at the latest, the middle of the following decade. For example, the façade of Palazzo Grassi still has simply its arched central door. The two lateral rectangular ones would be cut into the façade only later, in the course of renovations completed, as the nobleman Pietro Gradenigo notes in his *Notatori*, on October 28, 1766. On the front of Ca' Rezzonico—which appears in the finished form given it after the completion by Giorgio Massari of Longhena's building, terminated in April 1756—is visible the coat of arms of the Rezzonico family with the papal symbols added, which they were able to use only after July 1758, after Carlo, bishop of Padua, had been elected supreme pontiff, taking the name of Clement XIII. Gradenigo states that on February 6, 1758 (*more veneto*, thus 1759), "the magnificent Papal Arms were raised on the Palace of the Rezzonico Family on the Grand Canal side, well carved of wood, covered and chased, and gilded on top of the copper, and the temporary painted coat of arms [placed there] last July was removed. It is very expensively made and showy." Thus, it is evident that the view was painted during the span of time between the two notations made by

Antonio Visentini (?)
The Grand Canal from Ca' Foscari toward the Scuola Grande della Carità
70 x 122 cm
Venice, Private collection

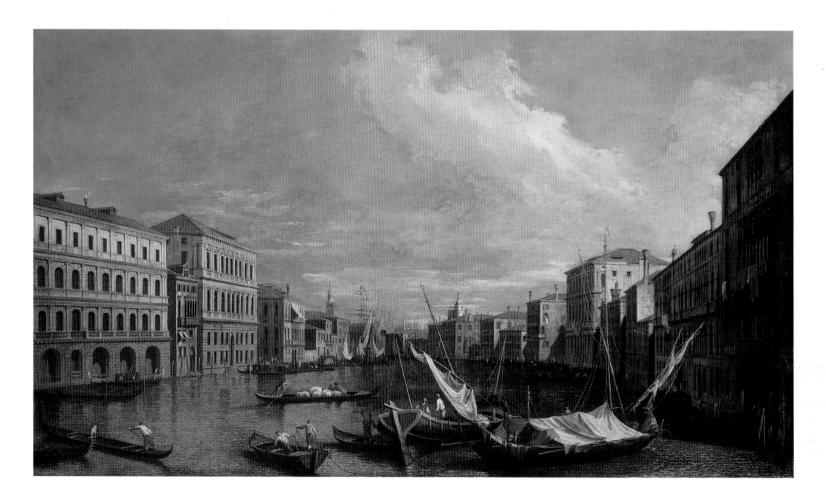

Gradenigo in 1759 and 1766. Given that in the painting Palazzo Grassi does not yet bear any sign of the work, which certainly lasted a long time given that it involved not only an enlargement of the original structure but also modification of the façade, it seems more probable that the execution of the view should be dated close to the time when the Rezzonico installed their new coat of arms with the papal insignia.

The compositional structure and the arrangement of the boats and oarsmen derive from a model which was well known to Visentini: the painting made by Canaletto in the second half of the 1720s for Joseph Smith, now at Windsor Castle, from which Visentini himself had made one of the engravings in the first edition, printed in 1735, of his *Prospectus Magni Canalis*. Compared to this model, the author of the painting presented here has brought the view up to date. The canvas depicts the completed construction of Palazzo Grassi, which was still in the future when Canaletto painted the canvas now at Windsor Castle, and the completed Ca' Rezzonico, which in the Windsor canvas appears finished only up to the top of the first floor and covered with the wooden pitched roof, as it appeared after the interruption of work following the death of Longhena in 1682. Moreover, the painter added a second barge behind the one placed across the foreground on the right, borrowing it from another Canaletto view in the same series, also engraved by Visentini.

Numerous paintings copied from Visentini's engravings are known, for the most part of rather mediocre quality. This view, however, emerges from the rest for its accurate rendering of the architecture and the precision of the perspective framework, which are elements that certainly would not be lacking in a painting by the painter-architect Visentini. The possibility of Visentini's authorship is reinforced even more by the technical characteristics of the painting, the use of paint soaked with light, the peremptory break between the areas in light and those in shadow, the execution of the lively little figures that populate the boats, and the rendering of the rosy, puffy clouds. All these are the very same elements that reappear in the few paintings that can be assigned with certainty and entirety to Visentini. Thus, this canvas contains all the paradigmatic traits that we would expect to find in views by Visentini: the close link with Canaletto's world (not coincidentally, the anonymous compiler of the "Catalogue" of paintings formerly the property of Gian Maria Sasso cites Canaletto as the teacher of Visentini and presumes that the two views were completed by the younger and more famous co-worker), the perfect rendering of perspective, and the stylistic similarity with the certain works by his inspirer and probable teacher.

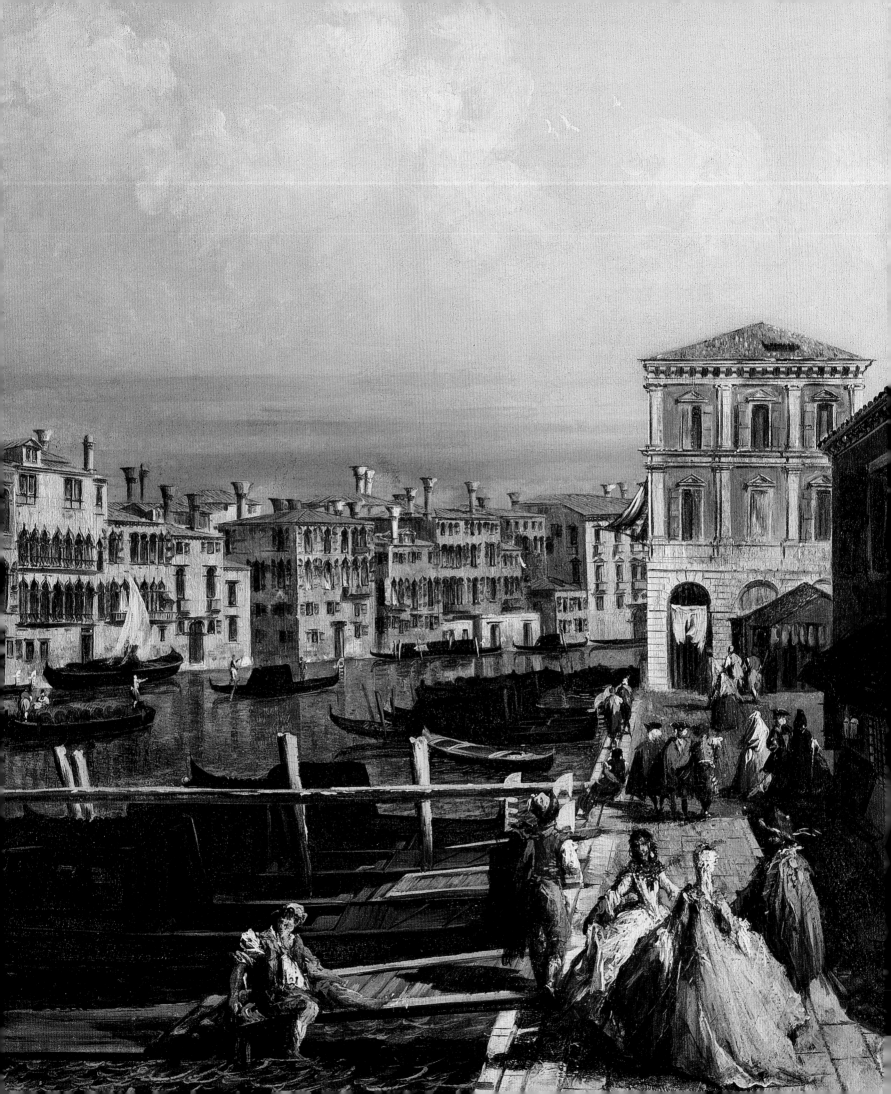

Michele Marieschi,
the "Picture Shops"
and Francesco Albotto

Michele Marieschi
The Grand Canal at the Pescheria
London, Private collection
Detail (entire painting on page 169)

Another very interesting view painter, who was some ten years older than Bernardo Bellotto, is Michele Marieschi (Venice 1710–1743). Marieschi's complex artistic personality is only now, thanks to numerous studies and a robust number of monographs published within the brief span of a few years, beginning to emerge from the oblivion into which it had fallen. Indeed, even relatively recently, his caprices have often been attributed, because of the similarity of their names, to Jacopo Marieschi, a Rococo painter active in the mid-eighteenth century who painted exclusively historical and mythological subjects.[47]

There is no doubt that Michele Marieschi—just as, before him, Canaletto and many other Venetian view painters—began his activity by working in the field of theatrical scenery, probably alongside his maternal grandfather Antonio Meneghini. In this world Michele, whose father died when he was very young, had the opportunity to meet the painter and stage designer Gaspare Diziani of Belluno, who was probably his first protector as well as a witness at his 1737 wedding to Angela Fontana. At a still young age, by 1735, Michele traveled to Germany, where, as his contemporary Pietro Guarienti (1735) tells us, "the bizarre nature and the copying of his ideas met the favor of numerous personages, who employed him in great and small operations." What these "operations" consisted of is not known with certainty, but it is interesting to note that Diziani had also been to Germany, between 1717 and 1719, where he had worked as a stage designer. It is thus possible that it was Diziani who pointed his young and promising protegé toward the German world of the theater or the ephemeral structures made for festivities in the palaces of the local nobility.

Some engravings survive to testify to Marieschi's activity as a set designer. One, made by him personally, represents a *Perspectival Set of a Large Courtyard*, and was created specifically, as the inscription implies, for the theater. The other two, taken from drawings of his that have been lost, were published to commemorate the funeral of Marie-Clementine Sobieski, the wife of the pretender to the throne of Scotland, James Stuart, which took place in Fano in 1735. Transferred onto copperplate by Giuseppe Camerata and Francesco Tasso, the two engravings show the *Funeral Apparatus* and the *Castrum Doloris* set up in the church of San Paterniano, clearly derived from the work of the Bibiena family. Traces of the Bibiena style also

Michele Marieschi
Courtyard with Stairs
35 x 55.5 cm
Prague, Narodni Galerie

appear in Marieschi's paintings, especially in his numerous caprices, for the most part structured around a single central vanishing point onto which the stage wings converge.

Among the paintings that are unanimously attributed to Marieschi are sketches for actual stage sets: these are the numerous small canvases (the literature recognizes more than twenty, but not all of them seem to be by Marieschi) which make up the series of the so-called *Courtyards with Stairs*, which are probably the earliest paintings by the artist that have survived to our day. In his youth Marieschi was connected, once again through his relationship with Diziani, to the circle of the family and closest friends of Sebastiano Ricci, who in turn was so passionate about the theater as to devote himself personally, even at a very advanced age, to the activity of theater impresario. Thus, Marieschi took the place of Marco Ricci, after his death in 1730, as stage designer of the theater where Sebastiano had influence.

Marieschi's stage designs have no figures in them, which is of course obvious when one considers that the sets were "peopled" by live actors; Marco Ricci's preparatory drawings for theater scenery, now at Windsor Castle, are also without figures. Marieschi's paintings were almost all completed with characters at a later date—with the sole exception of one of the two now in the Narodni Galerie in Prague, which still has no figures—probably when they were sold separately. This would then be the moment when the characters were painted in by other artists, among whom we can identify fairly confidently the hands of Francesco Simonini, Antonio Guardi, Gaspare Diziani, and even of Giambattista Tiepolo. The stage designs probably represent a minor part of Marieschi's production, as his fame undoubtedly rests on his extensive body of Venetian views and caprices. Nonetheless they are still quite interesting, showing that the young stage designer, from the very beginning of his career, had no familiarity with the depiction of the human figure.

This observation leads to one of the most pressing problems for those who—from the very moment of his "rediscovery" of Marieschi, thanks to the pioneering contribution made by Antonio Morassi in the mid-1970s, and the reawakening of interest in the painter starting in the mid-1980s—have dealt with Marieschi's

production, splitting equally into two opposing camps: one asserting that he is responsible for the entirety of his works, the other affirming that a co-worker helped him by painting the figures.

It seems clear that the second position is the correct one. The types of the characters in the certain paintings by Marieschi are significantly different from each other in style and nature, too different for them to have been—as claimed by those who strenuously defend the idea that Marieschi himself painted all elements of his pictures—the fruit of a chameleon-like ability on the part of the young painter to imitate other styles. Such a characteristic would have enabled him to take on, as the moment demanded, the methods and personality of Diziani, Antonio Guardi, Simonini, Tiepolo, Francesco Fontebasso, or Giuseppe Zais, sometimes even simulating two different hands in the same work (this is the case of the *Caprice with Gothic Porch and Building in Ruins* [private collection, Turin], whose figures can be assigned on the evidence partly to Simonini and partly to Fontebasso). What is more, in a great many cases these figures are clearly very well painted, of a technical quality too high to be considered the work of the hand, albeit highly skilled, of one sole artist.

As discussed above, this practice of collaboration constituted the most plausible working method in the so-called "picture shops," where the artists were called to prepare painting, in the majority of instances without the works having been requested by any specific commission. These would only be offered to potential purchasers after they were finished, sometimes even being displayed, just as today, in the shop windows. It is probable that this picture production was organized in a kind of assembly line, which took advantage of the specializations of the individual artists. This was the method in the successful shop owned by Marieschi's father-in-law, Domenico Fontana, established in the central Campo San Luca, where the painter worked for practically all his brief life, perhaps even in the years preceding his marriage to the daughter of his employer. Here Marieschi was entrusted with the task to which he was certainly best suited, that of painting the "perspectives," the

Michele Marieschi
View of the Courtyard of the Doge's Palace toward the Church
116.8 x 180.2 cm
Private collection

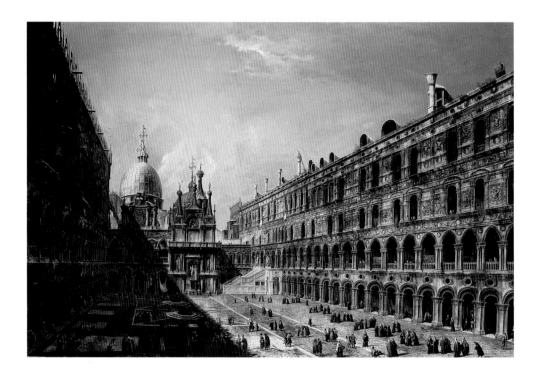

architectural and natural structures (skies, buildings, landscapes, bodies of water) in the views and caprices. Once his job was finished, the canvases would have been completed by the addition of the figures by whichever specialist in that area was available to do them.

This working method explains many things about Marieschi: for example, the almost serial repetition of the subjects, which were clearly those Fontana thought would be most appreciated by his clientele and easiest to sell; or the very broad range of characteristics and technical quality of the figures appearing in paintings otherwise certainly done by Marieschi. Moreover, it implies a corollary which critics are forced to take into consideration: the figures in Marieschi's paintings cannot ever be a determining element in the attribution of canvases to him. This must instead be based on a verification of similarity of technique with his certain works: in the rendering of the architectural structures, which are always painted with a well-soaked brush, the paint spread in overlapping strokes, and sometimes even using a palette knife; the identical manner, characteristic of Marieschi, of painting the waves of the sea, tracing thin regular half-moons with the tip of the brush; and the light, cottony clouds which fill his skies.

Marieschi's painting activity in Venice was quite brief, stretching from 1735, the year of his return from the sojourn in Germany documented by Guarienti and his enrollment in the Guild of Venetian Painters, and 1742. In January of 1743, the

Michele Marieschi
St. Mark's Square facing the Church
55 x 83 cm
Bergamo, Private collection

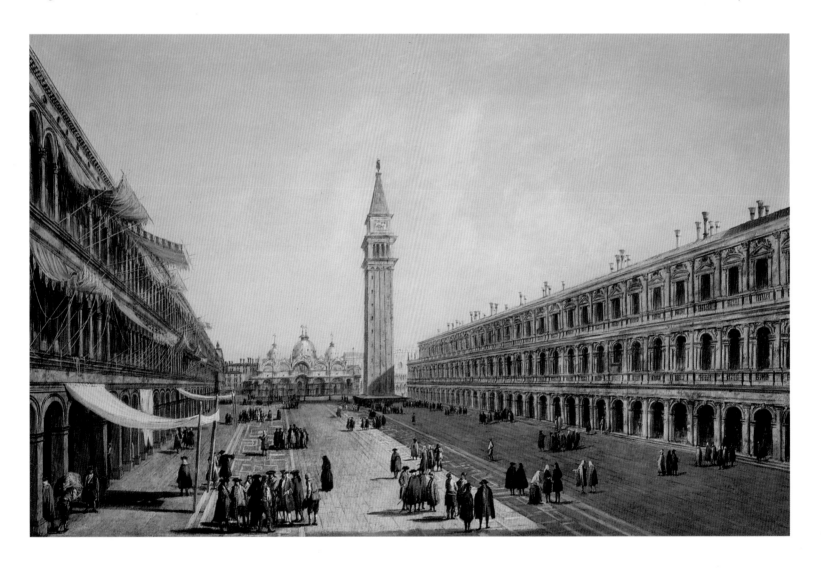

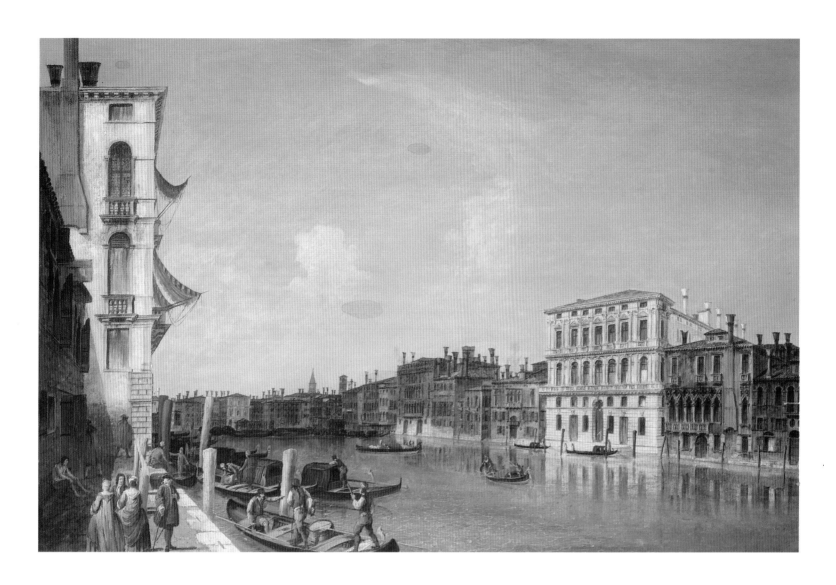

Michele Marieschi
The Grand Canal at Ca' Corner della Regina
55 x 83 cm
Bergamo, Private collection

painter, "burdened by illness," drew up his will. A few days later, at just thirty-two years old, stricken with "pneumonia and vomica of the chest," he concluded his brief but very hard-working life. Guarienti confirms that "his too assiduous devotion to labor and study brought about his death." His legacy was not unsubstantial, given that the most recent monograph on the painter attributes to him just under two hundred paintings. To this should be added the twenty-two large etchings published in 1741 with the title *Magnificentiores Selectioresque Urbis Venetiarum Prospectus*, which are undoubtedly among the great masterpieces of Venetian engraving in the eighteenth century, as well as some other smaller engravings.

It is possible that Marieschi initially enjoyed—perhaps in the wake of his success in Germany or because of his relations with Ricci's circle—a certain degree of esteem also among Venetian patrons. Evidence of this success is the fact that he obtained some prestigious commissions while still at a young age. For example, on November 20, 1736, Marshal Schulenberg commissioned from him, for the lofty price of 50 sequins, a *View of the Courtyard of the Doge's Palace* looking towards the church. This painting is variously identified as one of the two canvases with that subject now in England, both of them of very high quality, marked by the theatrical, unusual width and openness imparted to the courtyard and by the sharp distinction between the area wrapped in dark shadow and the zone flooded with a dazzling light, which

throws into emphasis every detail of the elaborate architecture. A comparison between these two canvases shows a significant difference in type between the figures in the two scenes, larger and technically more successful in the version formerly the property of the National Trust, tiny and less well executed in the painting offered at a Christie's sale in London on July 2, 1976.

In 1737 Schulenberg purchased another view by Marieschi, the one documenting *The Entrance of the Patriarch Antonio Correr*, which took place on February 7, 1735. The National Trust possessed until a few years ago a canvas (signed "MMF"—that is, it is thought, Michele Marieschi Fecit—on the barrel on a cargo boat) representing the procession of richly decorated gondolas accompanying the newly elected Patriarch, borne by a ducal ceremonial boat decorated with gilt carvings, to the Fondaco dei Tedeschi, where, following the established ritual for this occasion, the prelate would set foot on land to continue on his way to the basilica. But the substantial difference between the size of this painting and that listed in the precise inventories of Schulenberg's collection indicates that this was not the painting bought by Schulenberg, but probably the one painted by Marieschi at a time very close to the event—thus in 1735—and then replicated in a different size for his illustrious patron two years later. In an exceptional case of unanimity, even the most strenuous supporters of Marieschi's authorship of the characters now admit that the elegant figures rowing the ducal gondolas and those of the onlookers on the banks near the Rialto Bridge were painted by Gaspare Diziani.

In this picture, Marieschi demonstrates his taste for unnaturally dilated space, deriving from his work for the theater. It can be profitably compared to other of his celebrated paintings, for instance *The Rialto Bridge from the Riva del Ferro* (Hermitage, St. Petersburg), a spectacular work long attributed to Canaletto that critics have only recently restored to Marieschi, and which may be one of his highest achievements. Characteristic of both this work and its probable pendant *The Grand Canal from the Riva del Vin*, (Pushkin Museum, Moscow), is the wide-angled view, which tends to enlarge the scene to an unnatural degree. Also typical of Marieschi is the manner of painting the architecture with crossed overlapping brushstrokes, using thick lumpy paint. The beautifully done figures, however, were painted by Diziani.

It is not known who the patron was for this pair of views, but we do know the names of various foreign purchasers of Marieschi's works, a fact which may confirm that his fame may have spread beyond the territories of the Serenissima. Or, even more likely, it may serve only to underline the prestige of the Fontana picture shop, which was evidently capable of satisfying the needs of an international clientele. Three works by Marieschi—differing in date—were bought in 1743 in Venice by the father of the first earl of Malmesbury, James Harris. A group of eighteen views of various places in Venice was, by 1740, in Castle Howard, the residence of the earls of Carlisle who also collected the works of Canaletto and Bellotto.[48] A series of six views now in Berlin comes from the collections in the castle of Sans-Souci at Potsdam, having been purchased in Venice perhaps as a result of the friendship between Anton Maria Zanetti the Elder and Mathias Oesterreich, Inspector of the Gallery of the King of Prussia, who was in Venice in 1744.

The fact that at least two of these groups of paintings were bought in Venice after the painter's death in January 1743 greatly reduces the possibility that the views were commissioned from him personally, strengthening instead the hypothesis that they were painted for Fontana's shop and remained there after Marieschi's untimely decease.

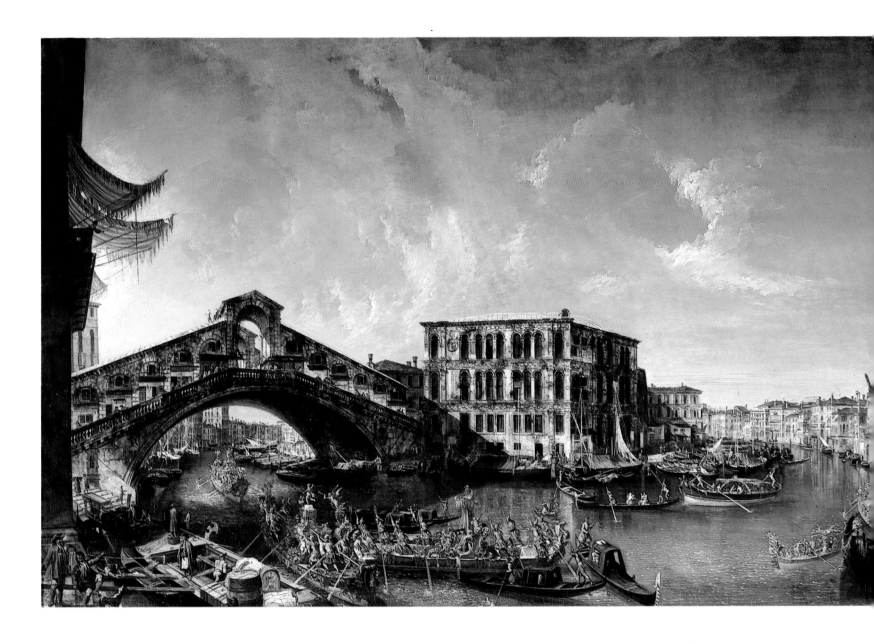

Michele Marieschi
The Rialto Bridge with the Entrance
of the Patriarch Antonio Correr
123 x 208 cm
Claydon House, Buckinghamshire
National Trust

(overleaf)
Michele Marieschi
The Rialto Bridge from the Riva del Ferro
131 x 196 cm
St. Petersburg, Hermitage

It is not easy to establish a precise chronology for Marieschi's works, which were painted in the brief space of a few years and thus without his style having had the chance to evolve to any significant degree. Only a few views can be dated with certainty, due to the presence of internal elements that enable the fixing of their precise chronological moment. Among these is a pair now in a private collection in London, in which the picture of *The Grand Canal at the Fondaco dei Turchi* shows, on the bank overlooking the canal at the Campo di San Marcuola, the marble already worked and ready to be set in place on the Grand Canal side of the new church designed by Giorgio Massari. It is known that the construction of the building was brusquely interrupted in 1736, and this detail shows that Marieschi's view (along with its pendant, *The Doge's Palace from the Basin*) can only have been painted in 1735.

Two splendid views of similar size and identical stylistic elements can be dated to 1739 or shortly thereafter (even the figures in both were painted by Simonini), representing *The San Marco Basin with San Giorgio Maggiore* and the *View of St. Mark's and the Riva degli Schiavoni from the Basin*. These two canvases were already

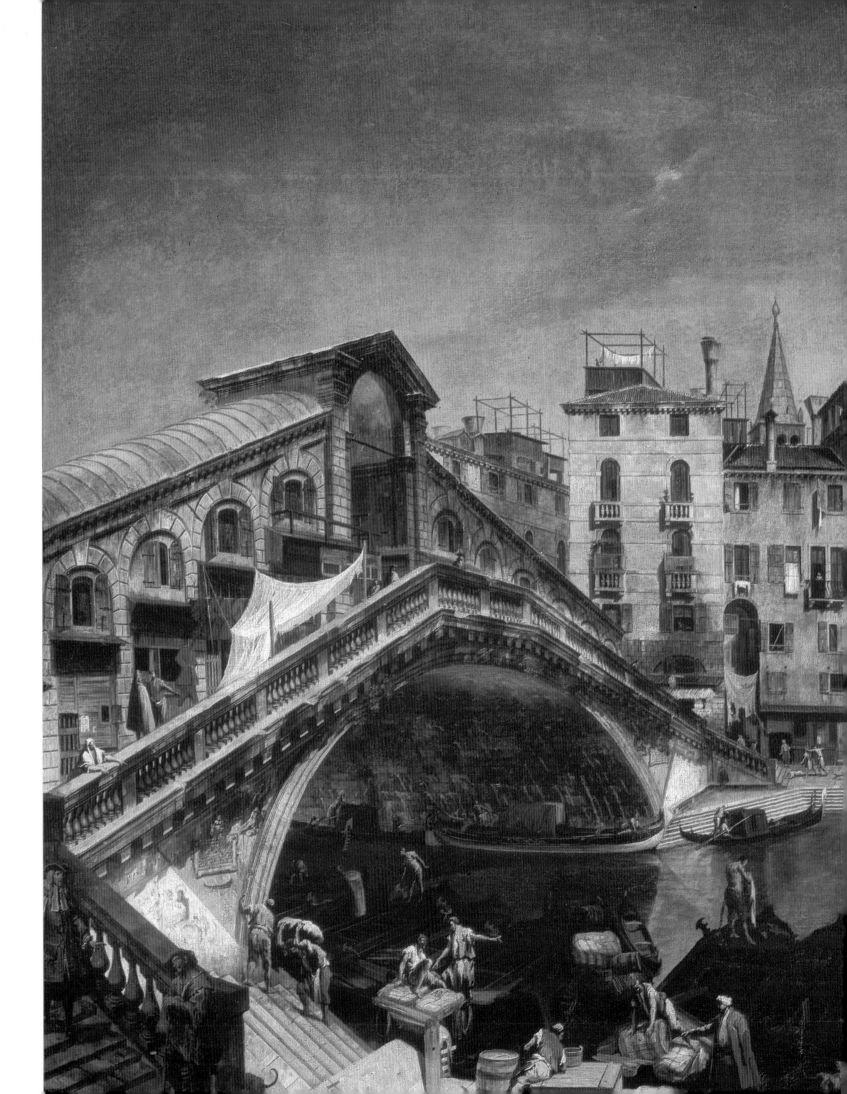

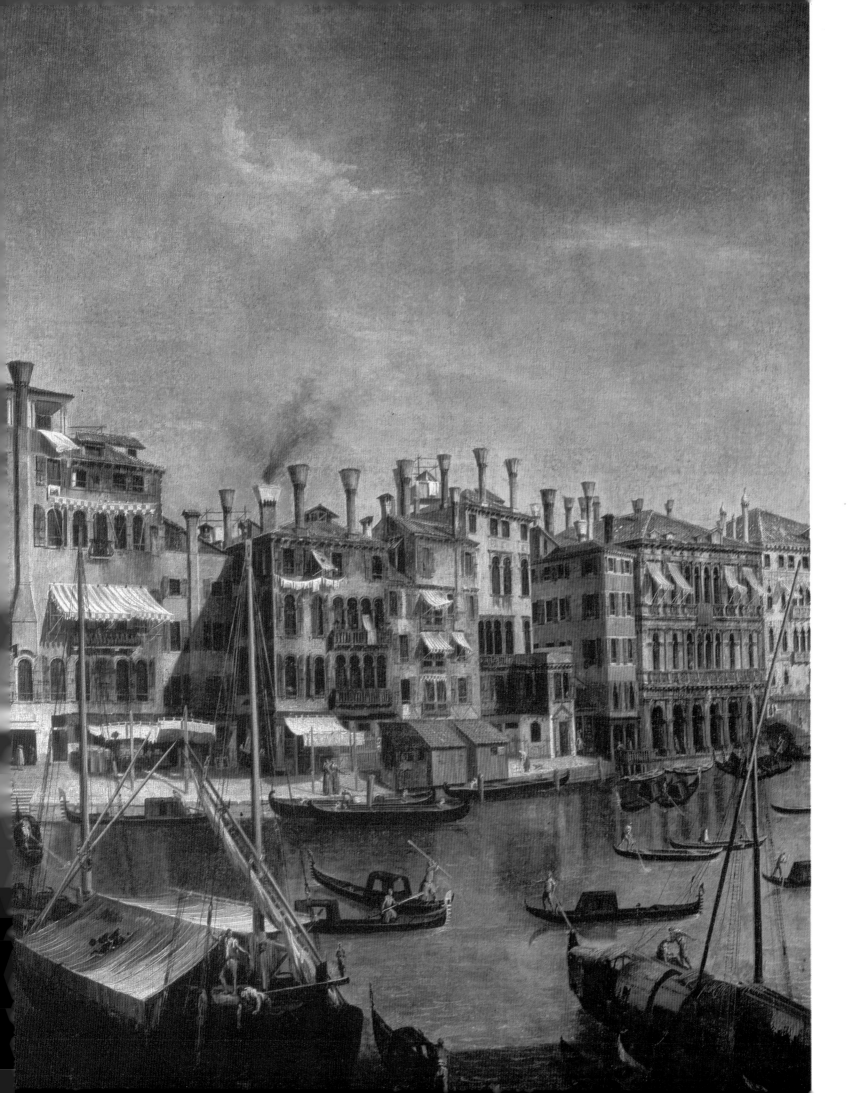

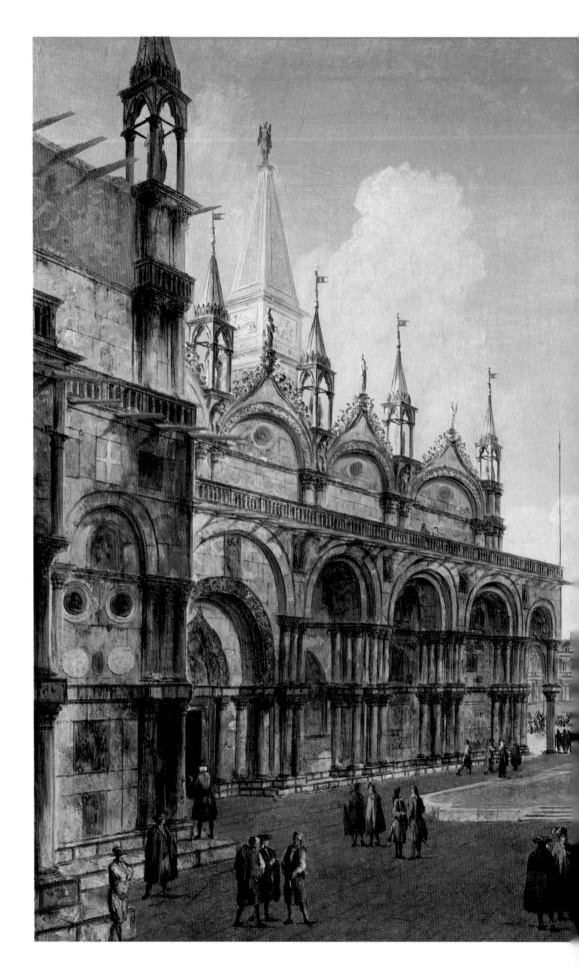

Michele Marieschi
The Piazzetta San Basso
54.4 x 83.7 cm
Munich, Alte Pinakothek

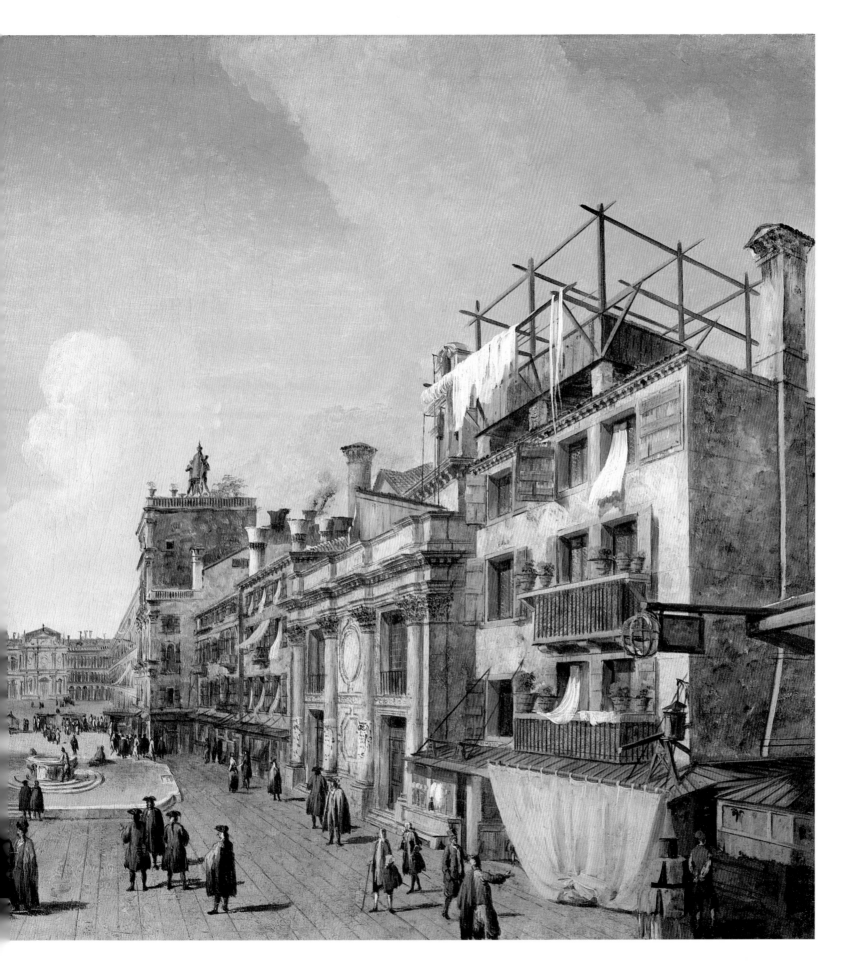

separated by the eighteenth century; only the second is cited in the handwritten catalogue of the collection of the earl of Malmesbury (where it still is today), drawn up by James Harris, the father of the first earl of Malmesbury, who died in 1780. Of the other, it is known only that in 1967, when it was shown at the exhibition of the Venetian vedutisti held in the Doge's Palace, it was the property of Lord and Lady Ednam of London; it subsequently changed hands in 1990, passing into a private collection in London.

The pair can be dated on the basis of the presence in the view belonging to the earl of Malmesbury of the bell tower of the church of Sant'Antonin, which was completed in the fall of 1738, while the preceding one had been torn down in 1680. The two canvases are certainly outstanding works in Marieschi's oeuvre, especially for the layout of the scenes, characterized by very wide, "impossible" vistas. It seems credible—and the proximity of the dates of execution could confirm this hypothesis—that they constituted a kind of response on Marieschi's part to Canaletto's works like the astonishing *View of the San Marco Basin* now in the Museum of Fine Arts in Boston, it too painted after October 1738 (as it also shows the bell tower of Sant'Antonin).

The unnaturally broad, sweeping vistas that characterize these pictures can be seen in other works by Marieschi which can probably be assigned to this same moment:

Michele Marieschi
The Grand Canal at Ca' Pesaro
54.4 x 83.7 cm
Munich, Alte Pinakothek

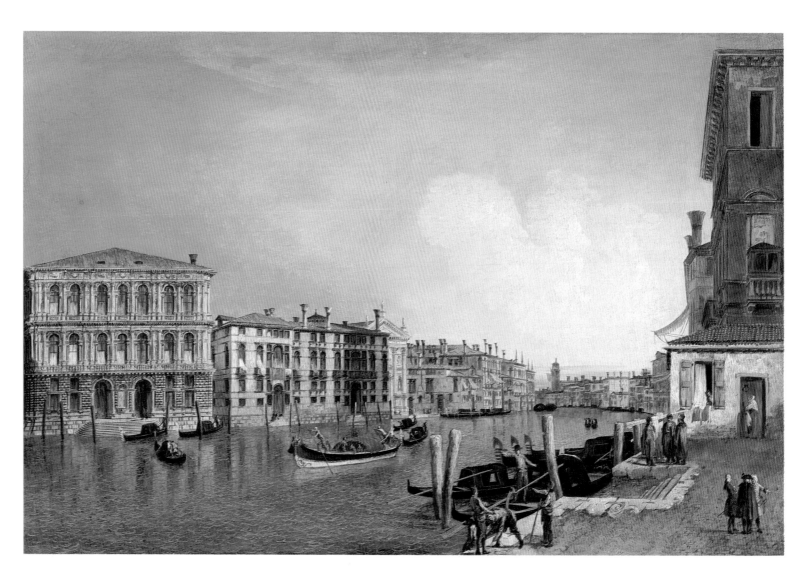

Michele Marieschi
The San Marco Basin with San Giorgio Maggiore
118 x 201 cm
Private collection

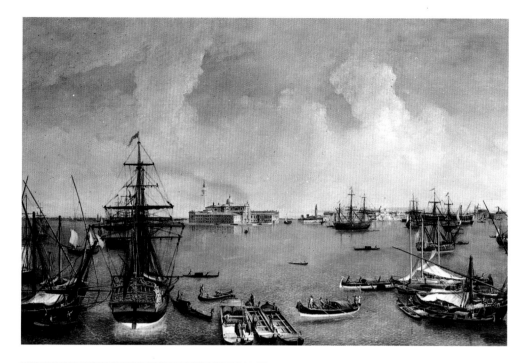

Michele Marieschi
The Prospect of St. Mark's
and the Riva degli Schiavoni from the Basin
120 x 200 cm
Private collection

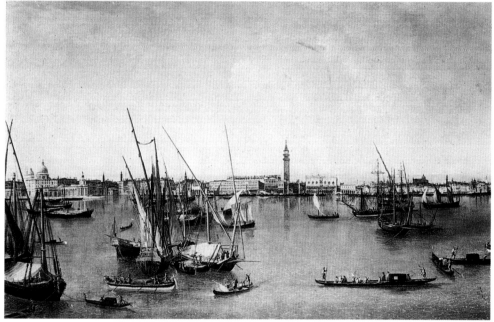

various wide-angle views of the places around San Marco, the splendid view of *The Grand Canal at the Church of Santa Maria della Salute Facing the Basin*, (Musée du Louvre, Paris) which, like almost all of Marieschi's best works, enjoys a long, well-rooted tradition of attribution to Canaletto; the view of the *Regata "at the Turn in the Canal"* formerly in the Cini collection in Venice. This last is a work of excellent quality, whose luminous palette has been perfectly recovered in a recent restoration. This image cannot be precisely dated, but construction appears to be complete of the palace belonging to the Civran family, as well as of the Rio della Frescada which begins on the right of Palazzo Balbi and the nearby house; the palace, designed by Giorgio Massari, was finished after 1735. The figures are very fine: the oarsman rowing the many gondolas of the noble families watching the event and the showy

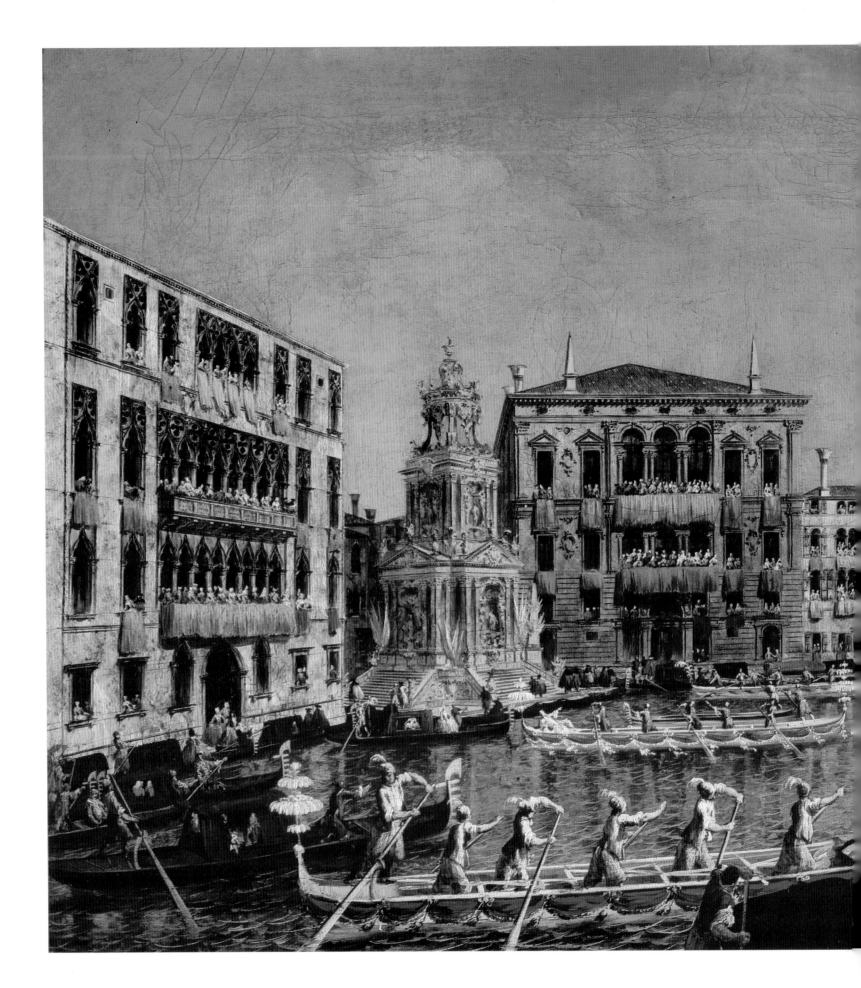

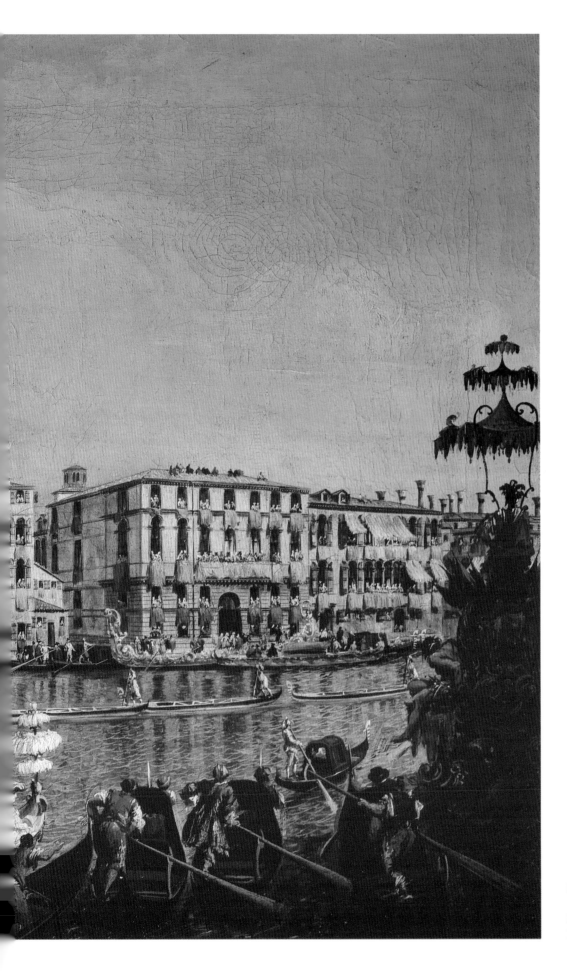

Michele Marieschi
The Regata "at the Turn in the Canal"
56 x 85 cm
Formerly Venice, Cini collection

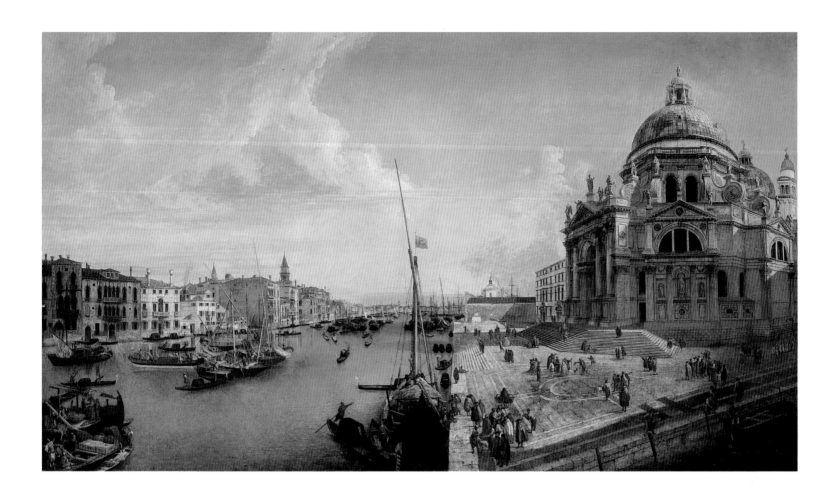

Michele Marieschi
*The Grand Canal at the Church of Santa Maria
della Salute Facing the Basin*
124 x 213 cm
Paris, Louvre

parade boats; as well as those, so numerous as to be painted almost in shorthand, of the spectators crowding into every window of the palaces, with some even on the grand "stage machine" of carved and gilded wood that marked the finish line. These figures have been attributed in the past by Antonio Morassi to Antonio Guardi, while the present author assigned them to Francesco Fontebasso. It seems that the latter hypothesis has been confirmed by the results of a recent restoration.

Antonio Guardi is the author of the figures, larger in size, present in the view of *The Grand Canal "at the Turn in the Canal"* (North Carolina Museum of Art, Raleigh, N.C.), where Marieschi uses the essentially identical angle of vision utilized for the more or less contemporary *Regata* formerly in the Cini collection. This is probably one of the earliest occasions of the collaboration between these two painters within the sphere of the Fontana picture shop, which recurred often in Marieschi's works of the early 1740s. Particularly successful among these, besides the many caprices, are the numerous views of *The Grand Canal Facing the Church of Santa Maria della Salute*, such as the Thyssen painting in Madrid (which appeared for the first time on July 12, 1957 at a Christie's sale in London); a canvas in the Art Institute of Chicago; the rare *View of Campo San Gallo* formerly at Heathfield in Sussex; and the series of four canvases with views of various sites along the Grand Canal, formerly the property of Miss C.M. Smith, and divided equally in 1965 between the Hallsborough and Agnew galleries in London. Among these four paintings, particularly important is the one whose vantage point is the Pescheria, in which appears the little palace bought by Consul Joseph Smith, where work had already begun on the renovations according to plans drawn up by Antonio Visentini, in the state it had reached in the

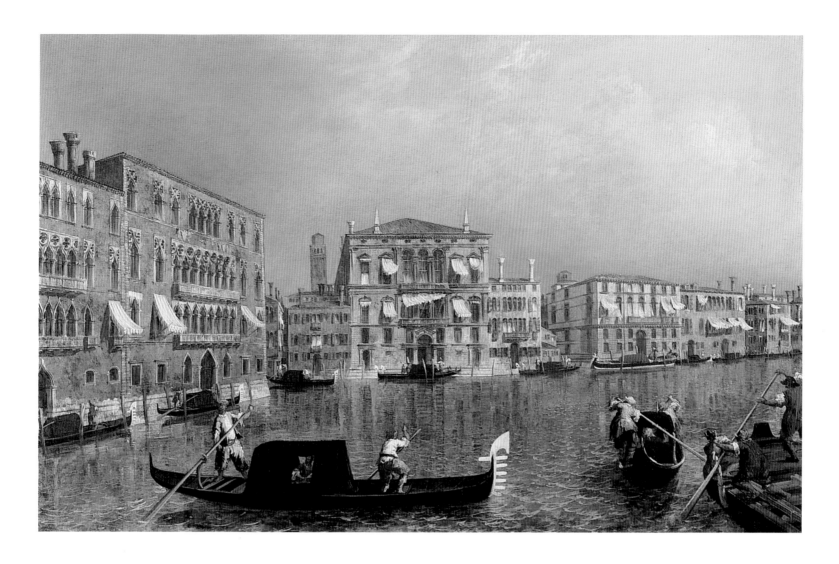

Michele Marieschi
The Grand Canal "at the Turn in the Canal"
61 x 96.2 cm
Raleigh, North Carolina Museum of Art

early months of 1742. This date, then, becomes a certain *terminus post quem* for the entire series, painted necessarily in a fairly restricted time span.

A view of the Grand Canal where it meets the Rio di Cannaregio is part of the same series. In this painting the railing and statue of St. John of Nepomuk, carved by Giovanni Marchiori and installed in May 1742 at the behest of Maria Labia, do not yet appear at the corner of the Fondamenta leading to Palazzo Labia. However, these elements are quite evident in the similar view now in the collection of the earl of Malmesbury at Basingstoke, which should thus be considered one of the last works by Marieschi before his death in January 1743. This proves that the painter, even faced with the serial work imposed on him by his tie to the Fontana shop, did not limit his efforts to slavishly copying the views he had painted on other occasions, but brought them up to date even in their most minor details.

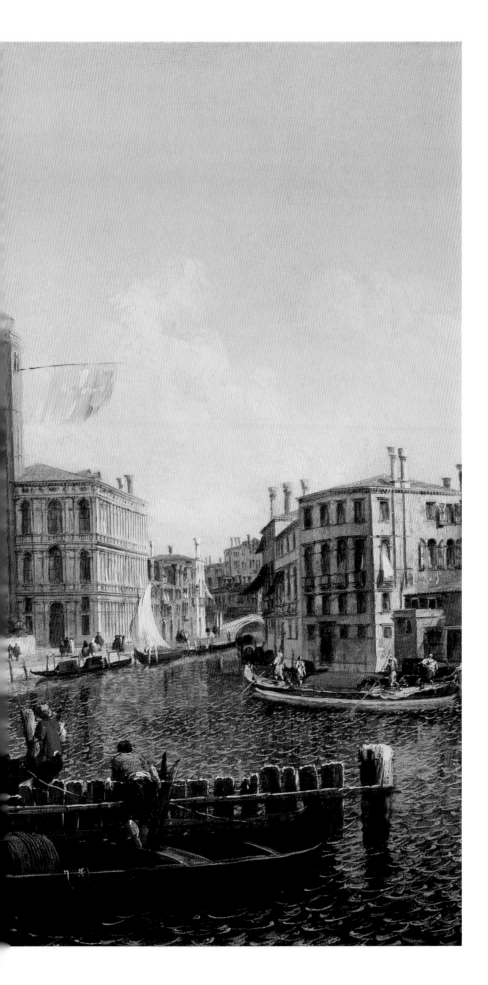

Michele Marieschi
*The Grand Canal at the Entrance
to the Rio di Cannaregio*
54 x 82.5 cm
London, Private collection

Michele Marieschi
*The Grand Canal Facing the Church
of Santa Maria della Salute*
55.7 x 84.2 cm
Chicago, Art Institute

Michele Marieschi
*The Grand Canal Facing the Church
of Santa Maria della Salute*
85.5 x 101.3 cm
Madrid, Thyssen Bornemisza collection

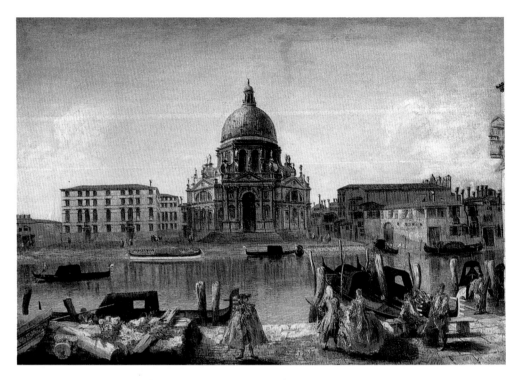

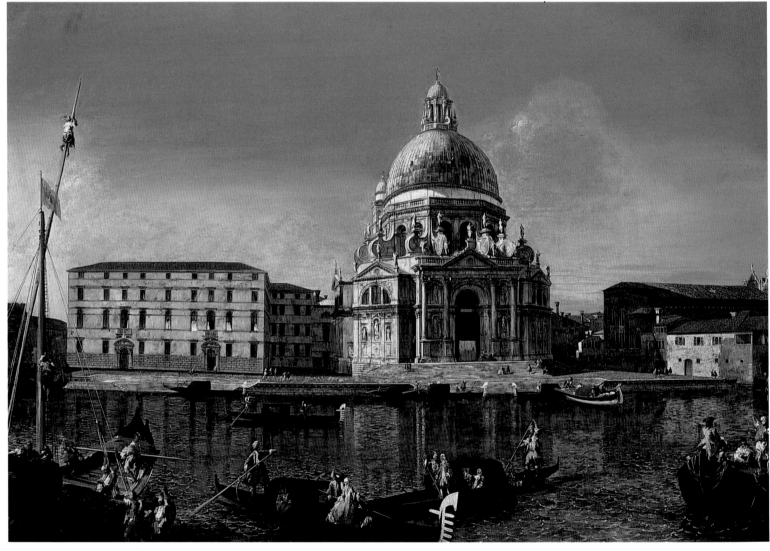

Michele Marieschi
The Grand Canal at the Pescheria
London, Private collection

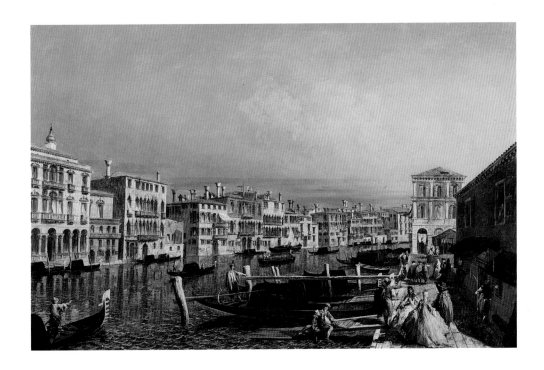

The Difficult Case of Francesco Albotto, Michele Marieschi's Pupil

The case of Francesco Albotto, the pupil and disciple of Marieschi, is one of the problems that has most fascinated recent scholars of eighteenth-century Venetian view painting. The critical fortune of this artist is quite complex; thus, the discussion should begin by verifying the known information.

It is known that Marieschi had an apprentice, one Francesco Albotto: Pierre-Jean Mariette mentions him briefly in his *Abecedaire,* written before 1774, furnishing information that would be confirmed by later research. The French historian and collector, a friend of Anton Maria Zanetti, writes that Albotto "peint des vues de Venise et des paysages ornés d'architectures qui ne sont pas mal touchés" [paints views of Venice and of landscapes decorated with architecture that are not at all badly done]; he further adds that Albotto called himself "the second Marieschi," as he had even married Marieschi's widow, Angela Fontana. From then on, the artist escaped attention completely until 1972, when a painting appeared on the New York art market, at Sotheby's Parke Bernet, a view of *The Doge's Palace from the Basin.* The back of the canvas bore the inscription, presumably by the artist, "Francesco Albotto F. in Cale de Ca Loredan a San Luca." Rodolfo Pallucchini immediately published the discovery, furnishing precise information.[49]

The extensive and fortunate archival research carried out first by Mario Manzelli[50] and then, even more successfully, by Federico Montecuccoli degli Erri[51] has made it possible to trace the outlines of the painter's biography quite precisely. Francesco Maria Albotto was born in the neighborhood of San Marcuola (the same one where Marieschi was born and spent his early years) on May 5, 1721, the son of Zuane *quondam* Lorenzo and Franceschina Carnera, and was immediately baptized by the midwife because he was in imminent danger of death. His mother had already given birth to a daughter, Margherita Santa, in 1718; his father died in 1735. Even before Marieschi's marriage to Angela Fontana, celebrated on November 27, 1737, the two painters had a working relationship. After Marieschi's death, Francesco married his

widow on October 29, 1744, and went to live in his former teacher's house, where Angela still resided, in the Calle di Ca' Lando near Campo San Luca. The couple—with whom lived the little Elisabetta, born from Angela's first marriage—sublet a part of their house to a religious, who paid sixteen of the thirty-six ducats required annually for the rent. After several unsuccessful pregnancies, the last of which resulted in the birth, on October 29, 1751, of their son Pietro Andrea, who died just twelve days after his birth, Angela Fontana died on December 31 of that same year. On September 13, 1756, Francesco married again, taking as his bride the twenty-one-year-old Giovanna Maria Pertesana, daughter of a well-to-do baker in the San Salvador neighborhood, who brought him a large dowry. But just four months later, on January 12, 1757, at the age of 35, Albotto himself died, having been sick, as his death certificate says, with "fever and liver and chest congestion for three months." His name appears registered in the Guild of Venetian Painters continuously only from 1750 to 1756.

This substantial biographical data is not matched by an equally profound knowledge of Albotto's pictorial production. Rather, the only painting of his ascertained to date is the view of *The Doge's Palace from the San Marco Basin* mentioned above, which is moreover known to scholars solely from the black and white photograph published by Pallucchini, as all trace has been lost of the canvas. It is known only that it was purchased at the 1972 sale by the Down Gallery in London.

Many—perhaps too many—paintings are attributed to Albotto, substantially on the basis of the criterion of "lower quality" in comparison to those by Marieschi. That is, this exercise of evaluation starts from the premise that every painting in the style of Marieschi, but of a lower quality than that generally achieved by him, or distinguished by topographical details that indicate a date after 1742, must be the work of Albotto. This system courts significant risk, given that this painter too is subjected to that insidious method of attribution "by exclusion" which in other cases has led to the most misleading results. Paradoxically, the same exercise was once applied to Marieschi's oeuvre, resulting in some of his best works being assigned to Canaletto and many mediocre views of Venice—those which could not be attributed to Canaletto nor to Francesco Guardi—being given to him.

Naturally, this does not negate the laborious efforts of those who have attempted to define a catalogue raisonné of Albotto's works, but their reconstruction takes shape exclusively on the basis of logical deductions, which are often well reasoned and can be accepted but cannot be considered absolute truths. It must be recalled that a great many painters were active in Venice around mid-century and that a large number of them were view painters. For example, who can state how Bernardo Zilotti painted, whose work is known only as an engraver but sources tell us was also the author of views and landscapes? And Giovan Battista Grassi? And Rinaldo Corniani? Gasparo Poli? It may very well be the case that in Fontana's workshop, where Marieschi was certainly the "leading" artist as far as the production of views and caprices was concerned, other painters were working on the same subjects and looking to him as their stylistic model, so as to cultivate a successful trend. The possibility thus cannot be excluded that among these and so many other names of "painters without paintings" there may have been another "second Marieschi." Therefore, it seems that before attributing a view (or a caprice, even though there is no indication that Francesco ever tried his hand at this type of painting) to Albotto, a comparison is unavoidable with the only certain work of his, which offers some interesting elements.

Francesco Albotto
The Doge's Palace from the San Marco Basin
60 x 95 cm
Formerly New York, Sotheby's Parke-Bernet

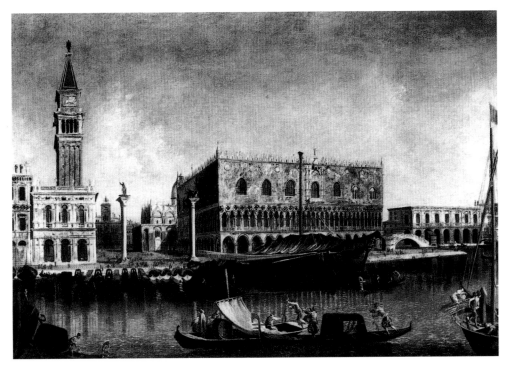

Michele Marieschi
The Doge's Palace from the Basin
62.3 x 96.5 cm
Private collection

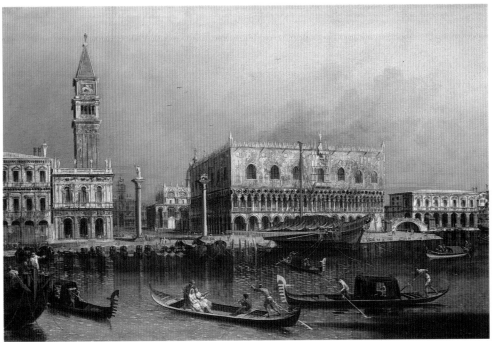

From the photograph reproduced by Pallucchini, it is clear that Albotto's painting technique appears significantly less elaborate than Marieschi's, as though the pupil tended to simplify that magmatic impasto of paint so characteristic of his teacher's works. The view appears rougher, more scholastic, and certainly less vital than those of the master, and the treatment of the water is slightly different, less precise in Marieschi's characteristic rendering of the waves as upside-down parentheses. But the difference between the two artists is most perceptible in the spatial relationships between the architectural elements, which appear to the eye as less carefully calculated in Albotto's work.

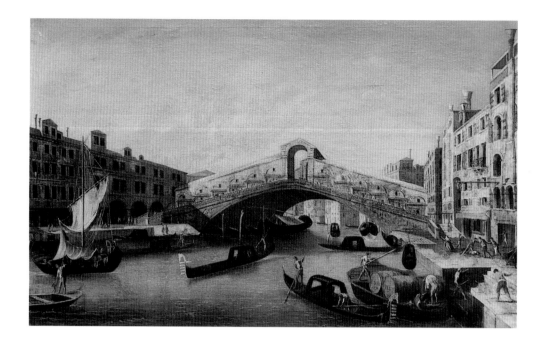

Francesco Albotto
The Rialto Bridge from the South
61 x 97 cm
Private collection

As a contribution to the discussion, I publish here the unfortunately mediocre
photograph of a second Venetian view that may be Albotto's. I use the conditional
out of prudence, as I have not been able personally to look at the painting (I found
the photograph in a photo library in Venice), so must refer to elements which may
be inexact. Nonetheless, it seems important to make the work known to the public,
because it might in some way contribute significantly to the *vexata questio*
Marieschi-Albotto and perhaps urge the unknown owner of this quite important
view to come out of hiding, offering it finally to the examination of the scholarly
community. The painting, which according to the information on the back of the
photograph measures 61 x 79 cm, shows *The Rialto Bridge from the South*; its
significance lies primarily in the fact that on one of the barrels on a barge on the
right is an inscription with Albotto's signature.

This painting is a virtually literal copy of a model that Marieschi replicated at least
twice: first in the canvas now in a private collection in London, which was shown in
the exhibition *Eighteenth Century Venice* held in London and Birmingham in 1951
and resurfaced at a Christie's sale in London on July 8, 1988. It was published by
Watson in 1953, and the attribution to Marieschi was accepted by a large part of the
subsequent criticism, with the exception of Dario Succi and Mario Manzelli, who
questionably attribute it to Albotto. The second time is the canvas now in the Bristol
City Museum and Art Gallery, whose assignment to Marieschi is proven by the
presence, precisely on the same barrel on the barge where Albotto's signature appears
in the view presented here, of the initials MM, presumably Michele Marieschi.

It is not necessary to dwell extensively on the abyss of difference in style between
the two views by Marieschi and the one by Albotto, which is decidedly weaker.
Immediately evident in the latter are the lower pictorial quality, the poorer handling,
the less-precise description of the architecture, and the different way of rendering
the waves and the boats. Not to mention—even though this element, as already
discussed, does not resolve the problems of the distinction between Marieschi's and
Albotto's hand and the identification of the stylistic characteristics of the latter's
work—the figures, which in Marieschi's paintings are very beautifully done, having

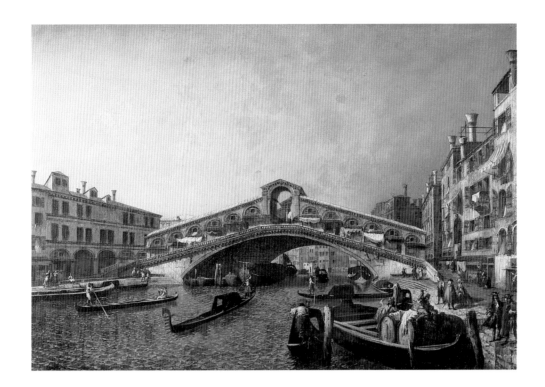

Michele Marieschi
The Rialto Bridge from the South
60.9 x 96.5 cm
Bristol, Museum and Art Gallery

been painted by Francesco Simonini and Antonio Guardi respectively, while in Albotto's canvas they are very stiff and rather generic. This view of *The Rialto Bridge from the South*—provided that the photograph's indication of Albotto's signature is confirmed by the requisite direct examination of the work—is stylistically quite close to *The Doge's Palace from the San Marco Basin,* which appeared in 1972. Similarities exist in the roughness of the paint, the imperfect perspective, and the weak rendering of the boats and water. These characteristics meaningfully underline the great distance separating the master's works from those that can be considered to be certainly by the pupil. The question thus arises on what foundation some paintings of a significantly high quality can be attributed to Albotto. Citing only the most outstanding examples in the field of view painting, leaving aside the even more complex problem of the caprices, possible Albottos include the two versions of *The Courtyard of the Doge's Palace Looking Toward the Church*; *The Grand Canal at Ca' Pesaro*, which is one of the two very beautiful canvases now in the collection of the Alte Pinkothek in Munich; and the splendid pair of views, (*The Grand Canal at Santa Maria della Salute* and *The Dock Showing the Doge's Palace and the Mint*) recently purchased by the Walpole Gallery in London. In particular, the second Walpole Gallery view has a very similar framing to that adopted by Albotto in the canvas that appeared in New York in 1972. This suggests that the latter painting was derived from the model in London, as it also repeats, with a few differences, the arrangement of the boats in the San Marco Basin. A simple visual comparison between these two works reveals the radical difference in quality that exists between the hand of the master and the much weaker and inconclusive one of the pupil.

In conclusion, a final biographical note that is rich in implications for any discussion of Albotto. The research carried out by Federico Montecuccoli degli Erri has revealed that Albotto was essentially unsuccessful as a painter, as witnessed by the enormous debts he ran up in just a few years, after having run through the modest resources of his first wife.

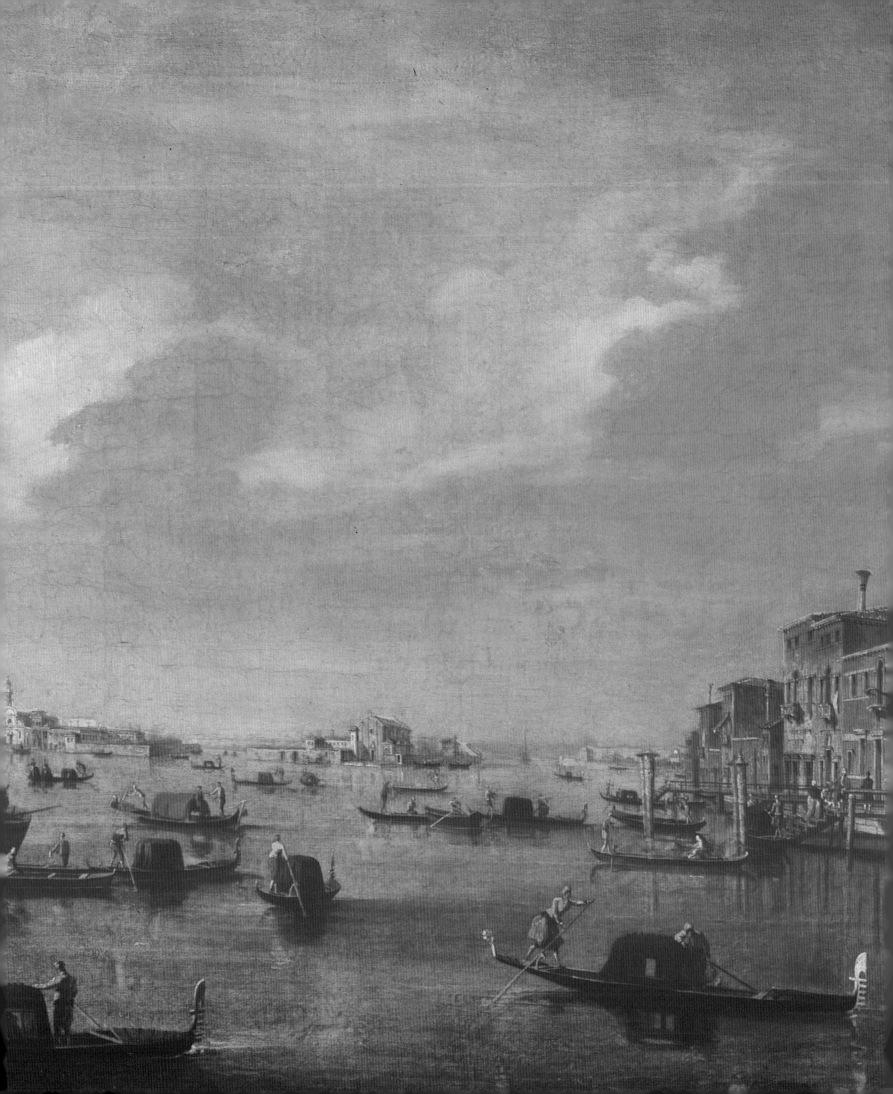

The So-Called "Minor Painters"

Perhaps as early as the beginning of the 1730s, the genre of view painting must have suddenly become much more popular. This would explain, along with the increase in commissions in particular from the foreign travelers who came to Venice during their Italian Grand Tour, the conversion to view painting of a great number of artists, practically all coming from the world of the theater. About them very little is known, and they are generally snubbed by critics, who assign to them the reductive label of "minor painters." Instead of dismissing these artists, a very interesting and profitable exercise would be to attempt to distinguish—among the countless views of Venice that are attributed to them—the works with certain authorship, so as to construct, albeit within the limits imposed by the early infancy of this line of study, a base on which to work.

Antonio Joli

An exemplary case in this group of *vedutisti* is Antonio Joli (c. 1700–1777), from Modena, whose main activity throughout his life was designing for the theater. He was very successful in this field, in Venice and abroad: the list of stage sets produced by him, as reported in the recent monograph by Mario Manzelli,[52] is indeed astounding. Joli was a tireless traveler, working not only in Venice but also in Rome, Dresden, Naples, London, and Madrid. He produced numerous views of these cities, generally distinguished by a wide-angled vista, precise rendering of the architecture, and remarkable skill at handling perspective.

Even though he was a native of Modena and received his artistic training in Emilia and in Rome, in the workshop of the Emilian Pannini, Antonio must have had a particular fondness for Venice. He went to the city for the first time around 1730, and his family always lived there—until their definitive move to Naples in 1762—during the times when his professional activity forced him to reside temporarily in the great cities of Europe. In Venice Joli certainly enjoyed fame and honor; he was named Prior of the Painters' Guild in 1739, was mentioned by Giacomo Casanova in his *Histoire de ma vie* as a "celebrated decorative painter," and was elected one of the first members of the newly created Academy of Venice in 1750. His success does not seem to have been tied only to his work for the stage,[53] but also to his view

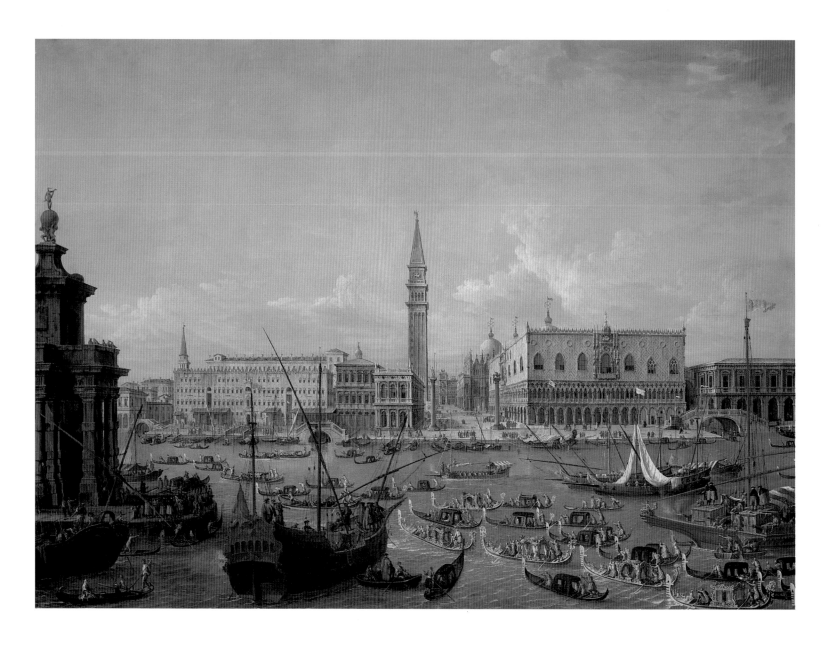

Antonio Joli
The San Marco Basin with the Entrance
of the Papal Legate Antonio Branciforti Colonna
160.7 x 221.6 cm
Washington, National Gallery of Art

painting, which, although not as frequent, was certainly noticed and appreciated by the major Venetian collectors. Evidence of this is the fact that two of his views (of Verona and of Naples) were purchased by Marshal Schulenburg between 1735 and 1736, and that subsequently he was given the prestigious commission to illustrate the entrance into Venice of an Apostolic Nuncio, with two large canvases that are now in the National Gallery in Washington.

Most recent criticism is divided over the precise episode narrated in these last two pictures, a detail which cannot be considered secondary, since recognition of the event is naturally a determining factor in dating the works. Dario Succi[54] deserves credit for having been the first to propose the name of Joli as the author of the two works, retrieving them from an anonymity that was embarrassing in light of their quality. He has suggested that the ceremony for which the painter has given us a visual narrative may be the one organized in April 1741 for the entrance into Venice of Monsignor Giovanni Francesco Stopani, former archbishop of Corfu. But an obstacle to this identification is the fact that the Loggetta of the bell tower, clearly visible in the background of the scene of a boat procession in the San Marco Basin,

Antonio Joli
*The Courtyard of the Doge's Palace with the Entrance
of the Papal Legate Antonio Branciforti Colonna*
160.7 x 221.6 cm
Washington, National Gallery of Art

shows the bronze railings installed there by Antonio Gai in 1742.[55] Moreover, this
same view reveals that the side wings on the clock tower had already been raised,
which was done in 1755 on a design by Giorgio Massari. These observations move
the proposed date of these paintings forward by at least fifteen years, thus supporting
Mario Manzelli's contention that they represent the official entrance into Venice of
the Papal Legate archbishop Antonio Branciforti Colonna, which took place on
December 3 and 4, 1758. This entrance would have followed the established
ceremonial, which prescribed that on the first day the new Legate be accompanied
by sea from the island of Santo Spirito in the Venetian lagoon to the seat of the papal
embassy, and that on the second day he go to pay homage to the Doge in his palace.
It is interesting to note in these works, in which the architecture is rendered with a
laden brush that closely recalls Michele Marieschi, the high quality of the
multicolored characters, attributed by Succi to Gaspare Diziani, the figure painter
from Belluno who was called on numerous occasions to complete the views and
caprices of Marieschi. This collaboration between Diziani and Joli provides further
proof that theater set designers were not practiced in painting figures; for them it

Antonio Joli
The San Marco Basin with the Customs House Point and the Island of San Giorgio
55.3 x 167.7 cm
Private collection

was almost obligatory, in the cases where they had to include a large number of characters in important paintings, to turn to specialists in this genre for help. Antonio Joli can be assigned some other views of Venice, only one of which is signed—*The San Marco Basin with the Customs House Point and the Island of San Giorgio,* which appeared at Sotheby's in London on April 17, 1996. This work is of great interest because its inscriptions indicate that it was painted on a commission from the London theater impresario John James Heidegger, for whom Joli worked during his stay in London between 1744 and 1749. This suggests that the view may have been painted in London, perhaps on the basis of preparatory material brought from Venice. Similarly, it seems Joli was the author of a few other works, including a view in a private collection with much the same subject, differing only in the widening on the right to take in the wall and square towers which gave the Palazzo Dandalo "delle Torri" ("of the Towers") its name. The palace stood, along with the church and convent dedicated to St. John the Baptist, in the area from which the Campo di Marte was created in the nineteenth century.

Jacopo Fabris

Another painter coming to view painting from the world of theater scenery is Jacopo Fabris, born in Venice in 1689 into a family perhaps of German, or more likely Friulan origin, and dead in 1761, in Copenhagen, at the age of seventy-two. From 1719 to 1721 he was court painter at Karlsruhe, in the court of Margrave Karl Wilhelm von Baden-Durlach, where he painted theatrical decorations. After this period, he continued to work in Germany as a stage designer: from 1724 to 1730 he was in Hamburg, and it seems that he went to London from there; at the end of the 1730s he worked in Mannheim, where he may have met Alessandro Galli Bibiena and Giannantonio Pellegrini, who were active there at the same time; and in 1742 he was in Berlin, in the service of Frederick the Great. Four years later, Fabris moved definitively to Copenhagen, to the court of the new king, Frederick V, where he continued his activity as a stage designer and painted numerous decorative works.[56] Fabris was also the author of a theoretical treatise on perspective and

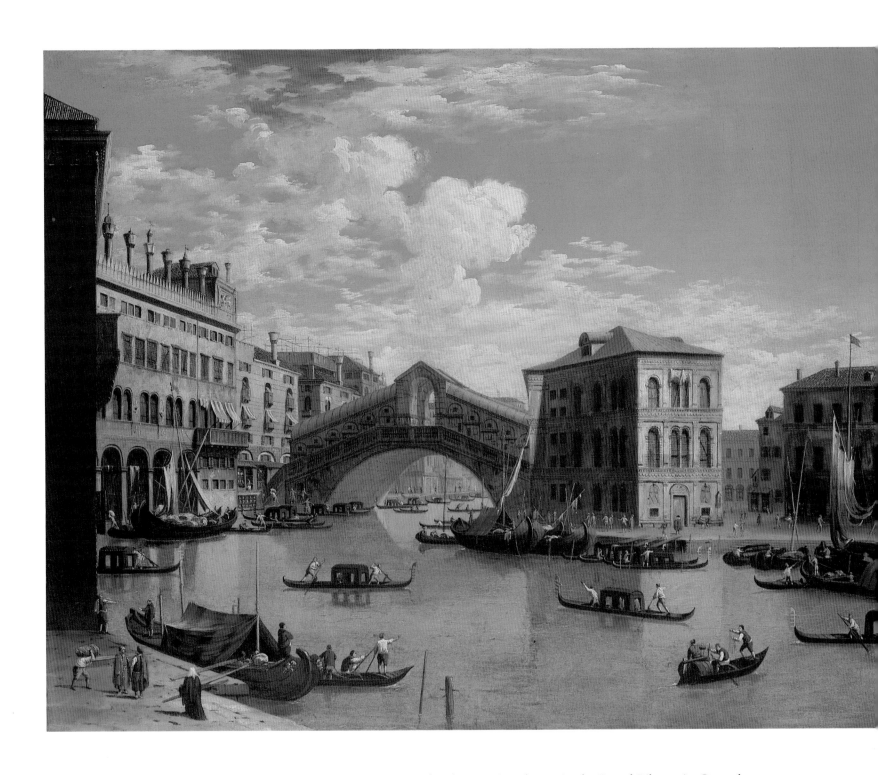

Jacopo Fabris
*The Grand Canal toward Rialto
with the Palazzo dei Camerlenghi*
87 x 109.2 cm
Private collection

architecture, completed in 1760 and now in the Royal Library in Copenhagen.
To Antonio Morassi in particular goes the credit for having pulled Fabris's work as a
view painter at least partially from the oblivion of anonymity, in his research in
1966.[57] From the paintings he published and the additions to the painter's catalogue
made subsequently by Mosco and Pallucchini[58] (especially the theatrical *Roman
Caprice with the Arch of the Argentari* now in a private collection, signed "Ja. Fabris
pin."), the figure emerges of an artist closely tied to Canaletto's early manner in the
execution of both caprices and his rare views of Venice. The cornerstone of the
reconstruction of the corpus of Fabris's Venetian images is the view of *The Grand
Canal toward Rialto with the Palazzo dei Camerlenghi*, signed "Ja. Fabris pin.," which

was earlier in an English private collection and was made known to the public by Morassi. Both this view and its pendant representing *The Dock with the Doge's Palace from the Basin* derive, as Mosco has indicated, from engravings of Canaletto paintings made in 1736 by the French engraver Boitard.

The signed canvas is of very high quality in the confident handling of the architecture and the lovely little figures, small in size but well defined in their gestures and clothing and chromatically very lively. It is not known when Fabris returned to Venice, interrupting his wanderings about Europe, which does not facilitate the task of assigning a credible date to the two works. It could very well be the case, given Fabris's habit of deriving his images—the Roman and the Venetian in equal measure—from models engraved by others, and considering also the absolute lack of any mention of him in the Venetian art literature of his time, that he never returned to his home city and that his paintings were all done abroad, where engravings of Venetian and Roman views were circulating in great number.

The views presented by Morassi have been joined over time by other images of Venice, including the four hanging in the dining room of the Lerchesgaard in Copenhagen, obviously dated to the end of the 1740s or beginning of the 1750s. Two of these represent different views of St. Mark's Square while the other two show the dock looking in opposite directions, one toward the Grand Canal and one toward Riva degli Schiavoni. These are works of discernibly inferior quality compared to the pendant mentioned above, as are, to an even greater degree, the five above-door paintings, also of Venetian subjects, which are in the same room, and which document the progressive depletion of Fabris's resources as a view painter.

Giovan Battista Cimaroli

A near contemporary of Fabris is Giovan Battista Cimaroli, born in Salò at the beginning of December 1687 and in his youth a pupil of Antonio Aureggio in Brescia and then of Antonio Calza in Bologna, where he resided from 1711 to 1713.[59] From Bologna, Cimaroli went immediately to Venice, where he married Giovanna Caterina Pachman, also in 1713. The painter died in the city on the lagoon on April 12, 1771.

Knowledge of Cimaroli's activity is still spotty, even though progress has been made since the early research on him by Watson and Morassi.[60] The additions to his catalogue made since then are largely due to the appearance on the art market of many works which can be assigned to him with certainty—in particular, caprices or views of fields and rivers. Conversely, an obstacle to a more profound knowledge of Cimaroli's activity is the highly unusual circumstance that very few of his pictures are easily accessible in public collections, including, to the best of my knowledge, all of the views of Venice that Cimaroli certainly painted in the course of his long career.

Two of these views, representing *The Customs House* and the *Carità,* were in the collection of Marshal Schulenberg, who bought them in 1727 for twelve sequins, along with two fantasy landscapes. Rodolfo Pallucchini[61] feels that the second one is a painting of rather modest quality which is now in the Hunterian Art Gallery of the University of Glasgow. Other works of his were at one time present in the collection of Zaccaria Sagredo and in other important Venetian and foreign collections.[62]

We can thus deduce from the scanty information available that Cimaroli was a successful artist in his day, often painting his pictures—as Pietro Guarienti testifies

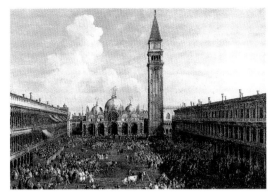

Giovan Battista Cimaroli
Chasing the Bulls in St. Mark's Square
156 x 205 cm
Private collection

Giovan Battista Cimaroli
Chasing the Bulls in St. Mark's Square
99 x 145 cm
Private collection

(1753)—"on commissions arriving to him from England, and from other far-away cities, where his paintings were appreciated." His close relationship with the English world is attested also by Count Tessin (1736), who, pointing out that Cimaroli "peint dans le meme gout" ("paints in the same vein") as Canaletto, wrote that the former "n'est pas encore arrivé au bout de l'échelle, du reste gaté per les Anglais, qui ont imaginé que le plus petit des ses tableaux vaut 30 sequins" ("has not yet reached the top of the scale, which has been ruined by the English, who have imagined that the smallest of his pictures is worth thirty sequins").

Currently, a substantial number are known of his fantasy landscapes, caprices, and views of the areas along the Brenta Canal, which were one of Cimaroli's favorite subjects. The same cannot be said about his activity as a painter of views of the city where he lived, of which only a few, very rare examples are known. Among these two different versions on the subject of *Chasing the Bulls in St. Mark's Square*, the oldest of which, appearing in a sale at the Semenzato gallery in Venice on May 28, 1989, coming from an English collection, can be connected with the event organized on February 16, 1740, on the occasion of the visit to Venice of Prince Frederick Christian, the eldest son of the king of Poland and Elector of Saxony, Augustus III. Evidence of this is the fact that the young men engaged in "pulling

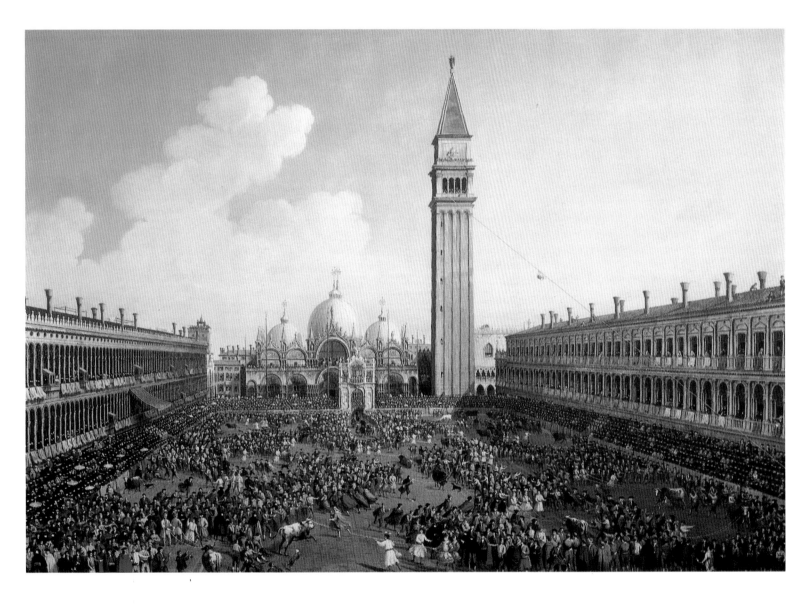

Giovan Battista Cimaroli
The Piazzetta Seen from the Basin
82 x 112 cm
Formerly San Francisco, California Palace
of the Legion of Honor

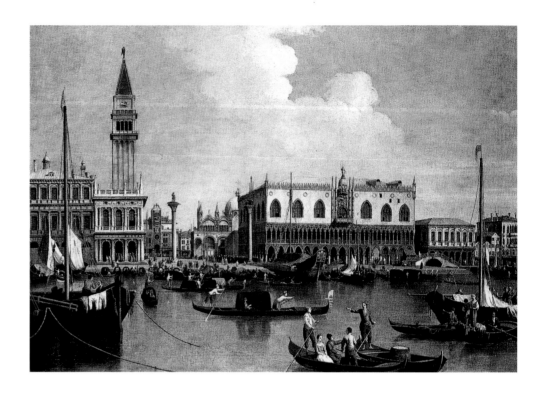

the bull" are dressed in the costumes of the four continents, and this detail
coincides with the description of the sumptuous event furnished by the historian
Michele Battagia.[63]

A replica exists of this painting, smaller in size and with numerous variants in the
arrangement of the figures. In 1761 it was the property of Bouchier Cleeve, a well-
known English collector, and later belonged to Watson, the English historian who
gave us the first artistic evaluation of Cimaroli's work. It too was put up for sale by
the Semenzato Gallery in Venice, on December 13, 1992. It is perhaps the artist's
best known work, and its critical history is certainly an interesting one. It has always
been thought to be the result of collaboration between Canaletto and Cimaroli, on
the basis of an old citation in the literature dating to 1761. The hypothesis of a
closeness between these two artists has been confirmed by the ascertained fact that
Cimaroli collaborated with Canaletto in the mid-1720s on the execution of *The
Allegorical Tomb of Archbishop Tillotson* (Moores collection, Liverpool), along with
Giambattista Pittoni, who painted the figures. Only quite recently has Morassi
affirmed Cimaroli's complete authorship of this second version of *Chasing the Bulls
in St. Mark's Square*, refuting the recurrent hypothesis that Canaletto painted the
architecture. It now seems evident that the confident handling of the buildings
facing onto the square has its perfect counterpart in that of the houses, villas, and
churches that appear in the numerous river views and caprices which are certainly
by Cimaroli. Nonetheless, this work constitutes a manifest confirmation of the
similarity of Cimaroli's manner of view painting with Canaletto's, resulting
undoubtedly from the same market—the English one—that both of them were
called to satisfy. For this same reason, Cimaroli, when painting caprices or landscapes,
would look particularly to the model of Francesco Zuccarelli, another artist working
in Venice who was particularly appreciated by the English.

Given these presuppositions, it seems obvious that Cimaroli's views must be hidden
among the large group of works that, over time, have been attributed to Canaletto

Giovan Battista Cimaroli
The Dock toward the Entrance to the Grand Canal
82 x 112 cm
Formerly San Francisco, California Palace
of the Legion of Honor

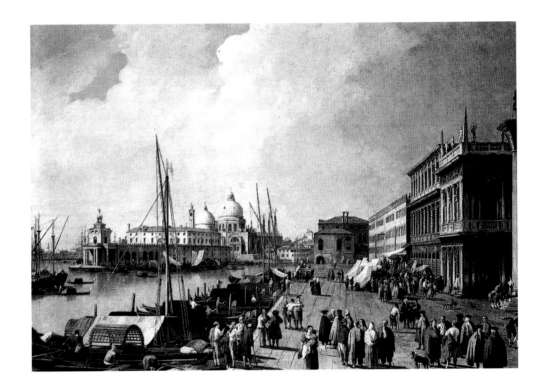

or his circle. For example, he could be the author of the pendant works once in the California Palace of the Legion of Honor in San Francisco, which are held by W.G. Constable[64] to be school variants on models by Canaletto. These represent respectively *The Piazzetta Seen from the Basin* and *The Dock toward the Entrance to the Grand Canal*, both characterized by the same meticulous, steady description of the buildings and the same type of characters which we find in the two versions of *Chasing the Bulls* mentioned above.

Gaspare Diziani

Even though he was not a specialist in the genre of view painting, Gaspare Diziani (1689–1767) is surely one of the painters most often mentioned in this book, because of his activity as a stage designer in Dresden, Rome, and Venice, and especially for his familiarity with the workshops where the view painters were working. Through the shops, he frequently collaborated with Michele Marieschi and Antonio Joli (and perhaps also with others) in painting the figures inside the architectural structures they had prepared.

However, agreement is unanimous, from the early nineteenth century on, in attributing to Diziani a large view of *The Feast of Santa Marta*, now in the Museo del Settecento Veneziano in Ca' Rezzonico. This work was certainly an exception in his production, which was normally directed towards large decorative canvases or frescoes for civil and religious buildings. And yet this is a painting of remarkable quality, in which Diziani certainly took advantage of the experience he had built up by painting sets for theatrical productions. The canvas shows the far point of the island of the Giudecca, viewed from the Fondamenta di Santa Marta. The buildings serve as a backdrop to the main scene, which is the parade of boats—a sort of "picnic on the lagoon"—held every year on July 29 and every Monday in August, with great public participation, and called the "feast of Santa Marta." The sites described by Diziani underwent profound modifications during the

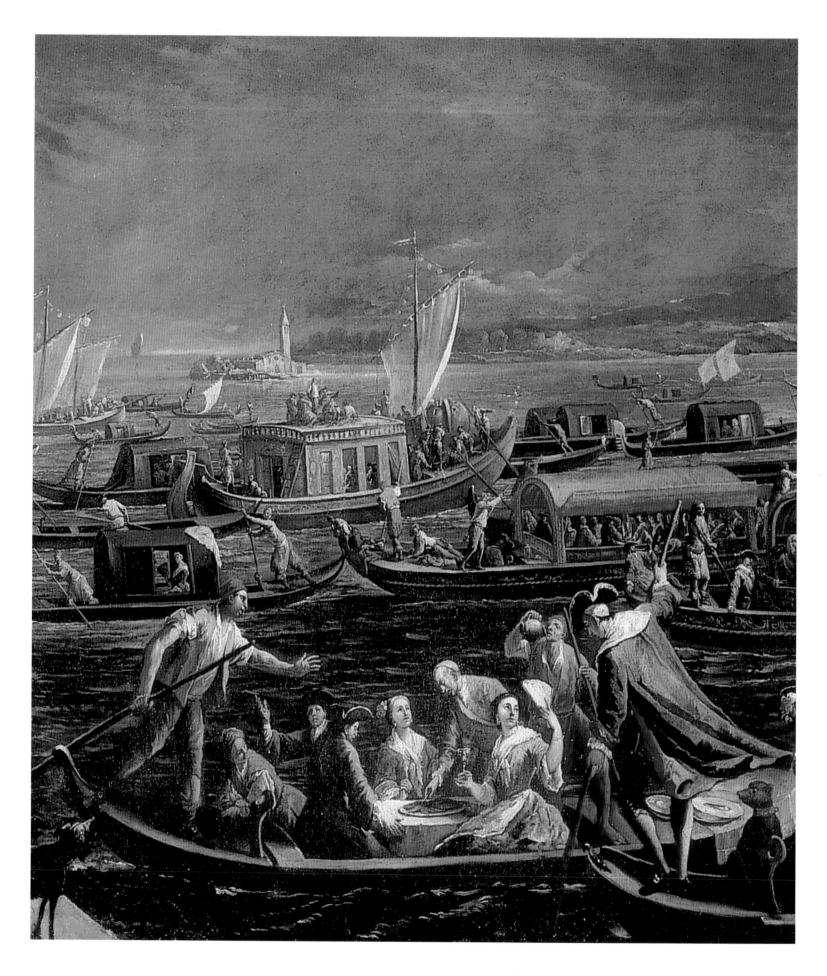

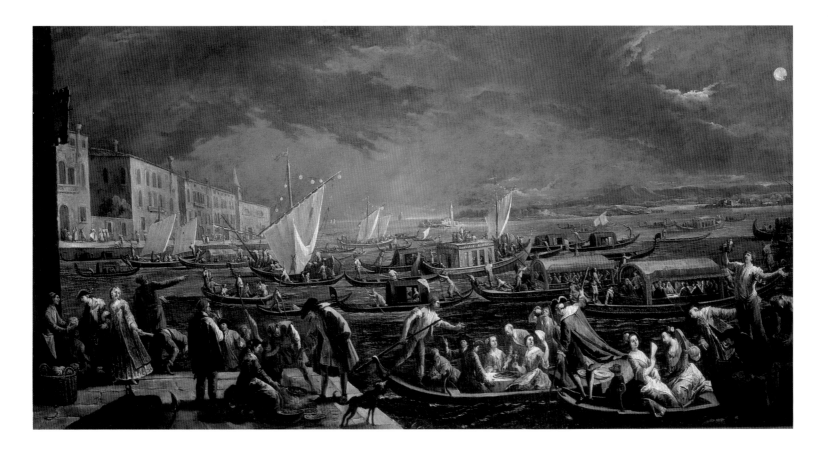

Gaspare Diziani
The Feast of Santa Marta
167 x 329 cm
Venice, Ca' Rezzonico

Gaspare Diziani
The Feast of Santa Marta
Venice, Ca' Rezzonico
Detail

nineteenth century, and are now difficult to recognize. On the left—with an unnatural widening of the angle of vision from the Santa Marta bank, where the commercial port of Venice is now located—appears the last section to the west of the Fondamenta della Giudecca. On the spot where the Molino Stucky now stands is still visible the ancient church dedicated to Saints Blaise and Cataldus, which was demolished in the early nineteenth century; a bit beyond, on the right, can be glimpsed the island of San Giorgio in Alga, now completely abandoned but in the eighteenth century still the site of an important Benedictine monastery; and finally, in the distance, is the hinterland beyond the lagoon, stretching to the Euganaean Hills.

Naturally, the figures animating the scene are of very high quality, a real myriad of characters intent on the most diverse activities, skillfully arranged on the banks and boats and depicted with great liveliness and an admirable feel for color. These little figures—whose authorship by Diziani has never been doubted—thus become the paragon against which all those appearing in paintings by other artists are measured. In some cases it has been thought that the view component of this painting may have been worked on by one of Diziani's artist sons, in particular Antonio, who painted primarily Arcadian and landscape scenes. Even though the framework of collaboration discussed extensively above makes this hypothesis plausible, the stylistic uniformity marking the work would make it ultimately unlikely.

Francesco Tironi

Another very interesting "minor" view painter was also a priest: Father Francesco Tironi, born in Friuli, about whom is known only the date of his sudden death, which occurred in his house in Corte Colonna a Castello on March 1, 1797, at the

age of about fifty-two. He was never enrolled in the Guild of Venetian Painters, nor was he ever part of the local Academy.[65] In 1806 Giannantonio wrote Moschini of his untimely decease, at an age that was still "too fresh," in tones of sincere regret, "since the Ports of Venice and the Islands drawn by him... give us a glimpse of what he might have accomplished."

The views of the ports and islands of the lagoon by Tironi to which the illustrious historian refers are probably the preparatory drawings for the panels which, engraved by Antonio Sandi of Belluno, make up the collection published in 1779 by Furlanetto with the title *Twenty-four Perspectives of the Islands in the Venetian Lagoon*. Very soon thereafter, he must have done the drawings, also engraved by Sandi, representing the four ports of Venice: Chioggia, Malamocco, Sant'Andrea, and Murazzi.

Terisio Pignatti has catalogued Tironi's graphic activity, which includes more than twenty sheets, twelve of which are preparatory drawings for the engravings made by Sandi.[66] These reveal a certain amount of confidence and ease, and indicate that Tironi looked mainly to models by Canaletto, but also to Guardi, as is evident in his habit of putting large boats in the foreground, often with shredded sails, peopled with numerous down-at-the-heel fishermen or oarsmen.

It is Voss's primary merit that he gave a shape also to Tironi's activity as a painter,[67] publishing three canvases which at the time were in various private collections in Germany. Two of these—the views of *San Giorgio Maggiore* and of the nearby islands

Francesco Tironi
*View of the Islands of San Michele
and San Cristoforo from the Fondamenta Nuove*
56.5 x 102 cm
Karlsruhe, Staatliche Kunsthalle

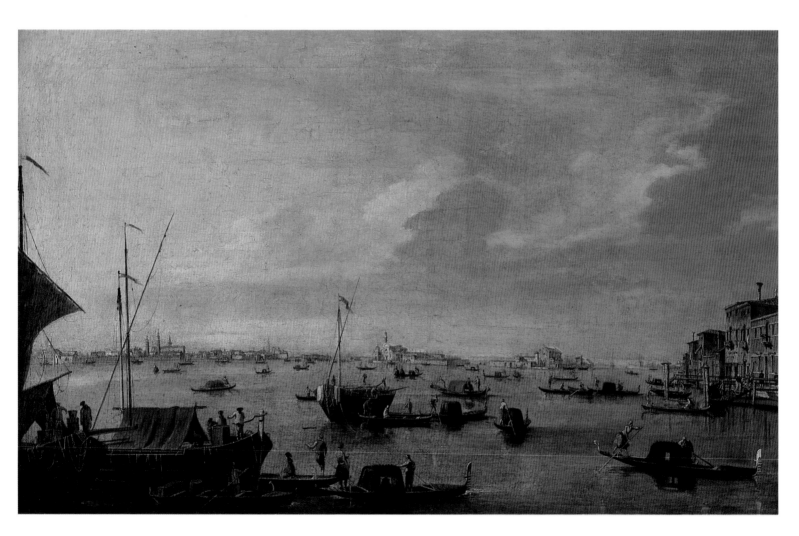

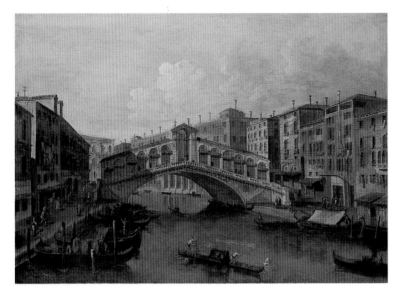 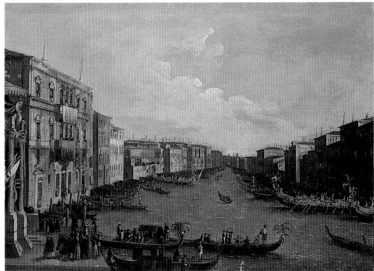

Francesco Tironi
The Rialto Bridge Seen from the South
83 x 114 cm
Private collection

Francesco Tironi
*The Grand Canal from Palazzo Balbi
toward Rialto*
83 x 114 cm
Private collection

of *San Michele and San Cristoforo*, the property of Von Liphart in Munich—are signed "F.T." The third canvas, a *View of Murano*, now in Berlin, is not signed but is part of a series with the other two.

While we do not know the current location of the works indicated by Voss, it is useful, in an attempt to pinpoint Tironi's painting style, to examine the *View of the Islands of San Michele and San Cristoforo* (on the right) *and Murano* (on the left), seen from the Sacca della Misericordia, now in the Staatliche Kunsthalle in Karlsruhe, also signed with the painter's initials.[68] This is a view of remarkable pictorial quality, structured, like certain works by Canaletto and Guardi, on an "impossibly broad" sweeping vista. The architecture—both that on the far right, which forms a kind of stage wing for the picture, and the almost miniature buildings on the horizon—is meticulously rendered, to the point that the individual buildings on the islands are easily recognized. The section of the lagoon is filled with a great many boats, a group of them placed on the far left to balance the group of houses on the far right. The arrangement of the scene repeats that of the drawings published by Pignatti, in particular in the habit—which was Giovanni Richter's before any of the other Venetian view painters—of placing in the foremost plane heavy cargo boats at anchor and slender gondolas slipping rapidly through the water. Quite fine and well articulated are the characters, just as are those in the drawings.

Numerous other Venetian views exist which can be credibly attributed to Tironi: for example, the very fine, privately owned pair with images of *The Rialto Bridge Seen from the South* and *The Grand Canal from Palazzo Balbi toward Rialto*, shown during a regata, reproduced here. These canvases contain stylistic elements completely analogous with those characterizing the fundamental view at Karlsruhe cited above. This is apparent in the precise rendering of the architectural details, in the very similar type of characters, and also in the use (notice the position of the "machine" in the picture of the regata) of architectural elements as theatrical backdrops.

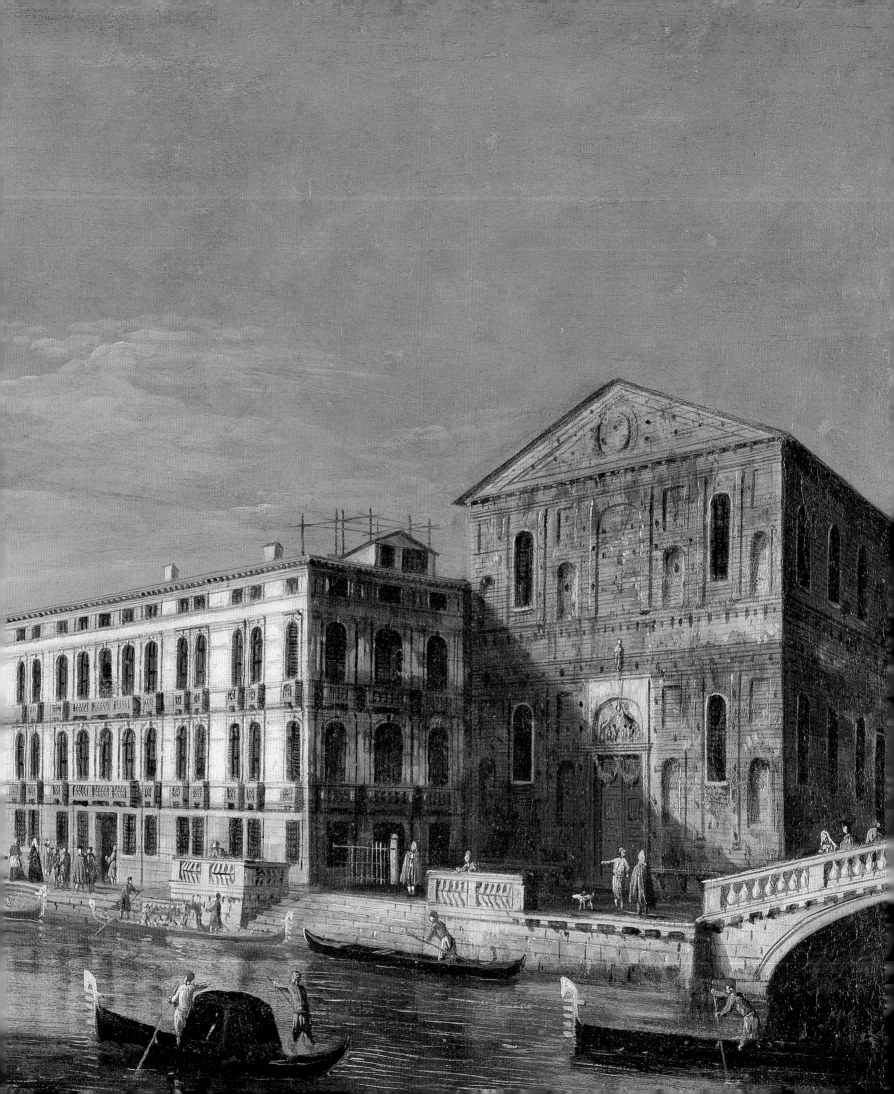

The Serial Views:
The Langmatt Master,
Gabriel Bella, and Others

The Langmatt Master
View of Palazzo Lezze
Baden, Langmatt Foundation
Detail (entire painting on page 190)

The Venetian "picture shops" were capable of satisfying all their clients' needs, even the most complex. As even Canaletto, Bernardo Bellotto, and Michele Marieschi did on some occasions, a number of Venetian artists painted entire decorative cycles, made up of numerous views of the city, destined to embellish one or more rooms in the residences of their patrons.

Emblematic of this trend is the series of thirteen views of Venice, recently published by Gertrude Borghero,[69] now in the Langmatt Foundation in Baden (Switzerland). The views probably came to their present location from a palace in Turin or a nearby castle, and nothing is known of their former history. The hypothesis has been offered that—given the presence among the paintings of a rare image of Palazzo Lezze alla Misericordia, at a moment when it appears that a visit from the papal legate is in progress, as his gilded gondolas are docked in front of the building—the view could have originally been part of the rich collection belonging to this Venetian family, which also included works by Titian, Paolo Veronese, Jacopo Robusti Tintoretto, and Giambattista Tiepolo; but this supposition awaits confirmation by documents.

The Langmatt views can be dated, on the basis of topographical elements appearing in them, to around 1743–44. Particularly decisive in determining this date is the fact that the view of *The Fondamenta delle Zattere on the Giudecca Canal* contains both the church of the Gesuati, as it could have appeared only after completion of the renovations carried out on a plan by Giorgio Massari and terminated in 1743 (visible in the painting are the construction sheds and stone materials), and the bell tower of the church of the Carità, which fell down the following year. The subjects of the canvases are particularly interesting, ranging from the canonical images of the area around San Marco to views of long sections of the Grand Canal to pictures of less famous places: Sansovino's Scuola della Misericordia; next to it, Longhena's Palazzo Lezze and the unprecedented vision of the Giudecca Canal; the Rio dei Mendicanti, dominated by the great structure of the Ospedale, encompassing also the church of the Incurabili; and the Campo dei Frari seen from the bridge that leads to Palazzo Zen. Stylistically, the paintings are extremely uniform, and there can be no doubt that these are all works by the

The Langmatt Master
View of Palazzo Lezze
47 x 73 cm
Baden, Langmatt Foundation

The Langmatt Master
The Fondamenta delle Zattere on the Giudecca Canal
25.5 x 30 cm
Baden, Langmatt Foundation

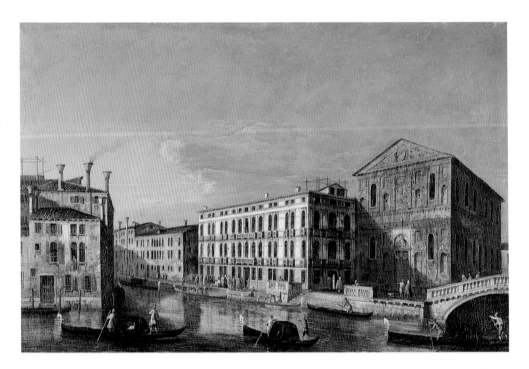

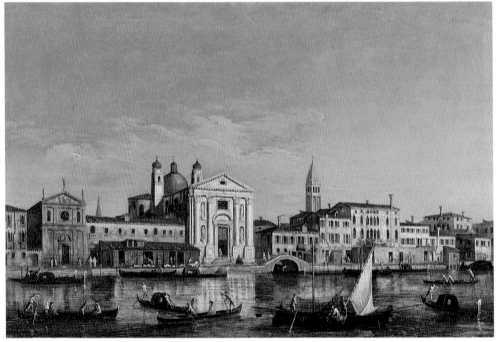

same painter. Dario Succi[70] indicates analogies with Marieschi's work, both on the grounds of stylistic similarities, evident for example in the heavy application of the clotted paint, and of their common trait of marked distortion in the perspective framework of the views, resulting probably from the use of the optical chamber. Nonetheless, or perhaps precisely as a consequence of this, the rendering of the individual architectural elements is precise, almost didactic. The characters, too, are skillfully painted, not numerous but all of them brightly colored and well defined. Despite Borghero's commendable research, it has not yet been possible to give a name to the author of this series. In consideration of the very fine technical quality of the works, this case provides a clear confirmation of the fact that the

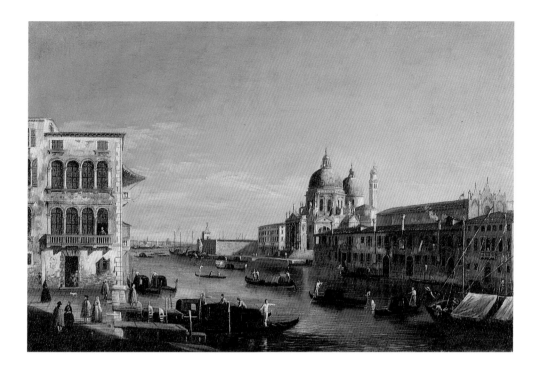

study of the "minor" Venetian view painters of the eighteenth century is still not far enough advanced.

The appearance of these views opened the way—especially on the art market—to the attribution to the so-called Langmatt Master of a great many works, in some cases quite different in style from these core works constituting the point of reference. Among the many views that have been put forward, it seems to me that this artist's hand can unequivocally be identified in the four paintings which appeared at a Christie's sale in London on July 7, 2000, whose quality is completely analogous in every way to the canvases now in the foundation in Switzerland.

These are a group of works of the same size (each one measures 73 x 95.5 cm), evidently prepared for the decoration of the same room. They represent *St. Mark's Square Facing the Church, The Piazzetta Seen from the Basin* during a regata, *The Dock toward the Entrance to the Grand Canal*, and *The Island of San Giorgio* seen from the Giudecca Canal. There are no elements within the pictures to help us fix a precise date for their execution, but they were certainly done before 1755, since the view of St. Mark's Square does not show the wings of the clock tower added during that year by Giorgio Massari. However, their stylistic uniformity with the Langmatt Foundation's pictures indicates that the date of these views is probably near the first half of the 1740s.

The two images of the square and the Piazzetta are completely similar in the placement of the figures and boats to the Langmatt Foundation canvases; the other two images differ. The one of the Dock and the entrance to the Grand Canal derives evidently from models by Canaletto, as it is similar to the canvas now in the Albertini collection, of 1735. A Canaletto prototype exists also for the other view, identified by Knox[71] as one of the four canvases painted by the artist for the Duke of Bolton.

The case of the anonymous Langmatt Master is not an isolated one, and numerous unassigned series of views are still intact in private and public collections. The

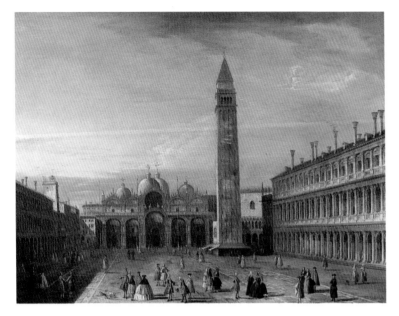

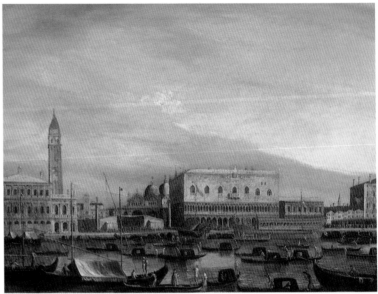

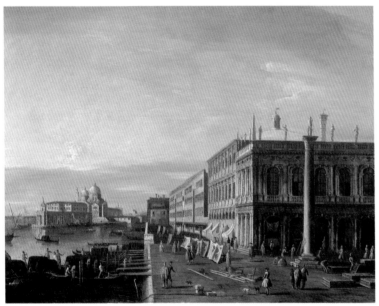

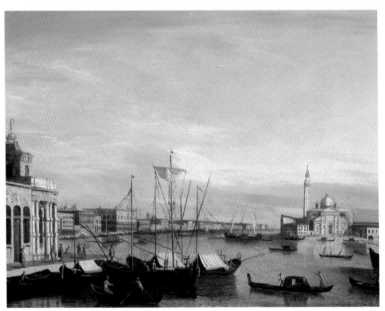

The Langmatt Master
St. Mark's Square Facing the Church
The Piazzetta Seen from the Basin
The Dock toward the Entrance to the Grand Canal
The Island of San Giorgio
73 x 97.5 cm (each)
Private collection

following two examples seem to be particularly interesting. The first is the quite large series of similar images of Venice and also of Rome, now, along with other works by Venetian artists, in the collection of Baron Landsberg-Velen in Vocklum Castle in Westphalia, which has been briefly treated by Stefan Kozakiewicz.[72] The subjects of some of these views seem to derive from those of the Langmatt series, but the technical quality of the paintings is visibly inferior. Kozakievicz tells us—on the basis of a document in the family archives now in the Staatsarchiv in Munster—that they were purchased in Venice in January 1752. The most interesting detail about them, which has recently been brought to light, is that they were all purchased at the same time, by an ancestor of their current owner, from a "picture shop" in Venice.

The second series, currently in the Alte Pinakothek in Munich, is made up of ten views of Venice, all approximately the same size (around 72 x 111 cm). They came to their present location from the castle of Seehof near Bamberg, and are

attributed in the most recent catalogue of the collection[73] to a follower of Canaletto. These are, for the most part, literal replicas of the engravings by Antonio Visentini of the master's views, which appear in the collected engravings published with the title *Prospectus Magni Canalis* for the first time in 1735 and then, significantly enlarged, in 1742. The date of the series thus must be later than 1742, even if some topographical elements (for example, the absence in the view of *The Grand Canal at San Geremia* of the statue of St. John of Nepomuk, placed there in 1742) might suggest an earlier date. It is probable that the anonymous painter limited his efforts to copying Visentini's engravings *tout-court* (in the case of the San Geremia view, from the version published in 1735), without being concerned to bring the details up to date.

Another rich series of paintings, now in the Querini Stampalia Foundation in Venice, is very valuable as visual documents, showing images of official and private festivities, scenes of religious life, and the play of the nobility and the people in equal measure. The canvases were largely furnished by Gabriel Bella to Ascanio Giustinian for the family villa at Campodipietra. In 1792, two years after the death of Gerolamo Ascanio Giustinian, they passed by inheritance into the hands of Andrea Querini, who had them transferred to his family villa at Santi Quaranta near Treviso, and subsequently into their Venetian palace at Santa Maria Formosa, where they remain today. In the 1796 inventory, the paintings in the series numbered a total of ninety-five, which then decreased to sixty-seven in the inventory drawn up in 1810, a number that is still valid today.

There is, however, documentary information[74] that Bella also worked for Andrea Querini himself, along with two assistants, from April 18 to June 21 of 1782, in the same villa at Santi Quaranta where at a later date the canvases earlier belonging to Giustinian would hang. This leads to the hypothesis that some of the paintings in the series were painted in this period for the Querini, and only later were the two separate series melded into one collection. Among these earlier paintings are certainly the one of *The Feast of February 2 at Santa Maria Formosa*,

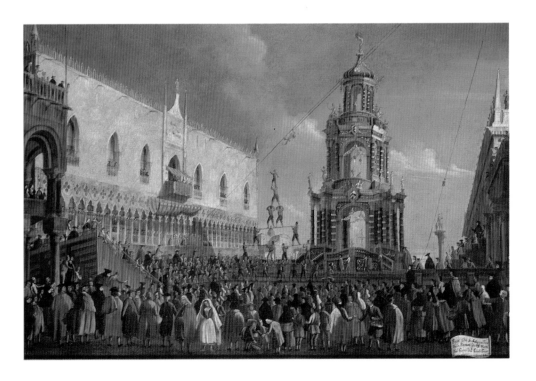

Gabriel Bella
The Jeudi Gras Festivities in the Piazzetta
96.5 x 146.5 cm
Venice, Querini Stampalia Foundation

Gabriel Bella
The Coronation of the Doge at the Head of the Giants' Staircase
97 x 147 cm
Venice, Querini Stampalia Foundation

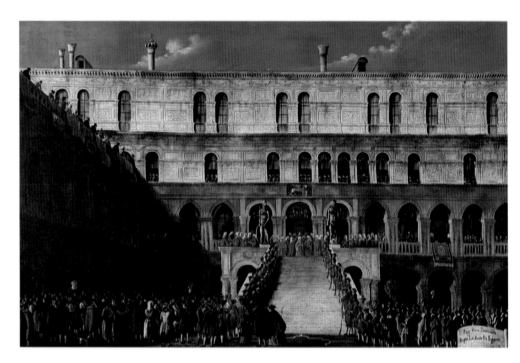

Gabriel Bella
The Bajamonte Tiepolo Conspiracy
97 x 150 cm
Venice, Querini Stampalia Foundation

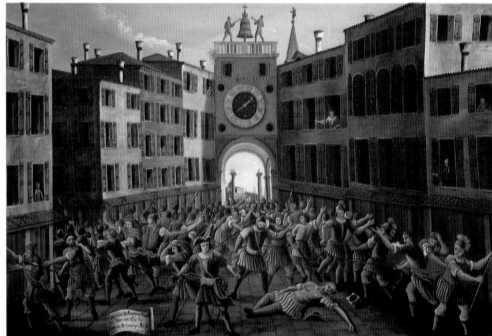

which shows on the left a part of the Venetian palace of the Querini, and *The Entrance of a Procurator of St. Mark*, which probably commemorates the election in 1716 to this important political office of Andrea's father, Zuanne Querini, whose coat of arms appears on the façade next to the house of the Mercerie, to the left of the church of San Salvador.

Not much biographical information is known about Gabriel Bella. He was born in Venice in 1730 and his name appears registered in the Guild of Venetian Painters just once, in 1760; soon after that date he married Maria Maddalena di Gaetana Pastora, with whom he had six children. At least at the end of his life, Bella lived near Santa Maria Formosa; he died tragically on June 3, 1799, when, as

Gabriel Bella
The Dance in the Campiello
94 x 121 cm
Venice, Querini Stampalia Foundation

his death certificate found by Sgarbi reads,[75] "he fell into the water at the Pignolli bridge and suffocated in the same."

The paintings in the collection of the Querini Foundation are his only ascertained works; it is only by stylistic comparison that some others, in private collections, have been hypothesized to be his. The views in the Venetian museum (those making up the former Giustinian series) are credibly datable to the 1780s, on the basis of some details appearing in them. Examples of such clues are the display in *The Jeudi Gras Festivities* of the arms of Doge Paolo Renier, who was in office from 1779 to 1789, and, in *The Last Day of Carnival*, the presence of a curious type of mask with a little light on the hat, which we know was used in 1788 during this feast by a group of people from Calabria.

Aside from all this, the most interesting thing about the sixty-seven paintings that have survived to our day is that they manifest evident differences in style, ranging from a fairly high painting quality (for example, works like *The Coronation of the Doge at the Head of the Giants' Staircase* or the above-mentioned *Jeudi Gras Festivities*, both of them derived from the famous engravings by Giambattista Brustolon taken from drawings by Canaletto) to a disarming technical poverty (like the *Promenade along Riva degli Schiavoni*, *The Dance in the Campiello*, or the improbable *Bajamonte Tiepolo Conspiracy*). This is an evident sign that the name of Gabriel Bella in reality conceals other painters who worked with him, taking the role not of simple assistants, as would seem to be the case from the Querini papers cited above, but as true co-workers on the same level as the master of the workshop, since they were responsible for entire paintings in the series.

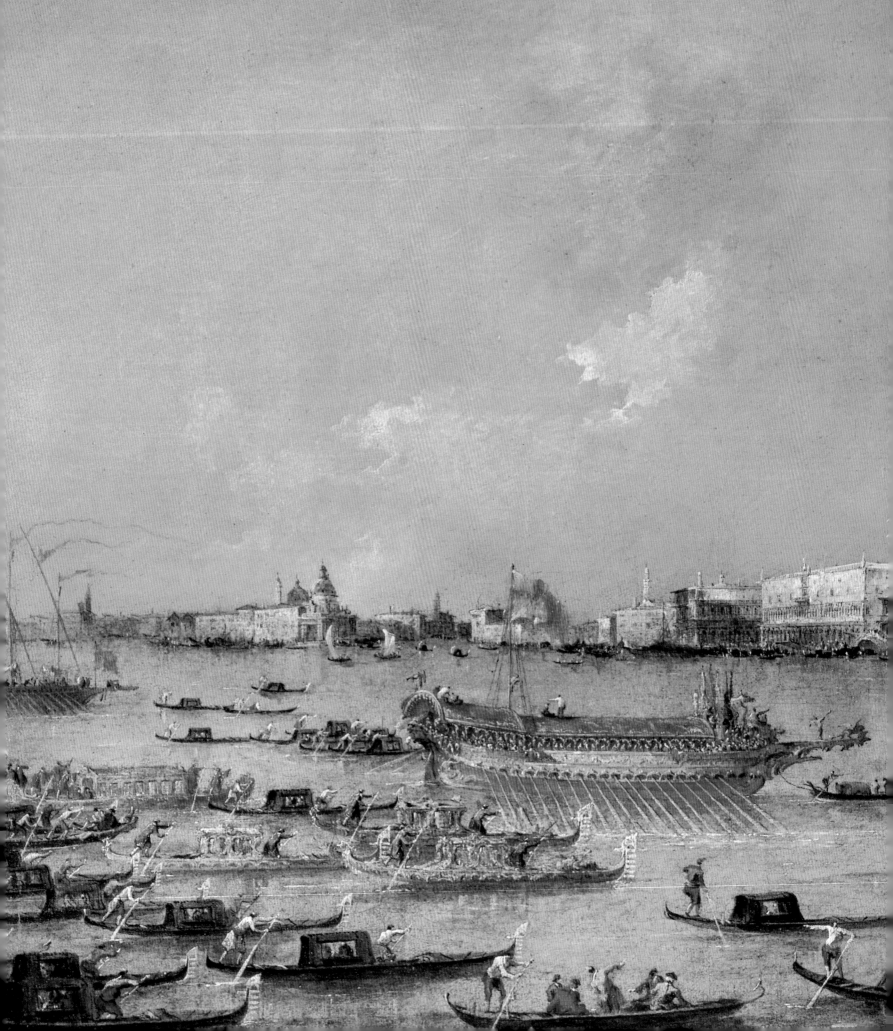

Francesco Guardi

Francesco Guardi
The Return of the Bucintoro
Milan, Private collection
Detail (entire painting on page 212)

The last great Venetian view painter, Francesco Guardi (Venice, 1712–1793), devoted his efforts to this genre only after the mid-1750s, thus at a remarkably advanced age. Before then, he had worked exclusively in the field of figure painting. In his youth he collaborated with his older brother Antonio, a figure painter and the last great protagonist of Venetian Rococo, who was certainly Francesco's first teacher, until the end of the 1720s, yet it seems credible that Francesco soon broke away from his tutelage. This may have already happened by 1729, when Antonio ceded to Francesco his position as house artist for the Giovanelli family, which he had received upon the death of his father Domenico in 1716, in order to enter the service of Marshal Schulenburg.[76] The Giovanelli possessed extensive property in Lombardy, Trentino, Austria, and Bohemia; the painters in their service were employed for the most part in making copies of works by Venetian artists both of earlier times and their contemporaries, to be used to decorate the palaces, villas, and churches belonging to the family spread throughout this territory. It could very well be the case, as was proposed in a paper read at the Venetian symposium on the Guardi brothers held in 1965[77] by the refined connoisseur of Austrian painting, Nicolò Rasmo, that the young Francesco may have been sent by his protectors to Austria. This would explain the presence in his early pictures of a painting manner that recalls more the dramatic works of a Franz Anton Maulbertsch or Christoph Unterperger than the airy rocaille lightness typical of the work of his older brother Antonio.

On his return to Venice, when his relations with the Giovanelli had probably begun to wane—without ceasing altogether, as is demonstrated by the painting of the *Roncegno Altarpiece,* done at the end of the 1770s—Francesco must have tried new paths. This would explain first his stylistic proximity, just after the middle of the 1740s, to Pietro Longhi, evident in works like the various versions of *The Ridotto of Palazzo Dandalo at San Moisè* or *The Nuns' Parlor at San Zaccaria,* then his decision to devote his efforts to the painting of views and landscapes. It has been greatly debated just when this second shift may have happened. Most recent criticism leans toward the hypothesis that Francesco Guardi's debut in view painting took place around the middle of the 1750s, thus corresponding with the

Francesco Guardi
San Giorgio Maggiore from the Piazzetta
49 x 83.5 cm
Treviso, Museo Civico

Francesco Guardi
St. Mark's Square
50 x 84 cm
Stockholm, Nationalmuseum

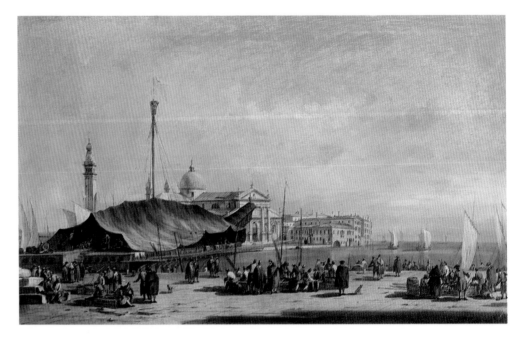

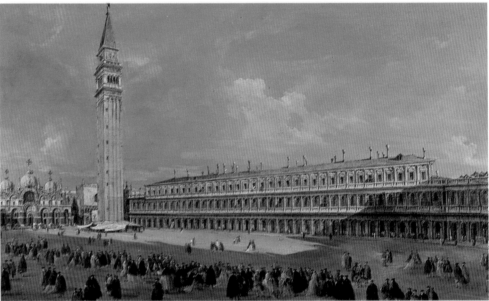

return of tourists to Venice after the end of the Wars of Austrian Succession.
The nobleman Pietro Gradenigo, in his *Notatori*, writes in the entry for April 25,
1764 that "Francesco Guardi, painter from the quarter of Santi Apostoli on the
Fondamente Nove, a good Pupil of the renowned Canaletto, having been very
successful, because of the Optical Chamber, in painting on two large canvases,
ordered by an English Foreigner, the views of the Piazza San Marco towards the
Church, and the Clock, and the Rialto Bridge, to the left the Buildings toward
Canareggio, today displayed them on the wings of the Procuratie Nove, and by
this earned for himself universal applause." This very specific and well-known
citation is one of the rare pieces of evidence from contemporary writers
concerning Guardi's activity, and is fundamental for understanding the direction in
which the painter moved once he decided to devote his efforts to views (without,
however, ever completely abandoning figure painting).

The fact that Gradenigo calls him a "good Pupil" of Canaletto should probably not be interpreted literally,[78] but rather as meaning that at the beginning of his activity as a view painter, Guardi took his inspiration primarily from the most famous artist in this specific field. In fact, the views of Venice that are unanimously considered by critics to be Guardi's earliest attest the artist's close attention to Canaletto's models, confirming the reliability of the information furnished by Gradenigo. Looking at views such as the one of *San Giorgio Maggiore* from the dock, now in the Museo Civico of Treviso, or the signed one, with a wide-angle view of *St. Mark's Square*, in the museum in Stockholm, this imitation is evident in the adoption of the widened perspective, the precise description of the architecture, and even in the type of characters.

An early, certain date in the chronology of Guardi's activity as a view painter is contained in the unusual nocturne representing a procession in St. Mark's Square, now in the Ashmolean Museum in Oxford (U.K). This canvas as Succi has noted,[79] represents the religious rite celebrated on the occasion of the election to pope of the Venetian Carlo Rezzonico, who took the name of Clement XIII, on July 6, 1758. Numerous views of the lagoon, also dating to the end of the 1750s, are done in a style that closely recalls, in the unusually wide vista, the celebrated drawings by Canaletto now in Windsor Castle and datable to the 1740s, with images of the lagoon seen from the *Motta di Sant'Antonio*. A very effective view in the Bentineck collection in Paris has as its absolute protagonist the silent stretch of water, plied by just a few cargo boats and delimited in the background by low

Francesco Guardi
Nocturnal Procession in St. Mark's Square
48 x 85 cm
Oxford, Ashmolean Museum

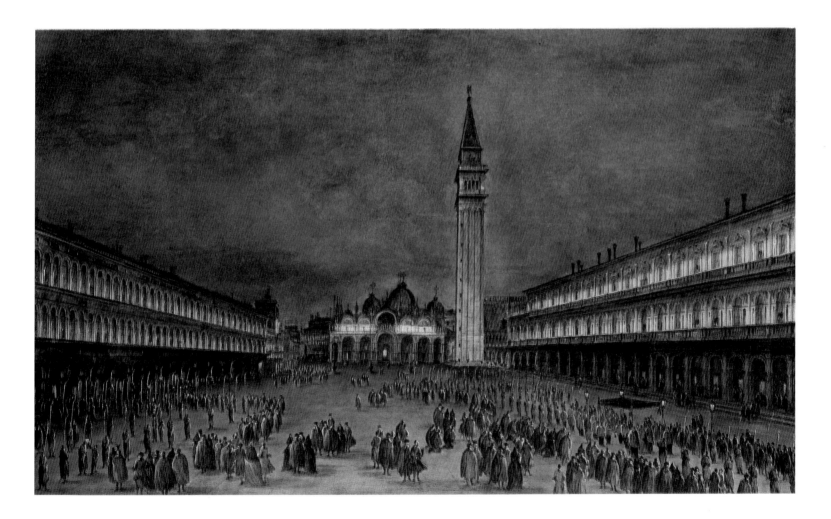

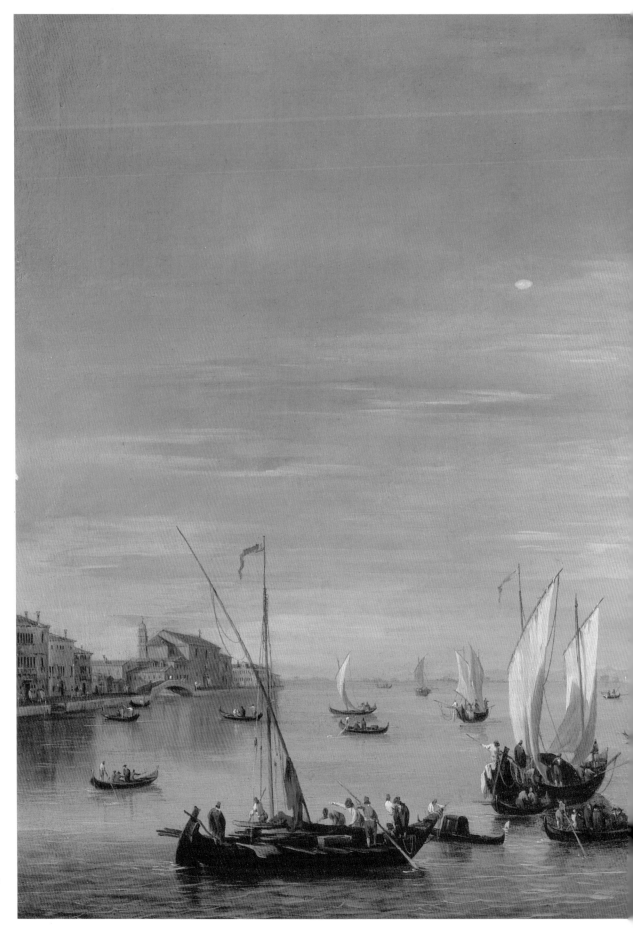

Francesco Guardi
The Giudecca Canal with the Zattere
72 x 120 cm
Private collection

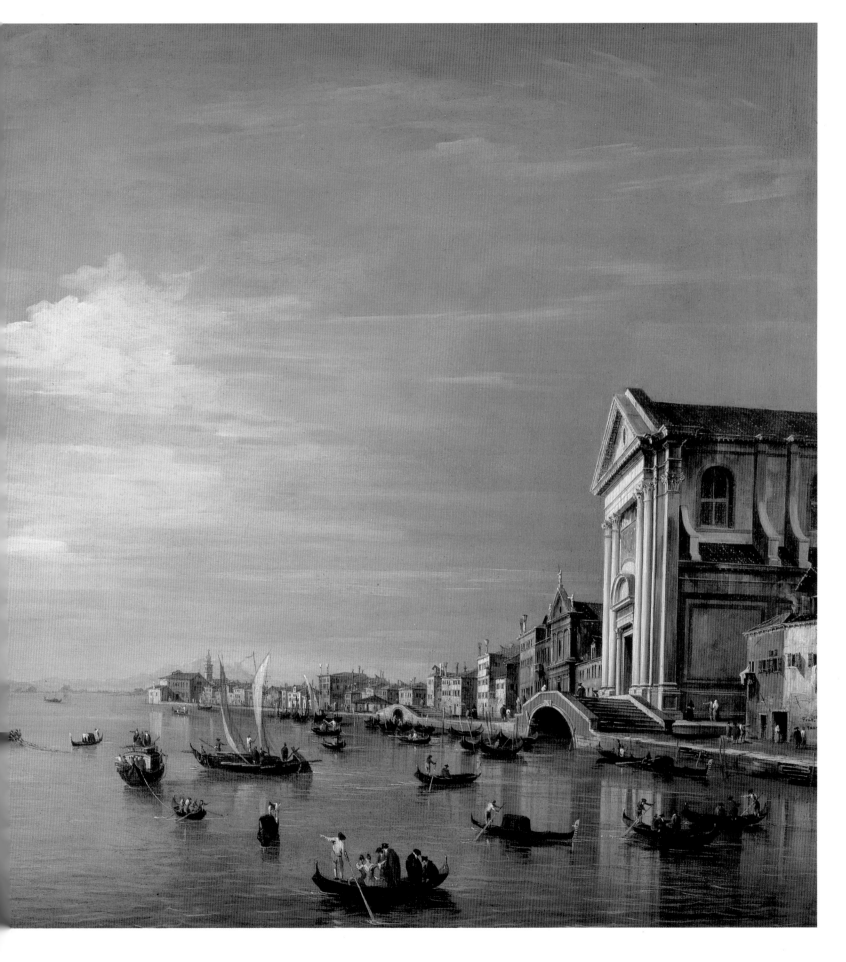

Francesco Guardi
The Lagoon Looking North
34 x 54 cm
Paris, Bentineck collection

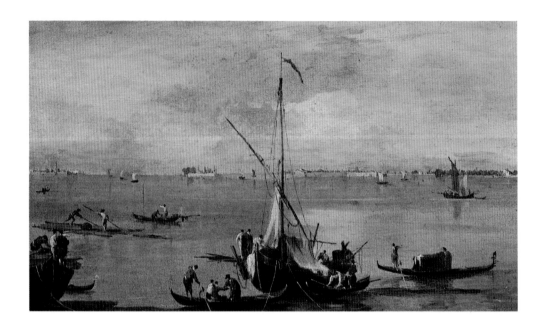

buildings. Also in this group are the two large views, formerly in the Buccleuch collection, representing *The Giudecca Canal with the Zattere*, dominated by the large marble bulk of the eighteenth-century church of the Gesuati, and *The Lagoon from the Fondamenta Nuove*, whose panorama is enclosed in the far distance by the bluish vision of the lower Alps.

Guardi's Canaletto phase must not have lasted very long. Already in the views of the early 1760s are signs of a change of direction, especially evident in the minor attention paid by the painter to the description of the architecture and in the use of a highly individual palette, tending toward warm colors. The characters become increasingly generic, almost standardized in the typical "flame-like" form, which returns in a great number of sketches and notations made by Francesco himself. During this time Guardi painted numerous other Venetian views, including the series of six that remain the property of the Duke of Buccleuch, in one of which—the view showing *The Rialto Bridge with the Palazzo dei Camerlenghi*—appears the bell tower of San Bartolomeo in the form it was given after 1754; the views now in the Alte Pinakothek in Munich representing *The Rialto Bridge with the Palazzo dei Camerlenghi* and *The Grand Canal at San Geremia*; the large canvases with the opposing views (that is, seen from the dock and from the lagoon) of *The San Marco Basin* now at Waddesdon Manor; and the *Campo Santi Giovanni e Paolo* in the Musée du Louvre, prepared using the remarkable drawing now in the museum in Budapest. Just shortly after this were painted the two views in the Pinacoteca di Brera, representing *The Grand Canal toward the Rialto Bridge* and *The Grand Canal at the Fabbriche Nuove*, in which the description of the buildings becomes more and more stenographic. Numerous views of the Piazza San Marco were done in this period, among which we should mention, for their high painting quality, at least those in the National Gallery in London, the Metropolitan Museum in New York, and the Accademia Carrara in Bergamo. All of these are characterized by a sharp division between the areas in shadow and those illuminated by a warm light, and by an unsually low vantage point, almost on a level with the pavement of the square, which forces the painter to place in the foreground figures that are quite large in proportion to the architecture.

This last characteristic disappeared in the works datable to the beginning of the next decade, when Guardi painted a large number of caprices, but also views like the one of *The San Marco Basin and The Island of San Giorgio Maggiore* in the Gallerie dell'Accademia in Venice. The latter work must be dated before 1774, the year of the collapse of the bell tower that here rises prominently to the left of the church of San Giorgio.

An important group of Guardi's works was painted at the end of the 1770s, the twelve *Festivities of the Doge* (Musée du Louvre, Paris) derived from the suite of engravings that Giovan Battista Brustolon made from drawings by Canaletto, which were probably published in their entirety only at the beginning of the 1770s.[80] It seems certain that these paintings were made on a commission from Doge Alvise IV Mocenigo, who held the highest political office in Venice from 1763 to 1778. This would thus be the first of three official commissions obtained by Guardi in this late phase of his activity. The dating of the *Festivities of the Doge* series to this decade is confirmed unequivocally by the style of the clothing worn by the female characters, which does not repeat slavishly that seen in Brustolon's engravings but is brought up to date to reflect the fashions being worn in Venice after 1775–76. A splendid effect is achieved, among these works, by the two very

Francesco Guardi
The Rialto Bridge
with the Palazzo dei Camerlenghi
72.2 x 120 cm
Munich, Alte Pinakothek

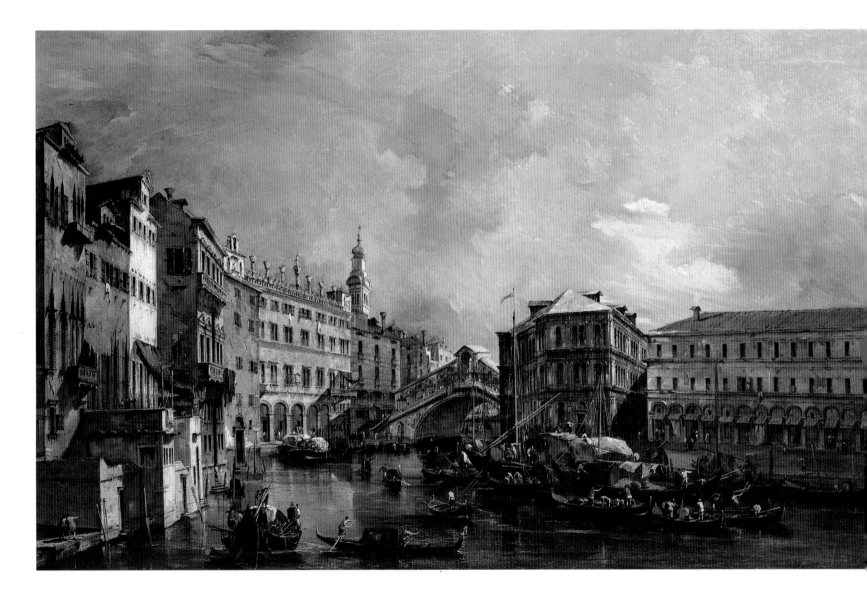

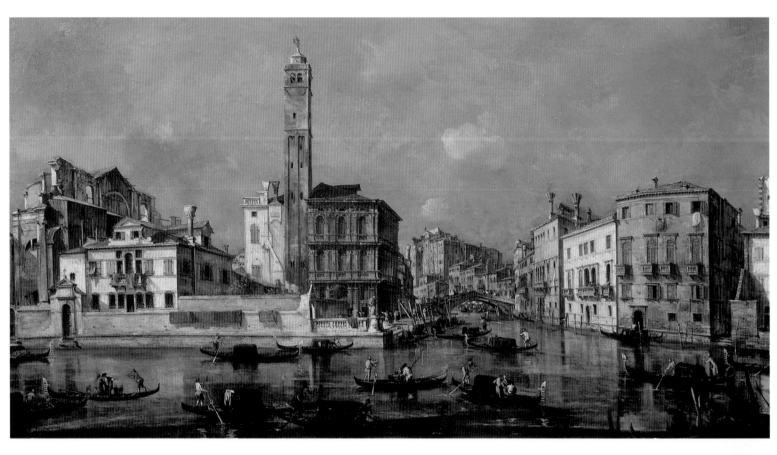

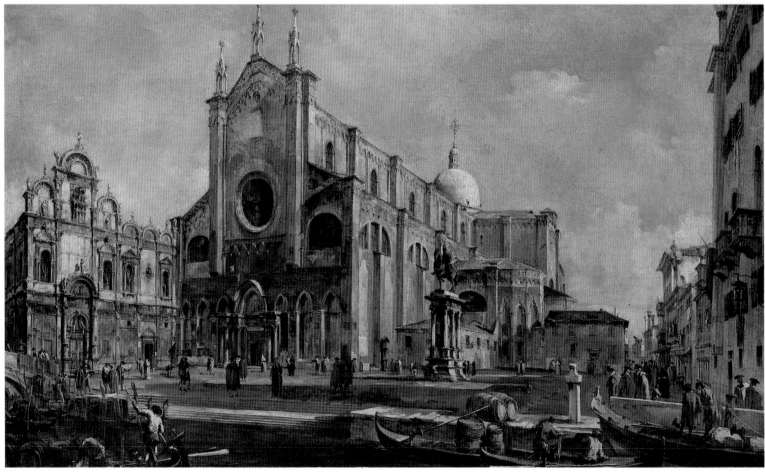

Francesco Guardi
The Grand Canal at the Fabbriche Nuove
56 x 75 cm
Milan, Pinacoteca di Brera

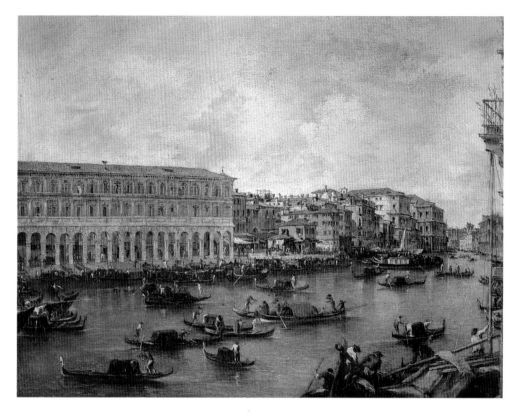

Francesco Guardi
The Grand Canal toward the Rialto Bridge
56 x 75 cm
Milan, Pinacoteca di Brera

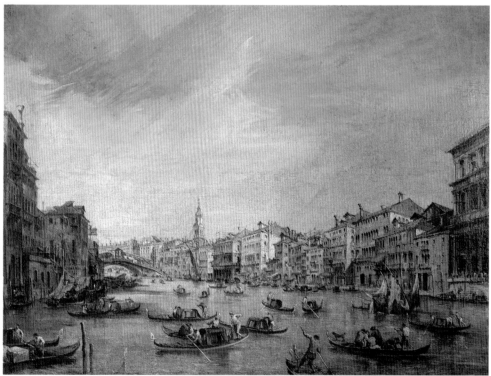

(opposite page)
Francesco Guardi
The Grand Canal at San Geremia
71.5 x 120 cm
Munich, Alte Pinakothek

Francesco Guardi
Campo Santi Giovanni e Paolo
75 x 120 cm
Paris, Louvre

lively images of *The Departure of the Bucintoro for the Lido* and *The Bucintoro in Front of San Nicolò*, marked by a crystalline chromatic quality.

Stylistically close to the canvases in the Louvre are some—the most beautiful—of the numerous views by Guardi now in the collection of the Gulbenkian Foundation in Lisbon. Particularly remarkable are the group of four showing

Francesco Guardi
St. Mark's Square
72.4 x 119 cm
London, National Gallery

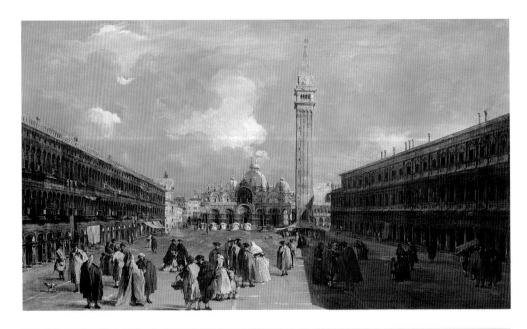

Francesco Guardi
The San Marco Basin
with the Island of San Giorgio Maggiore
69.5 x 93.5 cm
Venice, Gallerie dell'Accademia

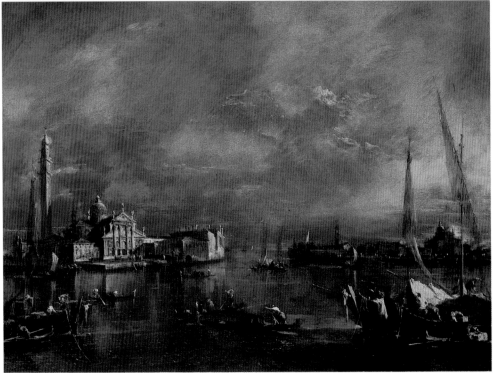

similar stylistic elements, representing *The Grand Canal from Ca' Foscari* during a regata, *The Departure of the Bucintoro, The Rialto Bridge as Designed by Andrea Palladio,* and *St. Mark's Square* with the temporary structures designed by the architect Bernardino Maccaruzzi for the Fair of the Ascension (the Sensa, to Venetians). Considering that this ephemeral apparatus, destined to house craftsmen's shops, was set up for the Sensa of 1777, this date must be considered valid for the execution of the entire group of views.

Two other public commissions were entrusted to Guardi in 1782, when he was called upon to produce a series of paintings commemorating the visit to Venice of Paul Petrovitz—the future tsar Paul I—and his wife Maria Teodorovna, who hid

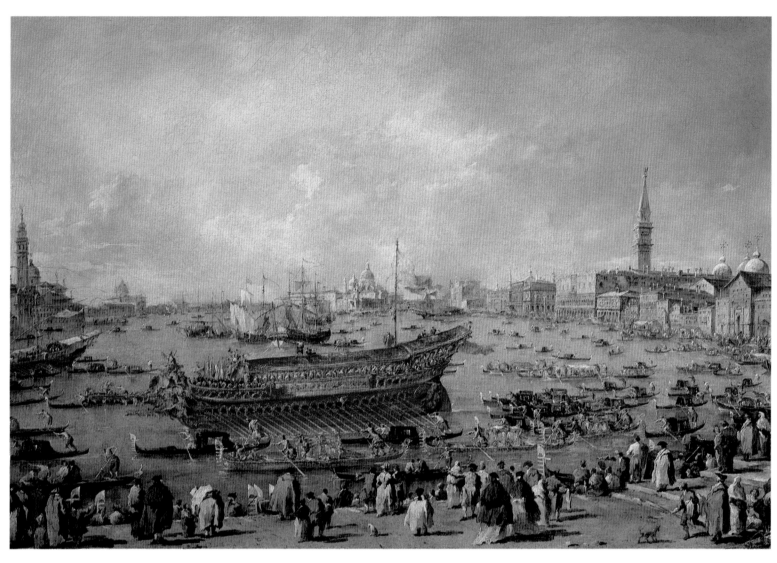

Francesco Guardi
The Departure of the Bucintoro for the Lido
66 x 100 cm
Paris, Louvre

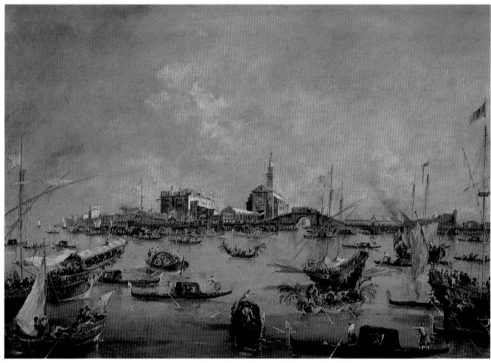

Francesco Guardi
The Bucintoro in Front of San Nicolò del Lido
67 x 100 cm
Paris, Louvre

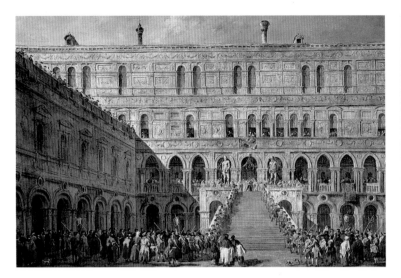

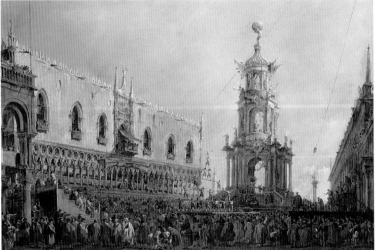

Francesco Guardi
The Coronation of the Doge at the Head of the Giants' Staircase
66 x 101 cm
Paris, Louvre

Francesco Guardi
The Jeudi Gras Festivities in the Piazzetta
67 x 100 cm
Paris, Louvre

Francesco Guardi
The Grand Canal from Ca' Foscari during a Regata
61 x 91 cm
Lisbon, Gulbenkian Foundation

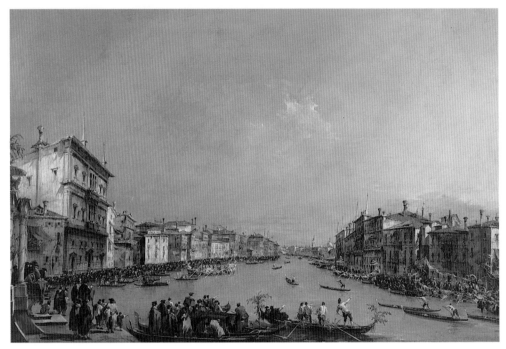

(opposite page)
Francesco Guardi
The Rialto Bridge as Designed by Andrea Palladio
Lisbon, Gulbenkian Foundation
Detail

their identity behind the pseudonym of Counts of the North, and a second series celebrating the visit of Pope Piùs VI. The canvases making up these two groups are now scattered among various collections, and a number of replicas exist of the second, certainly made for private patrons. Curiously, perhaps because the artist was forced to prepare a visual document, which was an unfamiliar task for him, some of the pictures are less well painted than others. But among them are some of Guardi's greatest masterpieces, such as the canvas of *Pius VI Blessing the Crowd in Campo Santi Giovanni e Paolo* (Ashmolean Museum, Oxford, U.K.), which shows the moment when the pontiff, from the height of a platform erected in front of the façade of the Scuola di San Marco, addresses the throng of people gathered in the square (in preparation for the arrival of a great crowd, the Rio dei Mendicanti had been covered with wooden planks). The multitude of onlookers is seen from behind, an expedient Guardi would use frequently in his late works and which we find again in masterpieces like *The Ascent of the Hot-air Balloon of Count Zambeccari*

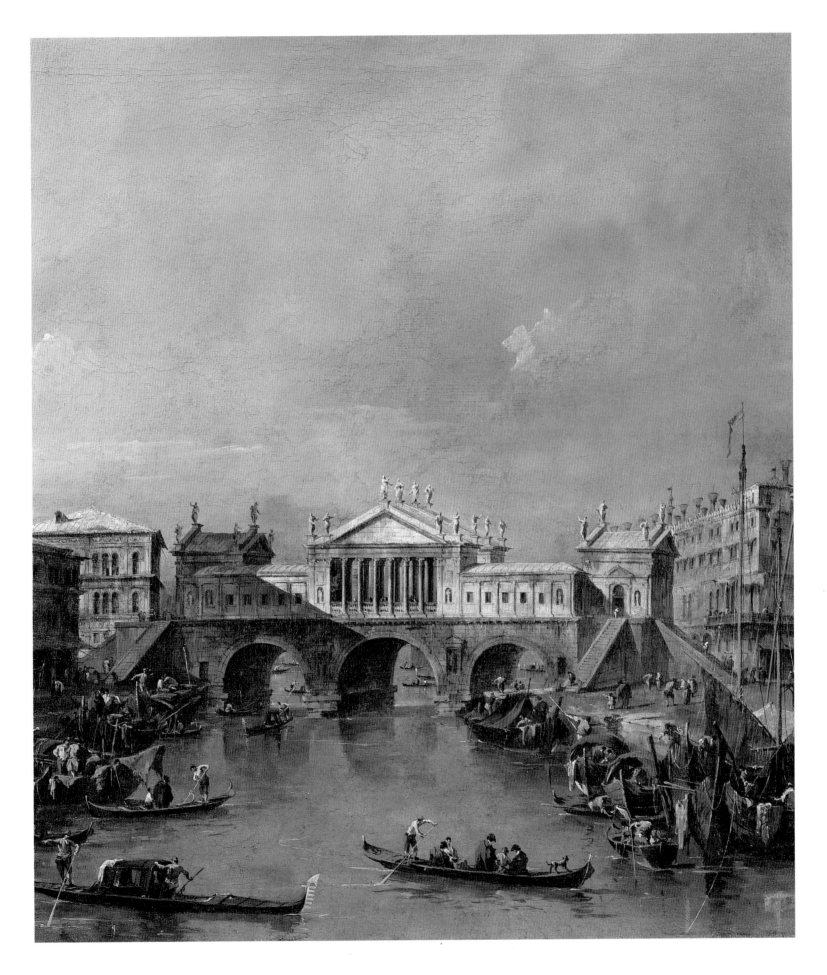

209

Francesco Guardi
*St. Mark's Square with
the Structures for the Feast
of the Sensa*
61 x 91 cm
Lisbon, Gulbenkian
Foundation

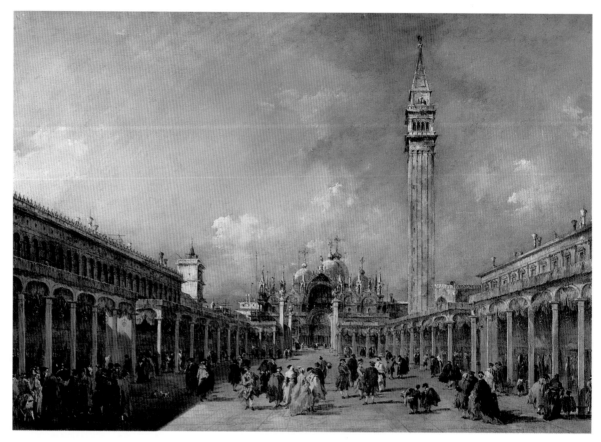

Francesco Guardi
*Pius VI Blessing the Crowd in
Campo Santi Giovanni e Paolo*
63.5 x 78.5 cm
Oxford, Ashmolean Museum

(opposite page)
Francesco Guardi
*The Ascent of the Hot-Air
Balloon of Count Zambeccari*
66 x 51 cm
Berlin, Staatliche Museen

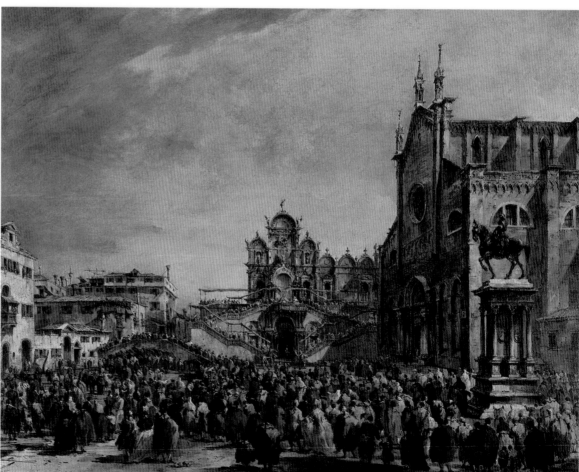

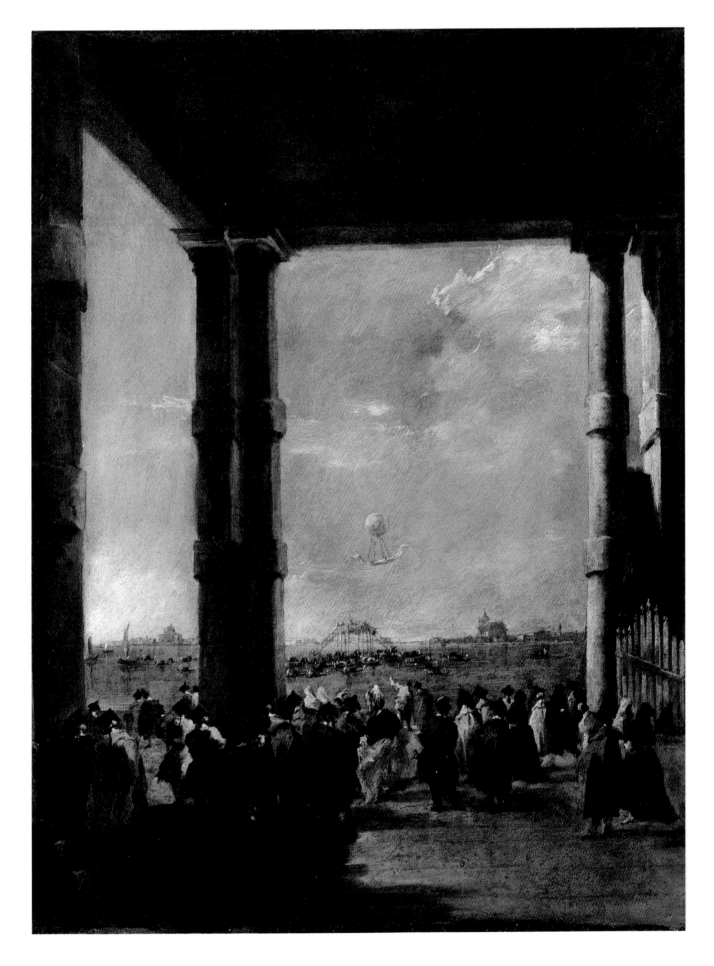

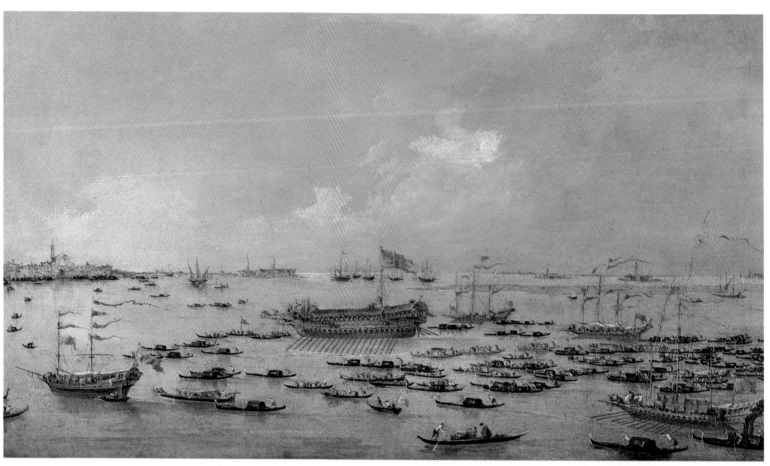

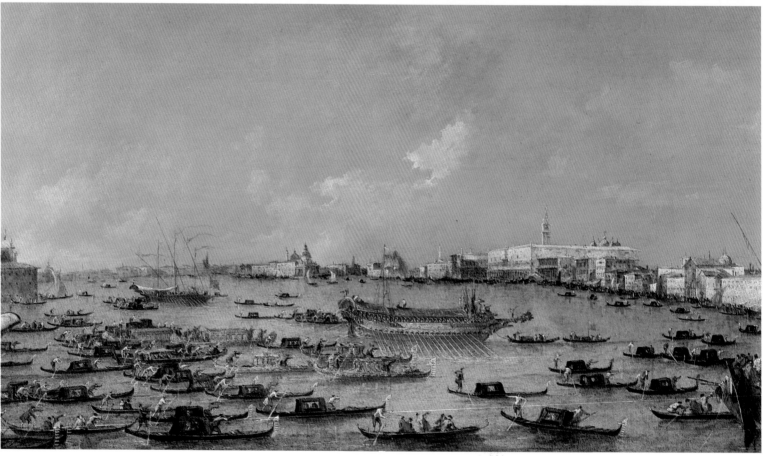

Francesco Guardi
The Piazzetta Facing San Giorgio Maggiore
45 x 72 cm
Venice, Ca' d'Oro

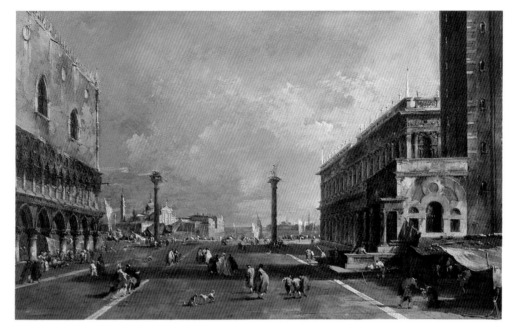

Francesco Guardi
The Dock with the Library
45 x 72 cm
Venice, Ca' d'Oro

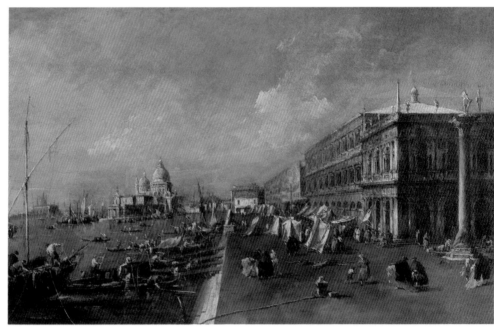

(opposite page)
Francesco Guardi
The Bucintoro on its Way to San Nicolò del Lido
50 x 80 cm
Milan, Private collection

Francesco Guardi
The Return of the Bucintoro
50 x 80 cm
Milan, private collection

(overleaf)
Francesco Guardi
Capriccio with Venice in the Background
38.5 x 54.3 cm
Private collection

of Berlin, of 1784, or the two versions of *The Fire in the Oil Warehouse of San Marcuola*, which occurred on December 19, 1789, now respectively in the Alte Pinakothek in Munich and the Gallerie dell'Accademia in Venice.

The series devoted to the visit of Pius VI to Venice includes the very fine canvas representing *The Meeting between the Pope and the Doge on the Island of San Giorgio in Alga* (private collection, Milan), which seems to anticipate the perhaps more famous masterpieces painted at the end of the 1780s in the last years of Francesco's life, *The Bucintoro on its Way to San Nicolò del Lido* and *The Return of the Bucintoro*, formerly in the Crespi collection. In these splendid works, the painter returns in his composition of the scenes to the images of the lagoon painted at the end of the 1750s or the beginning of the 1760s, when he was just beginning his activity as a view painter. The architecture delimiting impossibly wide vistas is just

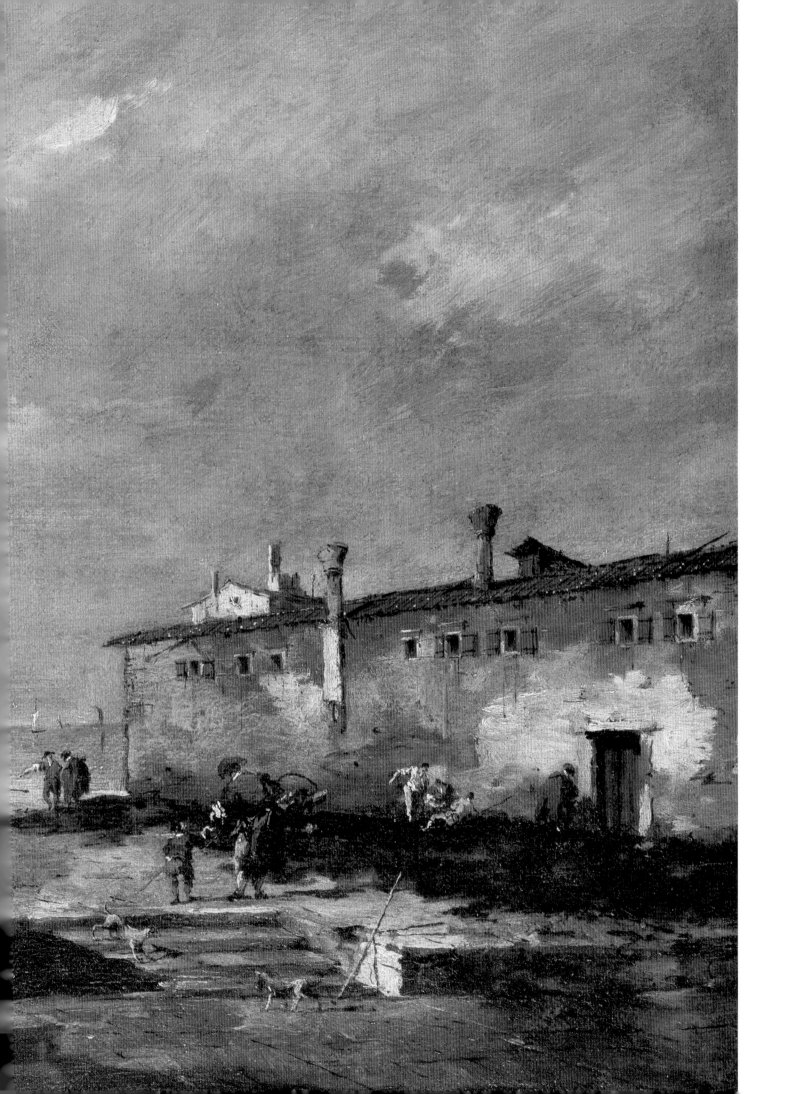

barely outlined, constituting only a thin line separating the blue of the sky sprinkled with a few white clouds from the soft green of the water plied by innumerable black gondolas escorting the magnificent ship of the Doge. Everything is a phantasmagoric vision of figures and boats immersed in a light that literally corrodes the contour lines of the forms.

Guardi reached similar heights of sublime poetry in some of his other final works. Among these are the pair in the Galleria Franchetti of the Ca' d'Oro in Venice, with images of *The Piazzetta toward San Giorgio Maggiore* and *The Dock with the Library and the Church of Santa Maria della Salute* in the background, and the two versions of the *Island of the Madonnetta* in the lagoon, now in the Fogg Art Museum in Cambridge, Massachusetts and the Gallerie dell'Accademia in Venice, all crystal clear and flooded with light. Even more noteworthy is the small *Rio dei Mendicanti* in the Accademia Carrara in Bergamo, where the architecture (see for example the detail of the sculpture at the top of the tympanum of the church, painted with an "open" brushstroke, without contour lines) is rendered in a pictorial shorthand of great fascination and charm. This stylistic element finds its counterpart in the airy, dissolving touch distinguishing the numerous drawings made at the same time, such as the very beautiful washed drawing now in the Museo Correr in Venice, showing the façade of the new *Teatro La Fenice*, designed by Giannantonio Selva and inaugurated on May 16, 1792, just seven months before the painter's death.

Guardi achieved the same poetic results in his last caprices, in some of which he seems to combine fantasy elements with others taken from Venetian reality. A splendid example is the scene depicted in a canvas in an English private collection, showing a stenographic view of the southern part of the city (recognizable are the church and bell tower of San Pietro di Castello) bathed in a dazzling light, seen

Francesco Guardi
The Teatro La Fenice
19.5 x 25.4 cm
Drawing
Venice, Museo Correr

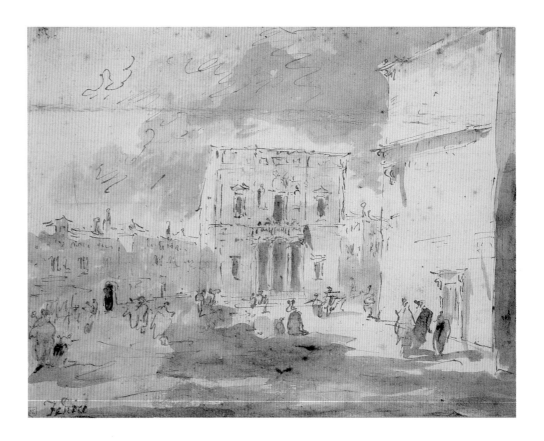

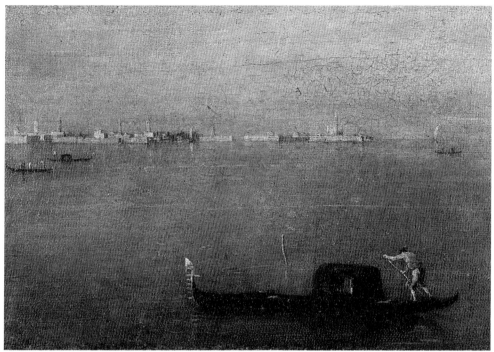

Francesco Guardi
The Rio dei Mendicanti
19.5 x 15 cm
Bergamo, Accademia Carrara

Francesco Guardi
The Gondola on the Lagoon
25 x 38 cm
Milan, Poldi Pezzoli

from a sort of *campiello* (small public square) on an island in the lagoon (perhaps the island of the Lido, toward San Nicolò), enclosed by sturdy walls on the left and a house on the right. Collectors would be entranced by these models, but too late for their impoverished author to benefit in his lifetime; his son, Giacomo, would work from them, and made of just this painting a smaller copy now in the National Gallery in London.

It has been said that these works, in the disintegration of their forms, seem the sad foreshadowing of an end that was drawing near—Francesco would die in January 1793, more than 80 years old. If this is true, then the disquieting *Gondola* in the Poldi Pezzoli in Milan, slipping solitary through the silent waters of the lagoon near the Fondamente Nuove in front of the islands of San Cristoforo and San Michele, can well be considered the supreme poetic emblem of a long and difficult life now nearing its close. The well-known letter written on June 23, 1804 by Pietro Edwards to Antonio Canova provides an almost cruel witness to this life: "You know however that this painter [Francesco Guardi] worked for his daily loaf of bread, bought rejected canvas with the worst quality of priming; and to get by day by day he used very oily paints, and painted a very thick first layer. Whoever buys his paintings must resign himself to losing them in a short time, and I personally would not guarantee that they would last another ten years."

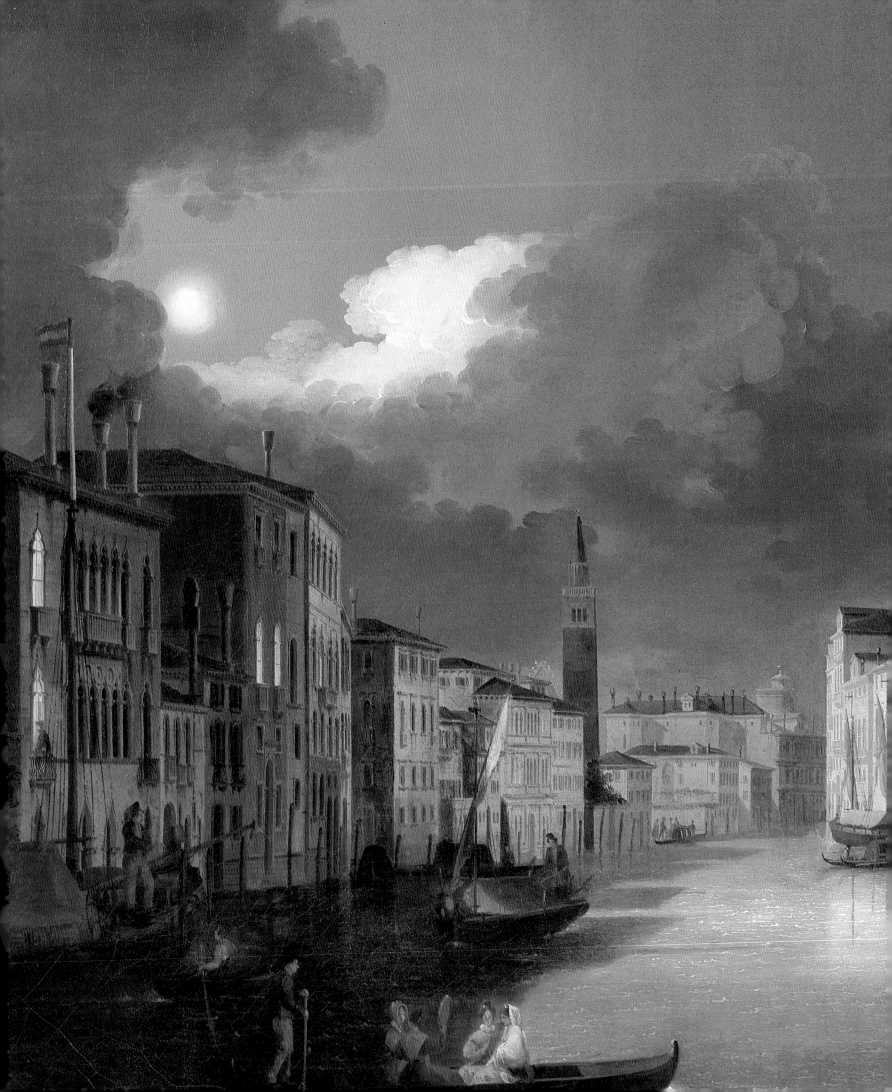

An Inglorious End?
Giacomo Guardi and Giuseppe Bernadino Bison

Giacomo Guardi

"He worked for his daily loaf of bread": Francesco must have left this same fate as his only legacy to his son Giacomo (Venice 1764–1835), who continued his father's activity well past the beginning of the new century, but without having either the elder's instinctive poetic vein or his inimitable talent as a painter. Indeed, for the most part his production is of veritable postcards, whose artistic dignity is severely limited. In particular, he produced an exorbitant number of drawings of little views, made in pen and ink and wash or tempera, for the man on the street, whose taste was not especially demanding. In addition to these little views are some rare images of the city painted on glass, like the two reproduced here, which are now in a private collection in Venice and represent respectively *The Customs House Point and the Island of San Giorgio* and *The Dock with the Doge's Palace* in the direction of the Riva degli Schiavoni.[81] Their attribution to Giacomo Guardi is proved by comparison with the drawings made in the final phase of his career, like the numerous sheets (more than two hundred, according to the most recent catalogues) that he sold between 1829 and 1830 to the collector Teodoro Correr and that are now in the Museo Correr in Venice, and those which belonged to the Bortolotto collection in Bassano del Grappa. The lively quality of the scenes is noteworthy in these two views painted on glass, marked by a clear, distinct line in the rendering of the architecture and great freshness of color.

To date, no canvas has been found signed by Giacomo Guardi, as opposed to the case with the drawings, which often bear the author's name on the back, along with his address "calle del peruchier" [alley of the barber] and the word "dimandar"—ask for him in the neighborhood—which was nothing more than a pathetic attempt at self-promotion. Perhaps as a result of this, over time he has been attributed a countless number of vaguely Guardesque paintings, some of them even with a "suspicious" dating (some are even the work of Poga, Corà, Zatterini, Visoni, i.e., the most skilled Guardi "imitators" in the late nineteenth and the twentieth centuries), which, being absolutely not attributable to Francesco, have at least found an easy name to "wear," one that can evoke, because of his father's fame, a kind of second-hand prestige. This totally

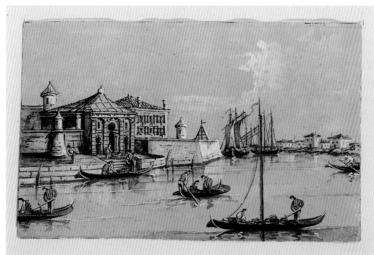 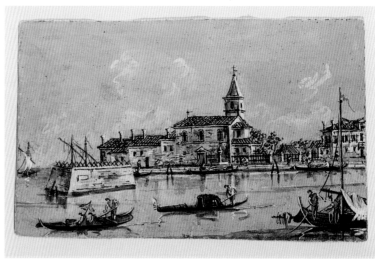

Giacomo Guardi
Four Little Views of the Lagoon
12.5 x 19 cm (each)
Drawings
Venice, Antichità Scarpa

unmerited reconstruction of the artistic figure of Giacomo has led critics to identify Francesco's son—even questionably sometimes thought to be a "counterfeiter" of his father's paintings—as a key culprit in the inglorious end of eighteenth-century Venetian view painting, which had previously been conducted on a very high plane.

While Giacomo cannot in any way be considered an artist of great talent, some paintings do exist which can reasonably be attributed to him and manifest a remarkable artistic level. This includes works like the canvas representing the water procession held in Venice for *The Triumphal Arrival of Napoleon Bonaparte* on November 29, 1807,[82] when the emperor of the French, escorted by viceroy Eugène Beauharnais and high court officials, was accompanied in triumph across the Grand Canal to the dock at the Piazzetta by a cortège of decorated gondolas and parade boats, repeating the kind of welcome reserved by the now-defunct Republic for its most prestigious visitors on the European political scene.

The painting technique reflects the manner typical of Francesco Guardi, thus completely different from those characterizing the work of Bison, Chilone, or Borsato, who are the most famous view painters active at the end of the 1800s, when the painting must have been done. The scene takes place in front of the Fabbriche Nuove at the Rialto, and the view sweeps along the entire bank of the

Giacomo Guardi
The Dock with the Doge's Palace
41 x 61 cm
(on glass)
Venice, Private collection

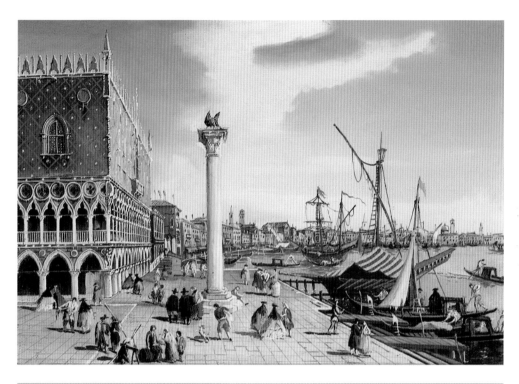

Giacomo Guardi
The Customs House Point
and the Island of San Giorgio
41 x 61 cm
(on glass)
Venice, Private collection

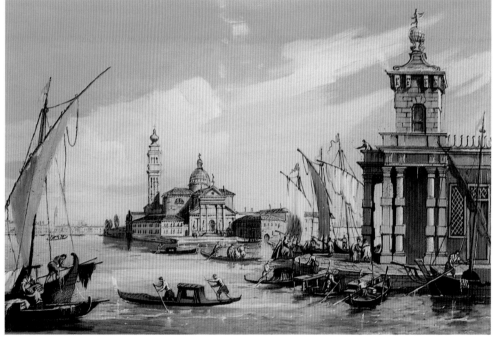

Grand Canal to Ca' Pesaro, glimpsed in the left background, with a framing that almost copies the one utilized by Francesco in a canvas now in a private collection in Bergamo,[83] which it also resembles in the dark tones used to paint the architecture. Particularly effective is the festive crowd of boats participating in the regata or tied up at the banks in great numbers, peopled with luminous, multicolored little figures painted with a truly astonishing ease of manner. These figures far surpass the stiff dummies, as motionless as pillars of salt, which populate the "postcards," mentioned above, and many other paintings that have been attributed to Giacomo over time.

Giacomo Guardi
The Triumphal Arrival of Napoleon Bonaparte
50 x 84 cm
Private collection

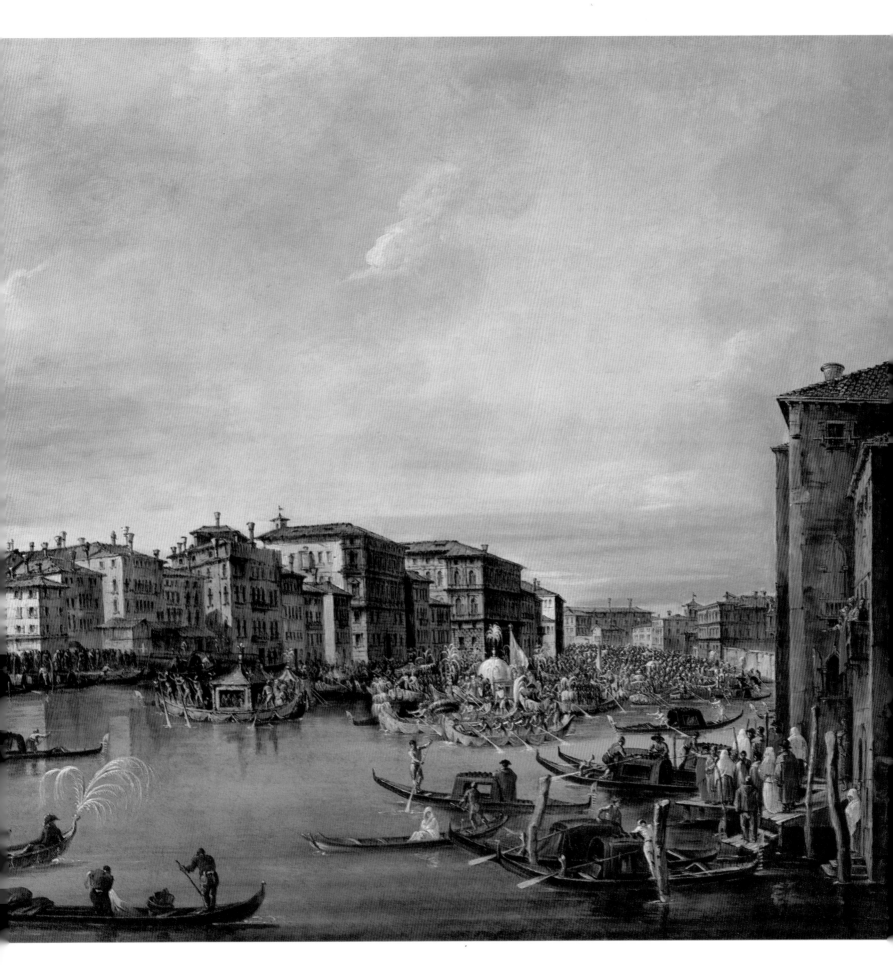

Giacomo Guardi
The Island of San Giorgio in Alga
16.8 x 24 cm
Private collection

Therefore, if this painting does belong to him, as seems beyond debate, then there is one more valid reason to rethink the artistic merit of Giacomo, rendering to him a dignity that has almost never been recognized in the past.[84] And this could open a new phase in Guardi studies, reversing the "negative" trend prevailing until now that has led critics to attribute to the son everything that could in no case be assigned to the father, because of a too-modest quality or the presence of elements in the views that were chronologically incompatible with Francesco's dates. What must be done now, instead, is to ascertain which ones of the great number of views and equally great number of caprices attributed to Francesco can be assigned to the neglected Giacomo. A starting point for such a task is the authentic mine of information and images that constitutes the two-volume work by Antonio Morassi on the Guardi brothers.

This operation of "cleaning out" Francesco's catalogue has in some measure already been attempted by recent critics, yielding appreciable results in the area of his graphic work.[85] Less has been done for the paintings, even if some of the attributions to Giacomo proposed by Dario Succi in his book on Francesco Guardi[86] seem to me completely endorsable. For example, the little views of the lagoon that appeared at Sotheby's in London on December 9, 1992, technically well painted but certainly not attributable to Francesco, and the views of the area around San Marco, largely replicas of Francesco's works but marked by a duller palette, a fairly generic handling of the figures, and a smaller size.

The same operation has been attempted for Nicolò Guardi, the younger brother of Antonio and Francesco, who was known to be a painter, but for whom no work, graphic or painted, has been found to date, either signed or documented. All that is known about him is some extensive biographical information:[87] he was born in Venice on December 9, 1715; he was married in 1738 to Cecilia dal Moro, from Murano, who was ten years older than he; he lived in the neighborhoods of Santa Marina, near Barbaria delle Tole, then Santa Maria

Formosa, and finally Santi Apostoli, even taking his older brothers into his house for certain periods, as he enjoyed a better financial position and was able to afford the fairly high rent of eighty ducats a year; and he died in 1786. It is not known in what genre he worked as an artist: he could equally have worked with Antonio, a figure painter, or Francesco, first a figure and then a view painter, or he could even have chosen a completely independent path.

Neither do the few notes on him contained in the literature of the late eighteenth century up to the middle of the nineteenth shed any definitive light on the problem. They tend to credit him with the authorship of a "little landscape sketched in pen on paper," the property of Canon Giovanni Vianelli of Chioggia. Or he is described as the holder "of a distinguished place in particular in the genre of perspective and landscape painting," alongside his brother Francesco, according to the testimony of a distant descendant from the Trentino region, pronounced, however, almost in the middle of the nineteenth century. An opposite—though not definitive—indication comes from a curious document dated April 24, 1754,[88] in which the youngest Guardi brother is surprisingly cited in an official document drawn up by a collaborator of the Avogadori di Comun with the nickname of "Nicolai Tiepolato." This could lead to the supposition that he carried out his activity within the circle of the very successful "enterprise" of his brother-in-law Giambattista Tiepolo (who as a very young man had married Cecilia, the sister of Antonio, Francesco, and Nicolò), thus working in an area completely different from view painting.

Given these premises, the recently initiated attempt to put together a catalogue of views by Nicolò, searching them out among the less successful works attributed to Francesco or among the numerous second-rate Venetian views that have appeared on the market over the years, is merely an academic exercise. It is obvious that if, instead of to Nicolò Guardi, we attributed these same pictures to, for example, Giuseppe Villotto or maybe to Ignazio Oliari—just some of the enormous

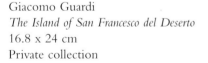

Giacomo Guardi
The Island of San Francesco del Deserto
16.8 x 24 cm
Private collection

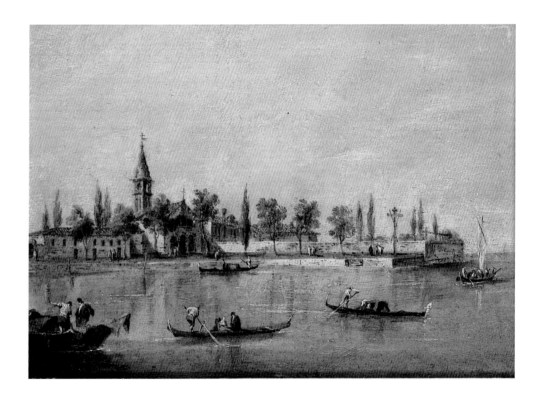

number of painters active in Venice during the eighteenth century for whom, as in the case of Nicolò Guardi, we know their names but not their works—the end result would not change one whit.

Giuseppe Bernardino Bison

In the variegated world of the view painters, a role of some prominence can also be assigned to Giuseppe Bernardino Bison (Palmanova 1762–Milan 1844). Bison is best known for his intense activity as a decorator in Venice, Padua, and around

Giuseppe Bernardino Bison
The Grand Canal from Palazzo Grimani Vendramin Calergi toward San Geremia
14.9 x 20.7 cm
Milan, Galleria Caiati

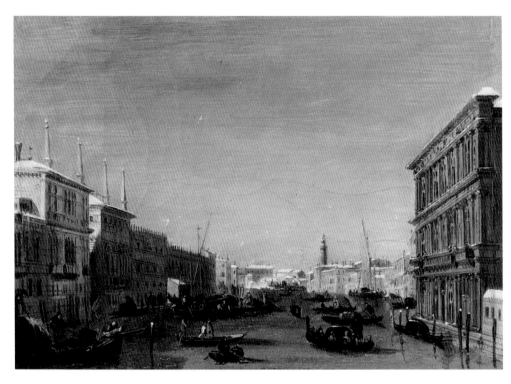

Giuseppe Bernardino Bison
The San Marco Basin
14.8 x 20.9 cm
Milan, Galleria Caiati

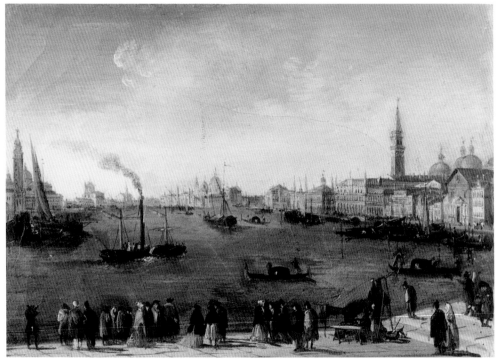

Treviso, but above all in Trieste and Milan, cities where he spent the last forty-five years of his life, working extensively also as a stage designer. It cannot be denied—despite the fact that he lived well into the nineteenth century—that Bison is a fully eighteenth century painter, both in training and in spirit. While in the field of grand interior decoration he looks to the work of Giambattista Tiepolo, as taught to him by Costantino Cedini, it is equally true that in the field of landscape and view painting his models are the great masters of the eighteenth century, from Marco Ricci to Giuseppe Zais to Canaletto.

Bison painted numerous views of Venice, for the most part small in size, in oils on canvas but also and above all in tempera on cardboard. The models are in the majority of cases the engravings made by Antonio Visentini of Canaletto's paintings, published in the *Prospectus Magni Canalis*. But these models are always interpreted and brought up to date by Bison, who takes advantage of the perspective framework used by Canaletto to insert figures and elements which are different or typical of his time. Good evidence of this procedure is a series of

Giuseppe Bernardino Bison
*The Grand Canal from Ca' Corner
della Ca' Granda toward the Scuola della Carità*
54.5 x 72.5 cm
Private collection

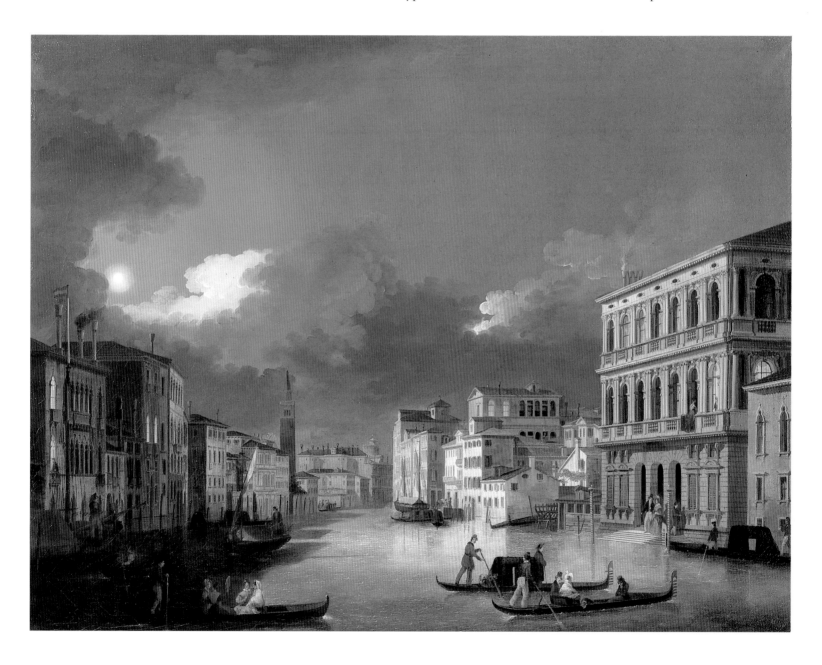

Giuseppe Bernardino Bison
The San Marco Basin
Private collection
Detail

five little canvases belonging to the Galleria Caiati in Milan, published by
Magani.[89] In one of these, showing *The Grand Canal from Palazzo Grimani
Vendramin Calergi toward San Geremia*, the painter eschews the solar atmosphere of
the original painting and the engraving derived from it to produce a rare image
of Venice in the winter, under a mantle of snow, made melancholy by a leaden
sky. In another, derived not from a print but from a Canaletto painting formerly
in the Erlanger collection in New York, he adds a very modern steamboat to the
boats filling *The San Marco Basin*.

Another Visentini engraving was the source for the view of *The Grand Canal from
Ca' Corner della Ca' Granda toward the Scuola della Carità* (private collection), in
which Bison gives a remarkable display of virtuoso painting, setting the scene at
night under a full moon and playing on the effects of the light bathing the right
of the painting, throwing into sharp relief the majestic buildings that make up the
parade of palaces, and leaving the entire left section in shadow. Also very close to
Canaletto's manner is the lovely image of *The San Marco Basin* with a wedding
procession on the water, painted in tempera,[90] adopting a composition tried out
on various occasions by the eighteenth-century master and reproducing at least in

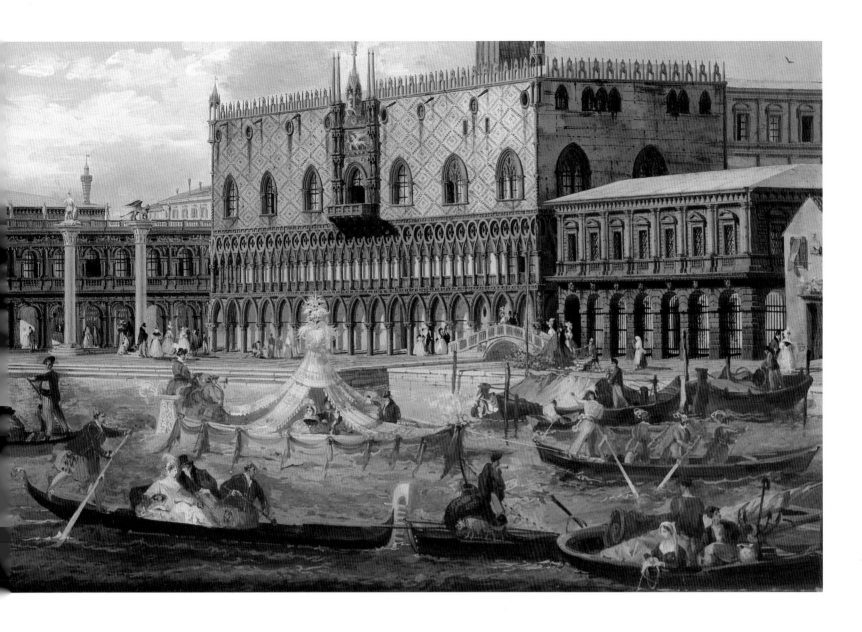

part the splendid luminous clarity of oil paintings. Elements within the painting—the presence of the Giardinetti Reali and the nearby buildings designed by Lorenzo Santi, completed in 1817, and of the church of the Ascensione, demolished in 1824—ensure that the view was painted by Bison during the years he was living in Trieste. Equally, these details indicate that the painter constantly brought up to date his figurative repertory based on the eighteenth-century engravings, perhaps in the course of periodic visits to Venice.

Once again a Canaletto model, engraved this time by Fabio Berardi, was the source for the unprecedented view of an island in the lagoon, now in the Regoli collection in Lucca.[91] The fact that Bison's composition follows the same orientation as the engraving, which is of course reversed with respect to the painting by Canaletto, now in the Uffizi, confirms the painter's typical working method, proceeding directly from prints, keeping up a practice dating to his days as a student at the Academy in Venice.

However, not only the engravings of Canaletto's canvases serve as models for Bison in the painting of his views. For example, two very fine works in the Salomon collection in Milan that recently appeared at an exhibition of Venetian

Giuseppe Bernardino Bison
Campo Santi Giovanni e Paolo Facing
the Scuola Grande di San Marco
63.5 x 78.7 cm
Milan, Private collection

Giuseppe Bernardino Bison
Campo Santi Giovanni e Paolo
Facing the Church
63.5 x 78.7 cm
Milan, Private collection

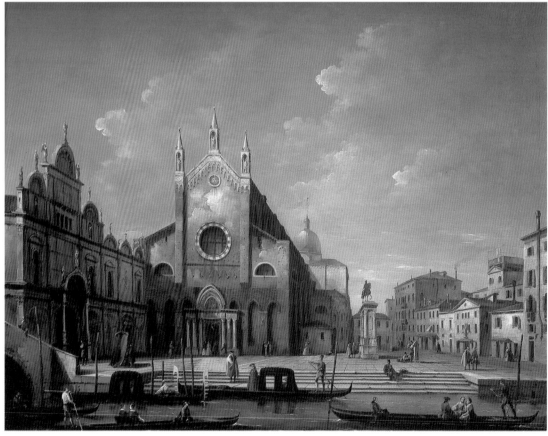

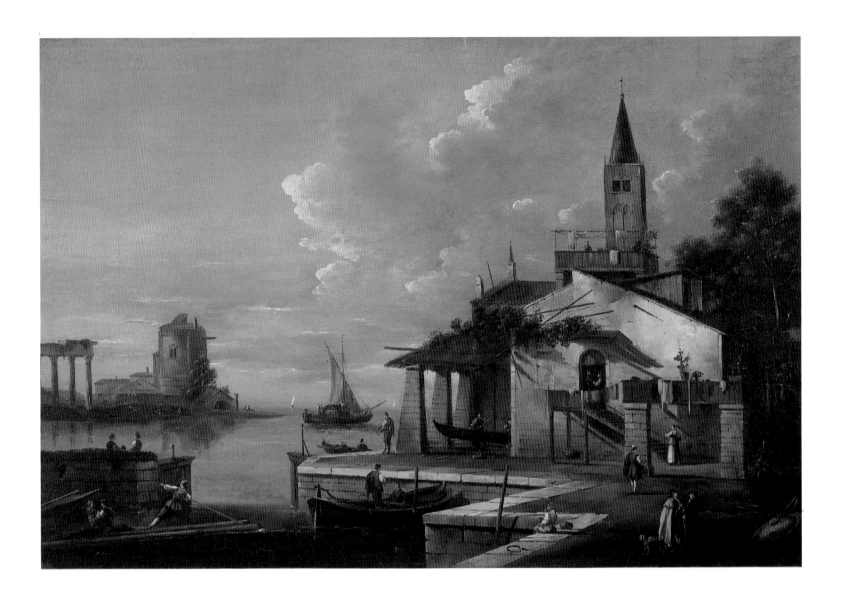

Giuseppe Bernardino Bison
View of an Island in the Lagoon
60 x 92 cm
Lucca, Private collection

painting held in Lodève,[92] which represent *Campo Santi Giovanni e Paolo*, looking toward the Scuola Grande di San Marco and toward the church, might in fact have their precedent in the early works of Bernardo Bellotto, from whom they derive the neatly defined structure of the architecture, the intense light flooding the scene, the sharply distinct play of light and shadow, and, partially, the structure of the figures.

Thus, with the "retro" figure of Bison, the splendid season of the eighteenth-century Venetian view painters draws to a close. It is an epic about which much is known, especially about the life and works of its leading protagonists. However, there still exist extensive areas where little has been unearthed, both concerning the so-called "minor painters" and the interrelationships between the painters, patrons, and the art world. These are, I believe, the elements on which critics must focus their attention in coming years, in order to know and appreciate more fully a phenomenon that is important not only for the great artistic heights it reached but also for the aspects of taste, culture, and even economics to which it bears witness.

Endnotes

[1] F. Montecuccoli degli Erri, "Il mercato dei quadri a Venezia nel XVIII secolo," in F. Montecuccoli degli Erri and F. Pedrocco, *Michele Marieschi. La vita, l'ambiente, l'opera* (Milan: 1999), pp. 11-18. See also in the same book, specifically concerning Michele Marieschi, the chapter entitled "Matrimonio di Marieschi e relative implicazioni," pp. 58-64.

[2] Montecuccoli degli Erri 1999, "Il mercato," pp. 20-21.

[3] A. Scarpa Sonino, *Marco Ricci* (Milan: 1991), cat. 014, p. 117.

[4] S. Mason, in *Venezia da Stato a mito,* exhibition catalogue (Venice: 1997), entry no. 345, p. 352.

[5] M. Nappi, François de Nomé e Didier Barra, *L'enigma di Monsù Desiderio* (Rome: 1991).

[6] Oil on canvas, 55.5 x 72.7 cm.

[7] In the catalogue devoted to Carlevaris published by the City of Padua in 1994, Dario Succi presented two canvases—representing respectively Piazza San Marco with *commedia dell'arte* actors beneath the bell tower and a view of San Nicolò di Castello (private collection, each one measuring 60 x 72 cm; cat. nos. 21 and 22)—which in his view furnish proof that the artist was directing his activity toward views of Venice already in the years when he was making the preparatory drawings for his collection of engravings printed in 1703, in other words before 1700. Succi cites as support for his hypothesis the fact that "the stiffness of the rendering of the architecture, which suggests the use of a ruling pen, recalls the absolute representation of his series of engravings," and that the unusual subject of the second painting appears in a similar form also in the engravings (plate 29), so that it is possible that the engraving derives from the painting. It goes without saying that this hypothesis, although there is no positive evidence refuting the possibility that Luca painted views before 1703, is based on premises that are clearly rather weak; in fact, it is also possible that the paintings are derived from the engravings rather than the contrary, and it does not seem that the two canvases in question show stylistic elements that are significantly more precocious than those that appear, for example, in *The Entrance of Ambassador de Pomponne*, in the Rijksmuseum in Amsterdam, which certainly dates to 1706.

[8] G. Briganti, *Gaspar Van Wittel e l'origine della veduta settecentesca* (Rome: 1966), pp. 236-242.

[9] Oil on canvas, 54 x 106.5 cm.

[10] Oil on canvas, each one 31.5 x 59.5 cm.

[11] According to Mauroner ("Collezionisti e vedutisti settecenteschi a Venezia," in *Arte Veneta* [1947], p. 49), he could be the Apollonio Domenichini who appears enrolled in the Guild of Venetian Painters in 1757.

[12] On Richter, see especially I. Reale, "Gio. Richter, svezzese, scolare di Luca Carlevarijs," in *Luca Carlevarijs e la veduta veneziana del Settecento*, exhibition catalogue (Milan: 1994), pp. 115-128, and especially E. Martini, "Note e precisazioni sul vedutista Johann Richter," in *Arte Documento*, 1994.

[13] E. Martini, *La pittura del Settecento veneto* (Udine: 1982), p. 490.

[14] Oil on canvas, 42 x 65 cm.

[15] R. Pallucchini, *La pittura nel Veneto. Il Settecento*, vol. 1 (Milan: 1995), p. 189.

[16] Martini 1982, p. 490, fig. 486. The canvas is a large one, measuring 91.8 x 127.3 cm.

[17] Oil on canvas, 59 x 97 cm; the painting was published by A. Rizzi in *Luca Carlevarijs* (Venice: 1967), p. 91.

[18] G. Fiocco, "Giovanni Richter," in *L'Arte* (1932), p. 13.

[19] A. Morassi, "Preludio per Antonio Stom detto 'Il Tonino,'" in *Pantheon*, 1962, pp. 291-306.

[20] R. Pallucchini, "Appunti per il vedutismo veneziano del Settecento," in *Muzeum i twòrka. Studiaz historii sztuki i kultury ku czci prof. Dr. Stanislawa Lorentza* (Warsaw: 1969), pp. 141-155.

[21] See in particular the additions proposed by M. Mosco, "Minori del Settecento veneto. Jacopo Fabris," in *Arte Illustrata* (1974), pp. 82-97.

[22] E. Povoledo, "La scenografia architettonica del Settecento a Venezia," in *Arte Veneta* (1951), p. 126.

[23] G.M. Pilo, *Marco Ricci*, exhibition catalogue (Venice: Bassano del Grappa 1963), p. XXXV.

[24] F. Montecuccoli degli Erri, "Committenze artistiche di una famiglia patrizia emergente: i Giovanelli e la villa di Noventa Padovana," in *Atti dell'Istituto Veneto di Scienze, Lettere ed Arti* (1992-1993), pp. 731-736.

[25] L. Puppi, "La gondola per procuratore. Committenza e peripezie di collezione di quattro dipinti di Canaletto," in *Bollettino dei Musei Civici Veneziani*, 1983-84, pp. 5-20. We must point out, however, that the numerous inventories made during the eighteenth century of the Sagredo collections do not list these works.

[26] R. Pallucchini, *La pittura veneziana del Settecento* (Bologna: University of Bologna, Italy, academic year 1951-52), p. 100.

[27] F. Pedrocco, "Gli anni giovanili del Canaletto. Le vedute già Liechtenstein," in *Canaletto & Visentini tra Venezia & Londra,* exhibition catalogue (Gorizia and Venice: 1986), pp. 27-32.

[28] M. Levey, "The Eighteenth Century Italian Paintings Exhibition at Paris: Some Corrections and Suggestions," in *The Burlington Magazine*, (April 1961): pp. 139-143.

[29] G. Moschini, *La Chiesa e il Seminario della Salute* (Venice: 1842), p. 35.

[30] The many worthy studies by A. Corboz devoted to Venetian view painting and to Canaletto in particular are listed in the general bibliography. Most recently, see: "Profilo per un'iconografia veneziana," in *Luca Carlevarijs e la veduta veneziana del Settecento* (Milan: 1994), pp. 21-34.

[31] The notebook was published for the first time in a facsimile edition by T. Pignatti, *Il quaderno dei disegni del Canaletto alle Gallerie di Venezia* (Milan: 1958); a recent new edition, edited by G. Nepi Sciré, is *Il quaderno del Canaletto* (Venice: 1997).

[32] Concerning this building, it has always been said that Smith lived there from the beginning and that he purchased it from a noblewoman from the Balbi family. This is not in fact the case: Smith, before purchasing the house in 1740, lived as a tenant in another building owned by the Balbi family, behind this one. He moved into the little palace only after the work was done, in 1753, and not in 1751 as has always been maintained (see F. Montecuccoli degli Erri, "Il console Smith. Notizie e documenti," in *Ateneo Veneto* (1995), pp. 136-142; 165-167).

[33] Oil on canvas, 68.3 x 115.5 cm.

[34] *Illustrated Catalogue of 100 Paintings of Old Masters of the Dutch, Flemish, Italian, French, and English Schools Belonging to the Sedelmeyer Gallery* (Paris: 1894), p. 71, no. 59. Oil on canvas, 53.4 x 70.8 cm.

[35] Oil on canvas, 56.8 x 102.3 cm.

[36] E. Schleier, "Sigismund Streit," in *Canaletto. Dipinti—disegni—engravings,"* exhibition catalogue (Venice, Vicenza: 1982), pp. 84-85.

[37] The dating of the views of Verona to Bellotto's last Venetian sojourn has been authoritatively confirmed by A. Bettagno, "Il Bellotto 'italiano,'" in *Bernardo Bellotto. Verona e le città europee,* exhibition catalogue (Verona, Milan: 1990), pp. 13-19.

[38] A.B. Kowalczyk, "Il Bellotto veneziano: 'grande intendimento ricercasi,'" in *Arte Veneta* (1996), p. 71.

[39] T. Pignatti, "Gli inizi di Bernardo Bellotto," in *Arte Veneta* (1966), pp. 218-229.

[40] D. Succi, "Bernardo Bellotto nell'atelier di Canaletto e la sua produzione giovanile a Castle Howard nello Yorkshire," in *Bernardo Bellotto detto il Canaletto,* exhibition catalogue (Mirano, Venice: 1999), p. 37.

[41] Oil on canvas, 62 x 98 cm.

[42] In the catalogue of the exhibition *Bernardo Bellotto 1722-1780* (Milan: 2001, edited by A.B. Kowalkzyk and M. da Cortà Fumei), which opened at the Museo Correr in Venice in February 2001, C. Beddington (p. 78, no.11) presented

another version of this painting, which from the photograph (oddly, the canvas is presented in the catalogue but is not actually present in the show) seems to be of very high quality, besides being distinguished from the other in certain aspects, i.e, several figures and the presence of sculptures on the pediment of the church of San Stae. Beddington maintains that the other version (the one I reproduce here, which was published for the first time as the work of Bellotto not by me, as is indicated in the catalogue, but by T. Pignatti in *Venezia. Mille anni d'arte*, Venice: 1989, p. 324) is "a life-sized copy" of the one he presents. The reason for the demotion of the painting lies in the observation—suggested to Beddington by one of the curators of the exhibition, A.B. Kowlakzyk—that it shows "in the far distance the bell tower of the church of San Bartolomeo in the form it assumed in 1754." I believe that all this is the result of a quite banal misunderstanding, probably due to a lack of familiarity with the places represented: it is in fact obvious—as anyone can easily ascertain by examining the reproduction of the painting on pages 7 and 8 of this book—that in reality the bell tower of San Bartolomeo does not appear in this picture, while the only bell tower which is indeed present (and appears exactly as it does also in the canvas published by Beddington) is the one belonging to the church of San Cassiano, which can be glimpsed behind the imposing mass of Ca' Pesaro.

[43] A. Cottino, in *Mostra di antichi pittori italiani ed europei XV-XVIII secolo*, (Vicenza: 2000), entry no. 16; oil on canvas, 76x128 cm.

[44] On the questions of the autograph nature of the figures in the eight canvases in Palazzo Contarini, see the varying positions of V. Sgarbi, "Le impossibili ville," in *F.M.R.* (December 1983), with an attribution to Gaspare Diziani, and of A. Delneri, "Ammirevole inganno di fantasie architettoniche," in *Canaletto & Visentini tra Venezia & Londra* (1986), pp. 53-69, in which the author demonstrates irrefutably Visentini's authorship of the characters.

[45] These notes are part of my essay entitled "Qualche ipotesi per Antonio Visentini pittore ed architetto," in a forthcoming volume of studies in memory of Rodolfo Pallucchini.

[46] Oil on canvas, 70 x 122 cm, Venice, private collection.

[47] For all references to Michele Marieschi, we refer readers in particular to the recent monograph by F. Montecuccoli degli Erri and F. Pedrocco, published in Milan in 1999, which contains the most up-to-date bibliography.

[48] D. Succi, "Bernardo Bellotto nell''atelier' di Canaletto e la sua produzione giovanile a Castle Howard nello Yorkshire," in *Bernardo Bellotto detto il Canaletto*, exhibition catalogue (Mirano, Venice: 1999), pp. 23-73.

[49] R. Pallucchini, "Francesco Albotto, erede di Michele Marieschi," in *Arte Veneta* (1972), pp. 222-223.

[50] M. Manzelli, "Ulteriori notizie su Francesco Albotto, erede di Michele Marieschi," in *Arte Veneta* (1984), pp. 210ff.; Manzelli, "Proposta per l'identificazione di Michele Marieschi e del suo alter-ego Francesco Albotto," in *Arte Veneta* (1987), pp. 111ff.; Manzelli, *Michele Marieschi e il suo alter-ego Francesco Albotto* (Venice: 1991).

[51] F. Montecuccoli degli Erri, "Angela Fontana e Francesco Albotto," in Montecuccoli degli Erri and Pedrocco, Michele Marieschi, pp. 86-101.

[52] M. Manzelli, *Antonio Joli. L'opera pittorica* (Venice: 1999).

[53] New documentary elements concerning Joli's life and his relationship with Francesco Battaglioli are contained in F Montecuccoli degli Erri, "Novità su alcuni pittori immigrati a Venezia nel Settecento e sui loro contatti professionali (Battaglioli, Joli, Zompini, Simonini, Zuccarelli e altri)," soon to be published in *Arte Veneta*.

[54] D. Succi, "Antonio Joli e Gaspare Diziani per l'ingresso del Nunzio Apostolico Stopani nel 1741," in *Luca Carlevarijs e la veduta veneziana del Settecento*, exhibition catalogue (Padua, Milan: 1994), pp. 81-85.

[55] E. Garberson, *The Collection of the National Gallery of Art. Italian Paintings of the Seventeenth and Eighteenth Century* (New York and Oxford: 1996), pp. 334-340.

[56] The reconstruction of Fabris's biography is the work in particular of M. Mosco, "Minori del Settecento veneto. Jacopo Fabris," in *Arte Illustrata* (1974), pp. 82-97.

[57] A. Morassi, "Anticipazioni per il vedutista Jacopo Fabris," in *Arte Veneta* (1966), pp. 279-281.

[58] R. Pallucchini, *La pittura nel Veneto. Il Settecento*, vol. II, (Milan: 1996), pp. 301-302.

[59] This and other information about Cimaroli's life is taken from the recent contribution by F. Spadotto, "Un artista dimenticato: Giovan Battista Cimaroli," in *Saggi e Memorie di Storia dell'Arte* (1999), pp. 131-187.

[60] J.F.B. Watson, "G.B. Cimaroli: A Collaborator of Canaletto," *The Burlington Magazine* (June 1953), pp. 205-207; A. Morassi, "Saggio su G.B. Cimaroli, collaboratore di Canaletto," in *Arte Veneta* (1972), pp. 167-176.

[61] R. Pallucchini, *La pittura nel Veneto. Il Settecento*, vol. II, (Milan: 1996), p. 295; the picture in Scotland was attributed to Cimaroli by C. Donzelli, *I pittori veneti del Settecento* (Florence: (1957), p. 69, fig. 91.

[62] Spadotto, 1999, pp. 133, 137.

[63] M. Battagia, *Storia dell'anno 1740* (Venice: 1844), p. 10, quoted in D. Succi, 1994, p. 79.

[64] W.G. Constable, *Canaletto* (Oxford: 1962), p. 227.

[65] The scanty biographical information we have for this painter is the fruit of the research of M. Stefani Mantovanelli, "Note d'archivio su Franceso Tironi," in *Arte Veneta* (1969), pp. 253-254.

[66] T. Pignatti, "Per i disegni di Francesco Tironi (c. 1/45-97)," in *Studi in onore di Giulio Carlo Argan* (Rome: 1984).

[67] H. Voss, "Ein vergessener venezianischer Vedutenmaler," in *Zeitschrift für Bildende Kunst* (1927-28), pp. 266-270. His subsequent contribution ("Francesco Gurardi und Francesco Tironi," in *Pantheon*, (1966), pp. 100-104), aimed at assigning to Tironi some views of the lagoon attributable to Francesco Guardi, has been refuted virtually unanimously by critics.

[68] J. Lauts, *Staatliche Kunsthalle Karlsruhe. Katalog Alte Meister bis 1800* (Karlsruhe: 1966), p. 96.

[69] G. Borghero, *Mythos Venedig. Venezianische Veduten des 18. Jahrhunderts*, exhibition catalogue (Baden, Milan: 1994).

[70] D. Succi, "Il sottile fascino di un anonimo veneziano," in G. Borghero, 1994, p. 45.

[71] G. Knox, "Four Canaletti for the Duke of Bolton," *Apollo* (1993), p. 246.

[72] S. Kozakiewicz, *Bernardo Bellotto* (Milan: 1972), p. 395.

[73] R. Kultzen and M. Reuss, *Venezianische Gemälde des 18. Jahrhunderts* (Munich: 1991), pp. 40-44.

[74] G. Busetto, *Cento scene di vita veneziana. Pietro Longhi e Gabriel Bella alla Querini Stampalia* (Venice: 1995), p. 12.

[75] V. Sgarbi, *Venezia felix. Gabriel Bella cronista della Serenissima*, (Milan: 1984), p. 10.

[76] On Antonio and his relationship with his brothers, see especially F. Pedrocco and F. Montecuccoli degli Erri, *Antonio Guardi* (Milan, 1992).

[77] N. Rasmo, "Osservazioni e proposte sulla formazione pittorica dei Guardi," in *Problemi guardeschi* (Venice: 1967).

[78] In effect, that Francesco Guardi was a student of Canaletto is an item of information that reappears more than once in the art history literature of the end of the eighteenth and beginning of the nineteenth centuries, being reported also by Lanzi (*Storia pittorica della Italia* (Bassano: 1795-96), p. 180 and Aglietti (in his *Giornale*, 1798). The *Dizionario Biografico Universale* (XXVI, 1826, p. 421), published in Venice and edited by Giovan Battista Missiaglia, goes so far as to state that "he was a contemporary of Antonio Canal, also known by the name of Canaletto, and walked in his footsteps; but he did not have either the skill at

draftsmanship nor the reason in his art, that were supreme in the intellect and the hand of the master. The latter sometimes gave him an already-drawn canvas for him to paint; reserving for himself the final touches, so that there could be no doubt as to who was the author." But this is—probably—a comment aimed at exalting the greatness of Canaletto over any possible "competitor," and in any case there have not yet been found any views of Venice which give evidence of collaboration between Antonio and Francesco.

[79] D. Succi, *Francesco Guardi. Itinerario dell'avventura artistica*, (Milan: 1993), p. 29.

[80] Succi, 1993, p. 87.

[81] Tempera on glass, 41 x 61cm each.

[82] Oil on canvas, 50 x 84 cm, private collection.

[83] Reproduced in A. Morassi, *I Guardi. I dipinti* (Milan: 1975), fig. 537.

[84] But on the hypothesis of a new evaluation of the figure of Giacomo, see also A. Dorigato, *L'altra Venezia di Giacomo Guardi* (Venice: 1977), p. 12, and M. Muraro, "Giacomo Guardi," in *Coloquio Artes*, (1974), p. 6.

[85] I refer in particular to the contribution by T. Pignatti on the large deposit of Guardi drawings in the Museo Correr in Venice, where the scholar has properly identified numerous works by Giacomo among those traditionally attributed to Francesco (T. Pignatti, A. Dorigato, and F. Pedrocco, *Disegni antichi del Museo Correr di Venezia*, vol. III [Vicenza: 1983]).

[86] D. Succi, 1993, pp. 167-190.

[87] In particular: F. Montecuccoli degli Erri, "Vicende private dei Guardi: nuovi documenti," in F. Pedrocco and F. Montecuccoli degli Erri, *Antonio Guardi* (Milan: 1992), pp. 58-60.

[88] F. Pedrocco, "Qualche novità per Antonio, Francesco e Nicolò Guardi," in *Fima Antiquari* (1994), no. 5, pp. 54-59.

[89] G. Bergamini, F. Magani, and G. Pavanello, eds., *Giuseppe Bernardino Bison pittore e disegnatore*, exhibition catalogue (Milan: 1997); F. Magani, *Giuseppe Bernardino Bison (1762-1844)* (Milan: 1998), pp. 20-29.

[90] F. Magani, in *Ottocento di frontiera*, exhibition catalogue (Gorizia, Milan: 1995), p. 122, entry no. 81.

[91] Oil on canvas, 60 x 92 cm.

[92] *Peintres de Venise. De Titien à Canaletto dans les collections italiennes*, exhibition catalogue (Lodève, Milan: 2000), nos. 79 and 80.

Bibliography

The bibliography on the Venetian view painters—especially on its leading figures—is extremely vast. Thus, for reasons of space, we have listed only the most recent contributions or those which are considered fundamental contributions to the literature on this subject.

Aikema, B., and B. Bakker. *Painters of Venice. The Story of the Venetian "Veduta,"* (exh. cat.). Amsterdam, 1990.

Barcham, W.L. "Canaletto and a Commission from Consul Smith." *Art Bulletin*, 1977.

Battagia, M. *Storia dell'anno 1740.* Venice, 1844.

Bernardo Bellotto. *Le vedute di Dresda.* Edited by A. Bettagno. (exh. cat.). Venice, 1986.

Bernardo Bellotto. *Verona e le città europee.* Edited by S. Marinelli. (exh. cat.). Milan, 1990.

Bernardo Bellotto detto il Canaletto. Edited by D. Succi. (exh. cat.). Venice, 1999.

Bernardo Bellotto 1722-1780. Edited by A.B. Kowalkzyk and M. da Cortà Fumei. (exh. cat.). Milan, 2001.

Binion, A. *La Galleria scomparsa del Maresciallo von der Schulenburg.* Milan, 1990.

Bleyl, M. *Bernardo Bellotto gennant Canaletto.* Darmstadt, 1981.

Brandi, C. *Canaletto.* Milan, 1960.

Borghero, G. *Collezione Thyssen Bornemisza.* Catalogue raisonné. Milan, 1986.

——. *Mythos Venedig. Venezianische Veduten des 18. Jahrunderts.* (exh. cat). Milan, 1994.

Briganti, G. *Gaspar Van Wittel e l'origine della veduta settecentesca.* Rome, 1966.

——. *I vedutisti.* Milan, 1968.

——. "Van Wittel e i rapporti con il 'vedutismo' veneziano." *Rappresentazione artistica e rappresentazione scientifica nel secolo dei lumi.* Venice, 1970.

Brunetti, E. "Per gli inizi di Luca Carlevarijs," *Arte Veneta.* 1956.

Byam Shaw, J. "Guardi and the Royal Academy." *The Burlington Magazine*, 1955.

Camesasca, E. *L'opera completa del Bellotto.* Milan, 1974.

Canaletto. Edited by K. Baetjer e J.G. Links. (exh. cat.). New York, 1989.

Canaletto. Disegni, dipinti, incisioni. Edited by A. Bettagno. (exh. cat.). Venice, 1982.

Canaletto & Visentini, Venezia & Londra. Edited by D. Succi. (exh. cat.). Mestre, 1986.

Capricci veneziani del Settecento. Edited by D. Succi. (exh. cat). Turin, 1988.

Catalogo dei quadri esistenti in casa del Signor Dr. Giovanni Dr. Vianelli Canonico della Cattedrale di Chioggia. Venice, 1790.

Cento scene di vita veneziana. Pietro Longhi e Gabriel Bella alla Querini Stampalia. Edited by G. Busetto. Venice, 1995.

Constable, W.G. *Canaletto. Giovanni Antonio Canal 1697 – 1768.* Oxford, 1962 (2nd edition revised and expanded by J.G.Links. Oxford, 1976: 3rd edition revised and expanded by J.G. Links. Oxford, 1988).

Corboz, A. "Sur la pretendue objectivité de Canaletto." *Arte Veneta*, 1974.

——. *Canaletto. Una Venezia immaginaria.* Milan, 1985.

Delogu, G. *Pittori veneti minori del Settecento.* Venice, 1930.

De Seta, C. *Storia d'Italia. Il Paesaggio.* "L'Italia nello specchio del 'grand tour.'* Turin, 1982.

De Zucco, L. *Arte in Friuli Arte a Trieste.* "Per Antonio Stom, pittore veneto del Settecento," 1976.

Donzelli, C. *Pittori veneti del Settecento.* Florence, 1957.

Dorigato, A. *L'altra Venezia di Giacomo Guardi,* (exh. cat.). Venice, 1977.

Favaro, E. *L'arte dei pittori in Venezia e i suoi statuti.* Florence, 1975.

Fiocco, G. "Giovanni Richter," *L'Arte*, 1932.

Fogolari, G. "Michele Marieschi pittore prospettico veneziano," *Bollettino d'Arte*, 1909.

——. "L'Accademia veneziana di Pittura e Scultura del Settecento," *L'Arte*, 1913.

Gambier, M., M. Gemin e E. Merkel, *I giochi veneziani del Settecento nei dipinti di Gabriel Bella,* (exh. cat.). Venice, 1978.

Garberson, E. *The Collection of the National Gallery of Art. Italian Paintings of the Seventeenth and Eighteenth Century.* New York and Oxford, 1996.

Giuseppe Bernardino Bison pittore e disegnatore. Edited by G. Bergamini, F. Magani and G. Pavanello. (exh. cat.). Milan, 1997.

The Glory of Venice. Edited by J. Martineau and A. Robison. (exh. cat.). London, 1994.

Goering, M. *Francesco Guardi.* Vienna, 1944.

Gradenigo, P. *Notizie d'arte tratte dai Notatori e dagli Annali del N.H. Pietro Gradenigo.* Edited by L. Livan. Venice, 1942.

Guardi. Metamorfosi dell'immagine, (exh. cat.). Treviso, 1987.

Guardi. Quadri turcheschi. (exh. cat.). Edited by A. Bettagno. Venice, 1993.

Haskell, F. "Stefano Conti, Patron of Canaletto and Others." *The Burlington Magazine.* 1956.

——. "Francesco Guardi as Vedutista and Some of his Patrons." *Journal of the Warburg and Courtauld Institutes*, 1960.

——. *Patrons and Painters*. London, 1963 (Italian edition, Florence, 1966; 2nd revised and expanded edition, London, 1980, and Florence, 1985).

Knox, G. "Four Canaletti for the Duke of Bolton." *Apollo*, 1993.

Konstens Venedig. (exh. cat.). Stockholm, 1963.

Kowalczyk, B.A. "Il Bellotto veneziano nei documenti," *Arte Veneta*, 1995.

——. "Il Bellotto veneziano: 'grande intendimento ricercasi,'" *Arte Veneta*, 1996.

Kozakiewicz, F. *Bernardo Bellotto*. Milan, 1972.

Kultzen, R., and M. Reuss, *Venezianische gemalde des 18. Jahrunderts*. Munich, 1991.

Lanzi, L. *Storia pittorica dell'Italia dal risorgimento delle Belle Arti fin presso la fine del XVIII secolo*. Bassano, 1795-96.

Lauts, J. *Staatliche Kunsthalle Karlsruhe. Katalog Alte Meister bis 1800*. Karlsruhe, 1966.

Levey, M. *National Gallery Catalogues. The Seventeenth and Eighteenth Century Italian Schools*. London, 1956 (2nd edition, London, 1971).

——. *Painting in 18th Century Venice*. London, 1959.

——. "The Eighteenth-Century Italian Paintings Exhibition at Paris: Some Corrections and Suggestions." *The Burlington Magazine*, 1961.

——. "Canaletto's Fourteen Paintings and Visentini's Prospectus Magni Canalis," *The Burlington Magazine*, 1962.

Links, J.G. *Canaletto and his Patrons*. New York, 1977.

——. *Canaletto*. Milan, 1981.

——. *Canaletto*. London, 1994.

Luca Carlevarijs e la veduta veneziana del settecento, Edited by D. Succi and I. Reale. (exh. cat.). Milan, 1994.

Magani, F. *Giuseppe Bernardino Bison*. Soncino, 1993.

——. *Giuseppe Bernardino Bison (1762 – 1844)*. Padua, 1998.

Magrini, M. "Pietro Maria Guarienti: un profilo." *Arte/Documento*, 1993.

Magugliani, L. *La pittura del giovane Canaletto (fino al 1728)*. Milan, 1976.

Mangini, N. *I teatri di Venezia*. Milan, 1974.

Manzelli, M. "Ulteriori notizie su Francesco Albotto, erede di Michele Marieschi," *Arte Veneta*, 1984.

——. "Proposta per l'identificazione di Michele Marieschi e del suo alter-ego Francesco Albotto," *Arte Veneta*, 1987.

——. *Michele Marieschi e il suo alter-ego Francesco Albotto*. Venice, 1991.

——. *Antonio Joli. L'opera pittorica*. Venice, 1999.

Marieschi tra Canaletto e Guardi, Edited by D. Succi (exh. cat.). Turin, 1989.

Mariette, P.J. "Abecedario ... ouvrage publié par Ph. De Chennevières et A. De Montaiglon," *Archives de l'Art Francais*. Paris, 1851-1860.

Marini, G. "'Con la propria industria e sua professione.' Nuovi documenti per la giovinezza di Bernardo Bellotto." *Verona Illustrata*, 1993.

Mariuz, A. "Luca Carlevarijs: 'L'ingresso solenne dell'Abate de Pomponne.'" *Arte Veneta*, 1994.

Martini, E. *La Pittura veneziana del Settecento*. Venice, 1964.

——. *Pittura veneta dal Ricci al Guardi*. Venice, 1977.

——. *La pittura del Settecento veneto*. Udine, 1982.

——. "Note e precisazioni sul vedutista Johann Richte." *Arte Documento*, 1994.

——. "Gaetano Vetturali e Apollonio Domenichini tra gli altri vedutisti minori del Settecento veneto." *Arte Documento*, 2001.

Mattioli Rossi, L. "Collezionismo e mercato dei vedutisti nella Venezia del Settecento," *Ricerche di Storia dell'Arte*, 1980.

Mauroner, F. *Luca Carlevarijs*. Padua, 1945 (2nd ed.).

——. "Collezionisti e vedutisti settecenteschi in Venezia." *Arte Veneta*, 1947.

Mazza, B. "La vicenda dei 'Tombeaux des Princes:' matrici, storia e fortuna della serie Swiny tra Bologna e Venezia." *Saggi e Memorie di Storia dell'Arte*, 1976.

Millar, O. *Canaletto. Paintings and Drawings*. (exh. cat.). London, 1980-81.

Montecuccoli degli Erri, F. "Committenze artistiche di una famiglia emergente: i Giovanelli e la villa di Noventa Padovana," *Atti dell'Istituto Veneto di Scienze, Lettere ed Arti*, 1993.

——. "Il Console Smith. Notizie e documenti," *Ateneo Veneto*, 1995.

——. "Sebastiano Ricci e la sua famiglia. Nuove pagine di vita privata," *Atti dell'Istituto Veneto di Scienze, Lettere e Arti*, 1995.

——. "Venezia 1745 – 1750. Case (e botteghe) di pittori, mercanti di quadri, incisori, scultori, architetti, musicisti, librai, stampatori ed altri personaggi veneziani." *Atti e Memorie dell'Ateneo Veneto*, 1998.

——. "Novità su alcuni pittori immigrati a Venezia nel Settecento e sui loro contatti professionali (Battaglioli, Joli, Zompini, Zuccarelli e altri)." *Arte Veneta*, forthcoming.

—— and F. Pedrocco, *Michele Marieschi. La vita, l'ambiente, l'opera*. Milan, 1999.

Morassi, A. "Considerazioni sull'inizio del Canaletto," *"Venezia e l'Europa," Atti del XVIII Congresso Internazionale di Storia dell'Arte*. Venice, 1955.

——. "Preludio per Antonio Stom detto 'il Tonino.'" *Pantheon*, 1962.

——. "La giovinezza di Canaletto." *Arte Veneta*, 1966.

——. *Profilo di Michele Marieschi*. (exh. cat.). Bergamo, 1966.

——. "Anticipazioni per il vedutista Jacopo Fabris." *Arte Veneta*, 1966.

——. "Giambattista Cimaroli collaboratore del Canaletto." *Arte Veneta*, 1972.

——. *Guardi. Antonio e Francesco Guardi*. Milan, 1973.

Moschini, G.A. *Della letteratura veneziana del secolo XVIII fino ai giorni nostri*. Venice, 1806.

——. *La Chiesa e il Seminario della Salute*. Venice, 1842.

Mosco, M. "Minori del settecento veneto. Jacopo Fabris." *Arte Illustrata*, 1974.

Mostra della pittura italiana del Seicento e del Settecento. (exh. cat.). Edited by N. Tarchiani. Florence, Rome, 1922.

Mostra di antichi maestri pittori italiani ed europei XV – XVIII secolo. Vicenza, 2000.

Mucchi, L., and A. Bertuzzi. *Nella profondità dei dipinti*. Milan, 1983.

Muraro, M. "Giacomo Guardi." *Coloquio Artes*, 1974.

Nappi, M. *Francois De Nomé e Didier Barra, l'enigma di Monsù Desiderio*. Milan-Rome, 1991.

Nepi Scirè, G. *Il quaderno del Canaletto*. Venice, 1997.

Olsen, H. *Italian Paintings and Sculpture in Denmark*. Amsterdam, 1961.

Orlandi, P.A. *Abecedario pittorico ...*, Bologna, 1704 (2nd edition edited by P. Guarienti, Venice, 1753).

Ottocento di frontiera. (exh. cat.). Gorizia, Milan, 1995.

Pallucchini, R. *La pittura veneziana del Settecento*. MA thesis, Università degli Studi di Bologna, 1951-52.

——. *La pittura veneziana del Settecento*, Venice – Rome, 1960.

——. "La triplice mostra canadese del Canaletto." *Arte Veneta*, 1964.

——. "Note sulla mostra dei Guardi." *Arte Veneta*, 1965.

——. *Francesco Guardi. Fundacao Gulbenkian Lisboa*. Lisbon, 1965.

——. "Considerazioni sulla mostra bergamasca del Marieschi." *Arte Veneta*, 1966.

——. "I vedutisti veneziani del Settecento." *Atti dell'Istituto Veneto di Scenze, Lettere ed Arti.* 1966-67.

——. "Appunti per il vedutismo veneziano del Settecento," *Muzeum i Twòrca: Studia z historij Sztuki i Kultury ku CZCI prof. Dr. Stanislawa Lorentza.* Warsaw, 1969.

——. "Francesco Albotto erede di Michele Marieschi" *Arte Veneta,* 1972.

——. "Per gli esordi del Canaletto." *Arte Veneta,* 1973.

——. "Risarcimento di Antonio Visentini." *Arte Veneta,* 1986.

——. *La pittura nel Veneto. Il Settecento.* Milan, 1995-96.

Parker, K.T. *The Drawings of Antonio Canaletto in the Collection of His Majesty the King at Windsor Castle.* Oxford-London, 1948 (2nd ed. edited by C. Crawley, Cittadella, 1990).

Pedrocco, F. "Qualche novità per Antonio, Francesco e Nicolò Guardi." *Fima Antiquari,* 1994.

——. *Canaletto e i vedutisti veneziani del Settecento.* Florence, 1995.

—— and F. Montecuccoli degli Erri. *Antonio Guardi.* Milan, 1992.

Peintres de Venise. De Titien à Canaletto dans les collections italiennes. (exh. cat.). Milan, 2000.

Pignatti, T. *Il quaderno dei disegni del Canaletto alle Gallerie di Venezia.* Milan, 1958.

——. "La Fraglia dei Pittori di Venezia." *Bollettino dei Musei Civici Veneziani.* 1965.

——. "Gli inizi di Bernardo Bellotto" *Arte Veneta.* 1968.

——. *Ventiquattro isole della laguna disegnate da Francesco Tirono e incise da Antonio Sandi.* Venice, 1974.

——. *Canaletto.* Milan, 1979.

——. "Per i disegni di Francesco Tironi." *Studi in onore di Giulio Carlo Argan.* Rome, 1984.

——. *Venezia, mille anni d'arte.* Venice, 1989.

——, A. Dorigato and F. Pedrocco. *Disegni antichi del Museo Correr di Venezia, Vol. III.* Vicenza, 1983.

Pilo, G.M. *Marco Ricci.* (exh. cat.). Bassano, 1963.

Povoledo, E. "La scenografia architettonica del Settecento a Venezia." *Arte Veneta,* 1951.

——. Entry on Canaletto, *Enciclopedia dello Spettacolo.* Rome, 1958.

Problemi guardeschi, acts of the international symposium. Venice, 1967.

Puppi, L. *L'opera completa del Canaletto.* Milan, 1968.

——. "La gondola del procuratore. Committenze e peripezie di collezione di quattro dipinti di Canaletto." *Bollettino dei Musei Civici Veneziani,* 1983-84.

Reale, I. "In margine alle origini del vedutismo veneto: Luca Carlevarijs e la macchietta." *Arte in Friuli Arte a Trieste,* 1982.

Riccoboni, A. *Prima mostra d'arte antica delle raccolte private veneziane.* Venice, 1947.

Rizzi, A. *Luca Carlevarijs.* Venice, 1967.

——. "Per Luca Carlevarijs." *Arte Veneta,* 1982.

Salerno, L. *I pittori di vedute in Italia (1580 - 1830).* Rome, 1991.

Scarpa Sonino, A. *Marco Ricci.* Milan, 1991.

Scene di vita veneziana di Gabriel Bella. Edited by G. Busetto. Milano, 1987.

Sgarbi, V. "Le impossibili ville." *FMR,* 1983.

——. *Venezia Felix. Gabriel Bella cronista della Serenissima.* Milan, 1984.

Spadotto, F. *Giovan Battista Cimaroli.* diss., Università di Venezia, 1997-98.

——. "Un artista dimenticato: Giovan Battista Cimaroli." *Saggi e Memorie di Storia dell'Arte,* 1999.

Splendori del Settecento Veneziano, (exh. cat.). Edited by G. Romanelli and G. Nepi Scirè. Milan, 1995.

Stefani Mantovanelli, M. "Note d'archivio su Francesco Tironi." *Arte Veneta,* 1969.

Succi, D. *Francesco Guardi. Itinerario dell'avventura artistica.* Milan, 1993.

Susinno, S. *La veduta nella pittura italiana.* Florence, 1974.

Terpitz, D. *Giovanni Antonio Canal, known as Canaletto 1697–1768.* Cologne, 1998.

Toledano, R. *Michele Marieschi. L'opera completa.* Milan, 1988 (2nd revised and expanded edition, Milan, 1995).

Vedute italiane del Settecento in collezioni private italiane. Edited by M. Magnifico and M. Utili. (exh. cat.). Milan, 1987.

Venedig Malerei des 18. Jahrhunderts. Edited by E. Steingraber. (exh. cat.). Munich, 1987.

Venezia da stato a mito. (exh. cat.). Venice, 1997.

Vertue, G. "Notebooks (1713 - 1751)." *Walpole Society.* Oxford, 1930-1938.

Vivian, F. *Il console Smith, mercante e collezionista.* Vicenza, 1971.

——. *La collezione del console Smith.* (exh. cat.). Milan, 1990.

Voss, H. "Francesco Tironi. Ein vergessener venezianischer Vedutenmaler." *Zeitschrift fur Bildende Kunst,* 1927-28.

——. "Francesco Guardi und Francesco Tironi." *Pantheon,* 1966.

Watson, F.J.B. *Canaletto.* London-New York, 1949.

——. "G.B. Cimaroli: A Collaborator with Canaletto." *The Burlington Magazine,* 1953.

Zampetti, P. *Mostra dei Guardi.* (exh. cat.). Venice, 1965.

——. *I vedutisti veneziani del Settecento.* (exh. cat.). Venice, 1967.

Zanetti, A.M. *Descrizione di tutte le pubbliche pitture della città di Venezia.* Venice, 1733.

——. *Della pittura veneziana e delle opere pubbliche de' veneziani maestri.* Venice, 1771.

Index

Photo Credits

Archives Filippo Pedrocco, p. 2, 7, 10, 14, 18, 19, 22, 23, 24, 25, 26, 28, 30, 31, 33 (top), 35, 36, 37, 38, 39, 40, 41, 45, 46, 47, 50-51, 52 (top), 55, 56, 58, 59, 60, 61, 62, 63, 64, 65,66, 67, 68, 69, 70, 72, 73, 75, 77, 79, 80, 81, 83, 84 (top), 86, 96, 97, 104, 105, 110, 114, 120, 123, 130, 132, 136, 137, 140, 141, 142, 143 (top), 144, 146, 150, 152, 153, 156-157, 161, 162-163, 168 (bottom), 169, 171, 172, 177 (bottom), 179, 181, 183, 184, 185, 187, 188, 190, 200-201, 206 (bottom), 207 (bottom), 209, 213, 214-215, 216, 217, 218, 220, 221, 222-223, 226, 227, 228-229, 230, 231

Archives RCS, p. 32, 33 (center), 76, 78, 93, 94-95, 98, 117, 193, 194 (top), 205, 217

Ashmolean Museum, Oxford, p. 54, 84 (bottom), 199, 210 (bottom)

Birmingham Museum & Art Gallery, p. 49 (bottom)

Blauel/Gnamm, Artothek, p. 158-159, 160, 203, 204 (top)

Osvaldo Böhm, Venice, p. 92

The Bridgeman Art Library, p. 116 (top), 173

Christie's Images, p. 135, 151, 191

© The Cleveland Museum of Art, Leonard C. Hanna, Jr., Fund, 1962.169, p. 139

Dallas Museum of Art, p. 81 (bottom)

Dulwich Picture Gallery, by permission of the Trustees of the Dulwich Picture Gallery, p. 116 (bottom)

Fitzwilliam Museum, University of Cambridge, p. 122

Fogg Art Museum, Harvard University Art Museums, Bequest of Grenville L. Winthrop, photo Katya Kallsen; © President and Fellows of Harvard College, Harvard University, p. 92

Fundação Calouste Gulbenkian – Museu, Lisbon, p. 208 (bottom), 209, 210 (top)

The J. Paul Getty Museum, p. 138

James Philip Gray Collection, Museum of Fine Arts, Springfield (Mass.), p. 141 (bottom)

Kunsthistorisches Museum, Vienna, p. 143 (bottom)

Museo Civico L. Bailo, Treviso, p. 33 (bottom)

Museo del Prado, Madrid, p. 44 (bottom)

Museo Thyssen-Bornemisza, Spain, p. 168 (top)

Museum of Fine Arts, Boston, p. 16, 106

© The National Gallery, London, p. 4-5, 12-13, 100-101, 111, 118, 119, 206 (top)

National Gallery of Art, Washington, pp. 109, 176, 177 (top)

National Gallery of Canada, Ottawa, p. 133, 134

Nationalmuseum, Stockolm, photo Erik Cornelius, p. 63, 198 (bottom)

The National Trust Photo Library, London, p. 154

The Nelson-Atkins Museum of art, Kansas City, Missouri, photo Mel McLean, p. 90-91

North Carolina Museum of Art, Raleigh, p. 163

© Rijksmuseum Amsterdam, p. 42, 49 (top)

Photo RMN – Béatrice Hatala, p. 208 (top)

Photo RMN – Hervé Lewandowski, p. 164, 204 (bottom), 207 (top)

The Royal Collection © HM Queen Elizabeth II, p. 87, 89, 115, 121

Scala, Florence, p. 8-9, 20-21, 44 (top), 99, 102-103, 107, 108, 112-113, 148, 162, 166-167, 194 (bottom), 195, 196, 198 (top), 202, 212

Sotheby's Transparency Library, p. 224, 225

Staatliche Kunsthalle Karlsruhe, p. 174, 186

Staatliche Museen zu Berlin – Preussischer Kulturbesitz Gemäldegalerie, photo Jörg P. Anders, p. 124, 126-127, 128, 129 (top), 211

Stiftung Preussiche Schlösser und Gärten Berlin-Brandeburg, Potsdam, p. 52 (bottom), 53

© Elke Walford, Fotowerkstatt, Hamburger Kunsthalle, p 129 (bottom)

The publishers are open to claims regarding those images for which it was not possible to determine the reproduction rights.